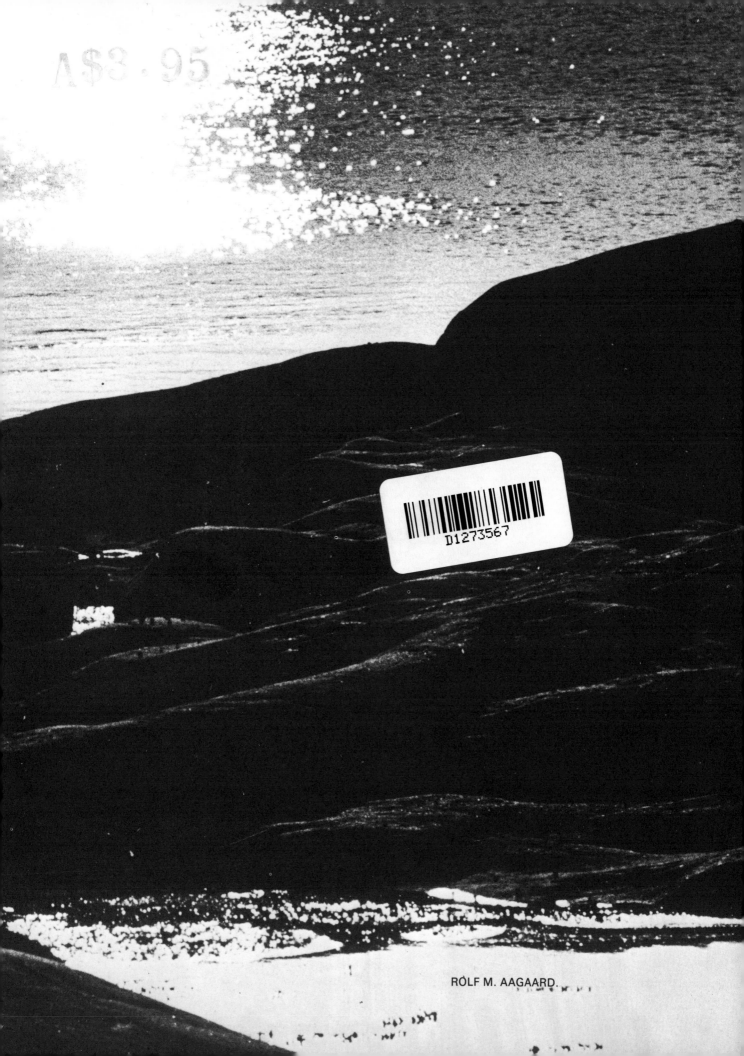

ROLF M. AAGAARD.

Photography Year Book 1974

Edited by JOHN SANDERS

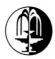

Published by FOUNTAIN PRESS

Model and Allied Publications Limited, 13-35 Bridge Street, Hemel Hempstead, Hertfordshire, England

© Fountain Press 1973 ISBN 0 85242 341 1

Printed in England by W. S. Cowell Ltd. Bound in England by The Pitman Press

Contents

Inhalt

Table des Matières

The Photographers

Editor's Introduction

Life Goes On

Two items of considerable significance to anyone interested in photography received considerable press comment at the time of writing this introduction. The first of these concerned three albums of photographs (containing 258 calotypes) by the Scottish photographers David Octavius Hill and Robert Adamson which had been entrusted to the Royal Academy of Art by Hill himself in 1848. The current President, Sir Thomas Monnington, was reported as saying that the Academy needed money for a new extension to house a painting by Michelangelo and that these photographs seemed the best things to sell! Unfortunately for Sir Thomas, he failed to anticipate the storm of protest that followed the announcement, voiced by individuals and by representatives of other institutions such as the Royal Photographic Society and the National Portrait Gallery, and rather belatedly, it dawned on the Royal Academy of Art that public interest in the work of pioneer photographers was greater than its officials had calculated, at which it postponed the sale in order to allow time for funds to be raised to keep the collection in Britain.

The second item was the sad news that *Life* magazine was to close. Although this was not altogether unexpected due to big increases in American postal rates and increased expenditure by advertisers on television, the shocked tones of some press comment on the closure seemed to imply that photography itself (or at least the dramatic and emotive type of picture or picture sequence that *Life* specialised in) was also about to draw its last breath.

Admittedly *Life* was, at that particular point in the history of journalism the last of the big English language picture magazines (and we are still the poorer by its passing) but perhaps one quote that 'no magazine has the right to appear indefinitely and that once it has outlived its time it should go' was the only realistic attitude to adopt towards the demise of one particular communications vehicle at the dawn of a new era in information storage and retrieval.

However we may also regard the apparent indifference of an Academy devoted to painting, drawing and sculpture to another visual medium deemed outside its scope, we must return to the only issue of any consequence, namely that while the paint brush, camera, printing press and cathode ray tube are all tools for communication, it is what they actually communicate that matters and to what extent this may, on occasion, be considered as art.

The classic reply to the question, is photography an art form? (No, but some photographers are artists) should have cleared up any confusion over medium and content for all time, for if art exists it can only do so in the mind. We see, therefore we think, and only through photography can images be frozen in the blink of a camera shutter. For most of us it is easy enough to see and equally easy to freeze what we see on film with the cameras now available. It could be argued (and is) that every snapshot ever taken was, in some respect, creative photography. Yet this would be to ignore the fact that few people can see anything that is new until it has been pointed out to them and that even fewer can see old familiar things in a new way.

To do so successfully demands a blend of intellectual curiosity, inspiration, experience, dedication, fast reflexes and sometimes great courage, that is extremely rare – and nowhere more than in the medium of photography which is so much closer to life than older forms of visual expression.

This might be one answer to critics who have suggested that previous editions of PHOTOGRAPHY YEAR BOOK have contained too much photo-journalism of a harrowing nature, for although gifted amateurs possessing all the foregoing qualities regularly send in excellent work from every corner of the globe, it is the professionals, such as *Life* employed, who have the facilities to get in closest – and who have the proven talent to take full advantage of them. It is they, more than any group, who most fully express the comment made by Edward Steichen on his ninetieth birthday: 'I think photography's principal function is to explain man to man, and to himself'.

A similar concept was put in rather more flamboyant terms by Henry R. Luce in 1936 in his original prospectus for *Life* magazine:

1 THOMAS GRANT

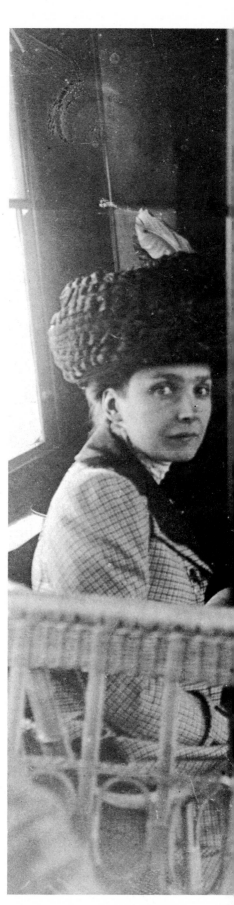

2 BERNARD GRANT

'To see life; to see the world; to eye-witness great events; to watch the faces of the poor and the gestures of the proud; to see strange things – machines, armies, multitudes, shadows in the jungle and on the moon; to see man's work – his paintings, towers and discoveries; to see things thousands of miles away, things hidden behind walls and within rooms; things dangerous to come to; the women that men love and many children; to see and take pleasure in seeing; to see and be amazed; to see and be instructed. Thus to see, and to be shown, is now the will and new expectancy of half mankind'.

after forty-two years service as a photographer, special correspondent and, for many years, picture editor. With his brother Horace and his youngest brother Bernard (who died of a lung disease contracted while on a photo assignment overseas the year before *Life* was born) he travelled the world with the cumbersome press cameras of the time obtaining marvellous pictures of almost everything described in the *Life* manifesto – only to see them reproduced on coarse screen newsprint which did little or no justice to the quality of the original prints.

Now that the present generation of

Während an diesem Jahrbuch gearbeitet wurde, erschienen in der Presse zwei Meldungen, die bei allen Freunden der Fotografie Aufsehen erregten. Die erste behandelte drei Fotoalben mit insgesamt 258 Kalotypien der schottischen Fotografen David Octavius Hill und Robert Adamson, die im Jahre 1848 von Hill persönlich der *Royal Academy of Art* vermacht worden waren. Nun wurde berichtet, der jetzige Präsident der Akademie, Sir Thomas Monnington, wolle die Alben verkaufen, da er Geld für die Erweiterung der Gemäldegalerie benötige. Ein Michelangelo

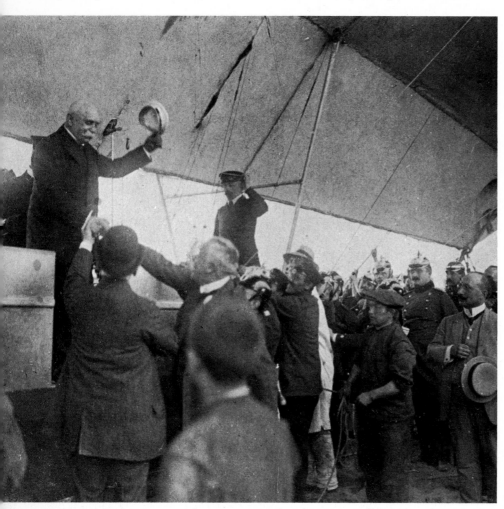

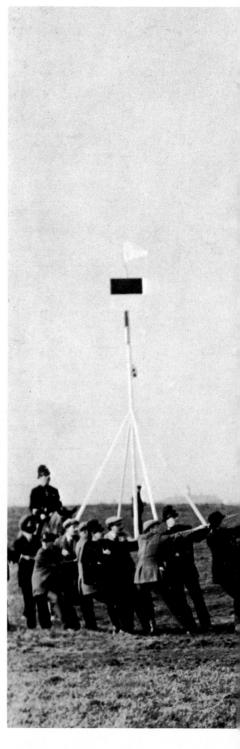

3 BERNARD GRANT 4/5 THOMAS GRANT

Life photographers certainly fulfilled this promise, but the magazine's greatest contribution to visual communication was its use of new techniques in process reproduction, printing and layout which gave even greater impact to the pictures used. It may be this which gave rise to the impression that *Life* somehow 'invented' photojournalism, but a glance at the pictures which accompany this text should prove that such was not the case. All are by one or other of the remarkable Grant Brothers who worked for the *Daily Mirror* in the years immediately before, and after the first world war. The eldest, Thomas Grant, joined the paper in 1905 and retired

photographers have increasing opportunities to appreciate that their grandfathers were capable of producing much more than stiff family portraits or salon exercises in stylised sentimentality, we think that many of the pictures in Photography Year Book 1974 will indicate that those who took them must have benefited in many ways from the treasure house of past photographic experience and, having seen and captured things that would have amazed their predecessors beyond belief (thanks to no less astonishing technical advances in cameras lenses and films) have thereby managed to reveal the world to itself in even sharper focus.

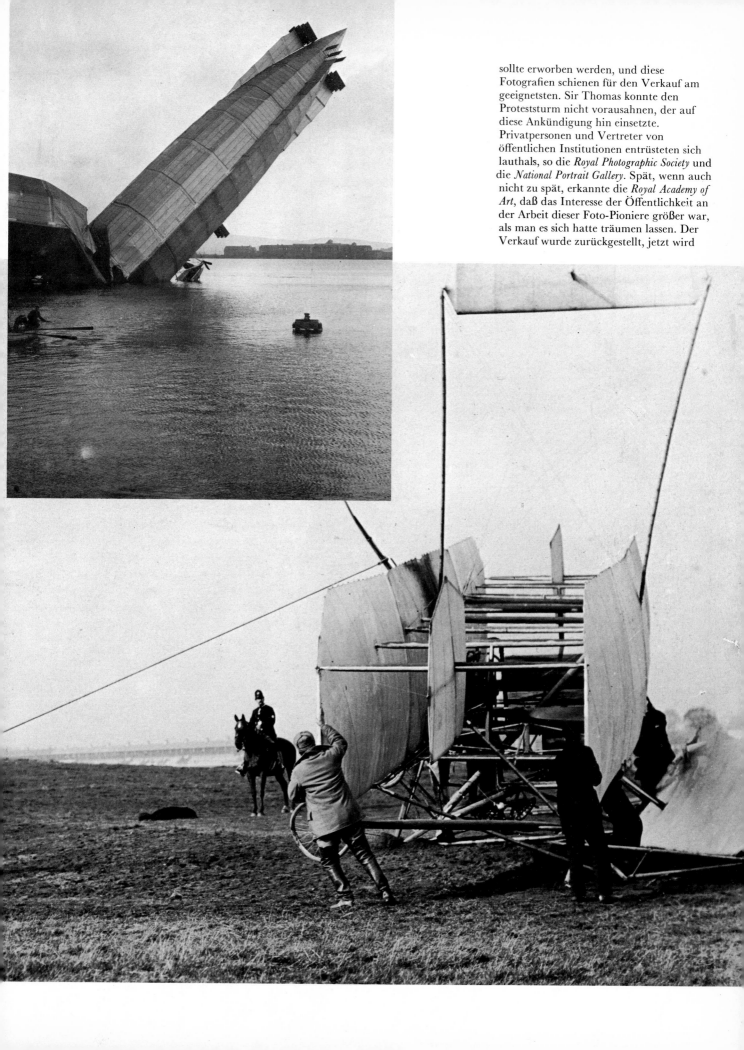

sollte erworben werden, und diese Fotografien schienen für den Verkauf am geeignetsten. Sir Thomas konnte den Proteststurm nicht vorausahnen, der auf diese Ankündigung hin einsetzte. Privatpersonen und Vertreter von öffentlichen Institutionen entrüsteten sich lauthals, so die *Royal Photographic Society* und die *National Portrait Gallery*. Spät, wenn auch nicht zu spät, erkannte die *Royal Academy of Art*, daß das Interesse der Öffentlichkeit an der Arbeit dieser Foto-Pioniere größer war, als man es sich hatte träumen lassen. Der Verkauf wurde zurückgestellt, jetzt wird

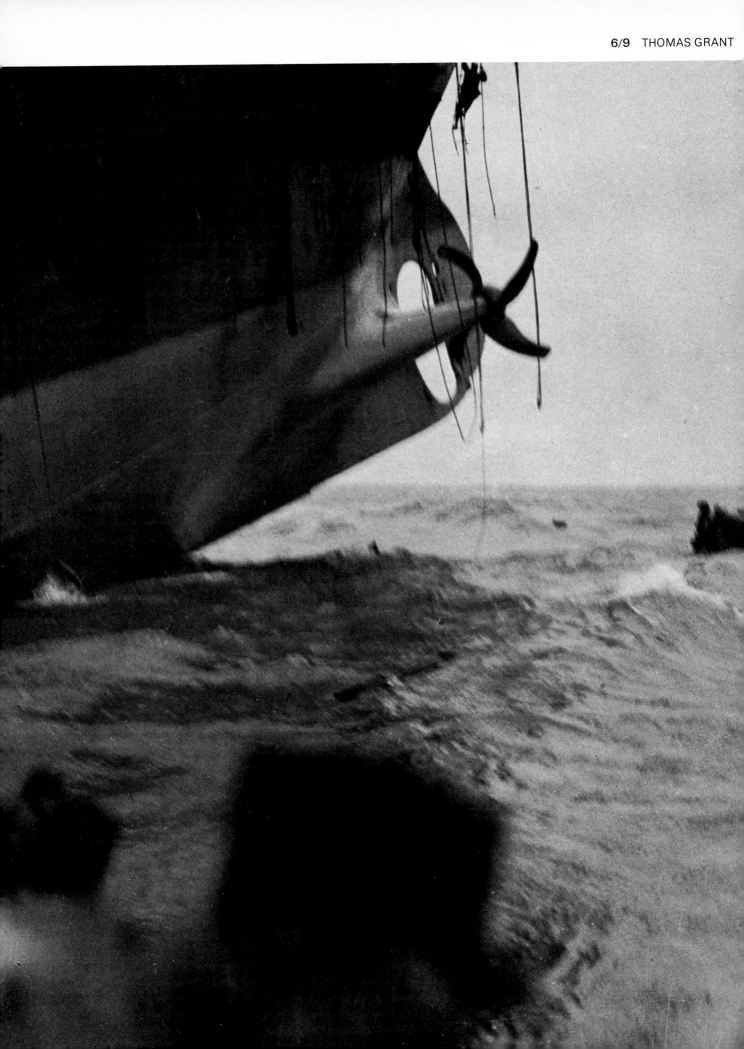

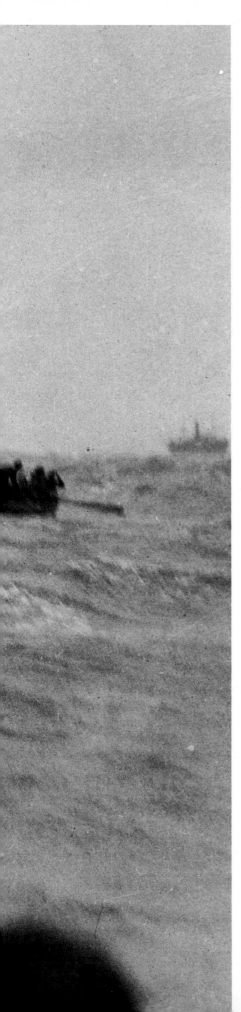

nach Mitteln und Wegen geforscht, die es
ermöglichen, daß diese Sammlung in
England bleiben kann.

Die zweite Nachricht war umso trauriger,
da sie endgültig war: *Life* stellte ihr
Erscheinen ein. Das kam nicht unerwartet,
da die Postgebühren in den USA stark
gestiegen waren und ein großer Teil der
Werbemittel zum Fernsehen abwanderte.
Trotzdem wurde von einigen schockierten
Kommentatoren das Ende der Fotografie
prophezeit, zumindest das Ende der
dramatischen und erregenden Fotoreportage,
die *Life* immer wieder so glänzend vertreten
hatte.

Zugegeben: *Life* war in dieser Beziehung
das letzte große, englische Fotomagazin der
Zeitungsgeschichte. Daß es *Life* nicht mehr
gibt, hat uns arm gemacht – und doch war
der Kommentar vielleicht der einzig
realistische, der besagte, daß keine
Zeitschrift das Recht zum unbegrenzten
Erscheinen hat. Wenn sie sich selbst überlebt
hat, muß sie abtreten. Das Ableben eines
einzigen, wenn auch noch so liebenswerten,
,,Kommunikations-Vehikels", muß bei
Beginn des Zeitalters der elektronischen
Informationsspeicherung eben hingenommen
werden.

Wenn man die oben geschilderte
Gleichgültigkeit bedenkt, die ein
Kunstinstitut, das sich auf Gemälde,
Zeichnungen und Skulpturen spezialisiert
hat, gegenüber anderen visuellen Medien
außerhalb dieses Rahmens an den Tag legt,
muß man klar betonen: Pinsel, Kamera,
Druckmaschine und Laserstrahl sind
vorrangig Mittel zur Kommunikation.
Wichtig ist vor allem, was wirklich
mitgeteilt wird. Erst dann kann man die
Frage stellen, in welchem Umfang man es
als Kunst betrachten kann.

Die klassische Antwort auf die Frage, ob
Fotografie Kunst sei (,,Nein, aber viele
Fotografen sind Künstler!"), sollte eigentlich
alle Zweifel über dieses Medium für immer
beseitigt haben. Denn: wo Kunst existiert,
existiert sie nur in Gedanken. Wir sehen, und
wir denken über das Gesehene nach. Nur
mit Hilfe der Fotografie können visuelle
Eindrücke festgehalten und auch für andere
wieder sichtbar gemacht werden. Manchmal
wird der Standpunkt vertreten, daß jede
beliebige, irgendwann entstandene
Fotografie schon Kunst sei. Aber wird da
nicht übersehen, daß viele Menschen Neues
nicht beachten wenn sie nicht darauf
aufmerksam gemacht werden, und daß nur
wenige Menschen die alltäglichen,
gewöhnlichen Dinge in neuem Licht sehen
können?

Doch um das mit Erfolg zu praktizieren,
ist eine Kombination aus intellektueller
Neugier, Einfallsreichtum, Erfahrung,
Engagement, rascher Auffassungsgabe und
manchmal großem Mut nötig, die jedoch
sehr selten anzutreffen ist. Nötig, nirgendwo
mehr, als beim Medium Fotografie, das dem
lebendigen Leben näher ist, als alle
traditionellen Formen der bildenden Künste.

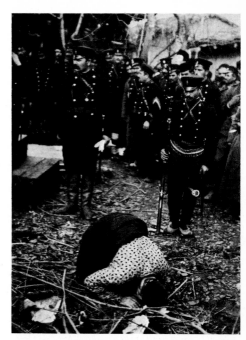

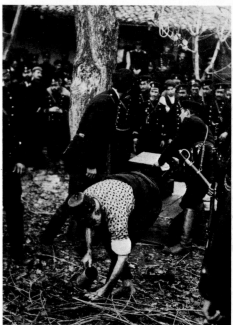

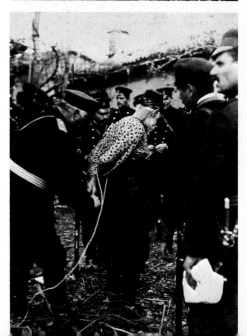

Das, als Antwort auf einige kritische
Stimmen, die meinten, daß in den früheren
Ausgaben des Foto-Jahrbuchs zu viel
engagiert-kritischer Fotojournalismus
vertreten gewesen sei. Obwohl begabte
Amateure, die mit allen oben aufgezählten
Eigenschaften ausgestattet sind, uns
regelmäßig aus allen Himmelsrichtungen
ausgezeichnete Arbeiten einsandten, so
fingen doch die Professionellen – wie die, die
für *Life* arbeiteten – das Leben am
direktesten ein. Sie haben ungezählte
Möglichkeiten dazu und sie bewiesen auch
die Fähigkeit, diese Möglichkeiten
wahrzunehmen und auszunutzen. Sie sind es,
die mehr als jede andere Gruppe
verwirklichen, was Edward Steichen an
seinem 90. Geburtstag sagte: „Ich denke, die
erstrangige und prinzipielle Funktion der
Fotografie ist es, dem Mitmenschen und sich
selbst ‚den Menschen‘ verständlich zu
machen.“

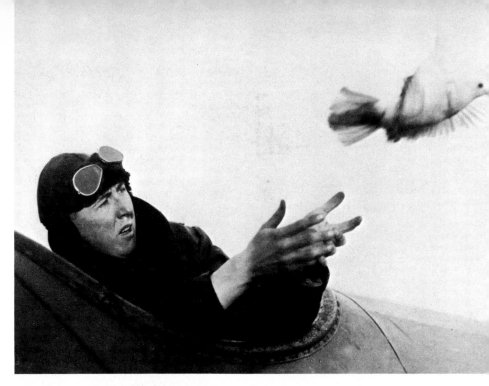

Henry R. Luce drückte in flammenden
Worten ähnliches aus. Hier ein Zitat aus
seiner Ankündigung für *Life*, 1936: „Sieh das
Leben, sieh die Welt! Sei Augenzeuge großer
Ereignisse, sieh die Gesichter der Armen und
die Gesten der Stolzen! Sieh das Fremde,
das Neue und das Unheimliche: Maschinen,
Armeen, Menschenansammlungen. Schatten
im Dschungel und auf dem Mond. Sieh das
Werk des Menschen: seine Gemälde, seine
Festungen und Entdeckungen. Sieh Dinge,
die tausende von Meilen entfernt sind; sieh
die von allen Männern begehrte Frau, sieh
die Kinder der Welt. Sieh um des Vergnügens
willen, sieh um zu lernen. Zu sehen, und
gesehen zu werden – das ist jetzt das
Bedürfnis und die Erwartung der halben
Menschheit.“

Die Fotografen von *Life* haben diese
Erwartungen sicher nicht enttäuscht. Aber
den bedeutendsten Beitrag zur visuellen
Kommunikation schuf *Life* mit seinen neuen
Verfahrenstechniken in der Reproduktion,
im Druck und im Layout, die Wirkung und
Eindringlichkeit der abgedruckten Fotos
noch steigerten. Das mag auch der Anlaß
zur Vermutung sein, daß *Life* den
Fotojournalismus erfunden habe. Aber schon
der erste Blick auf die im Vorwort
abgedruckten Bilder beweist, daß es nicht
so war. Diese Bilder stammen alle von den
Gebrüdern Grant, die vor und während des
1. Weltkrieges beim *Daily Mirror* in London
arbeiteten. Der Älteste, Thomas Grant,
begann dort 1905 und ging nach 42
Jahren in Pension. Er war Fotograf,
Sonderkorrespondent und lange Jahre
Bildstellenleiter. Mit seinen jüngeren Brüdern
Horace und Bernard (er starb an einer
Lungenkrankheit, die er sich bei einer
Fotoreise in Übersee zugezogen hatte –
1 Jahr bevor *Life* geboren wurde) reiste er
durch die Welt. Mit den unförmigen,
schweren Kameras dieser Zeit machten sie

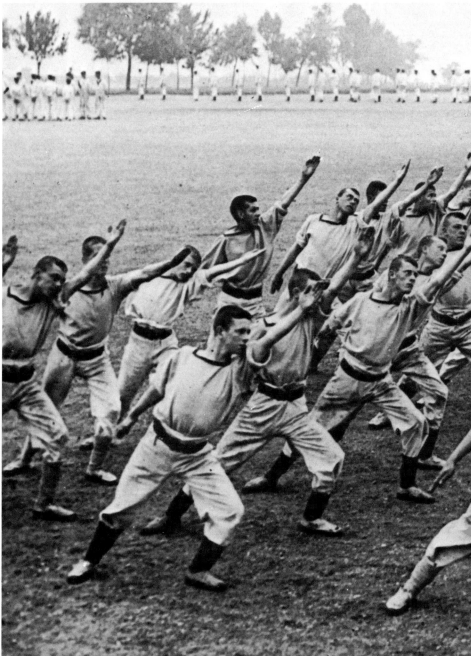

10/11 BERNARD GRANT

Bilder von den meisten Dingen, die dann
später in der *Life*-Ankündigung beschrieben
wurden. Um sie dann auf schlechtem
Zeitungspapier gedruckt zu sehen, das der
Qualität der Fotoabzüge wirklich nicht
gerecht wurde.

Die Fotografen unserer Zeit haben jetzt in
wachsendem Maße die Gelegenheit
festzustellen, daß ihre Großväter durchaus
mehr und besseres produzieren konnten, als
nur steife Familienbilder und Innen-
aufnahmen von stilisierter Sentimentalität.
Viele Bilder in diesem Jahrbuch zeigen
anschaulich, daß ihren Urhebern die
Erfahrungen und Experimente der
Vergangenheit zugute kamen. Sie haben
jetzt Dinge gesehen und festgehalten, die
ihre Vorgänger noch in große Verwunderung
versetzt hätten (was auch den nicht weniger
wunderbaren technischen Fortschritten bei
Kamera, Linse und Film zu verdanken ist)
und sie haben es geschafft, die Welt aus noch
schärferem Blickwinkel zu sehen.

A la date de rédaction de cette introduction,
deux événements d'une grande importance
pour quiconque s'intéresse à la photographie
ont été largement commentés dans la presse.
Le premier concerne trois albums de
photographies (contenant 258 calotypes) par
les photographes écossais David Octavius
Hill et Robert Adamson qui avaient été
remis à la Royal Academy of Art par Hill
lui-même en 1848. Le président, Sir Thomas
Mornington, aurait déclaré que l'Académie
ayant besoin de fonds pour la construction
d'une nouvelle salle destinée à abriter une
peinture de Michelange, ce qu'il y avait de
nieux à faire était de vendre ces
photographies! Malheureusement pour Sir
Thomas, il n'avait pas prévu le torrent de
protestations qui suivirent cette déclaration,
protestations émises tant par des particuliers
que par les représentants d'autres institutions
telles que la Royal Photographic Society et la
National Portrait Gallery, et c'est un peu
tard que la Royal Academy of Art s'est rendu

compte que l'intérêt du public pour l'oeuvre
des pionniers de la photographie était plus
grand que ne l'avaient supposé les
responsables de l'Académie, et devant ce fait,
la vente a été reportée afin de donner le
temps de rassembler des fonds qui
permettront de conserver cette collection en
Grande-Bretagne.

Le second évènement est la triste nouvelle
de la cessation de Life Magazine. Bien que
l'on ait pu s'y attendre étant donné la
hausse des tarifs postaux en Amérique et
l'importance accrue de la publicité à la
télévision, le ton navré de certains
commentaires de presse consacrés à la
disparition de ce magazine semblait impliquer
que la photographie elle-même (du moins la
photographie ou séquence photographique
du genre spectaculaire et émotionnel qui
était la spécialité de Life) était sur le point de
rendre son dernier souffle.

Il est certain qu'à ce point précis de
l'histoire du journalisme, Life était le dernier

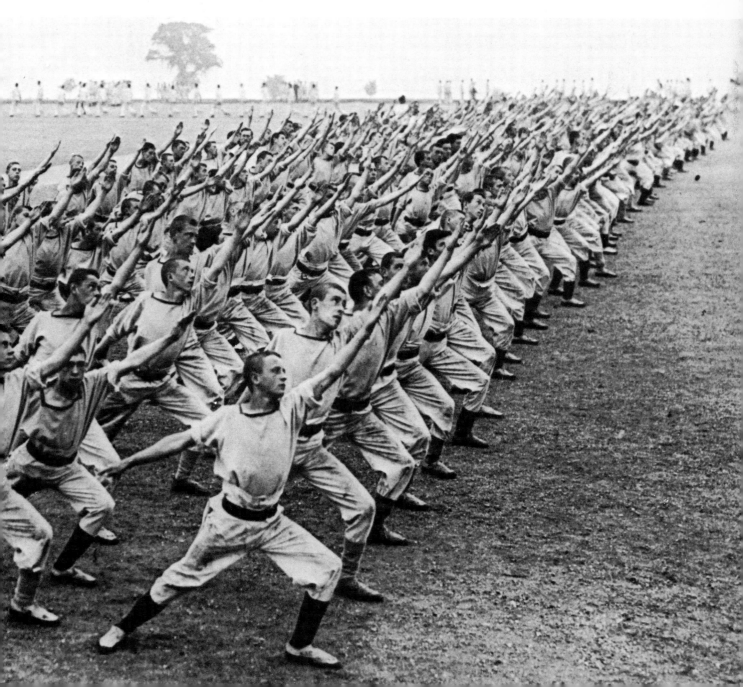

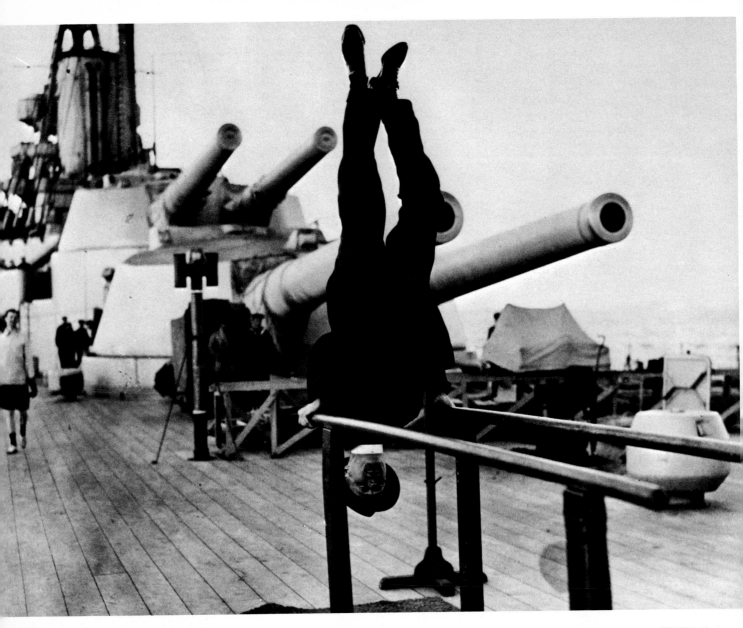

des grands magazines illustrés de langue anglaise (et sa disparition ne fait que nous appauvrir), mais peut-être cette remarque « aucun magazine n'a le droit de paraître indéfiniment et quand il a fait son temps il doit disparaître » indiquait-elle la seule attitude réaliste à adopter devant la disparition d'un certain moyen de communication à l'aube d'une nouvelle ère dans l'emmagasinage de données.

Quelle que soit également la façon dont nous considérons l'apparente indifférence d'un Institut consacré à la peinture, au dessin et à la sculpture pour un autre moyen visuel, nous devons toujours en revenir au seul point important, c'est-à-dire que le pinceau, l'appareil-photo, la presse à imprimer et le tube à rayon cathodique sont tous des instruments pour communiquer, que c'est ce qu'ils communiquent qui importe et dans quelle mesure cela peut parfois arriver à être considéré comme de l'art.

La réponse classique à la question, la photo est-elle une forme de l'art? (Non, mais certains photographes sont des artistes), devrait avoir éclairci pour toujours toute confusion sur le moyen et le contenu, car si l'art existe il ne peut exister que dans l'esprit. Nous voyons, donc nous pensons et ce n'est qu'au moyen de la photographie que les images peuvent être immobilisées par le déclic du diaphragme de l'appareil. Pour la plupart d'entre nous il est assez facile de voir et également facile avec les appareils-photo modernes d'immobiliser sur la pellicule ce que nous voyons. Il est possible d'avancer l'argument (et cela a été fait) selon lequel tout cliché est, d'un certain point de vue, de la photographie artistique, mais cela serait ignorer le fait que peu de gens sont réellement capables de voir une chose nouvelle avant qu'elle ait été portée à leur attention et que plus rares encore sont ceux qui peuvent voir les choses familières avec un oeil neuf.

Pour y parvenir il faut un mélange de curiosité intellectuelle, d'inspiration,

d'expérience, de vocation, de réflexes rapides et parfois une grand courage, toutes choses qui sont extrêmement rarement réunies, et nulle part ailleurs plus que dans la photographie qui est tellement plus proche de la vie que toutes les autres formes plus anciennes d'expression visuelle.

Il y a peut-être là une réponse aux critiques qui sont extrêmement rarement réunies, et de l'Annuaire Photographique étaient trop orientées vers le reportage photographique d'un caractère tragique, car si des photographes amateurs de talent possédant toutes les qualités énumérées ci-dessus envoient couramment des oeuvres excellentes des quatre coins du globe, ce sont les photographes professionnels, tels que ceux employés par Life, qui ont les moyens de s'approcher au plus près et qui ont prouvé qu'ils avaient la capacité de tirer tout le profit possible de ces moyens. Ce sont eux, plus qu'aucun autre groupe, qui illustrent le mieux cette réflexion d'Edward Steichen le

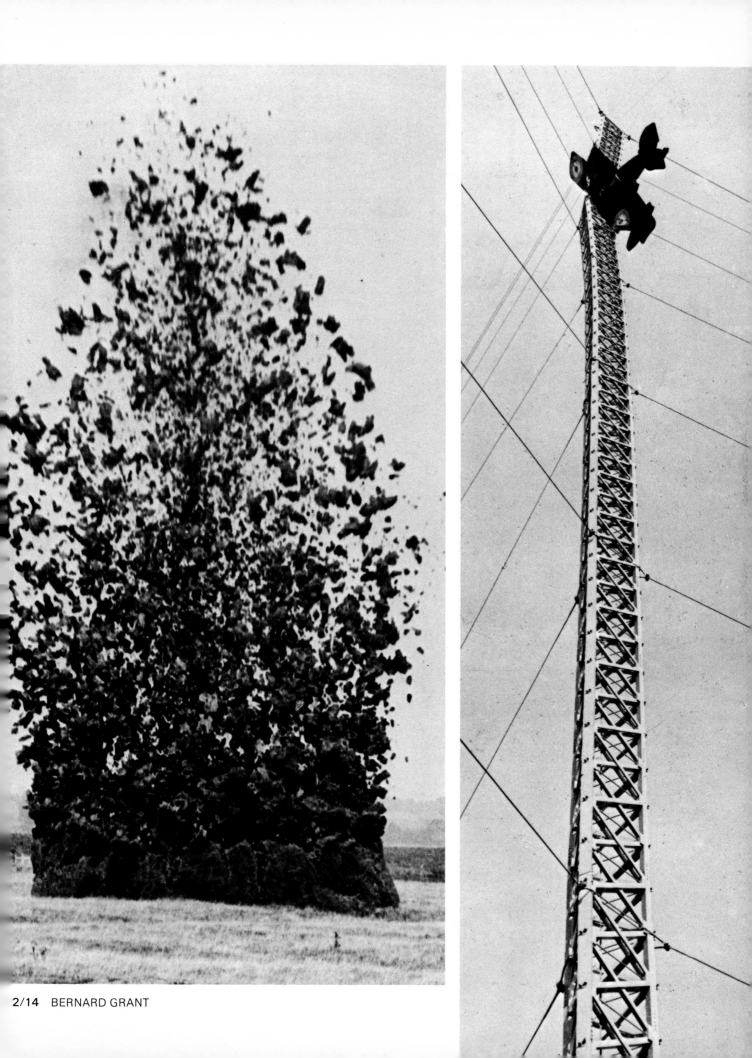

jour de son quatre-vingt dixième anniversaire:
«Je pense que la principale fonction de la
photographie est d'expliquer l'homme à
l'homme et à lui-même».

En 1936 dans le premier prospectus
annonçant le magazine Life, Henry R. Luce
exprimait cette même idée en des termes un
peu plus brillants «Découvrir la vie,
découvrir le monde; être le témoin visuel des
grands événements; voir les visages des
pauvres et les gestes des orgueilleux;
découvrir des choses étranges – machines,
armées, foules, ombres dans la jungle et sur
la lune; découvrir l'oeuvre de l'homme – ses
tableaux, ses tours et ses inventions;
découvrir ce qui se trouve à des milliers de
kilomètres, ce qui se cache derrière les murs
et dans l'intérieur des bâtiments: ce qu'il

15/16 HORACE GRANT

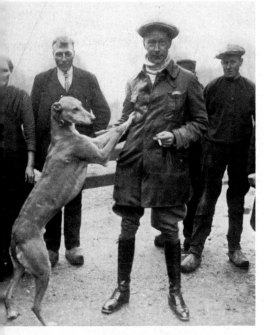

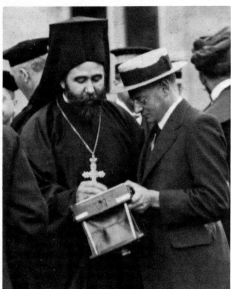

serait dangereux d'approcher; les femmes
que les hommes aiment et un grand nombre
d'enfants; découvrir et en tirer du plaisir;
découvrir et s'émerveiller; découvrir et
s'instruire. Ainsi découvrir, et se laisser
montrer, est désormais le désir et le nouvel
espoir de la moitié de l'humanité».

Les photographes de Life ont assurément
rempli cette promesse, mais la plus grande
contribution du magazine à la
communication visuelle a été l'utilisation
qu'il a faite des nouvelles techniques dans la
reproduction, l'impression et la mise en page
qui donnaient encore plus de force aux
photographies choisies. C'est peut-être ce qui
a donné naissance a cette idée que. Life avait
en quelque sorte «inventé» le reportage
photographique, mais il suffit de jeter un
coup d'oeil sur les photos qui accompagnent
ce texte pour voir qu'il n'en est rien. Toutes
ont été prises par l'un ou l'autre des
remarquables frères Grant qui travaillèrent
pour le Daily Mirror dans les années juste
avant le première guerre mondiale et celles
qui suivirent. L'aîné, Thomas Grant, entra
au journal en 1905 et se retira après
quarante-deux ans de service en tant que
photographe, envoyé spécial et, pendant de
nombreuses années, rédacteur artistique.
Avec son frère Horace et son plus jeune
frère Bernard (qui mourut d'une maladie
pulmonaire contractée lors d'un reportage
photographique à l'étranger l'année
précédant la naissance de Life) il parcourut
le monde avec l'encombrant équipement de
reportage de l'époque, prenant des
photographies merveilleuses de presque tout
ce qui est décrit dans le prospectus de Life –
pour les voir ensuite reproduites sur du
papier journal à la trame grossière qui
rendait peu ou pas du tout justice à la
qualité des épreuves originales.

Aujourd'hui où la présente génération de
photographes a de plus en plus l'occasion de
découvrir que nos grands-pères étaient
capables de produire bien autre chose que
des portraits de famille figés ou des exercices
de salon d'une sentimentalité stylisée, nous
pensons que beaucoup des clichés présentés
dans l'Annuaire photographique 1974
révéleront que ceux qui les ont prises ont dû
bénéficier de plusieurs façons du trésor de
l'expérience photographique des années
passées et, ayant vu et capturé des choses qui
seraient apparues à leurs prédécesseurs
comme des merveilles incroyables (grâce aux
progrès techniques non moins étonnants dans
les objectifs et les films) ont ainsi pu révéler
le monde à lui-même avec une mise au point
encore plus précise.

17 THOMAS GRANT

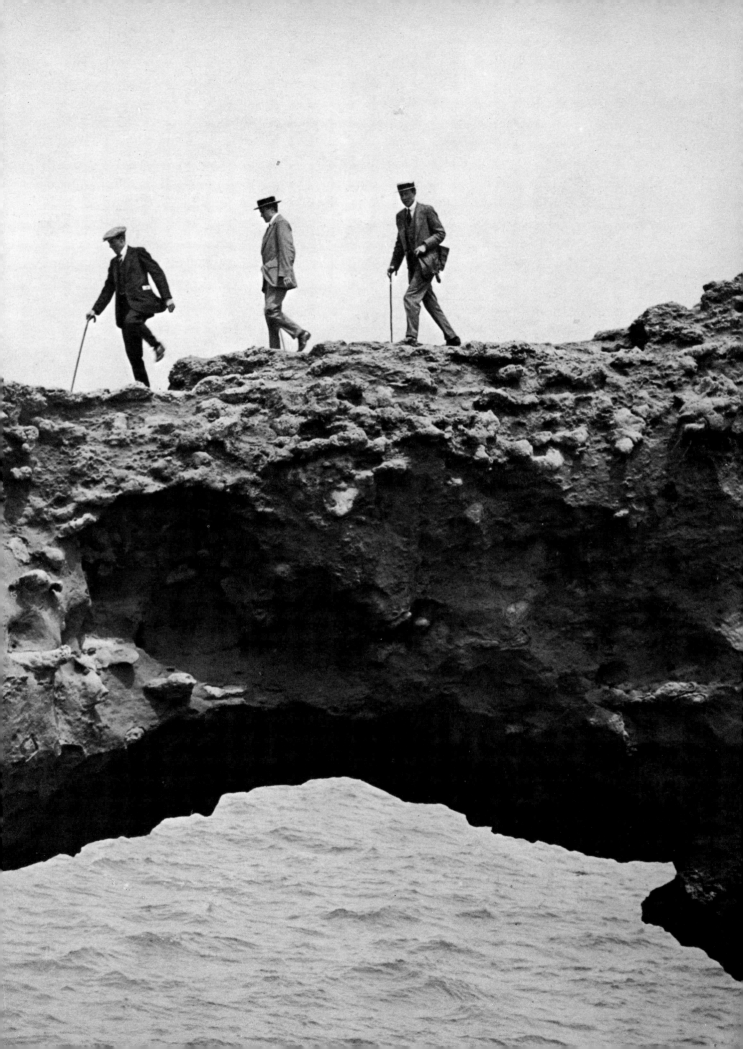

International Photography

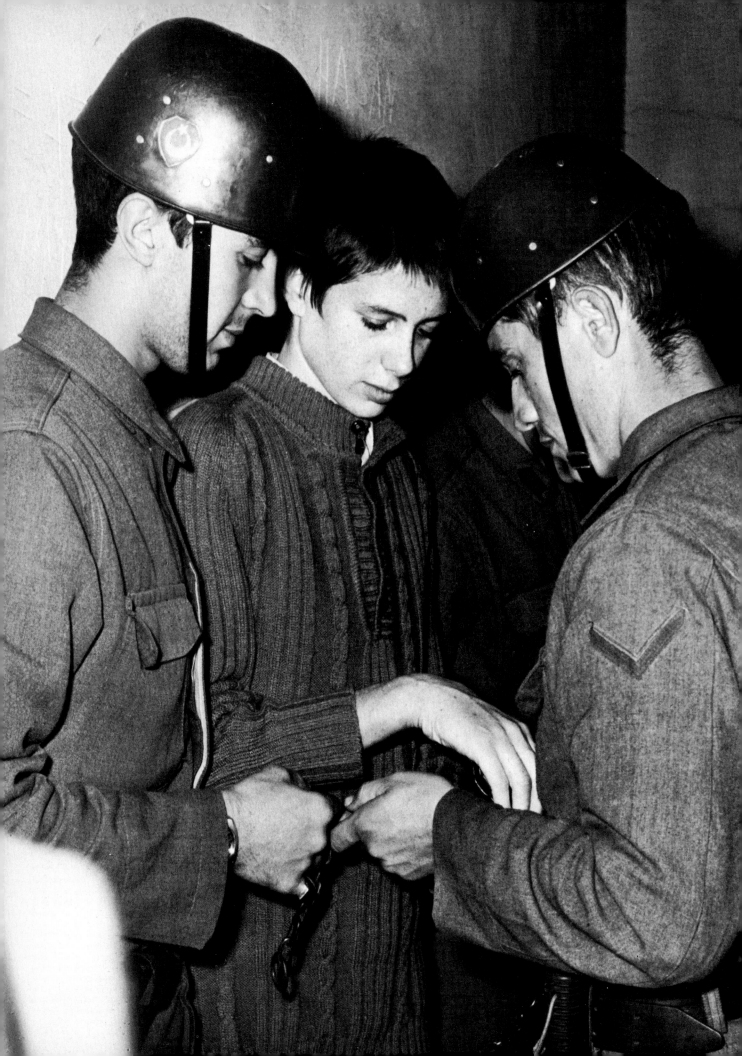

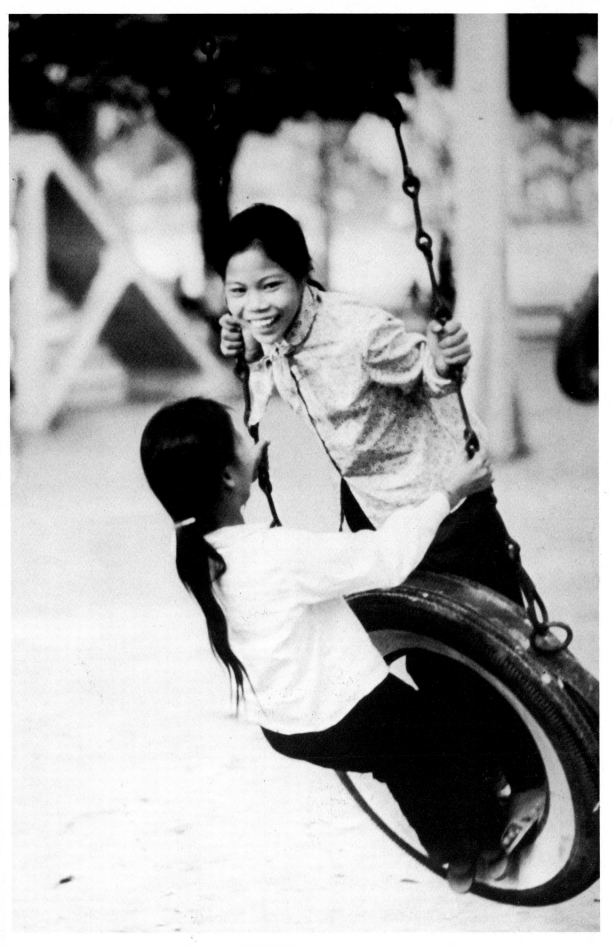

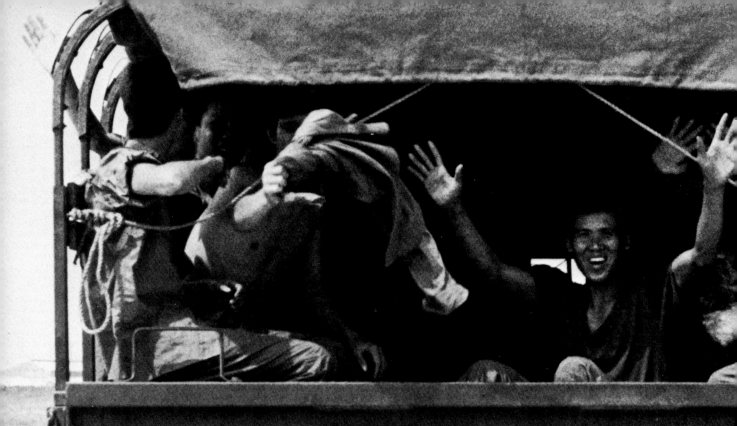

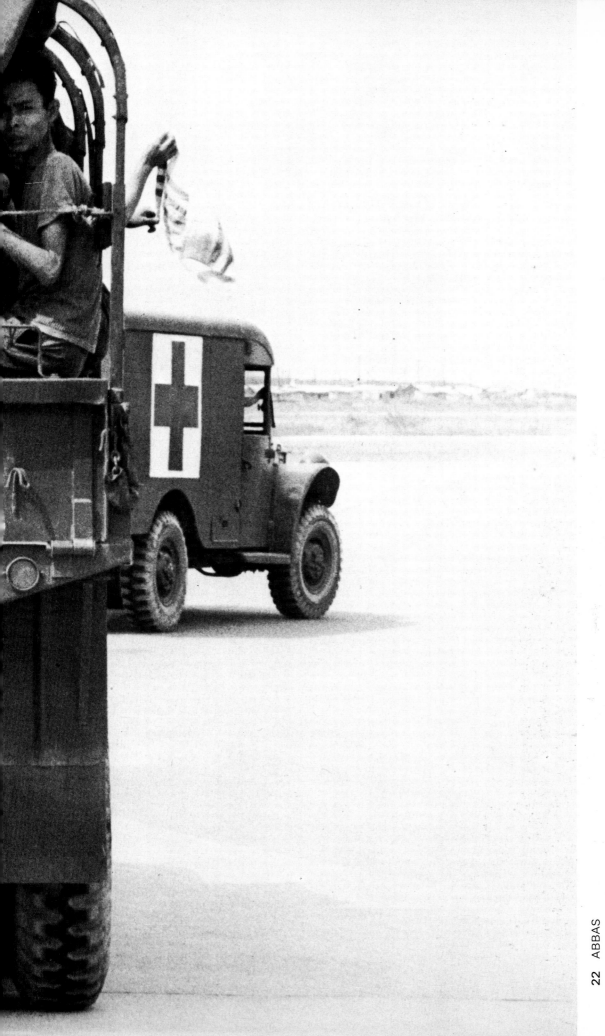

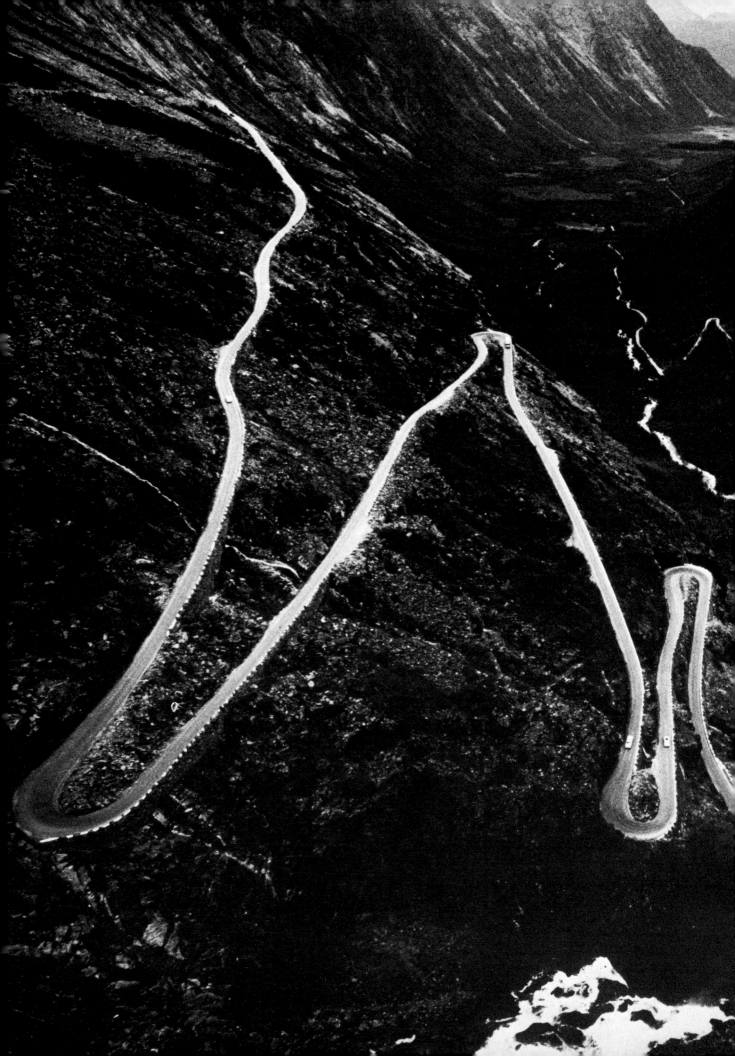

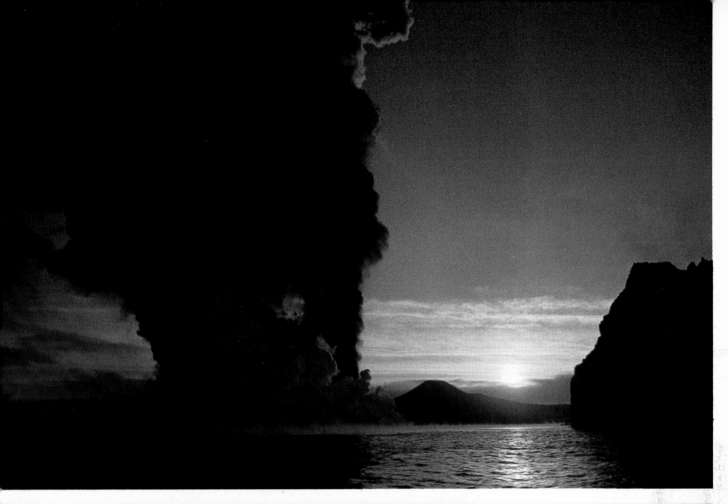

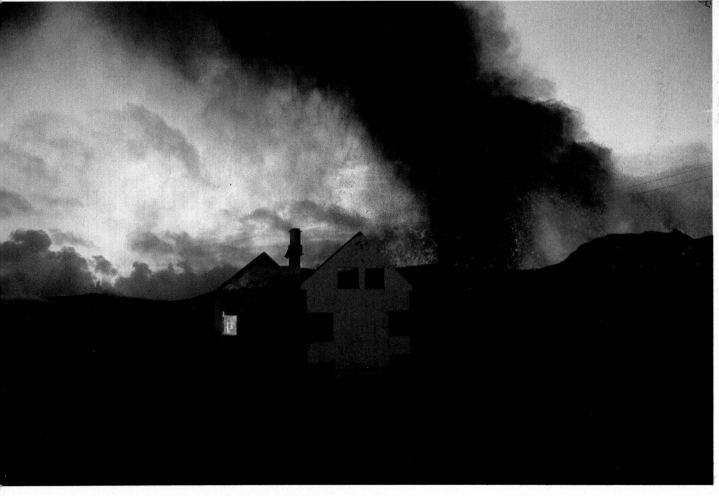

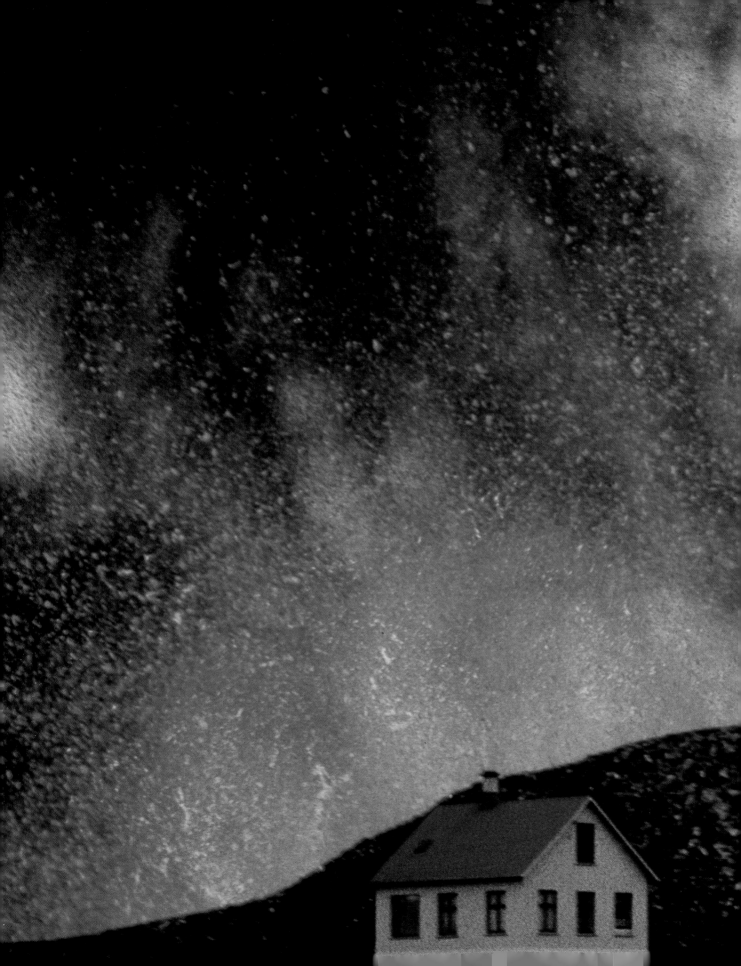

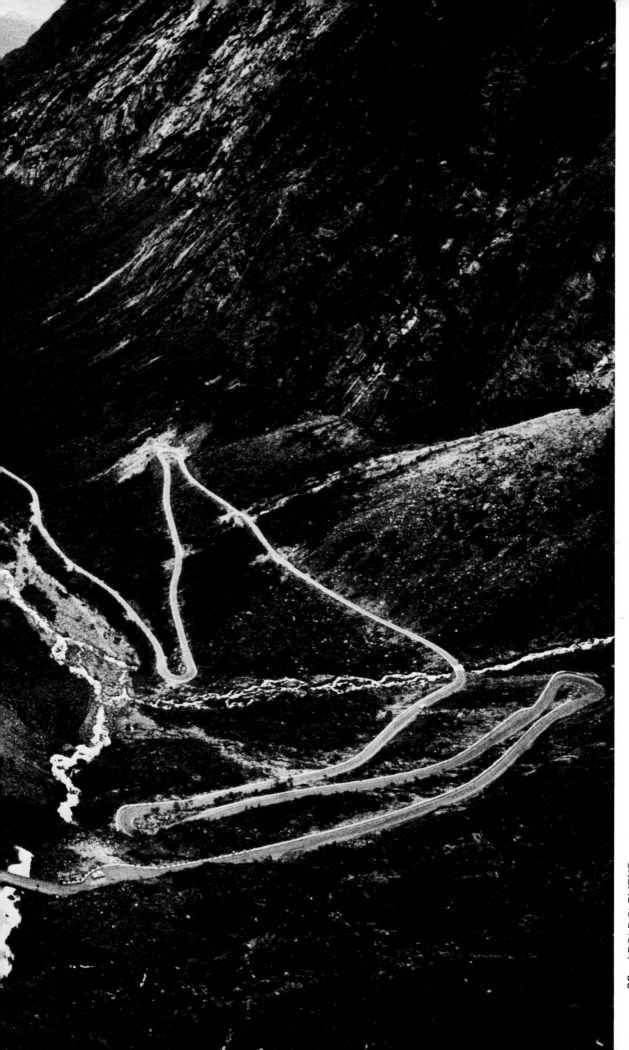

24 WERNER STUHLER 25 PETER FRAENKEL

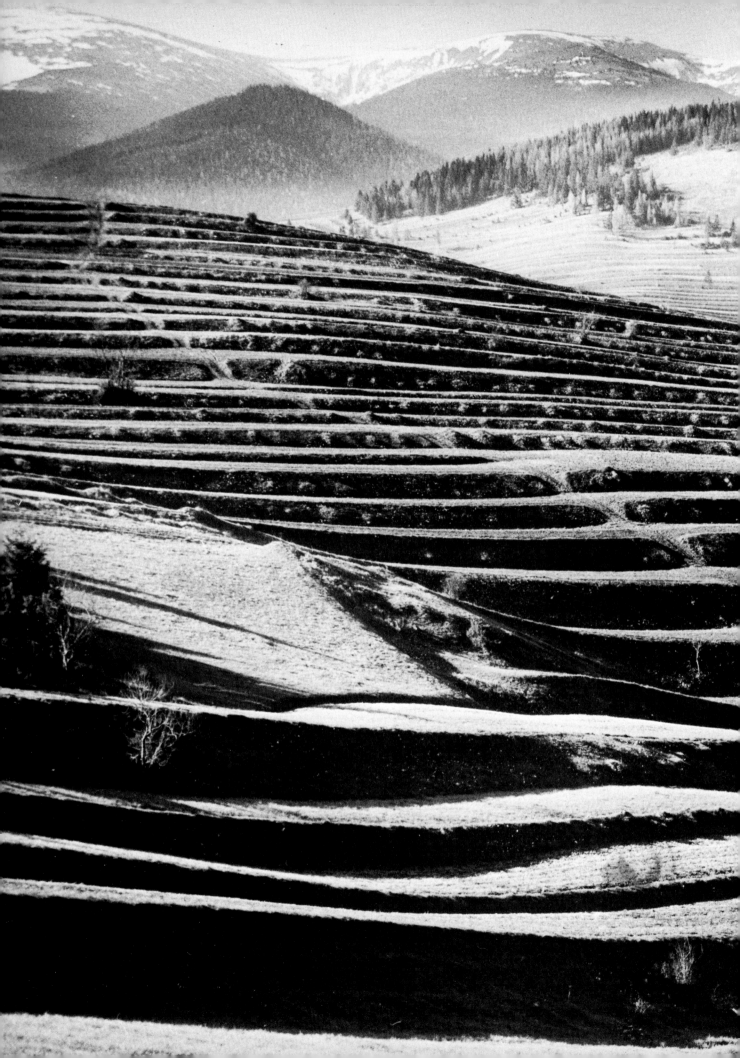

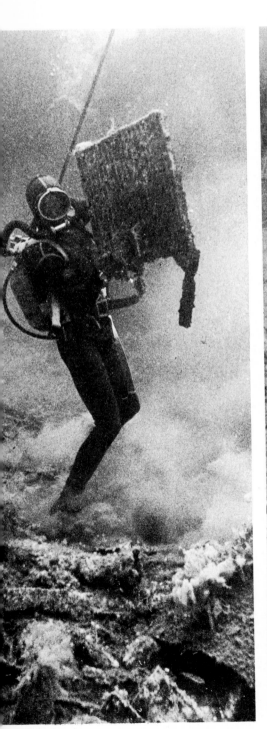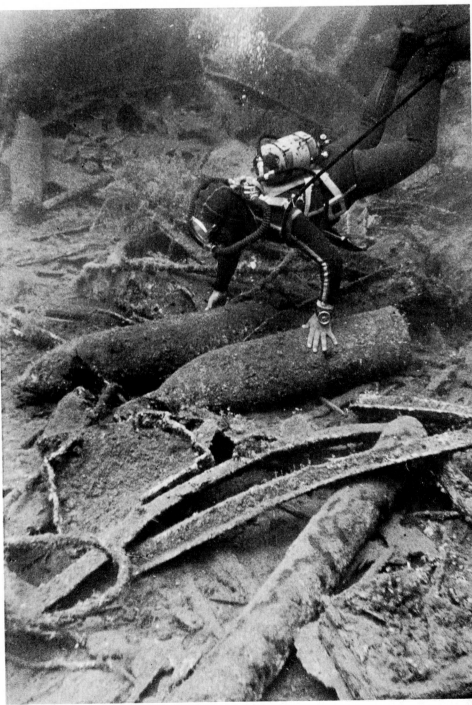

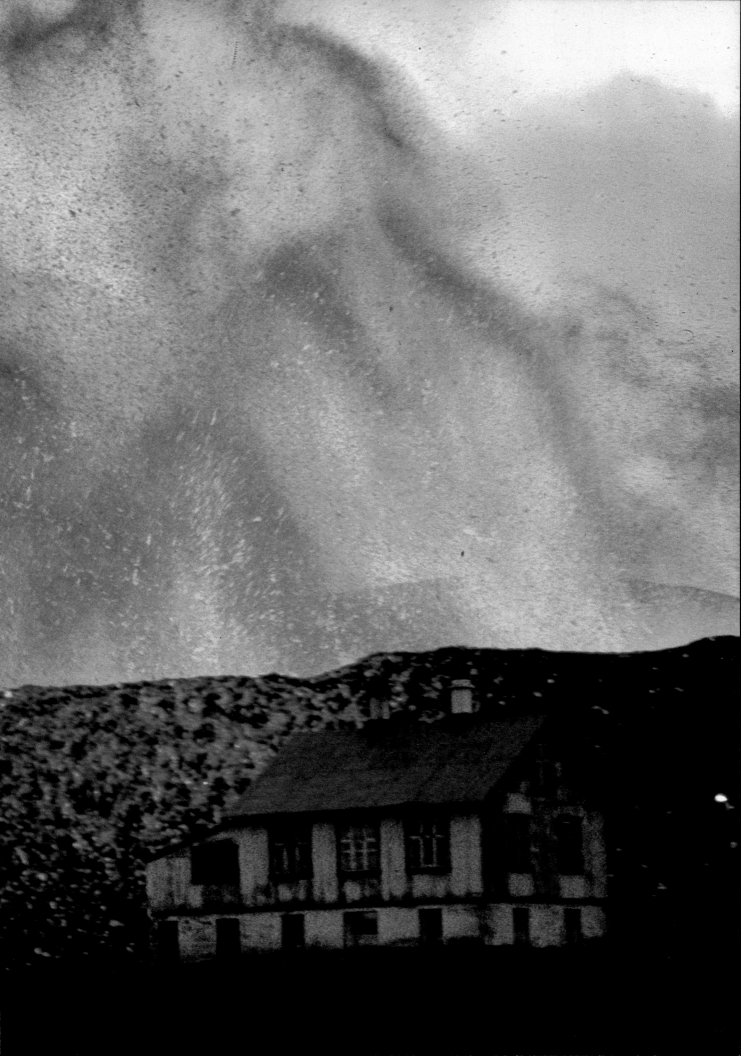

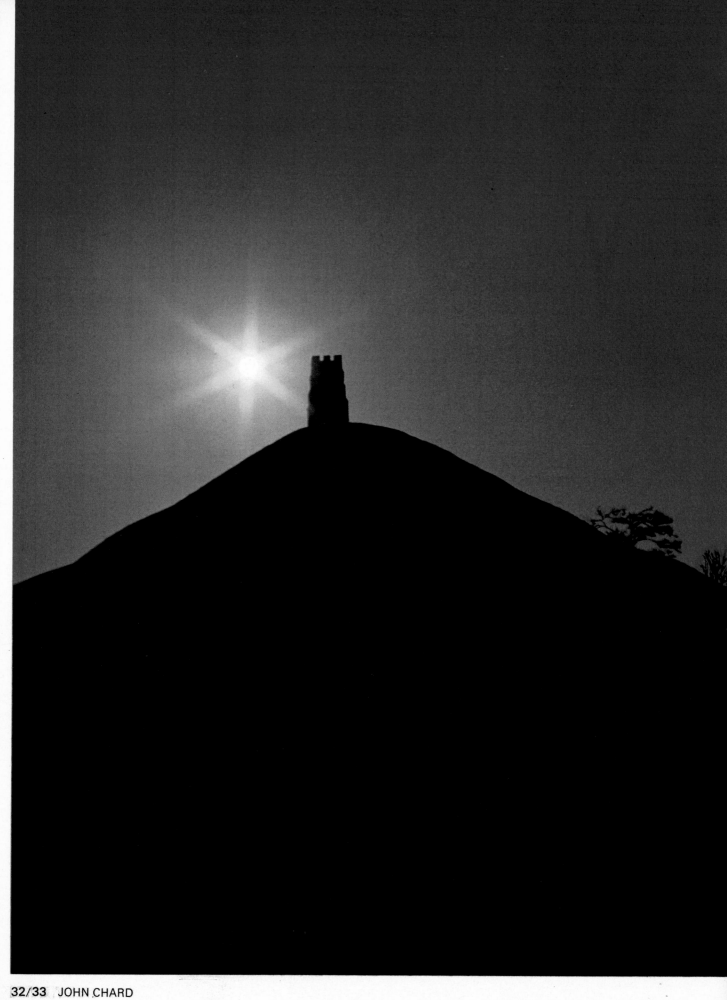

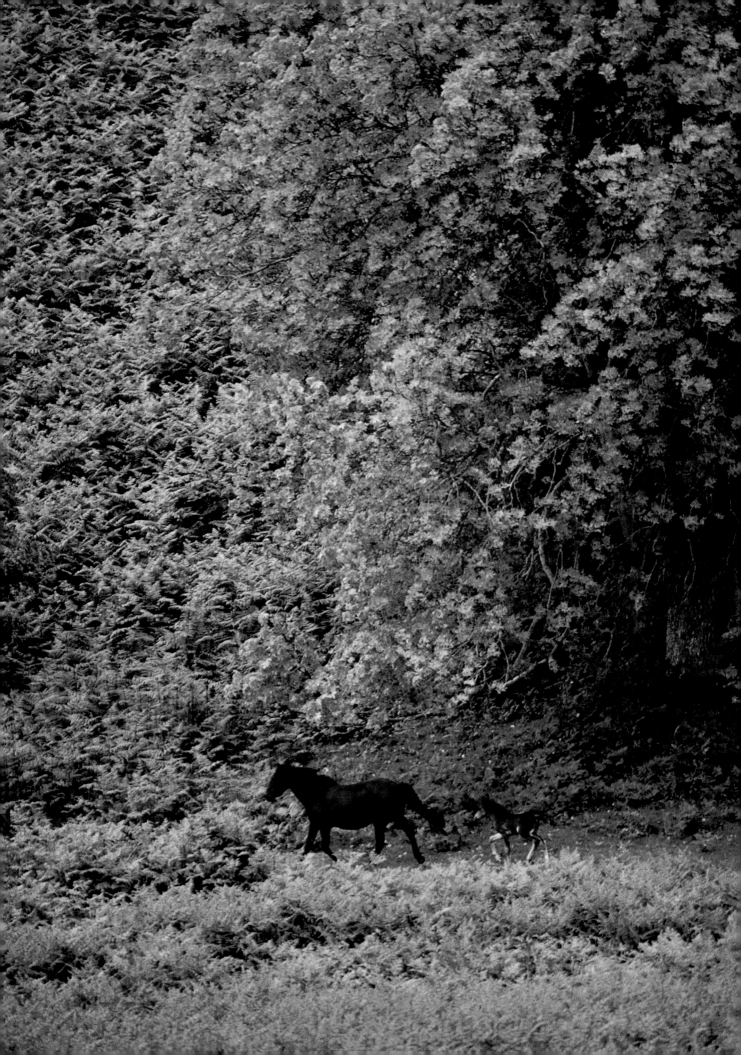

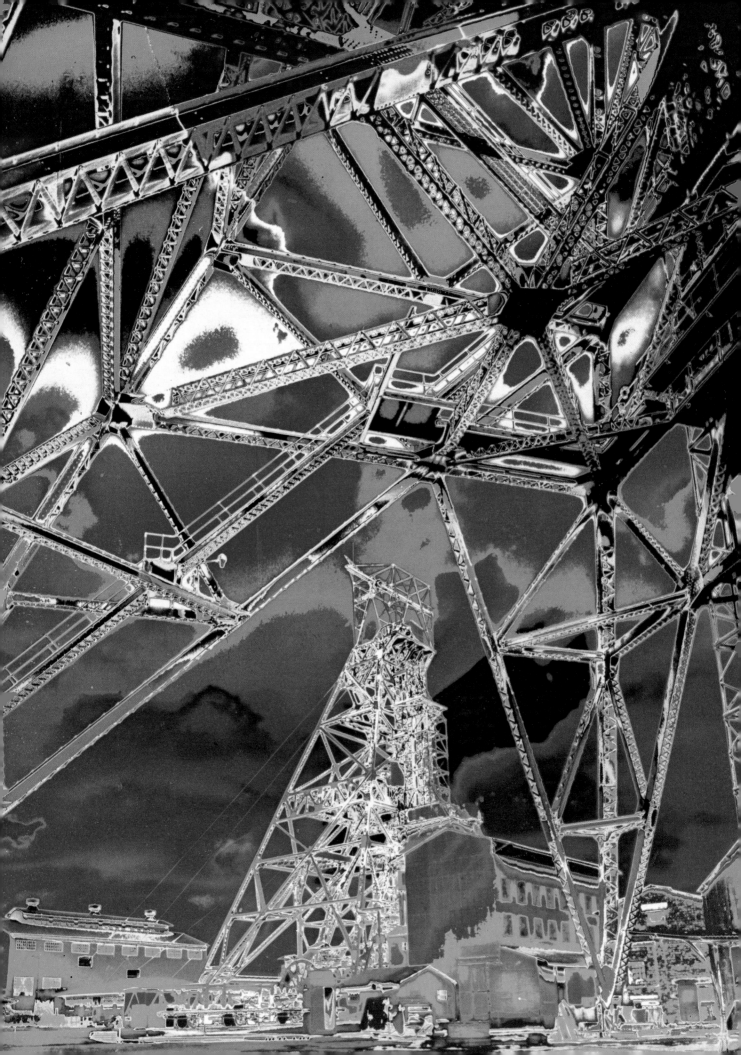

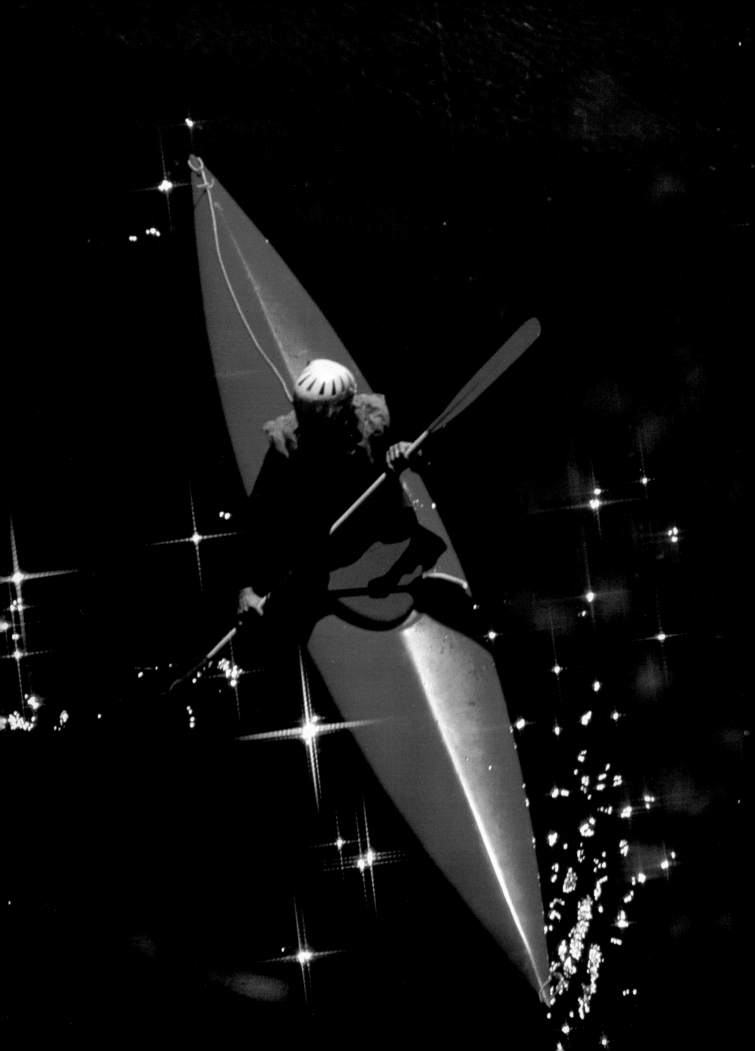

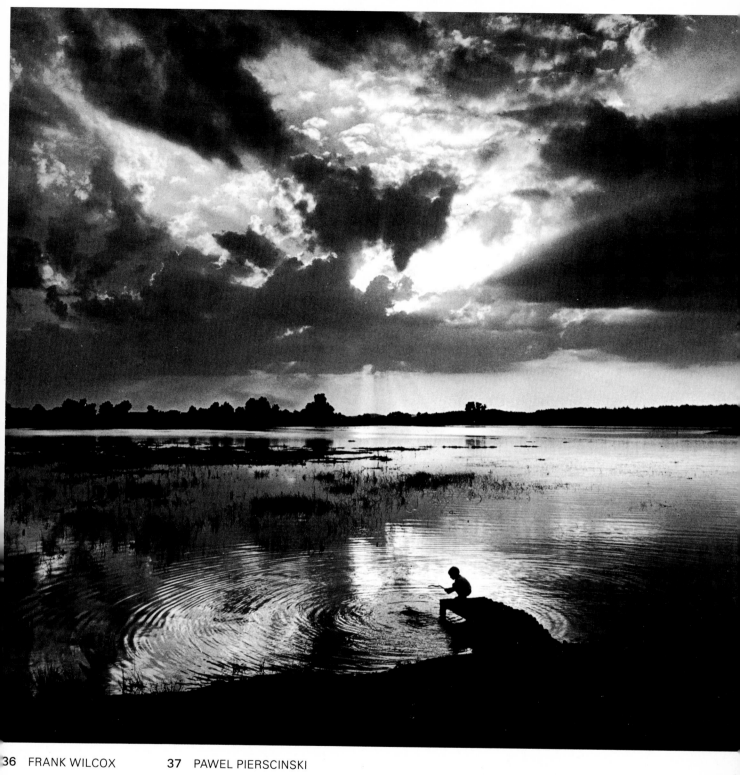

36 FRANK WILCOX **37** PAWEL PIERSCINSKI

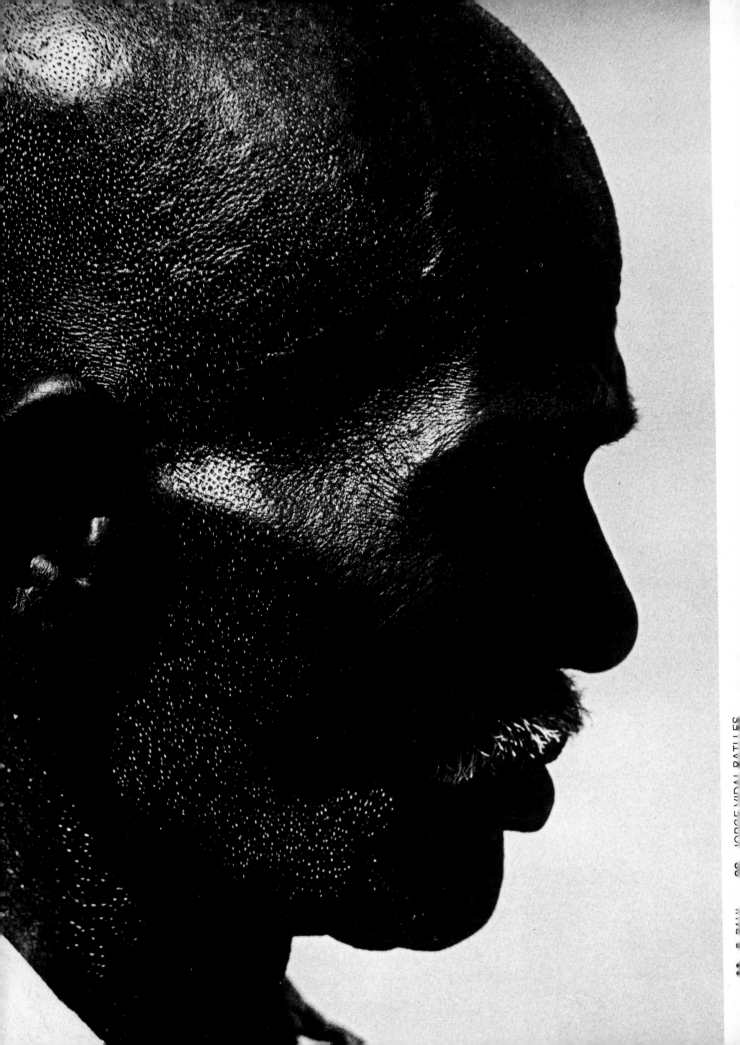

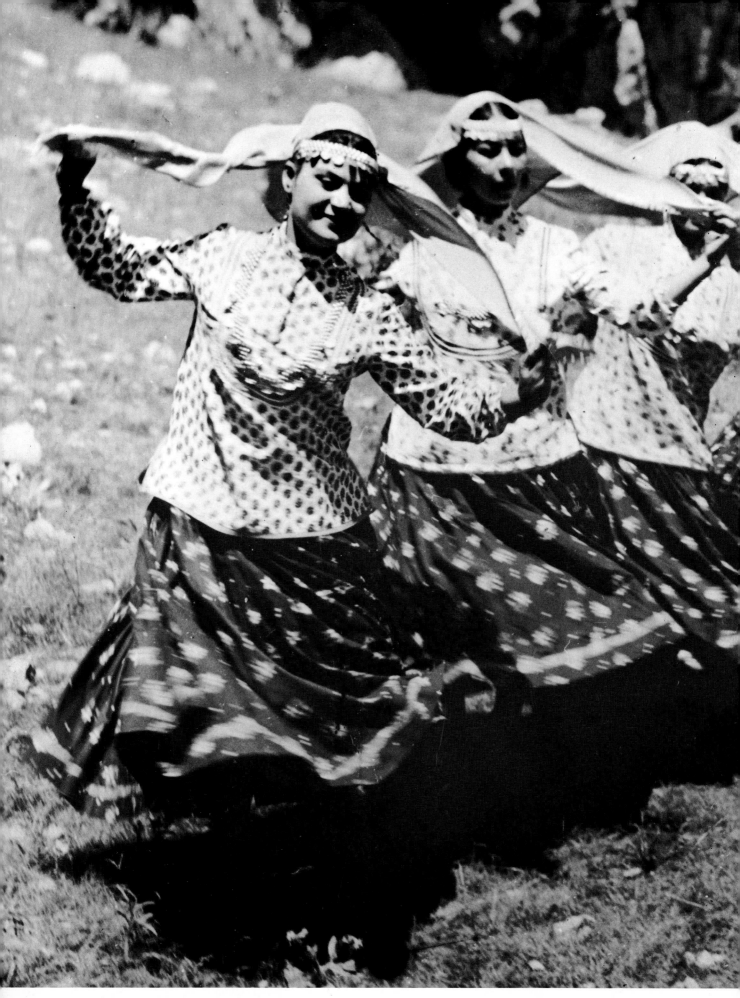

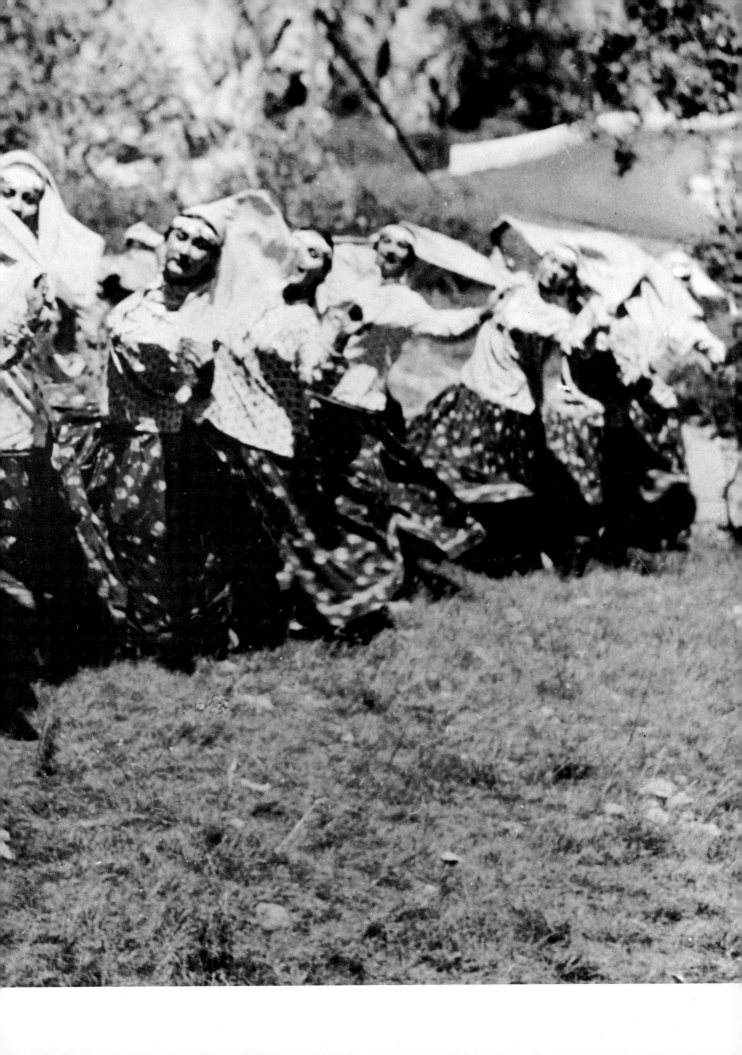

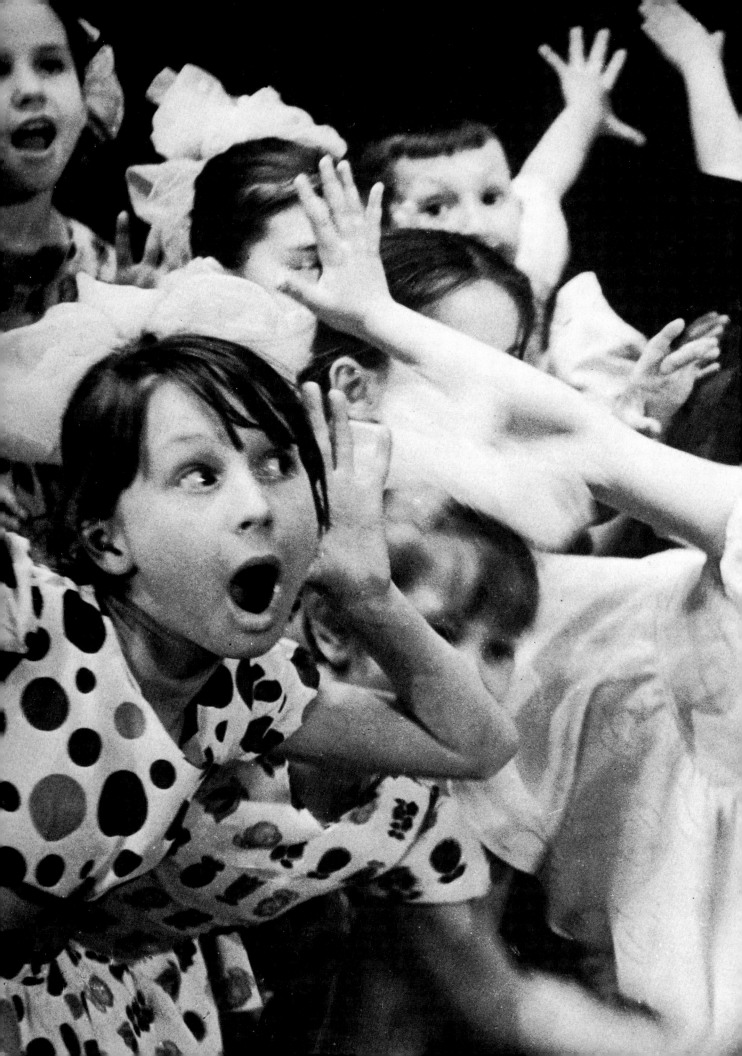

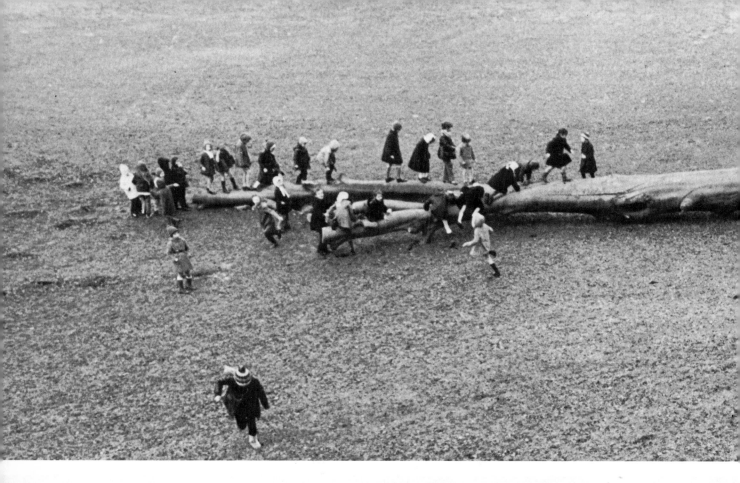

44/45 CARL UYTTERHAEGEN

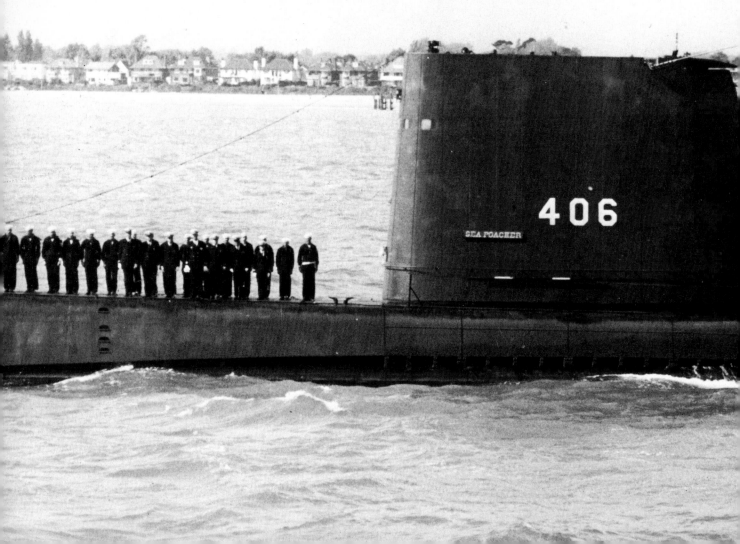

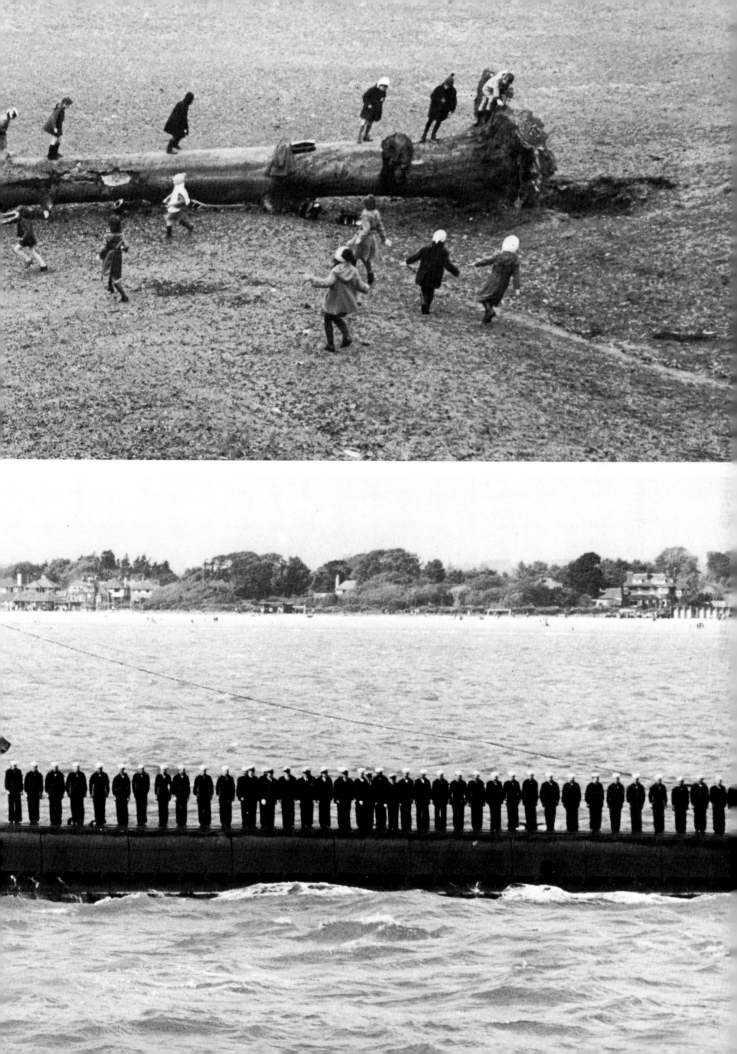

46/47 GERHARD E. LUDWIG

48/51 F. STOPPELMAN

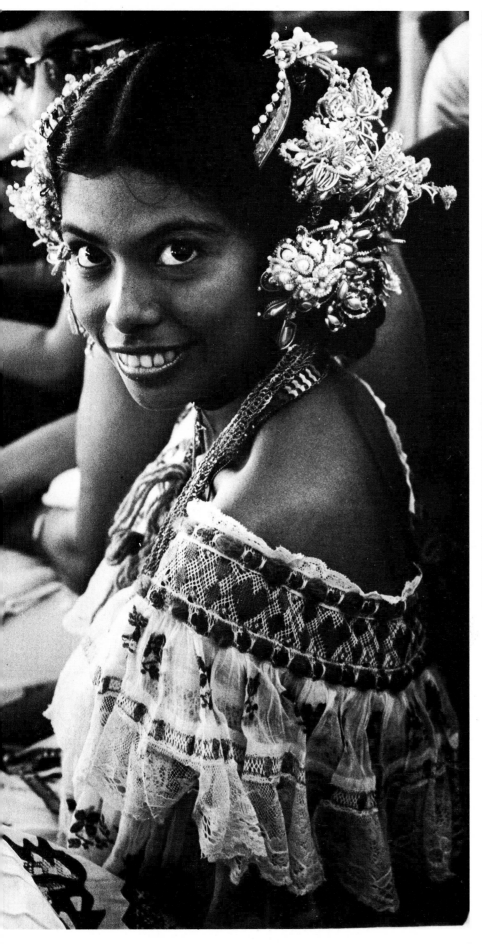
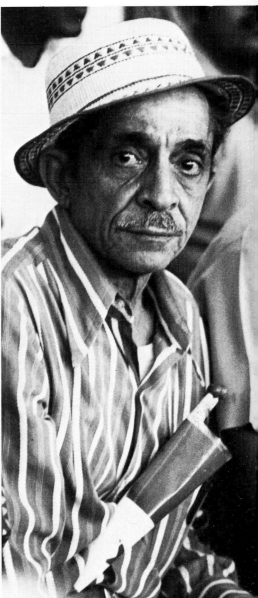

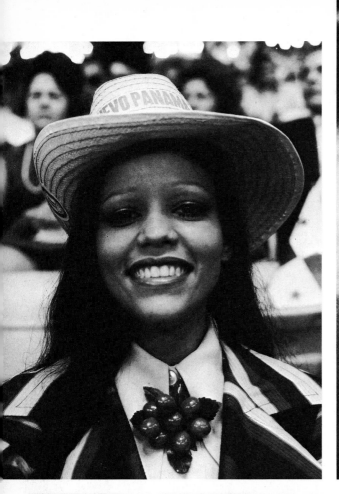

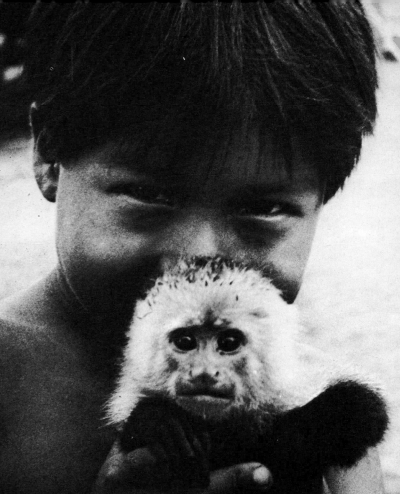

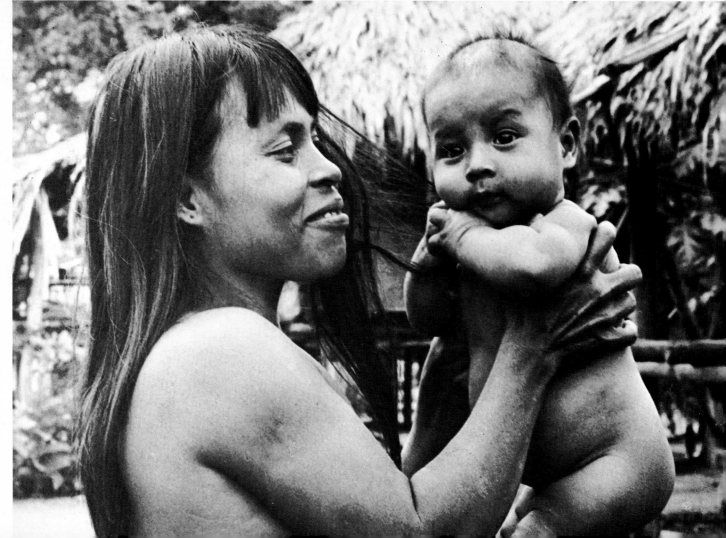

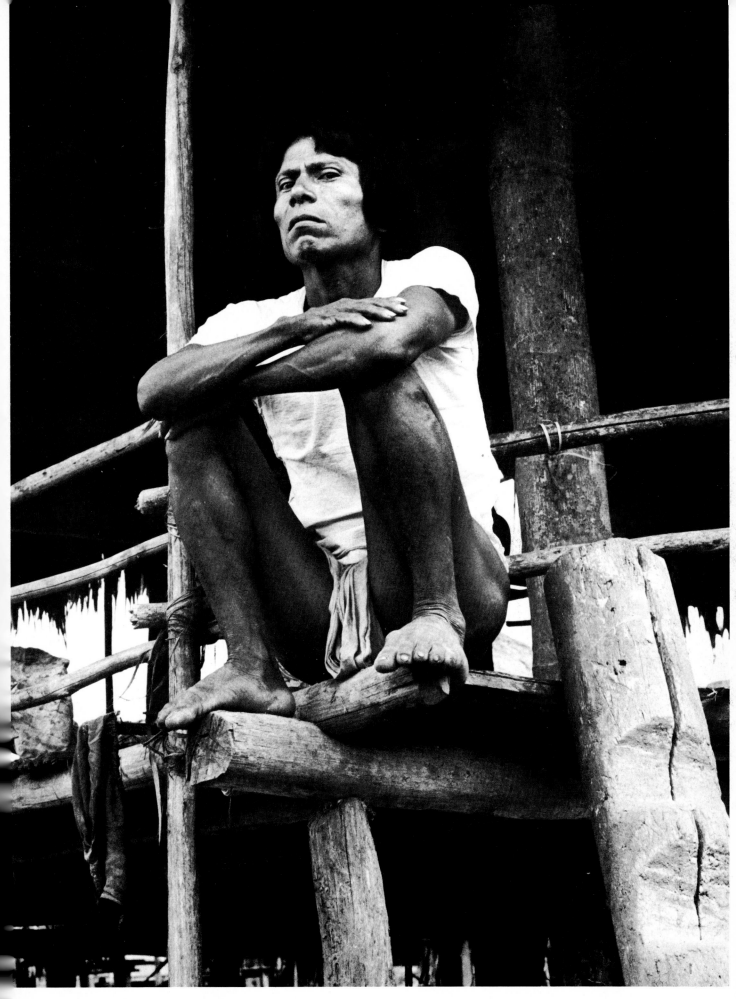

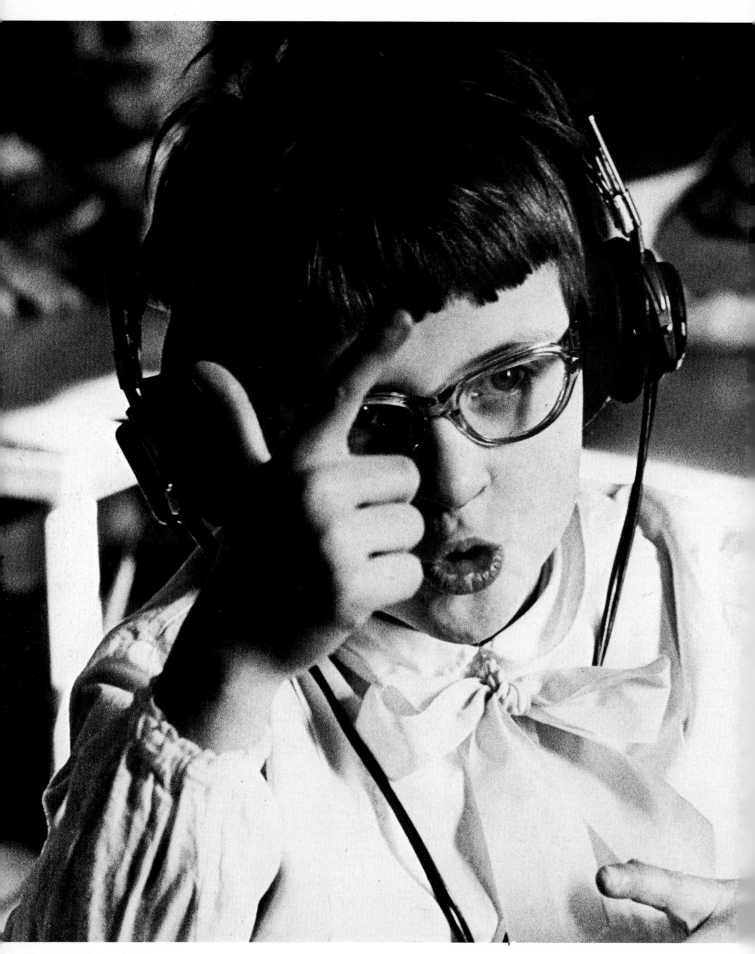

56/58 GASTONE ROSSI

59 GASTONE ROSSI

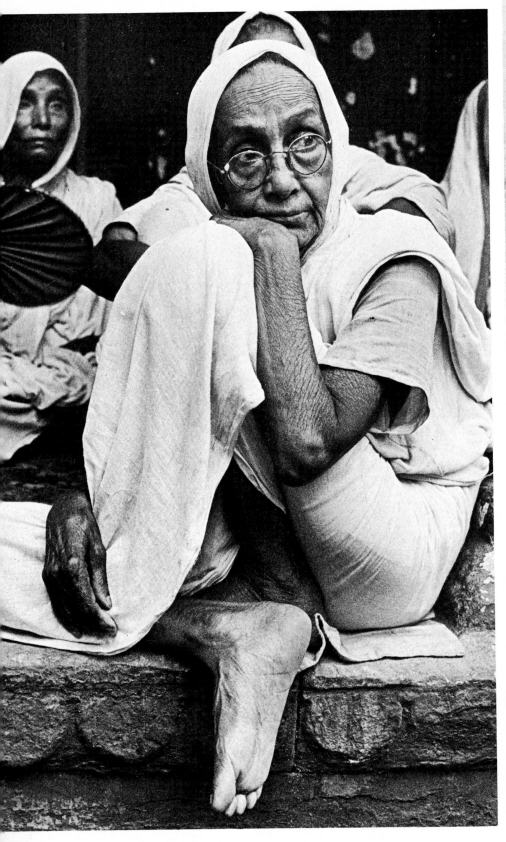

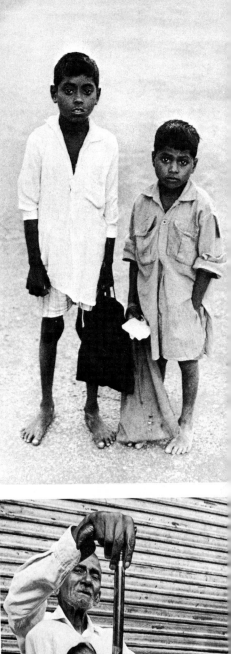

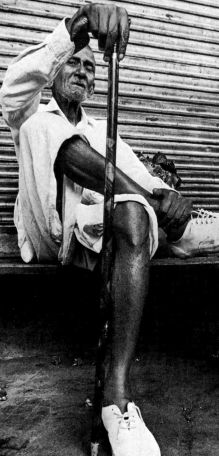

61/65 SATINDER KUMAR CHADHA

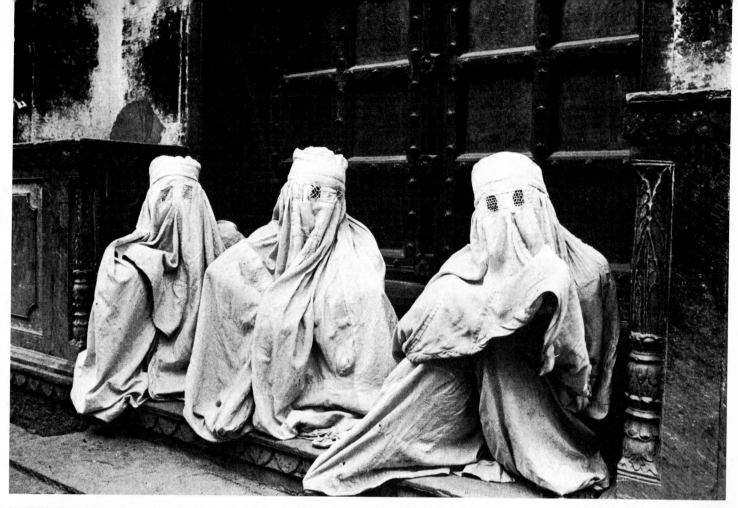

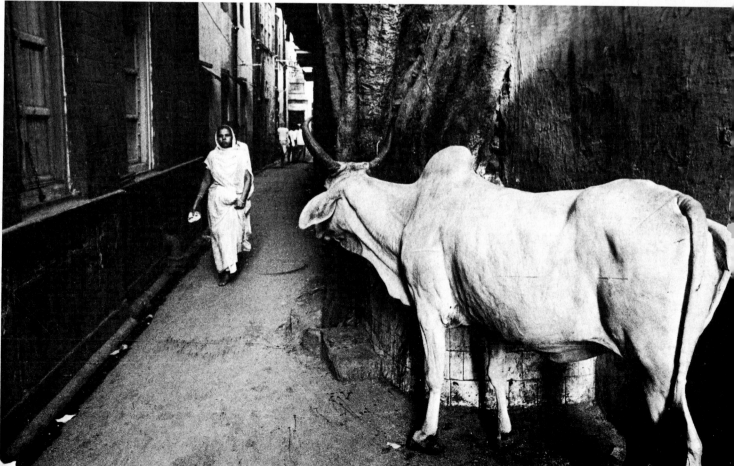

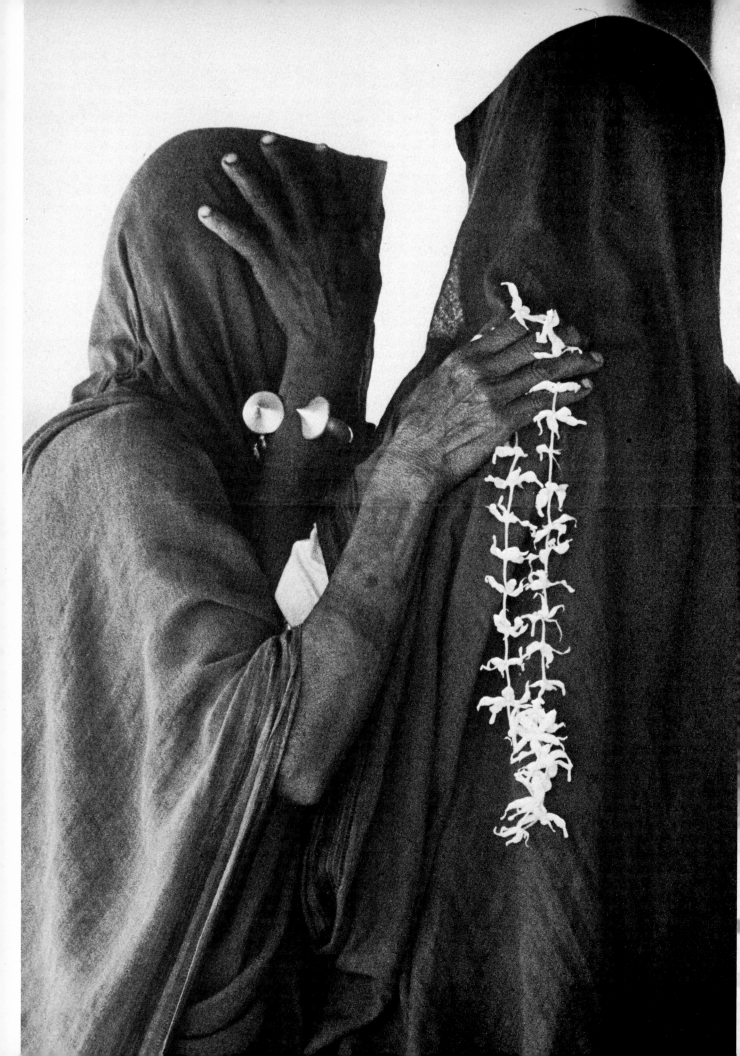

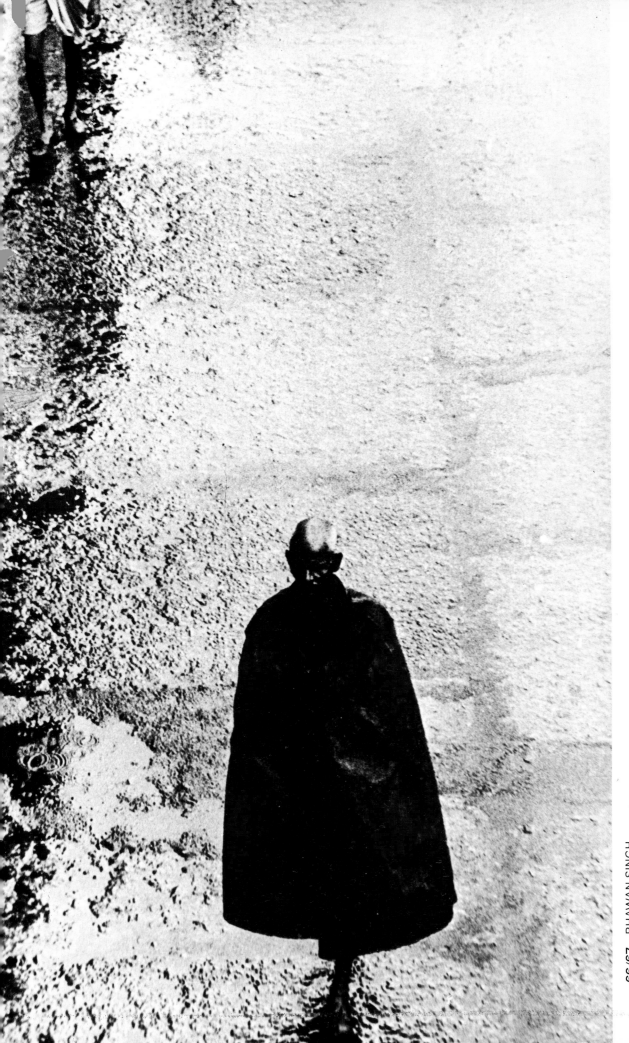

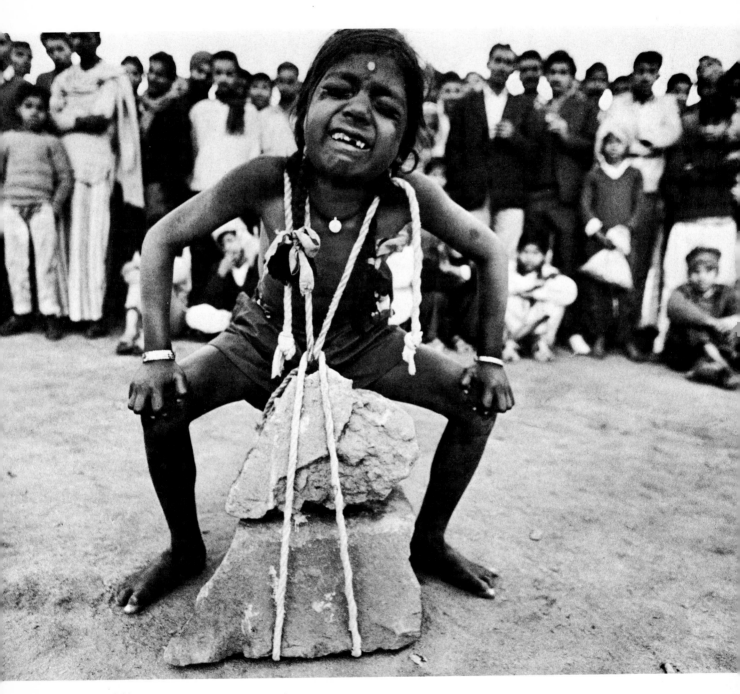

68/69 RAGHU RAI

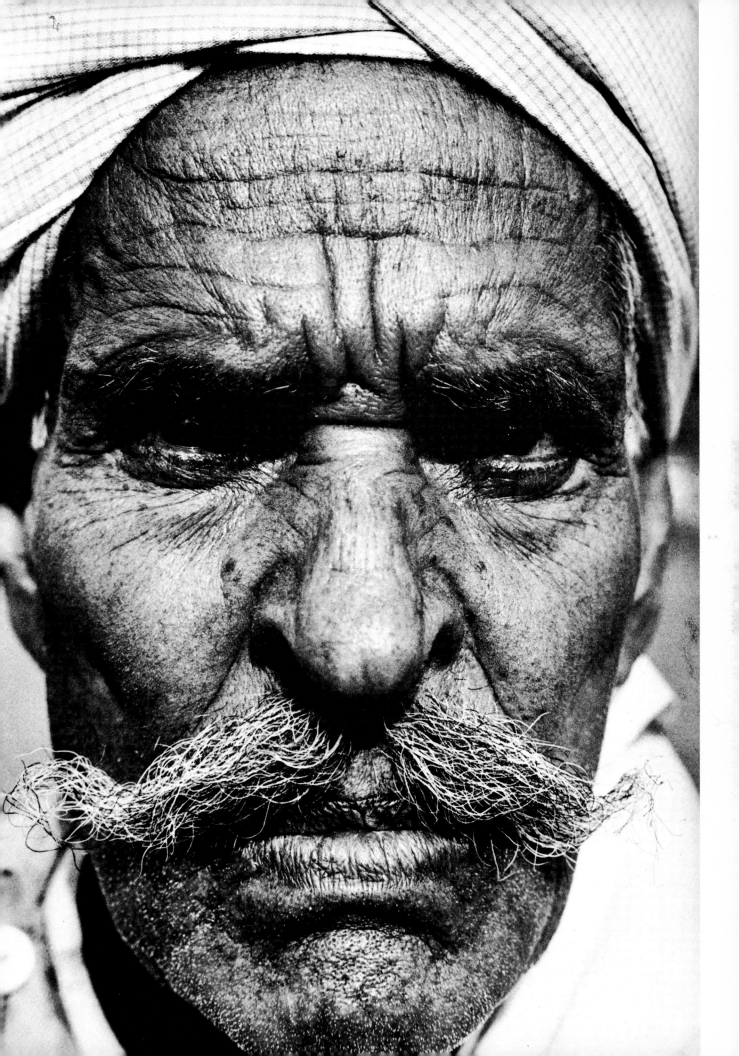

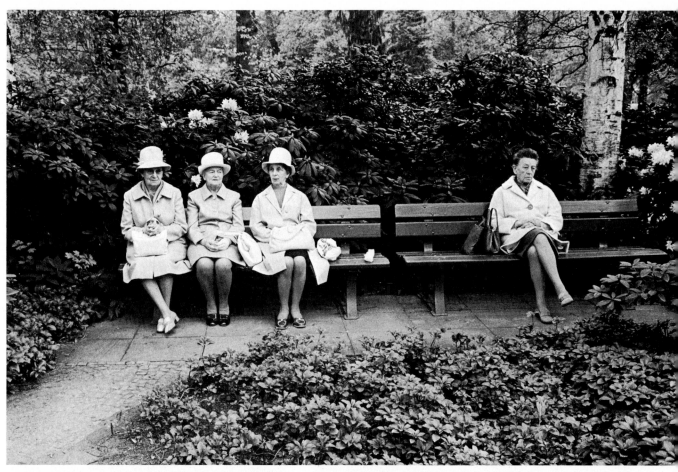

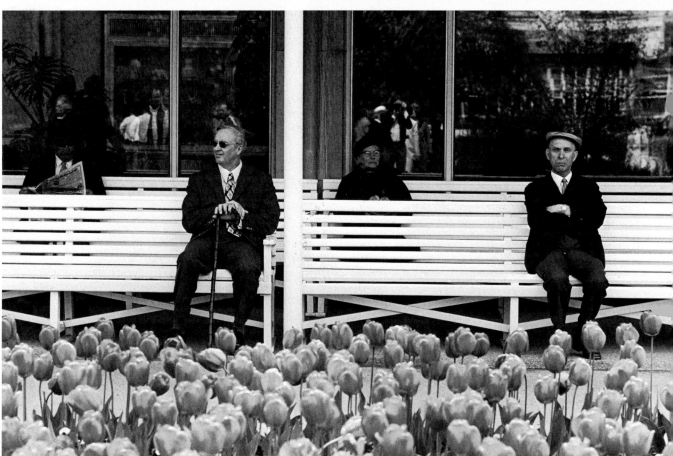

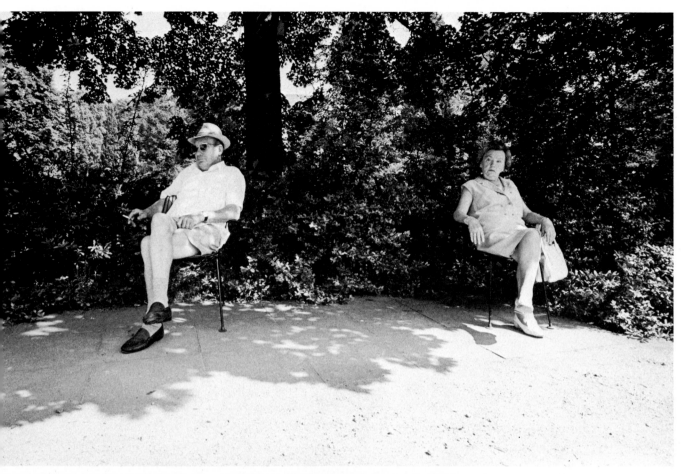
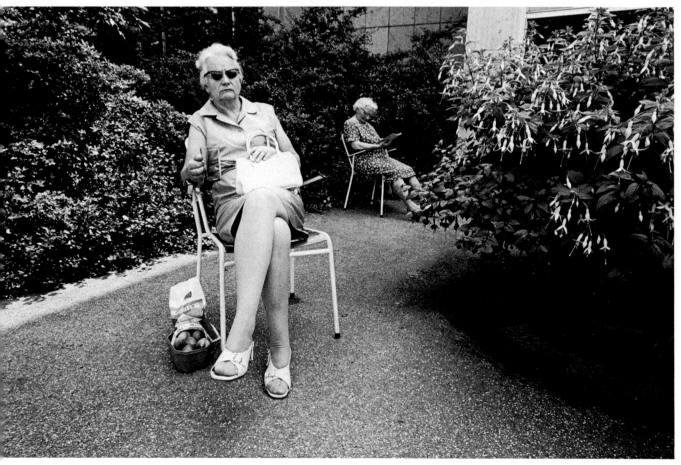

74 DEREK SHUFF **75** LEILA BADARO

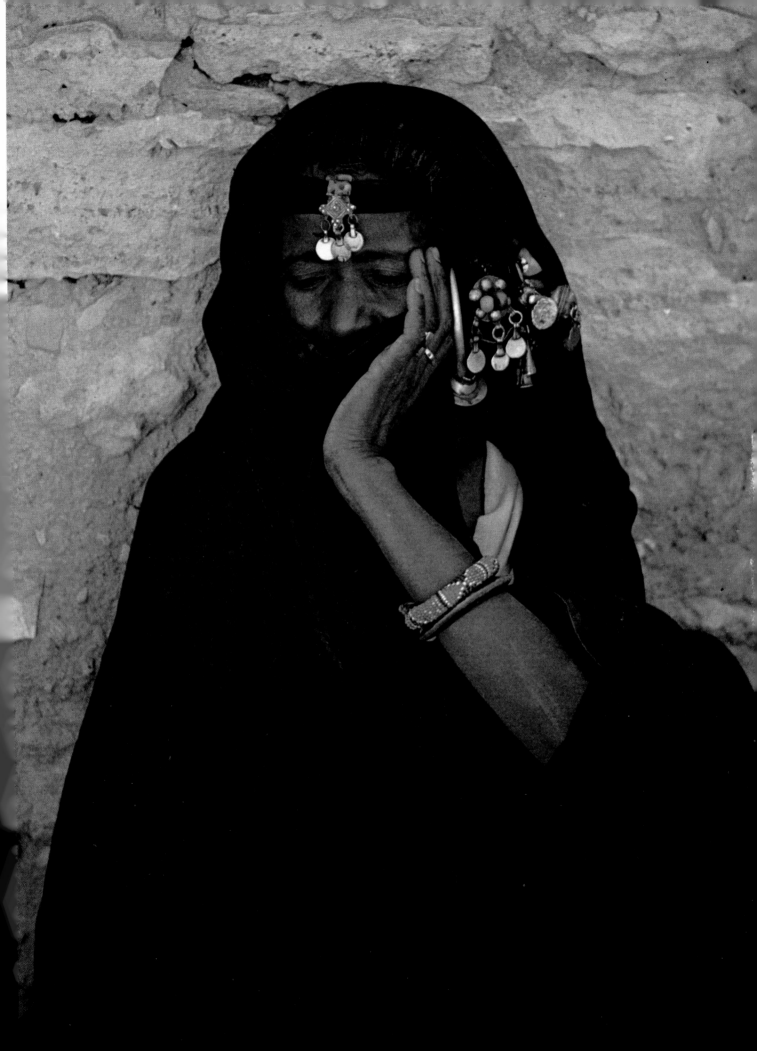

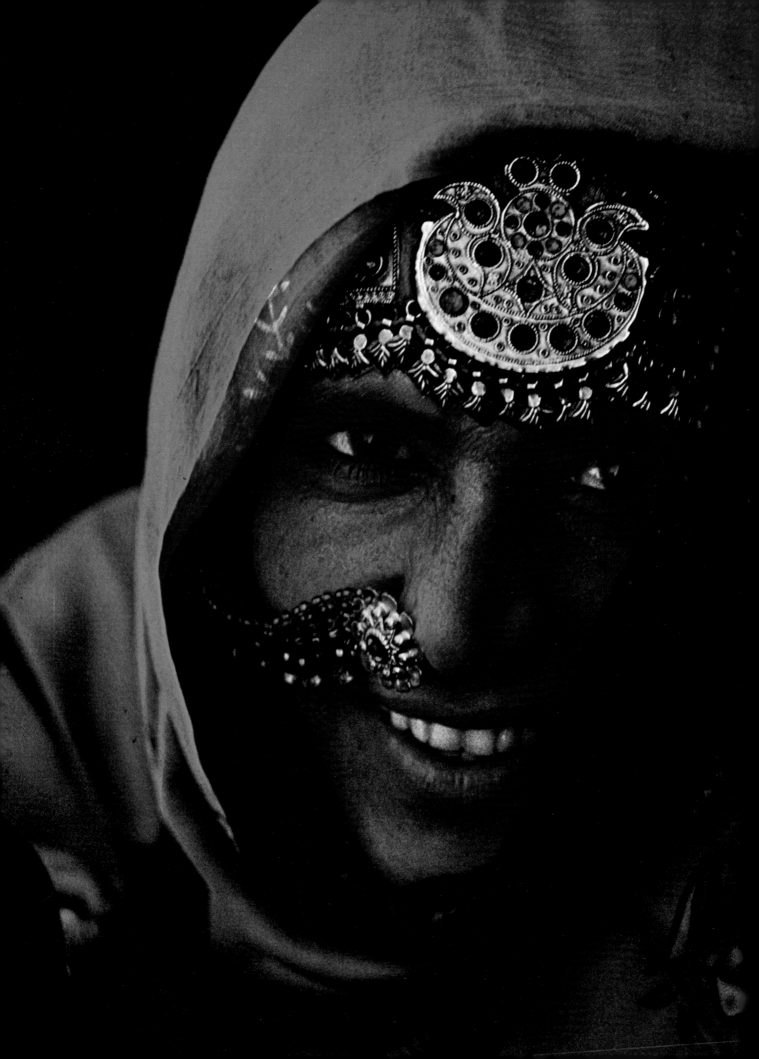

LEILA BADARO

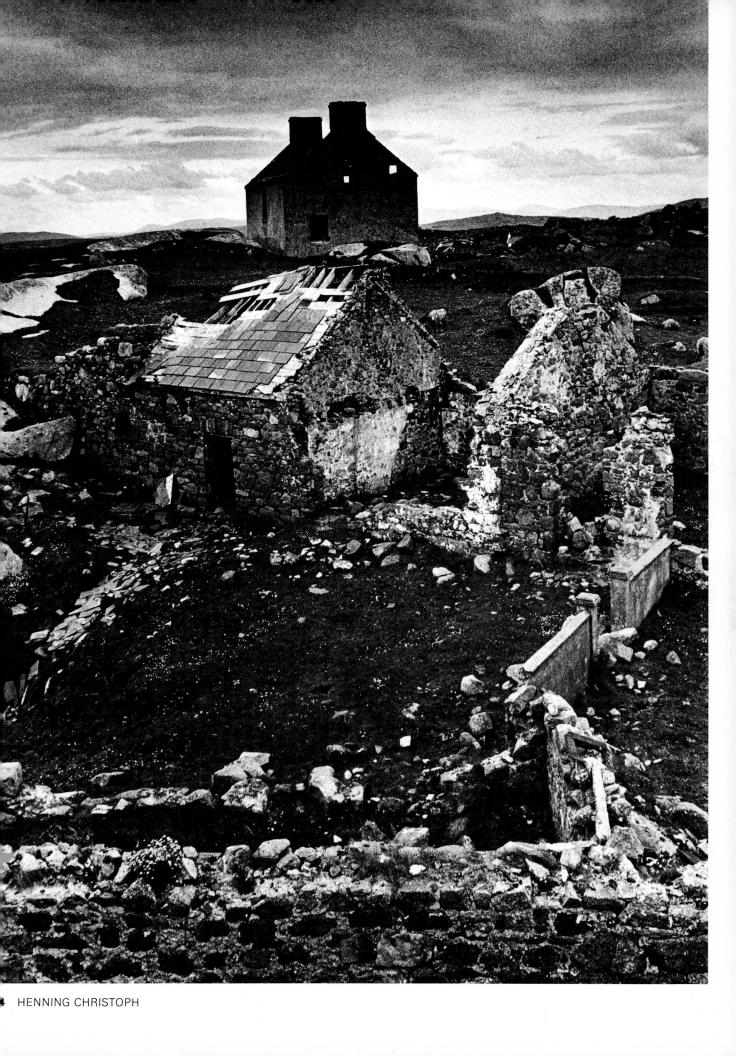

HENNING CHRISTOPH

85/86 HENNING CHRISTOPH

87/88 HENNING CHRISTOPH

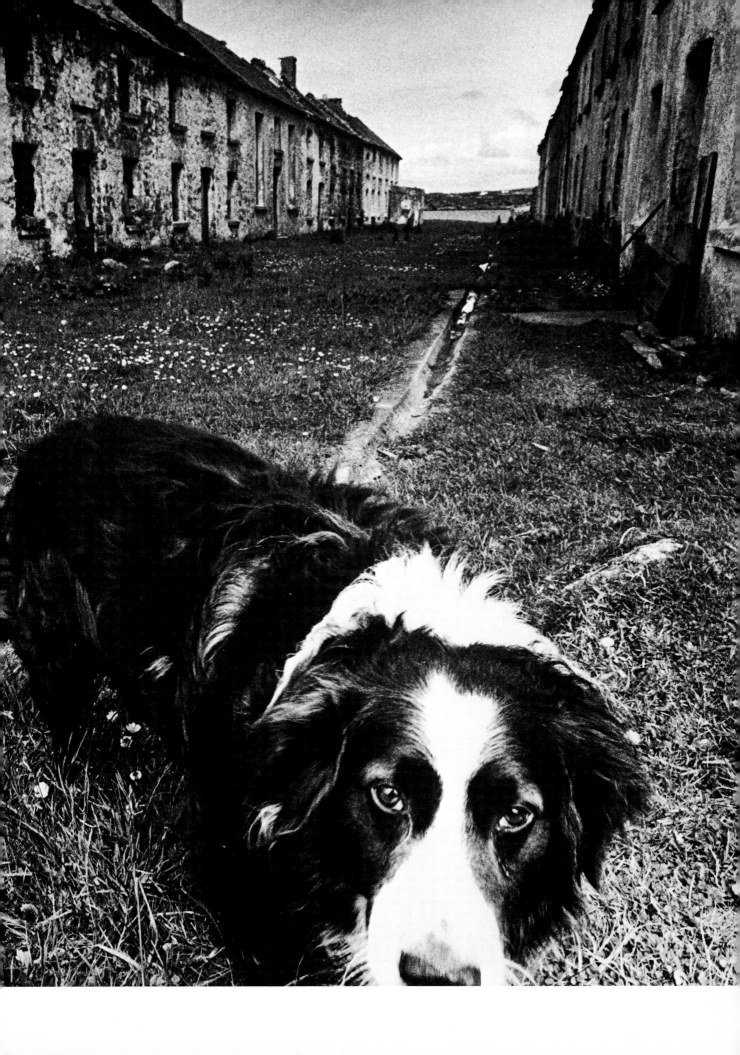

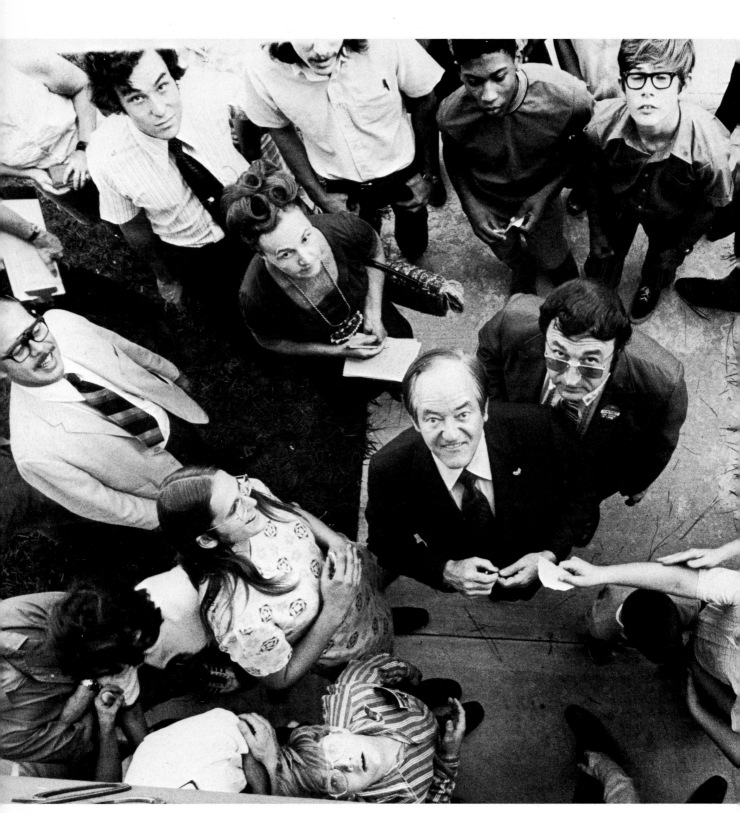

89 JERRY COOPER 90 J. CLARE

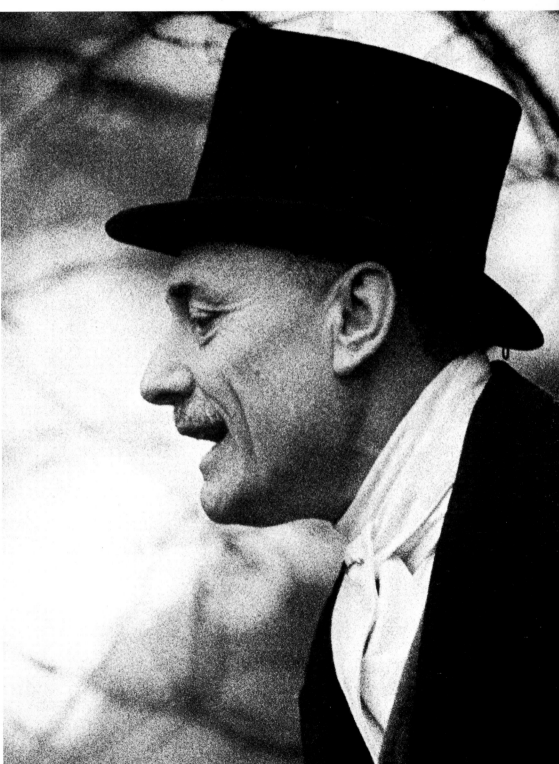

91 STEPHEN SHAKESHAFT **92** ALIZA AUERBACH

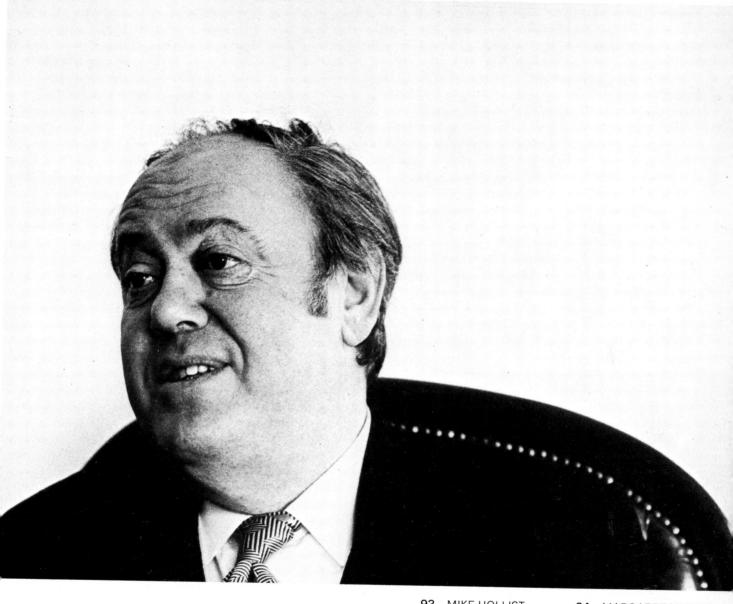

93 MIKE HOLLIST **94** MARGARET MURRAY

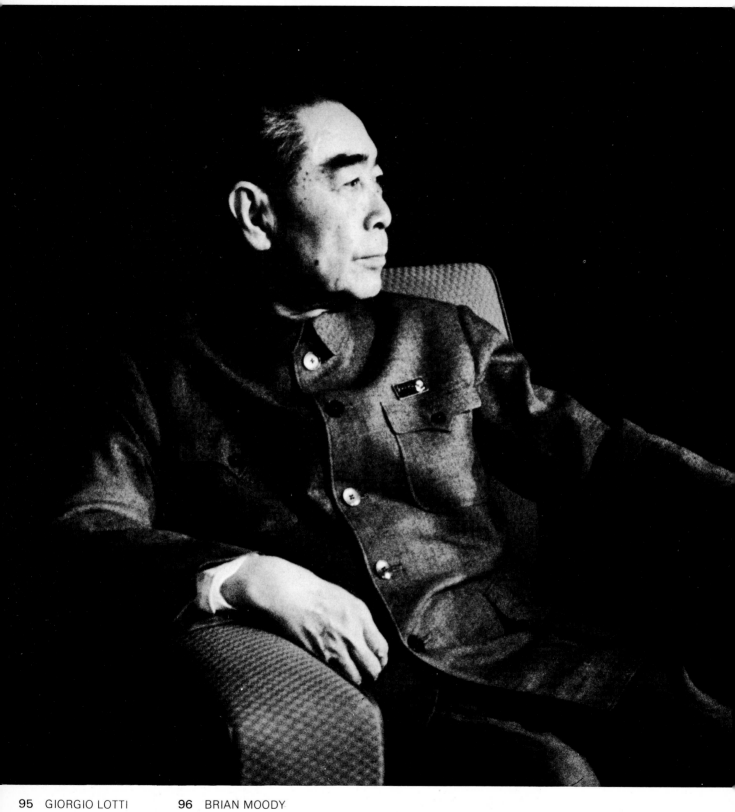

95 GIORGIO LOTTI 96 BRIAN MOODY

97/104 MICHAEL EVANS

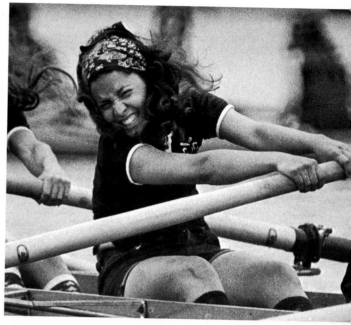
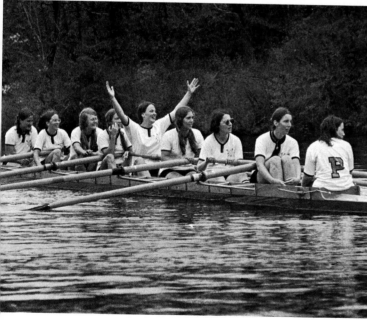
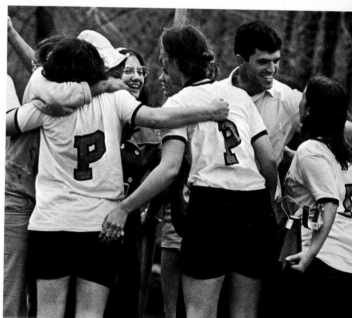

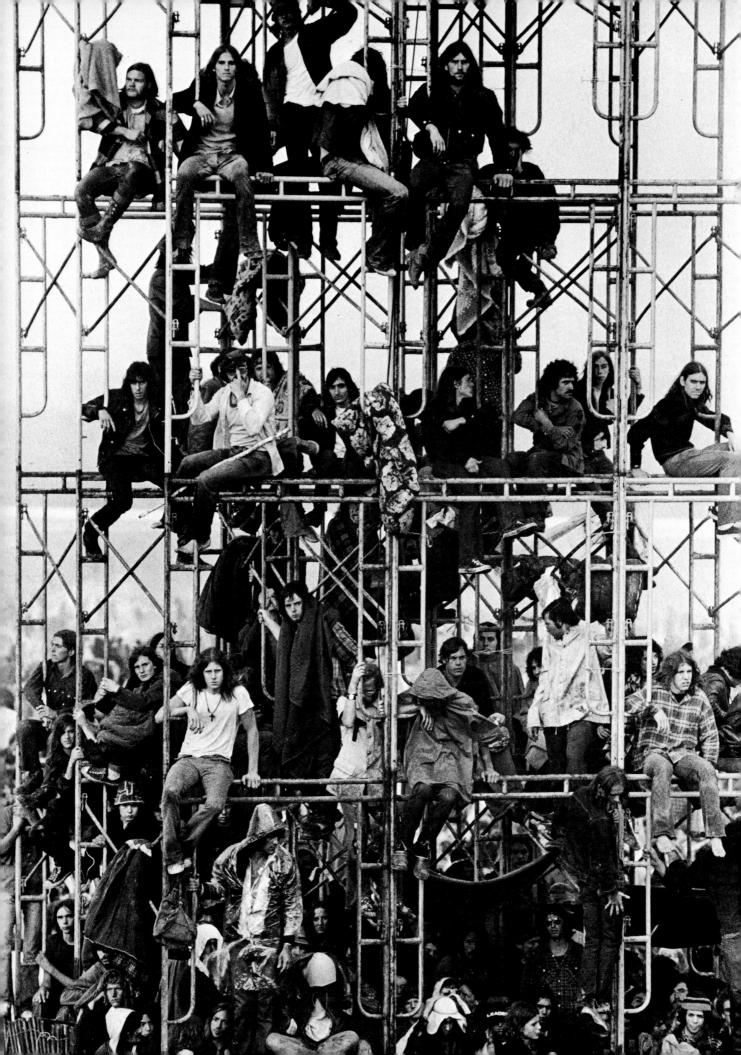

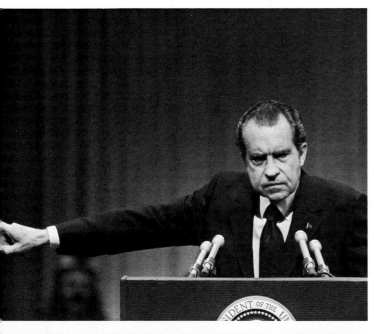
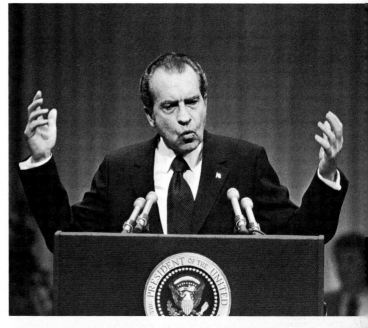
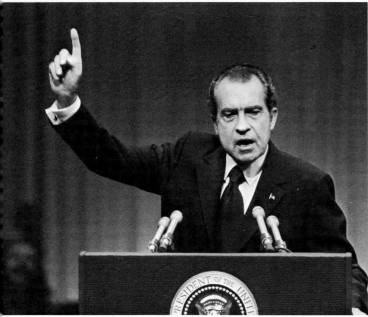
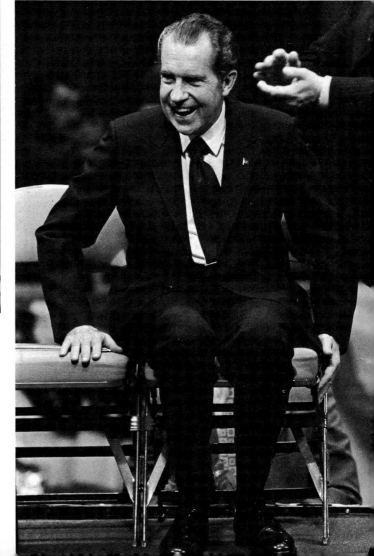

MICHAEL EVANS

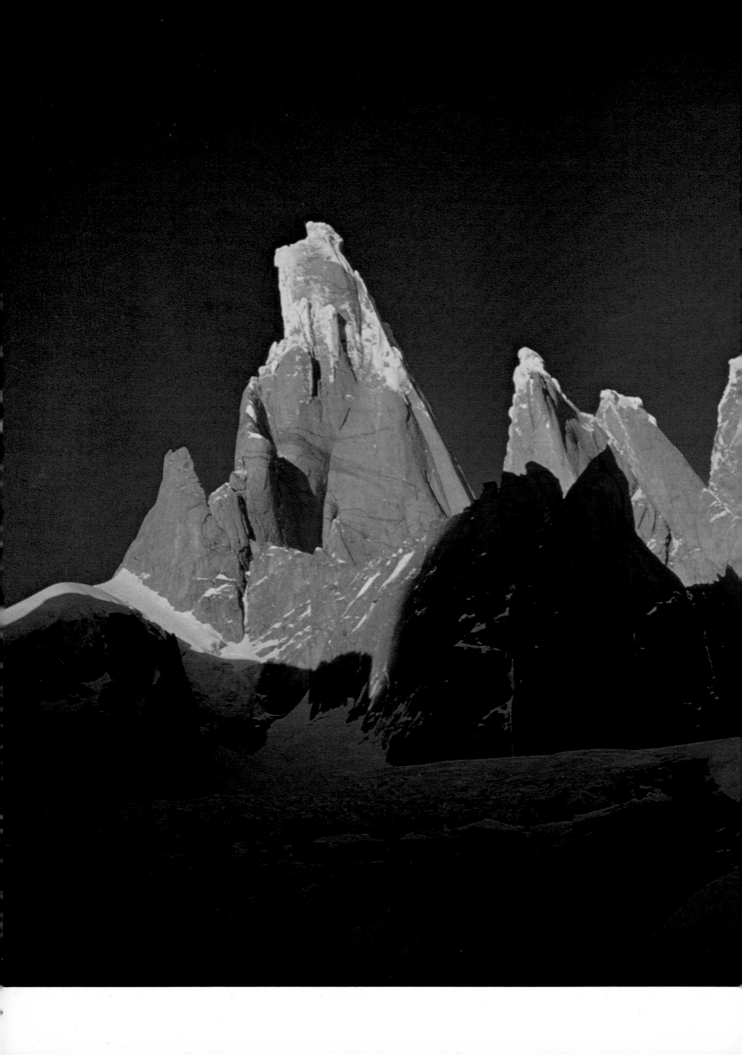

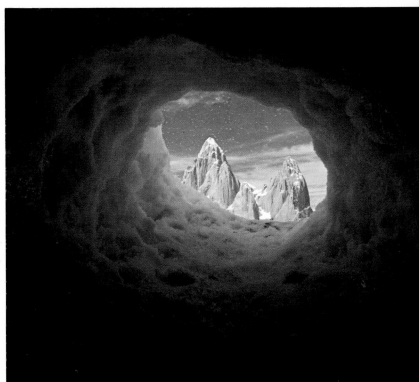

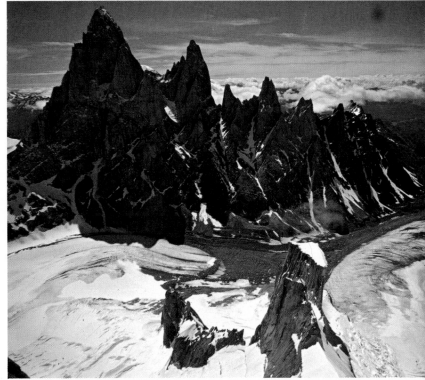

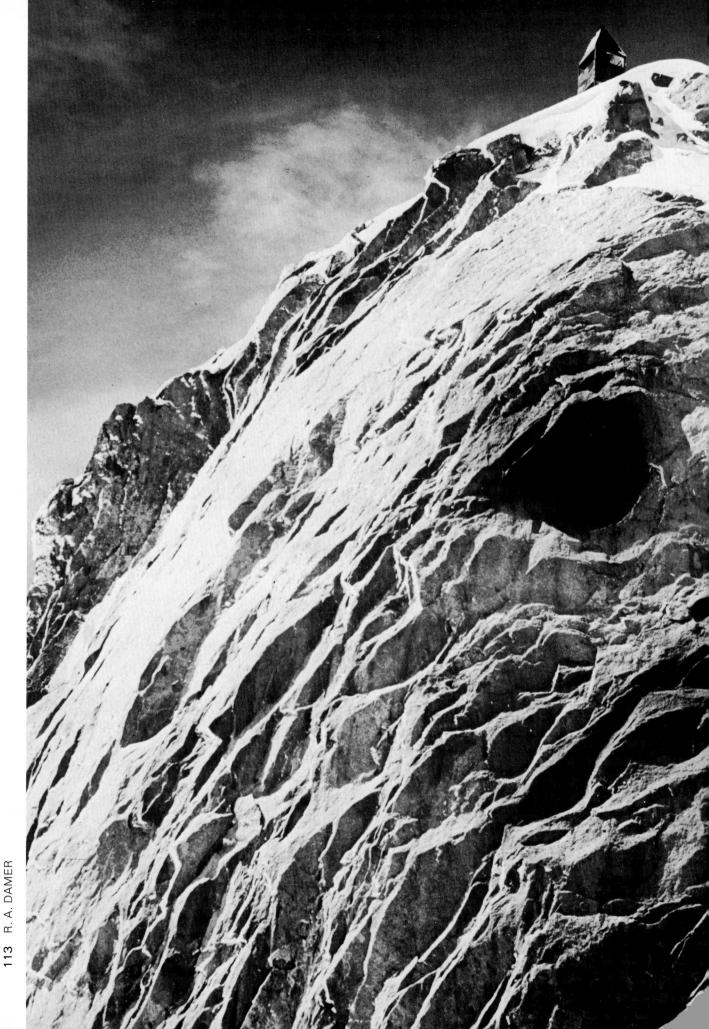

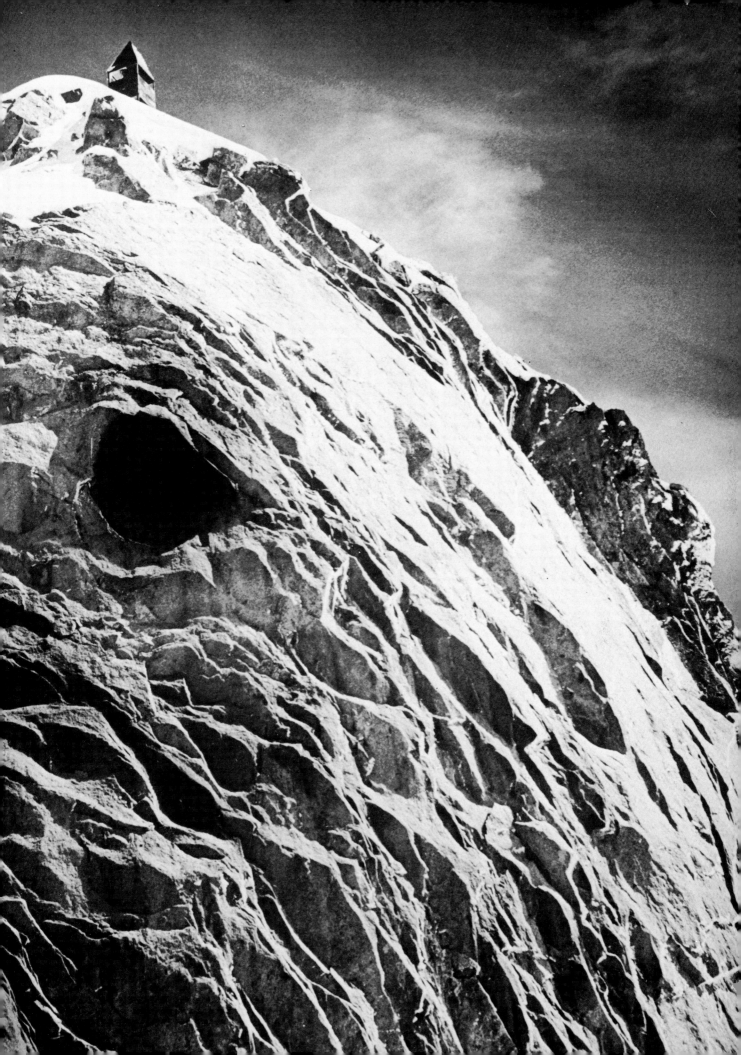

114/115 WOLFGANG VOLZ

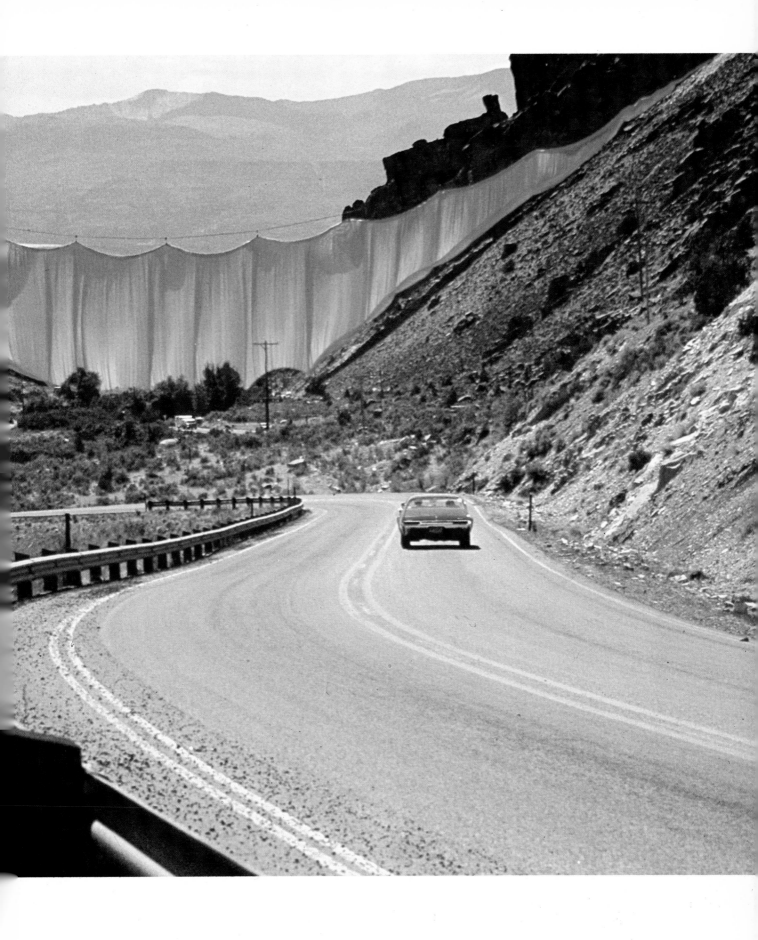

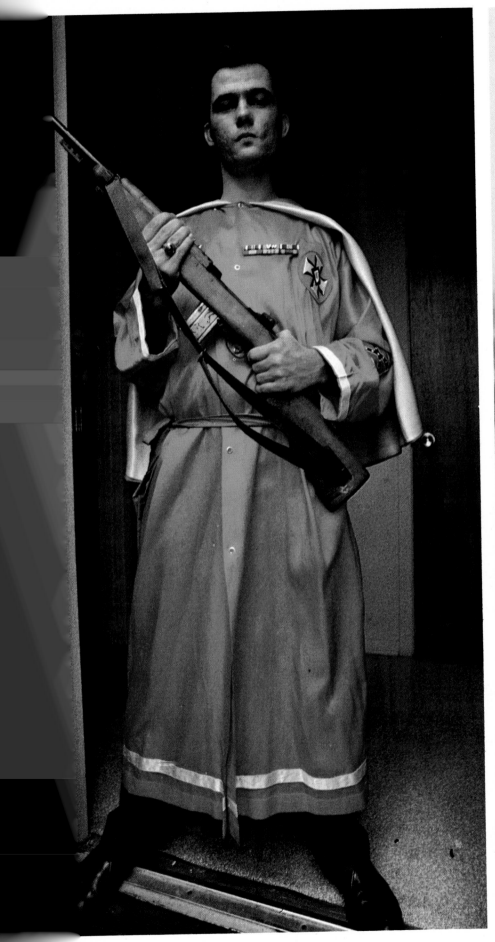

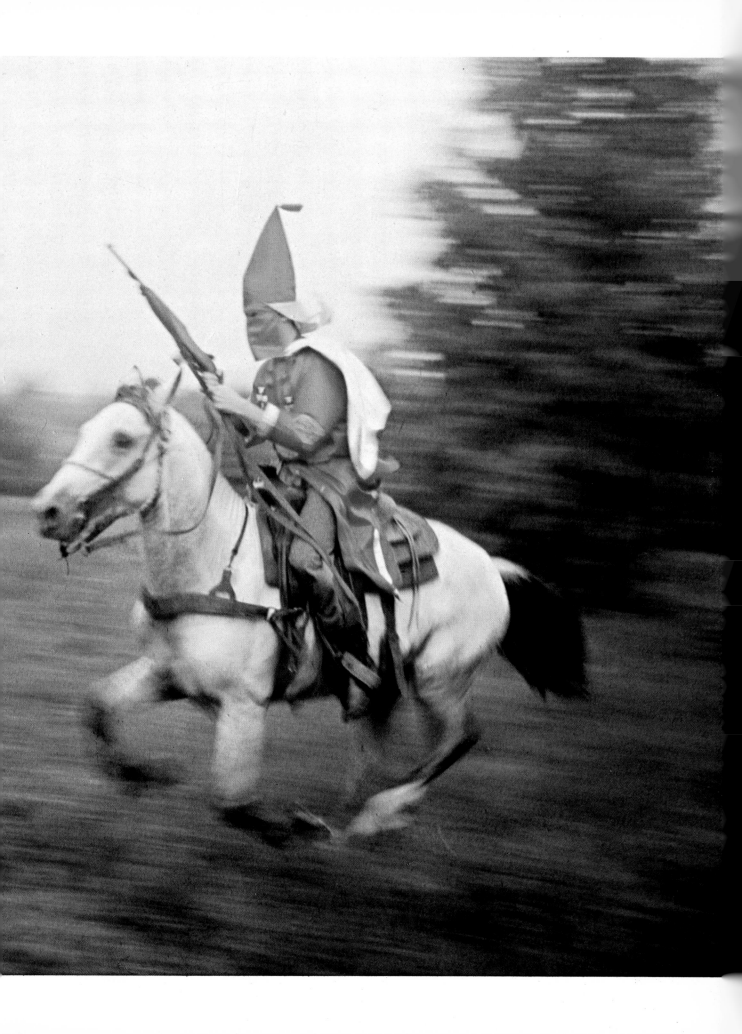

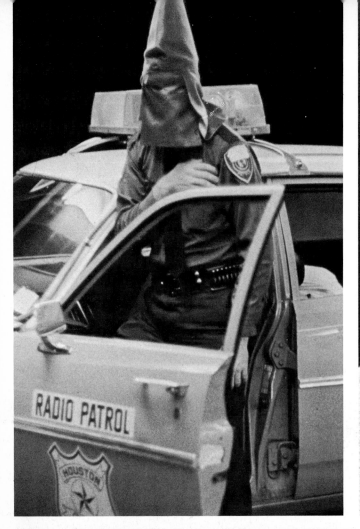

124/128 RON LAYTNER

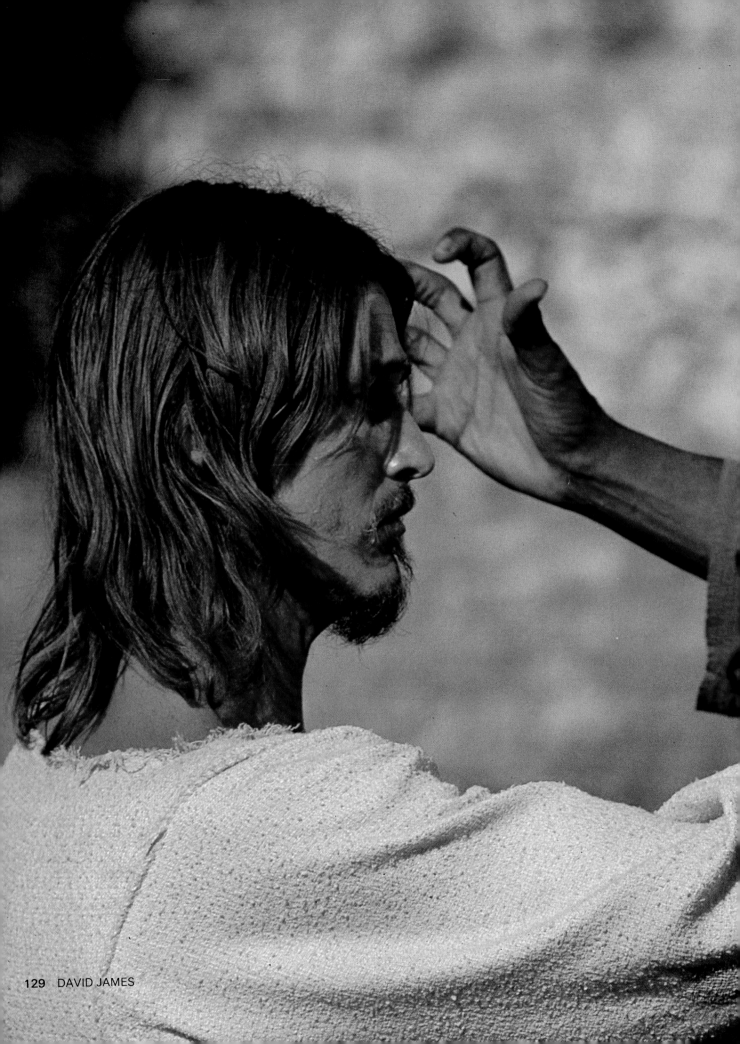

129 DAVID JAMES

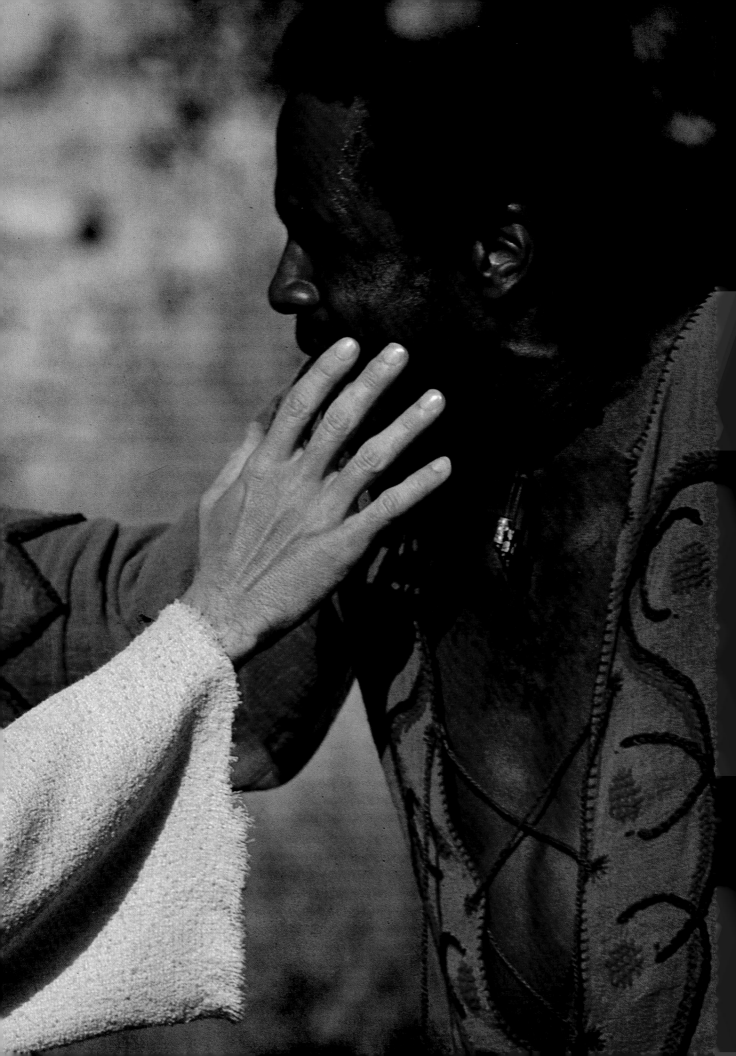

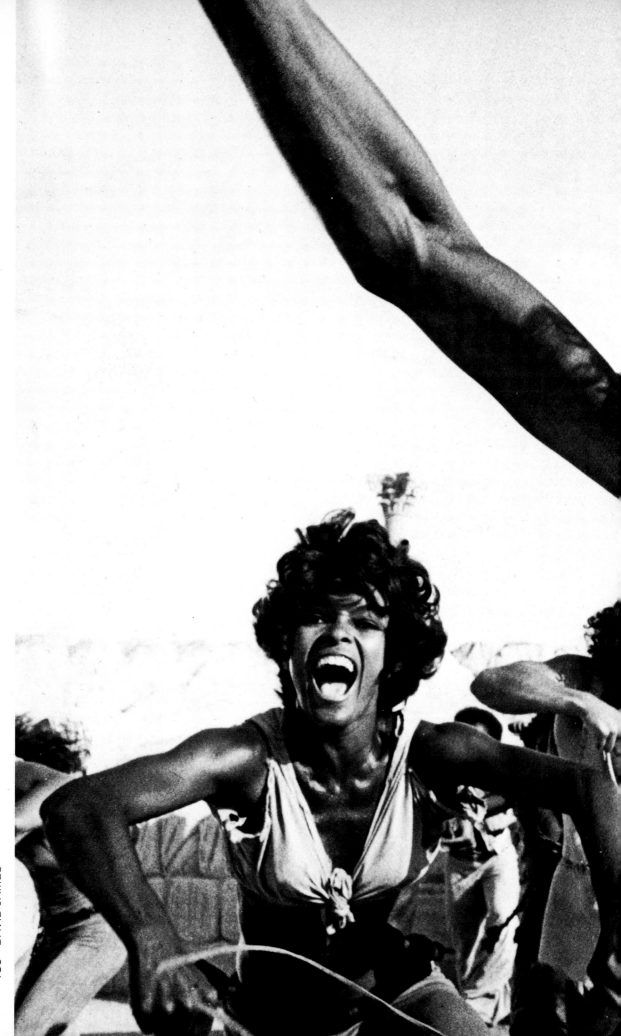

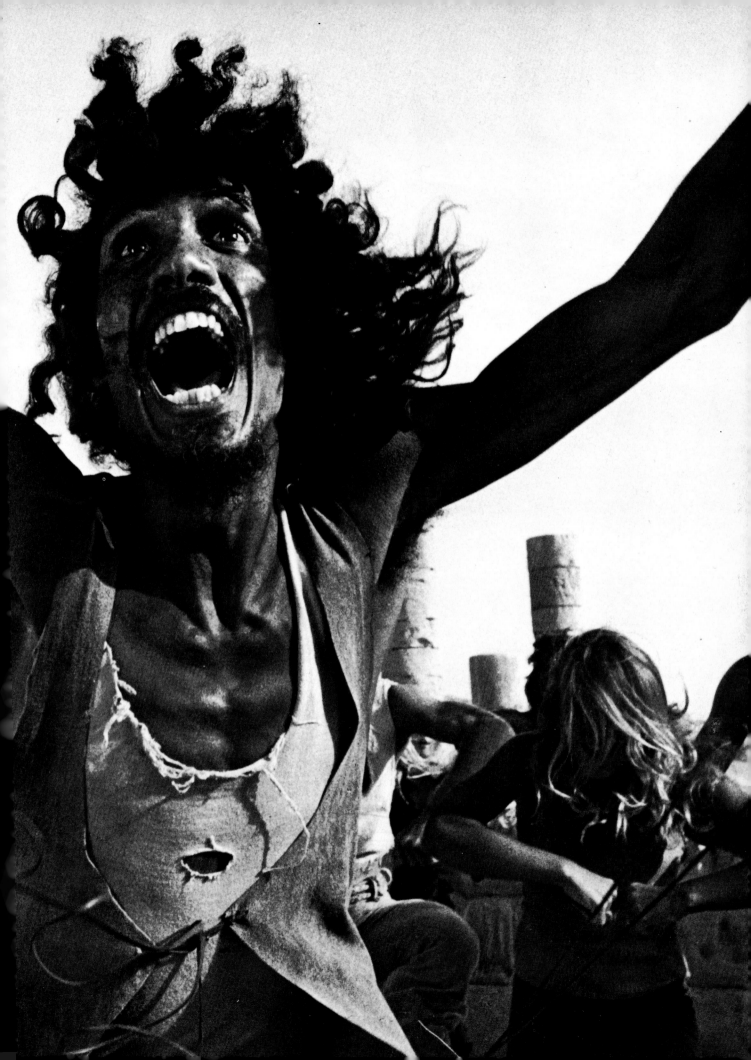

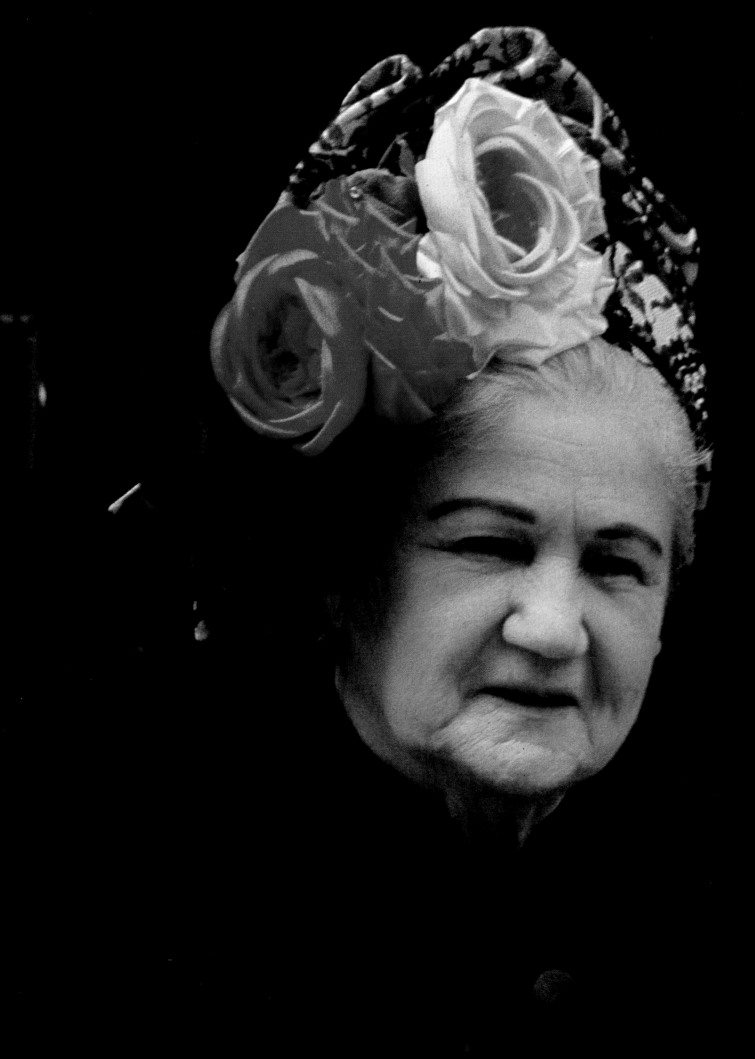

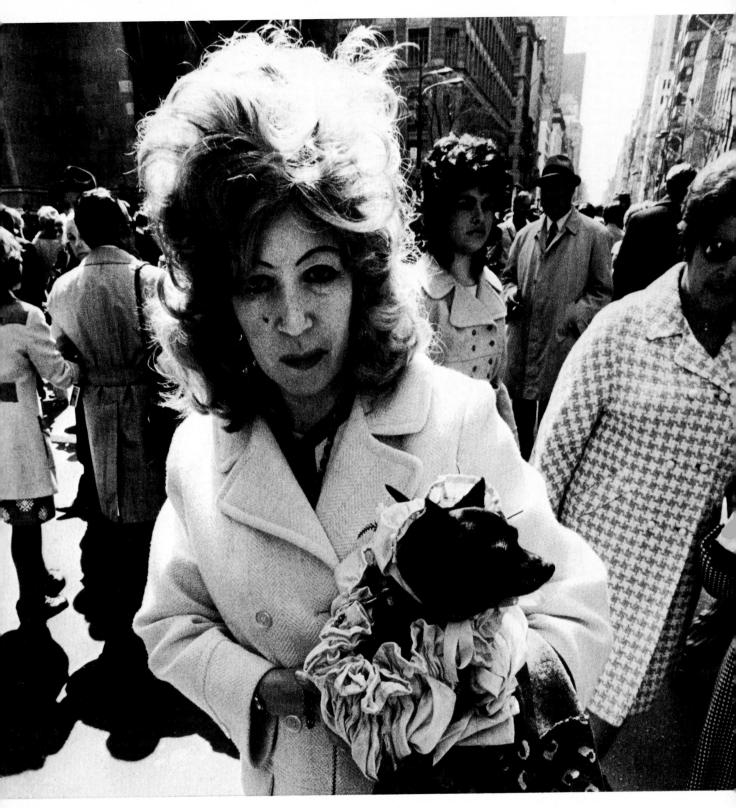

132/133 GERI DELLA ROCCA DE CANDAL

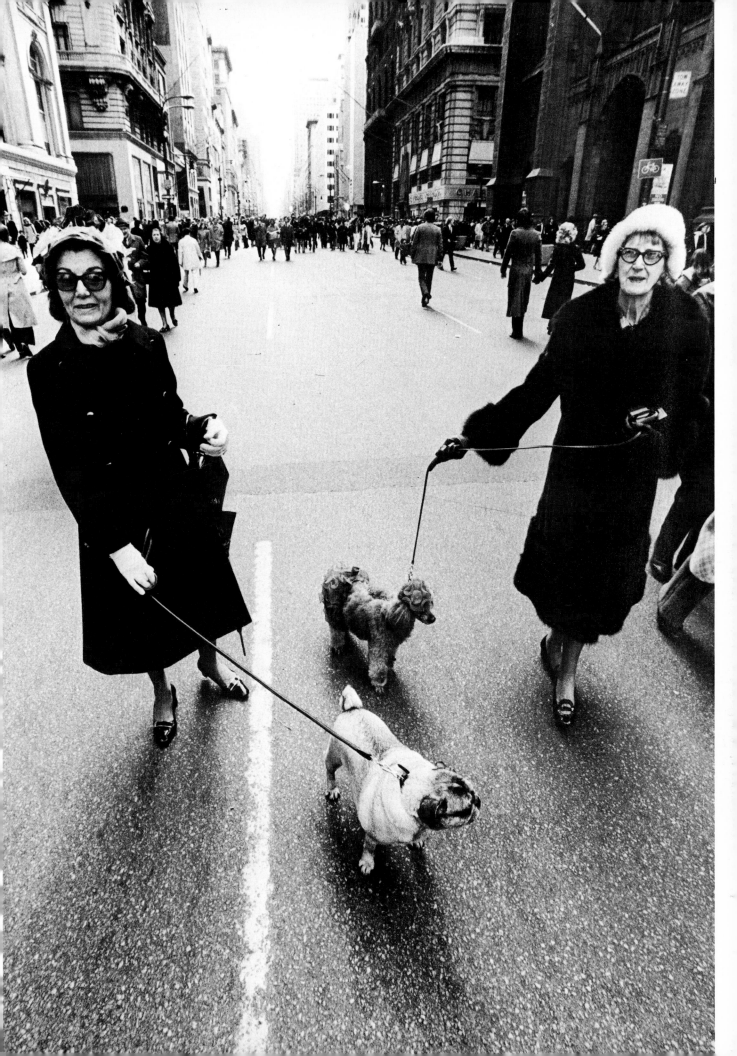

134/135 F. FLORIAN-STEINER

136/145 BOGDAN PALUSZYNSKI

147/148 SAM HASKINS

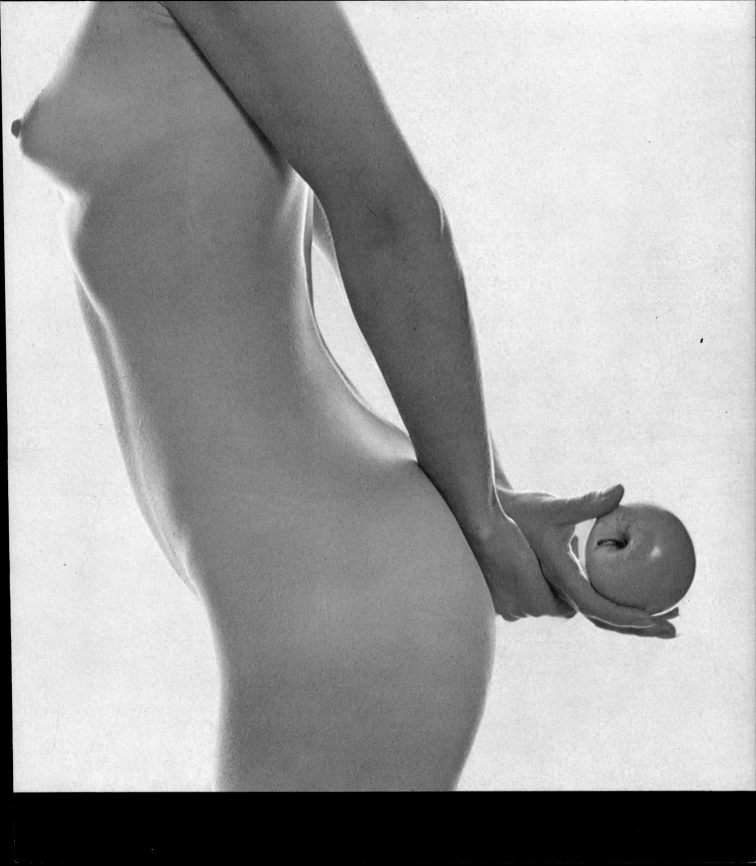

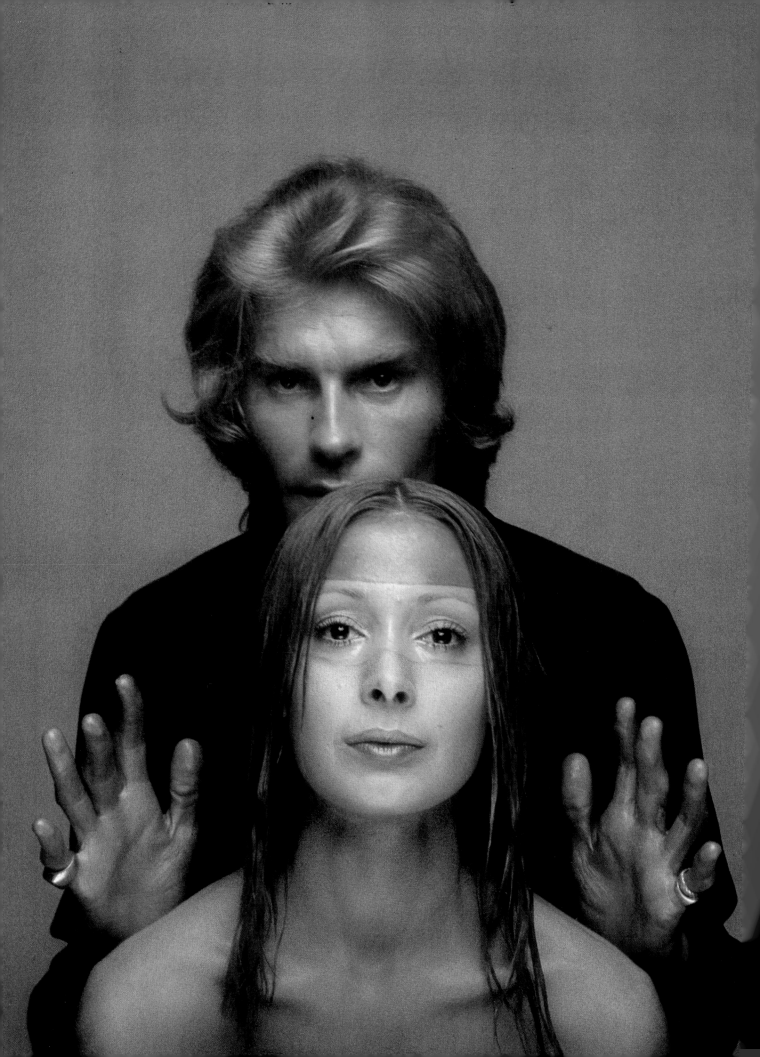

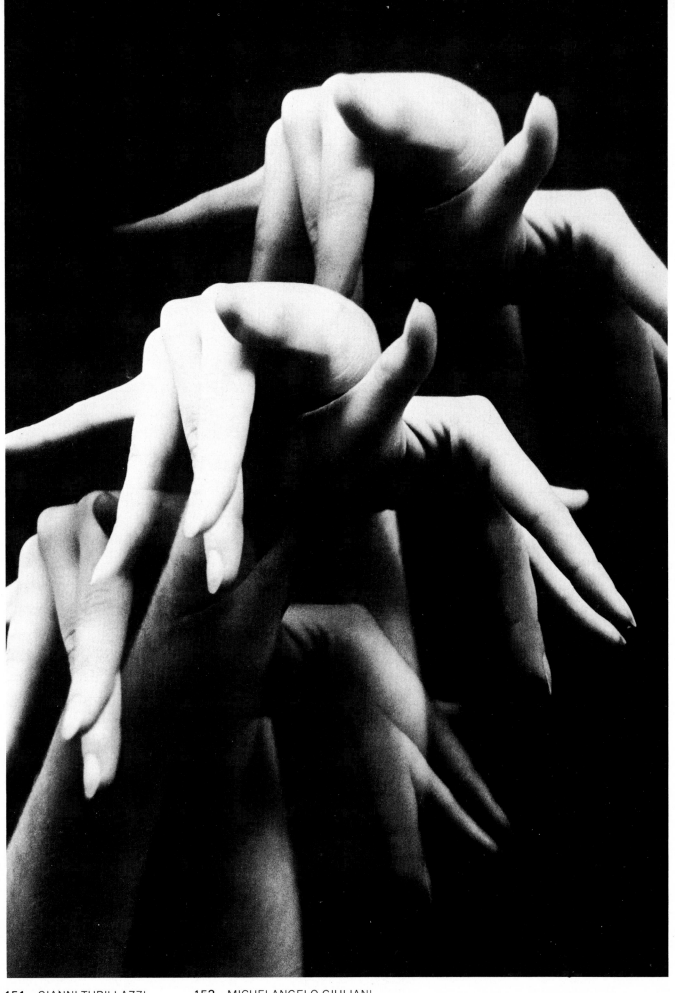

151 GIANNI TURILLAZZI 152 MICHELANGELO GIULIANI

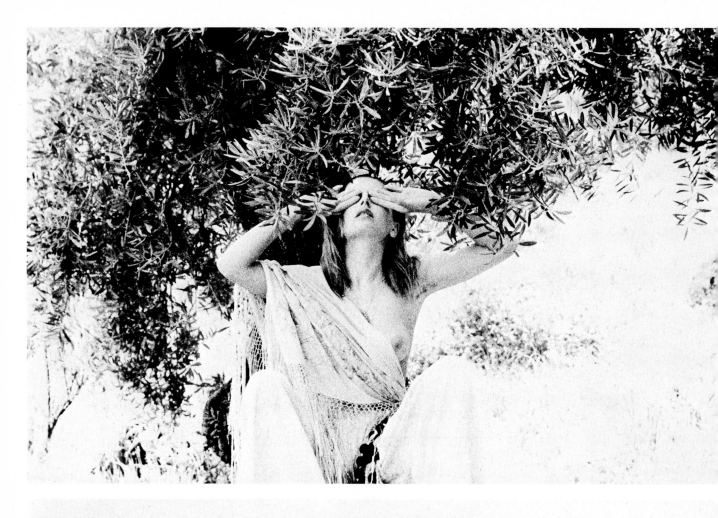

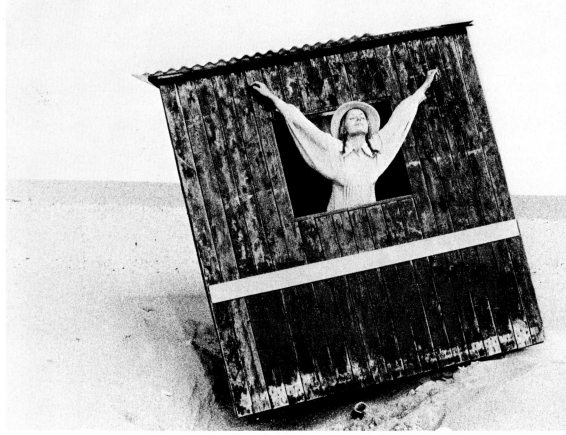

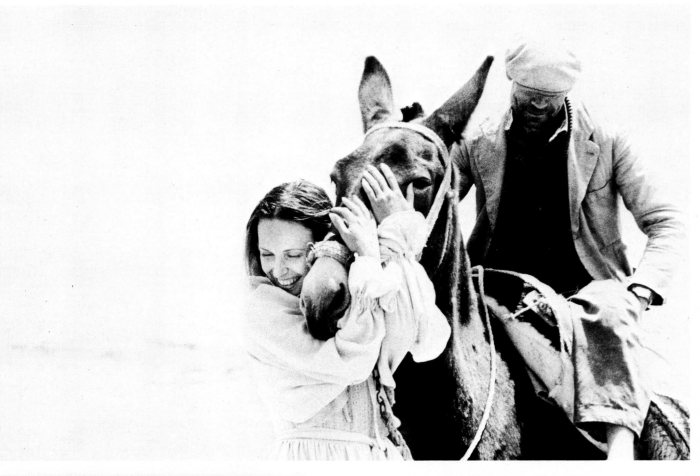

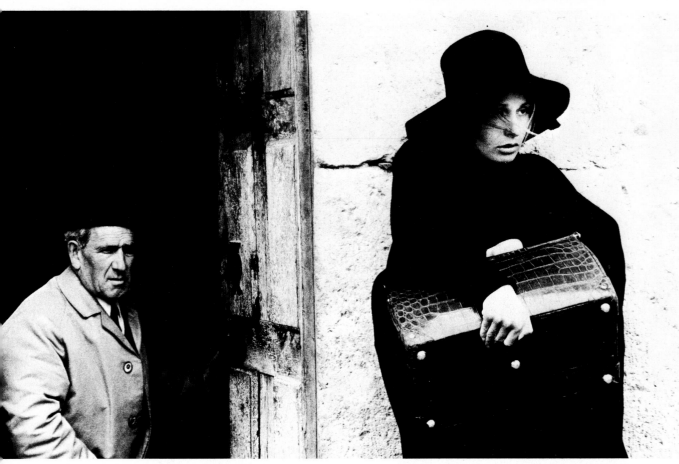

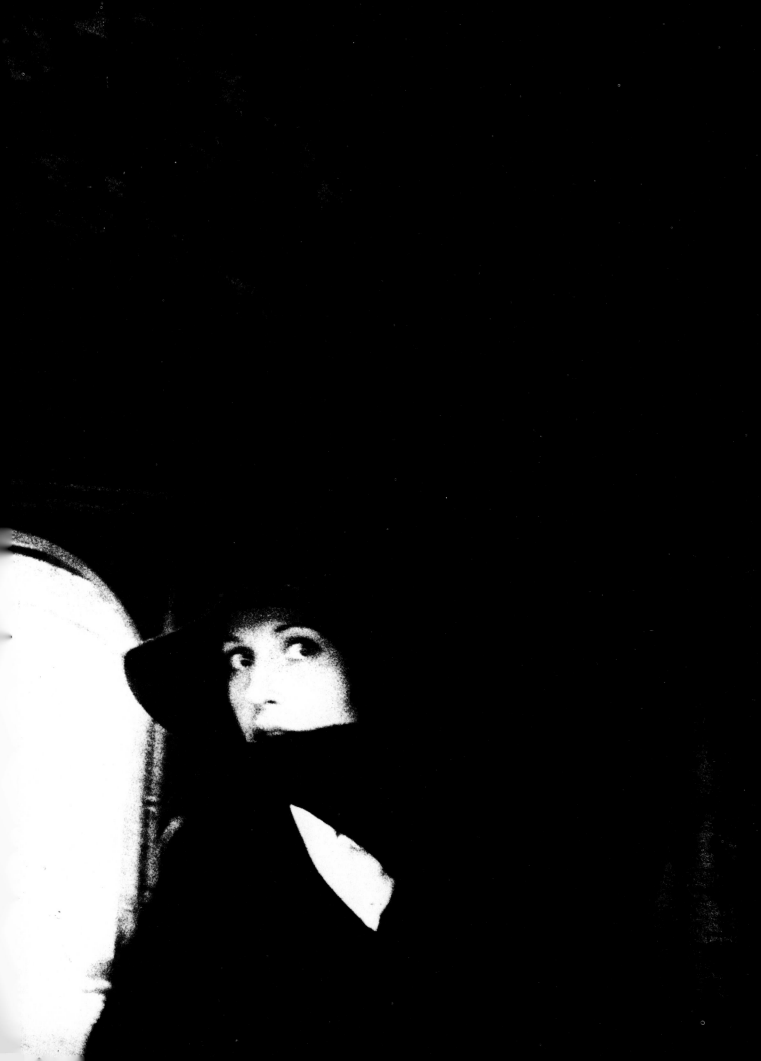

158 A. FLETCHER 159 WIESKAW DEBICKI

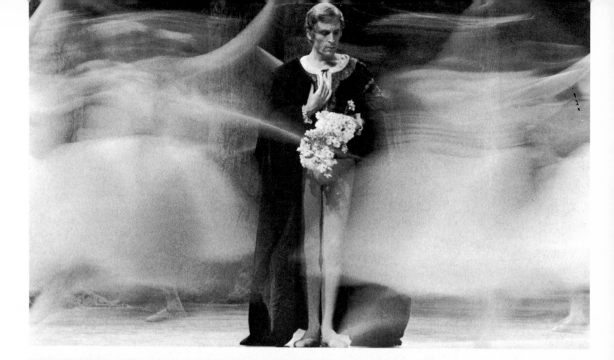

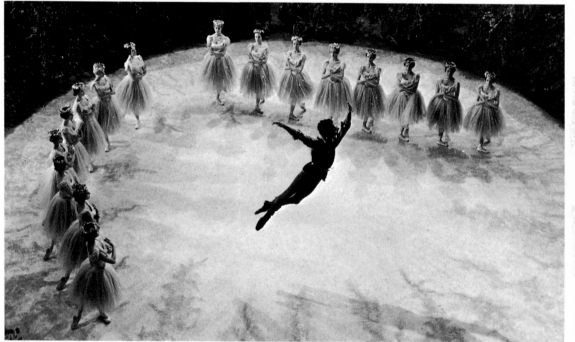

FEDERICO GRAU

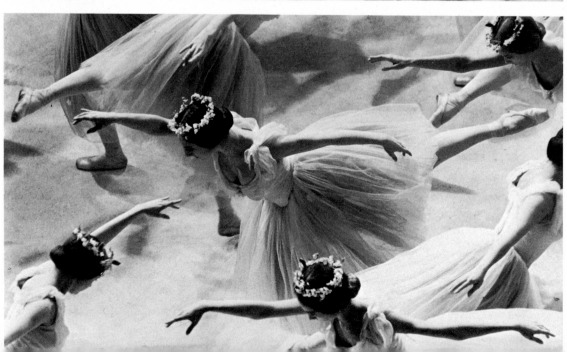

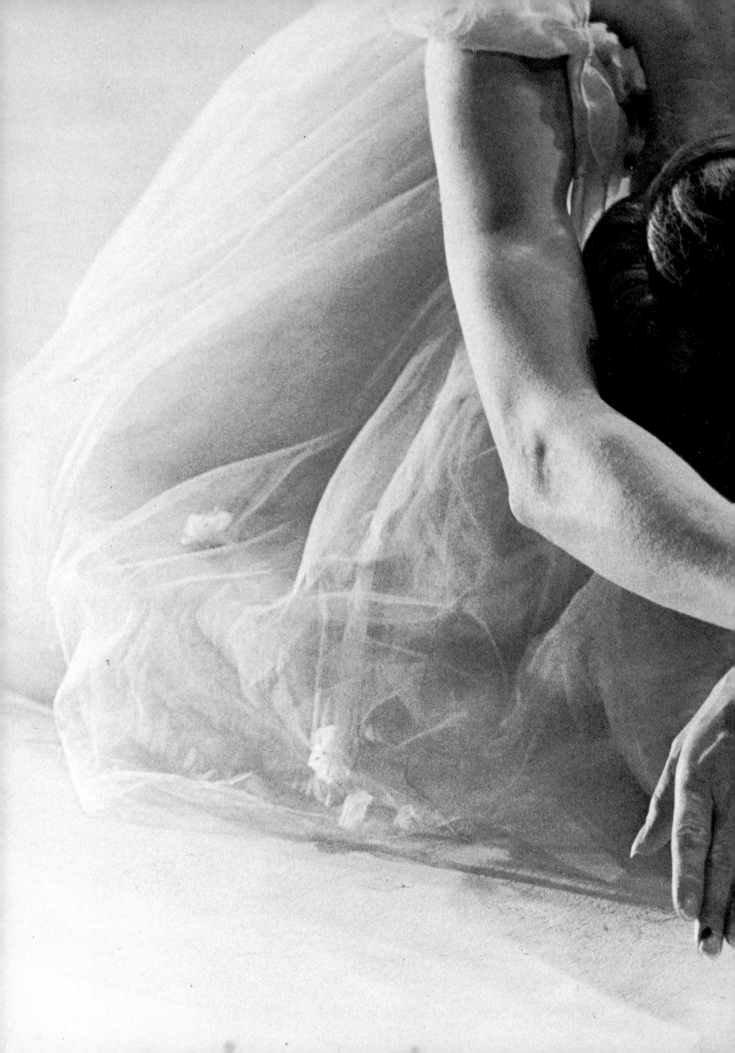

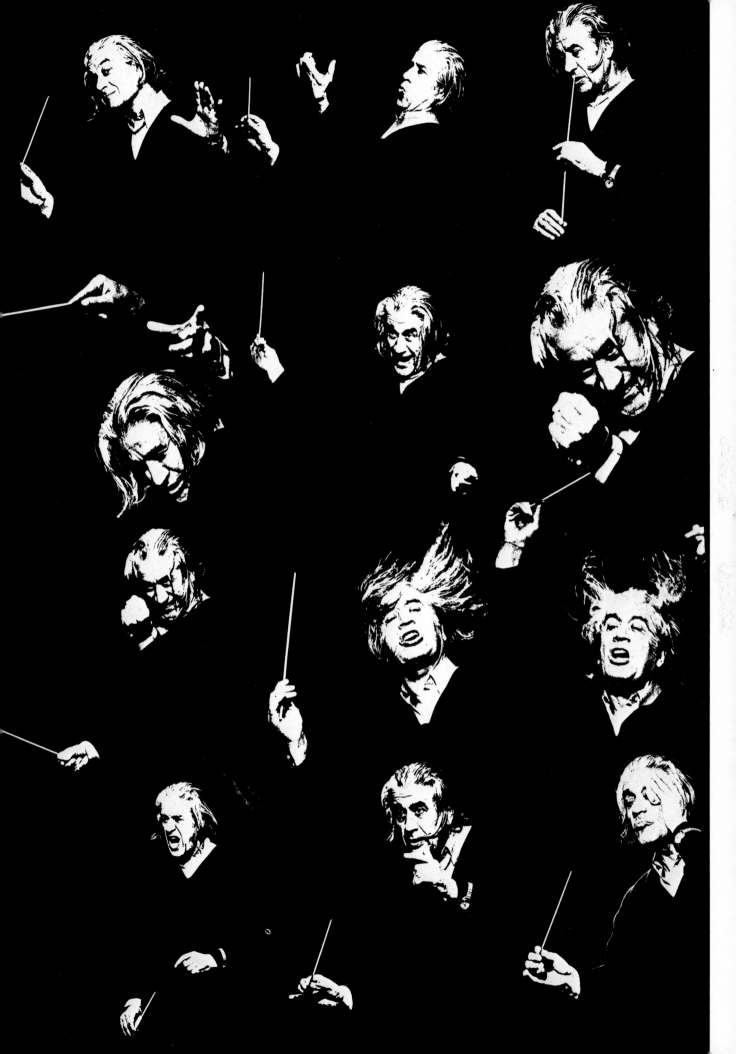

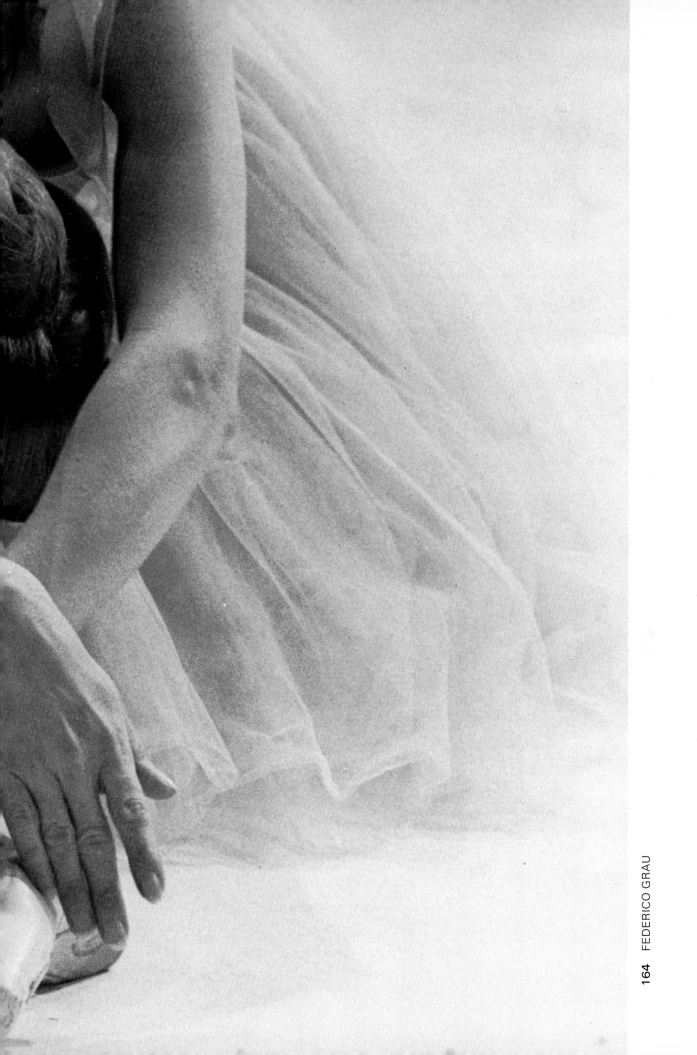

165/166 DAVID REDFERN 167 MORTEN LANGKILDE

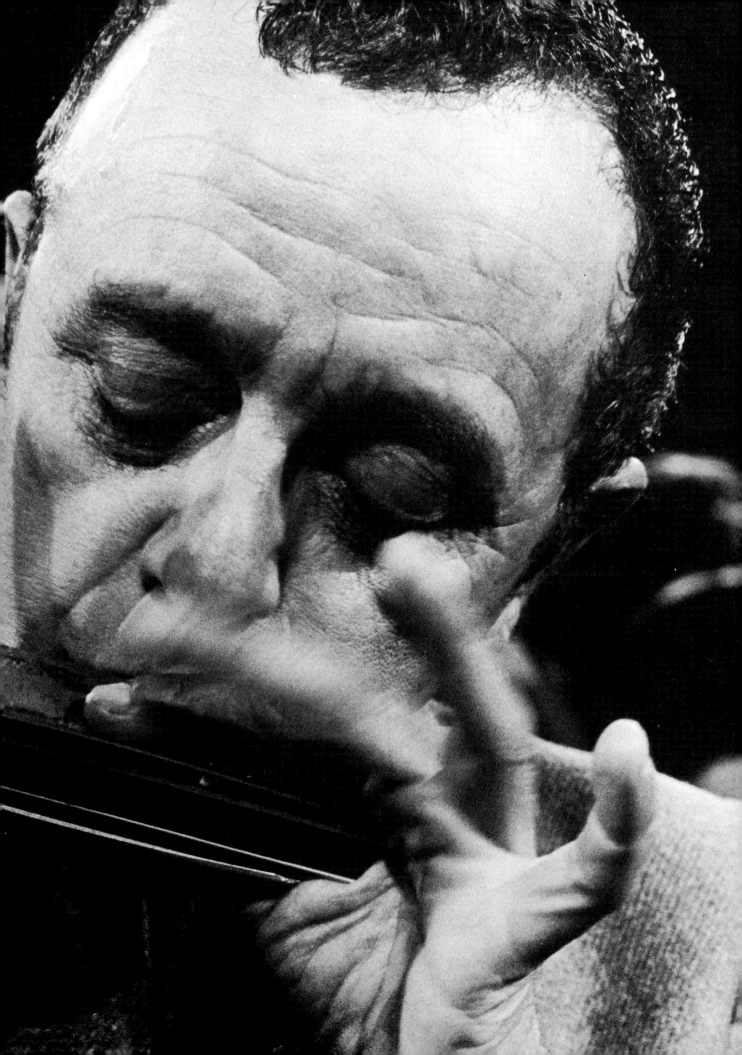

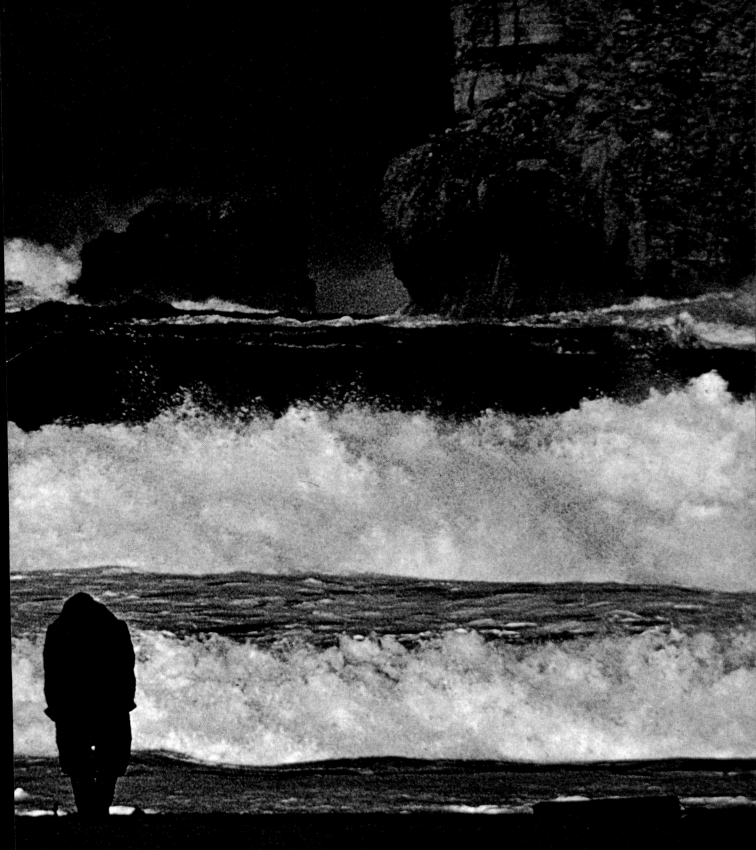

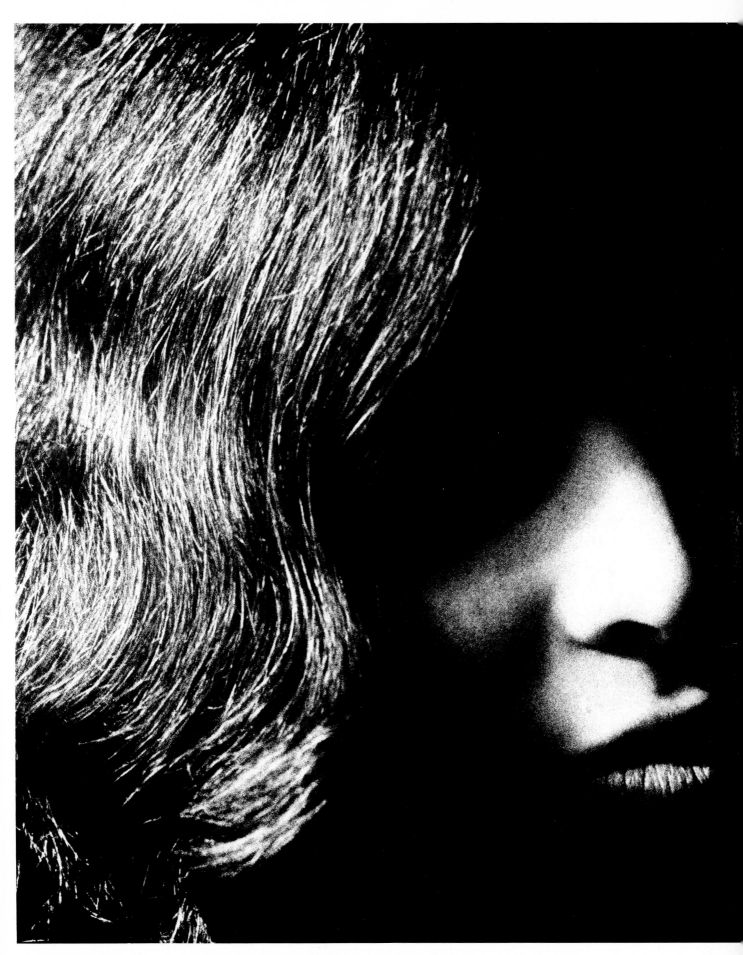

173 PETE TURNER 174 ALGIMANTAS BAREISIS

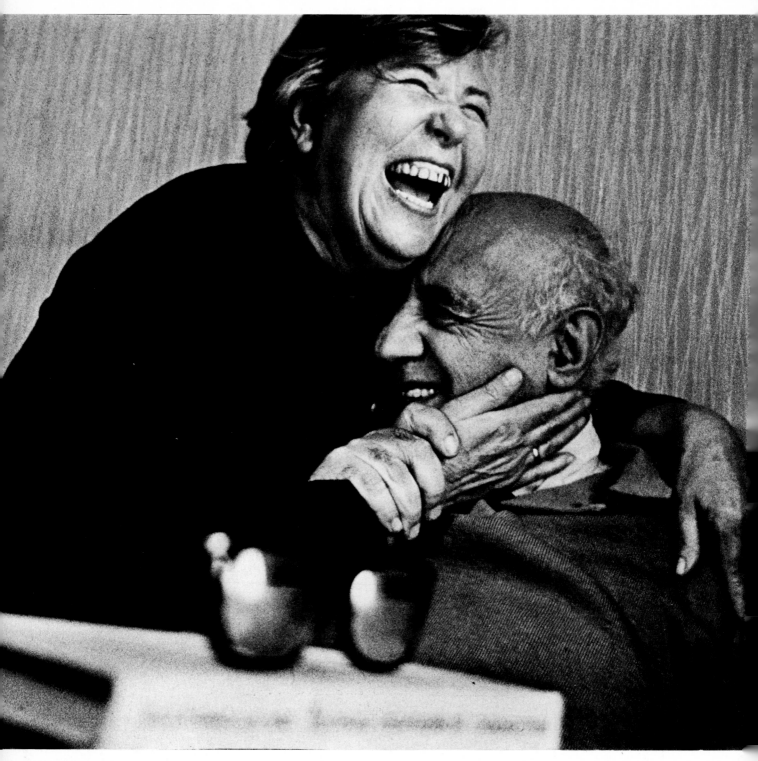

175 ALEKSANDRAS MACIJAUSKAS 176 V. KOPIUS 177 ROMUALDAS RAKAUSKAS

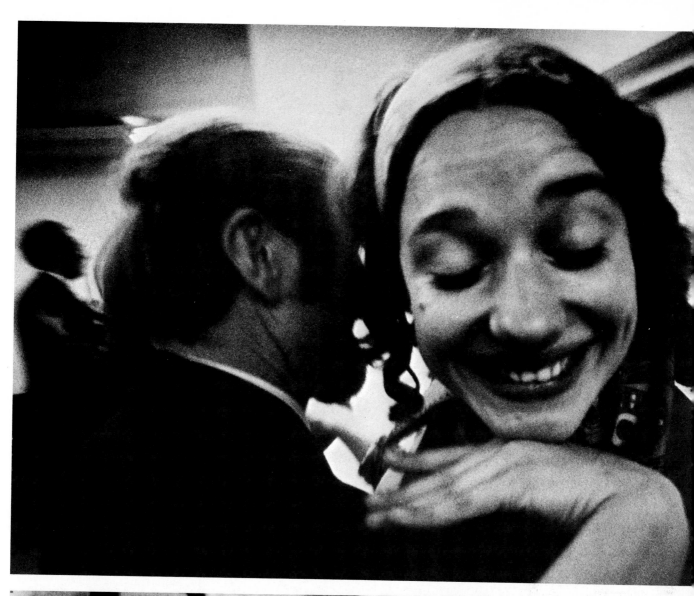

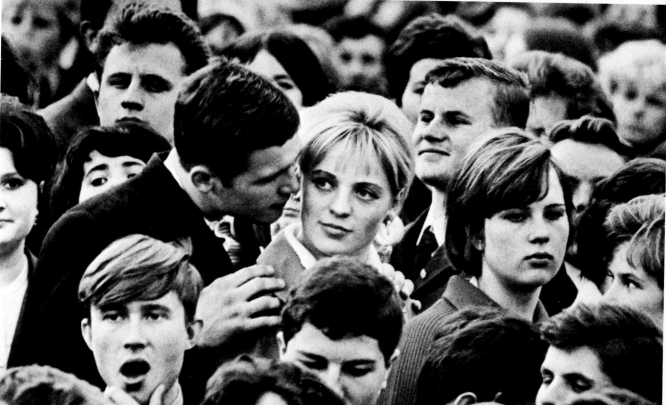

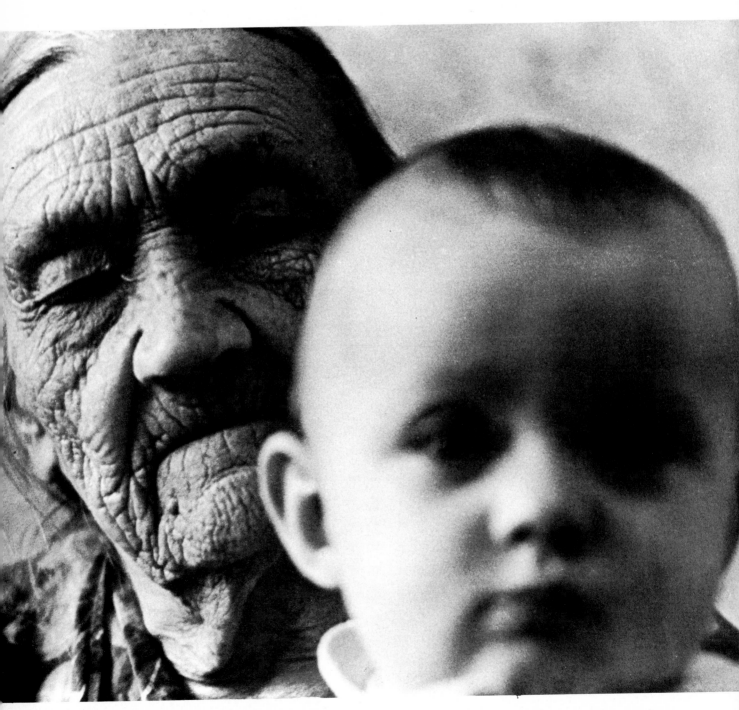

178 ROMUALDAS RAKAUSKAS 179 L. RUIKAS

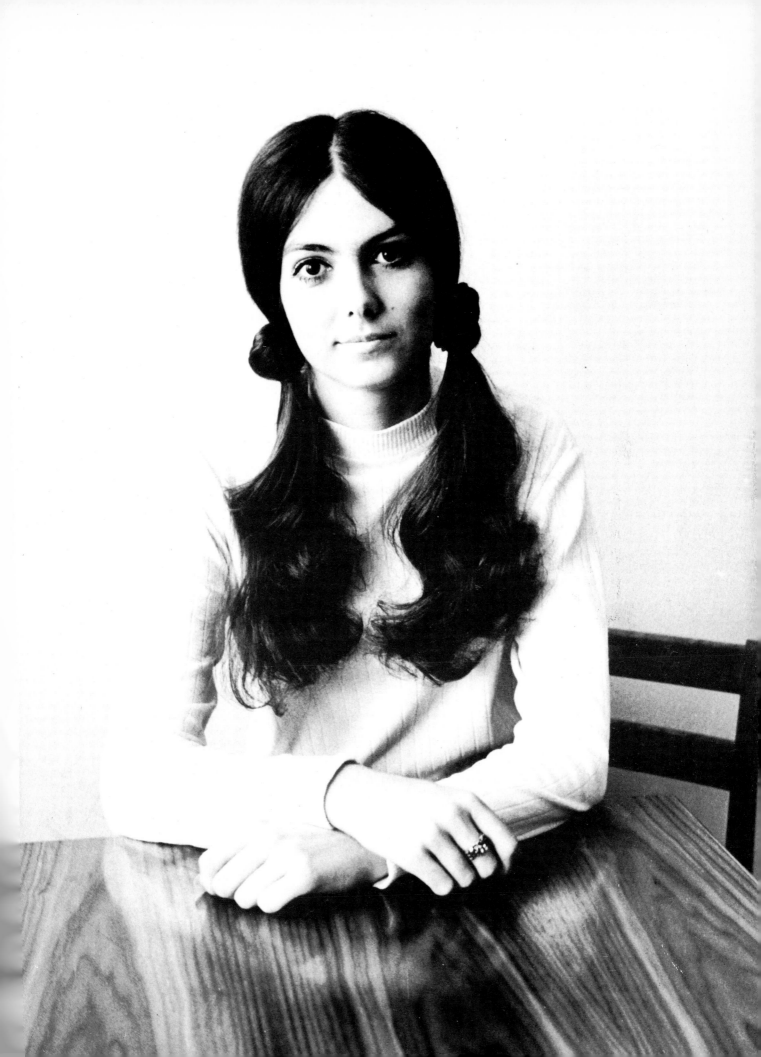

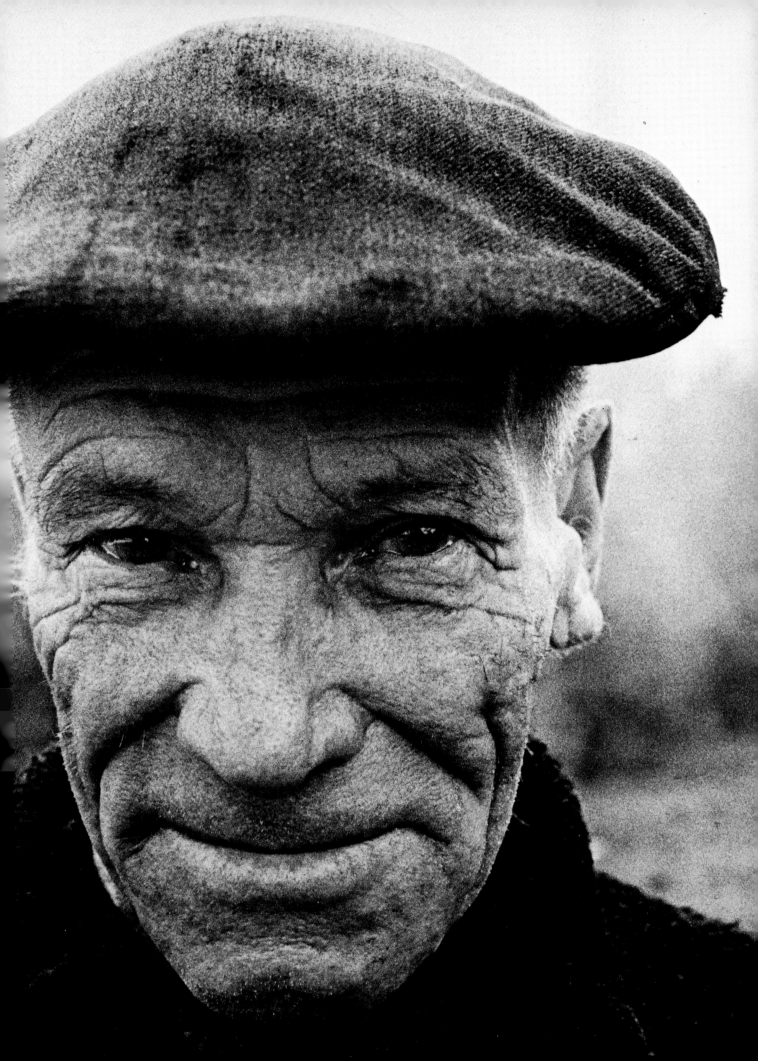

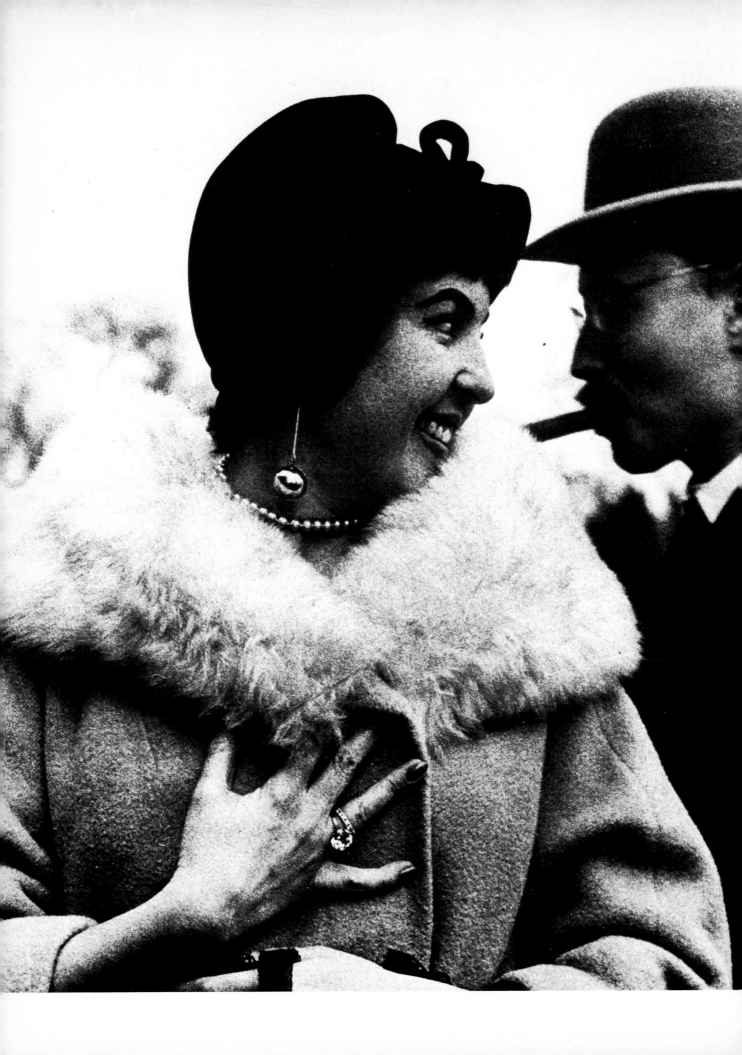

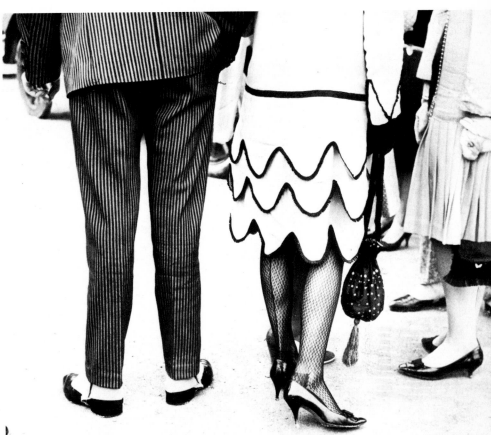

181/182 J. VILASECA PARRAMON

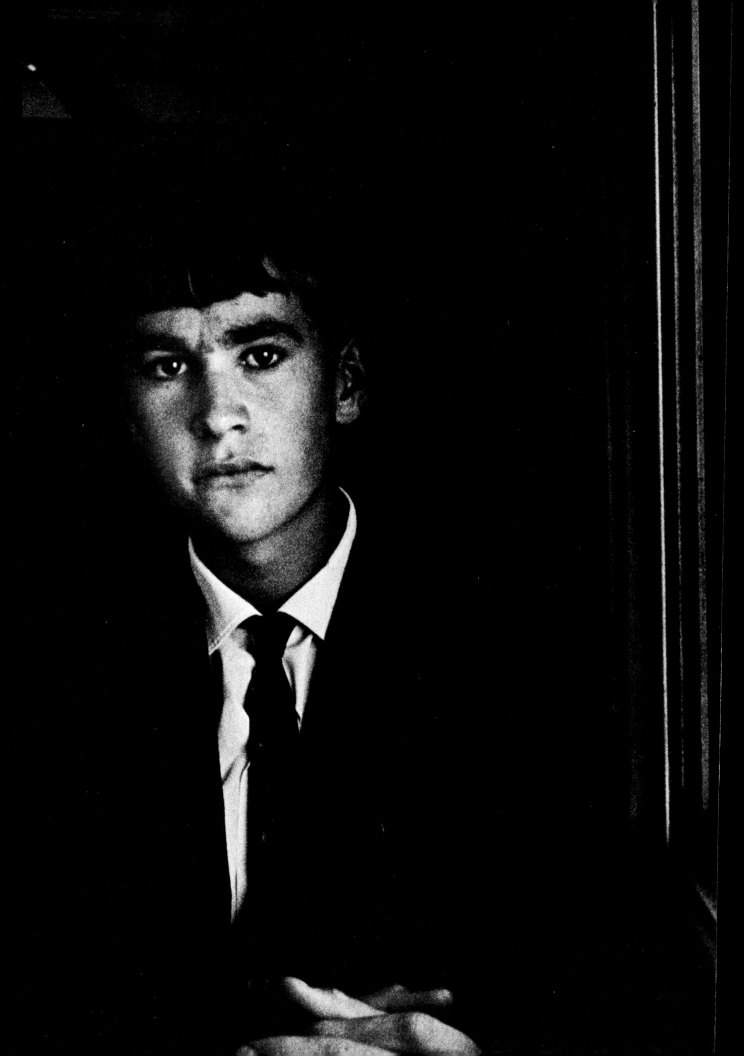

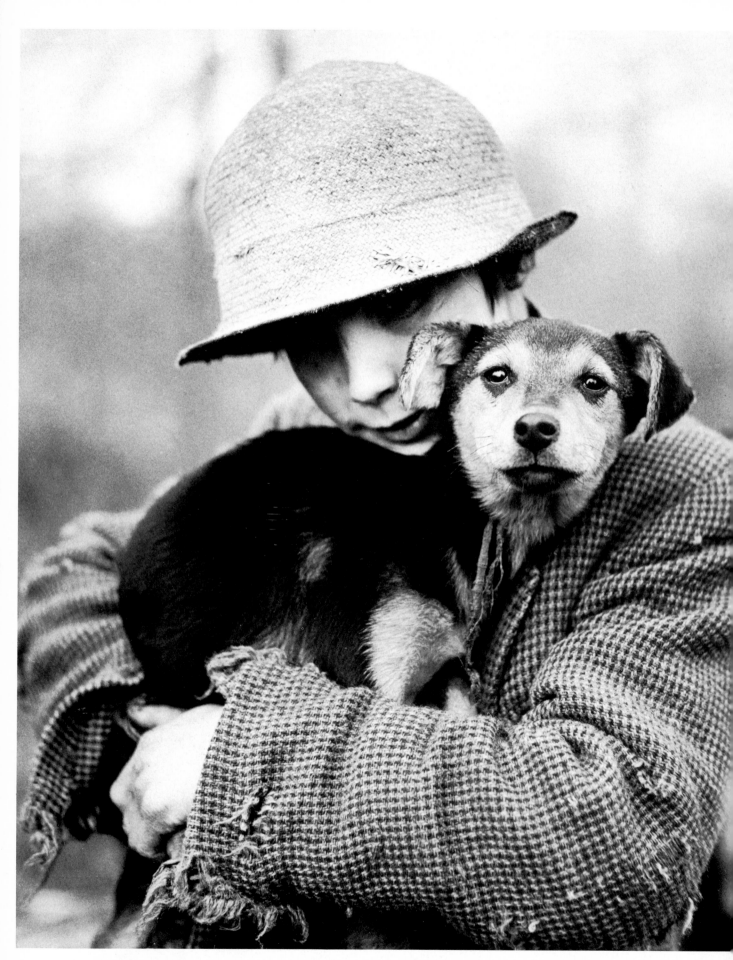

184 TONY BOXALL 185 KALERVO OJUTKANGAS

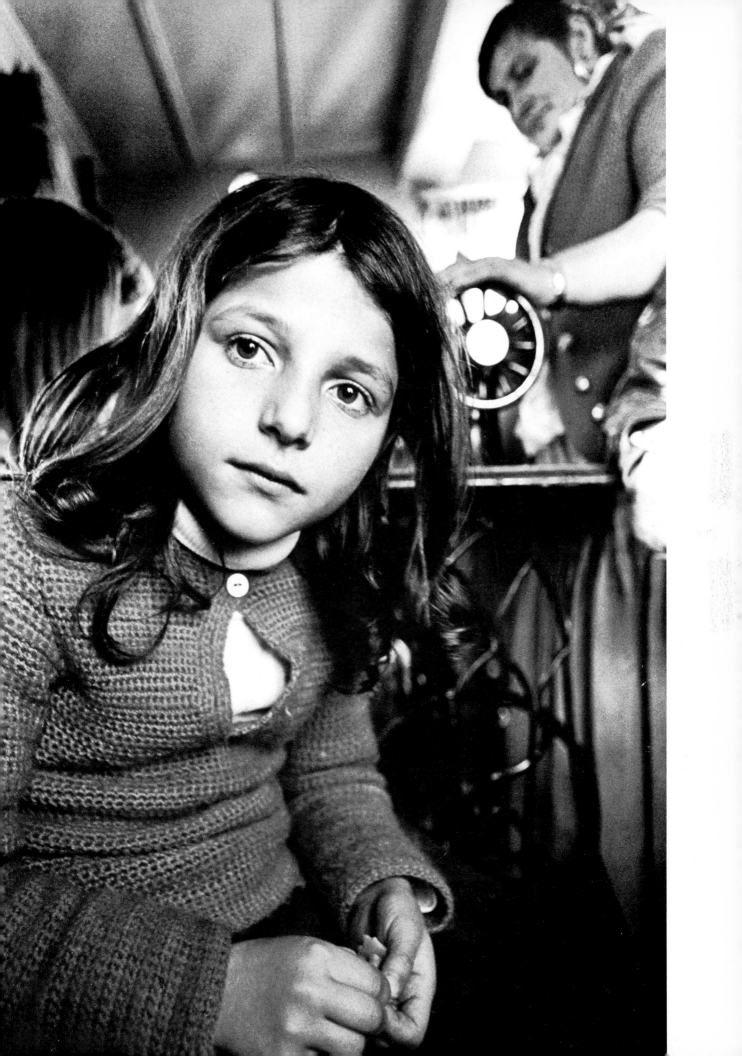

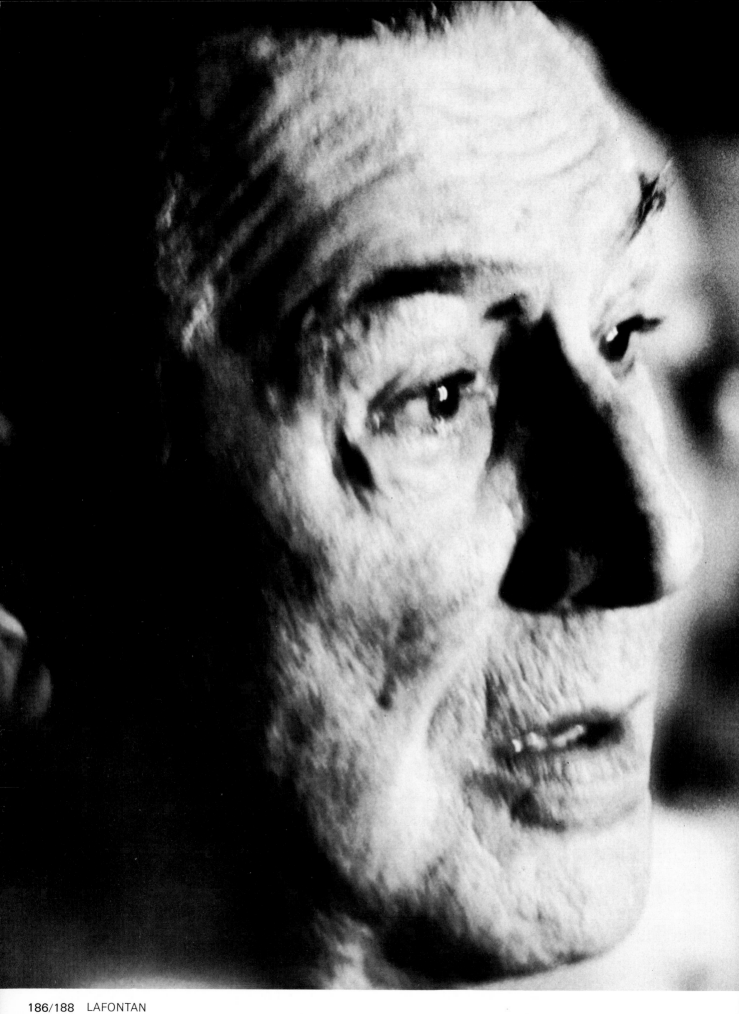

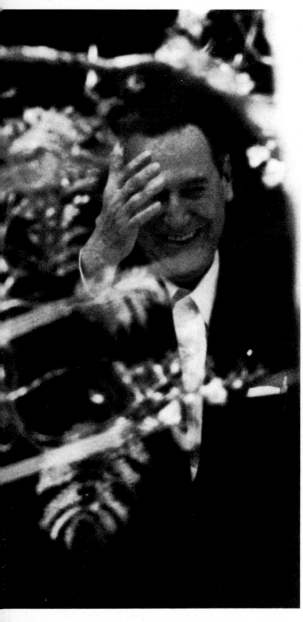

186/190 LAFONTAN

191 PETER O'REILLY **192** ROBERT MICHEL

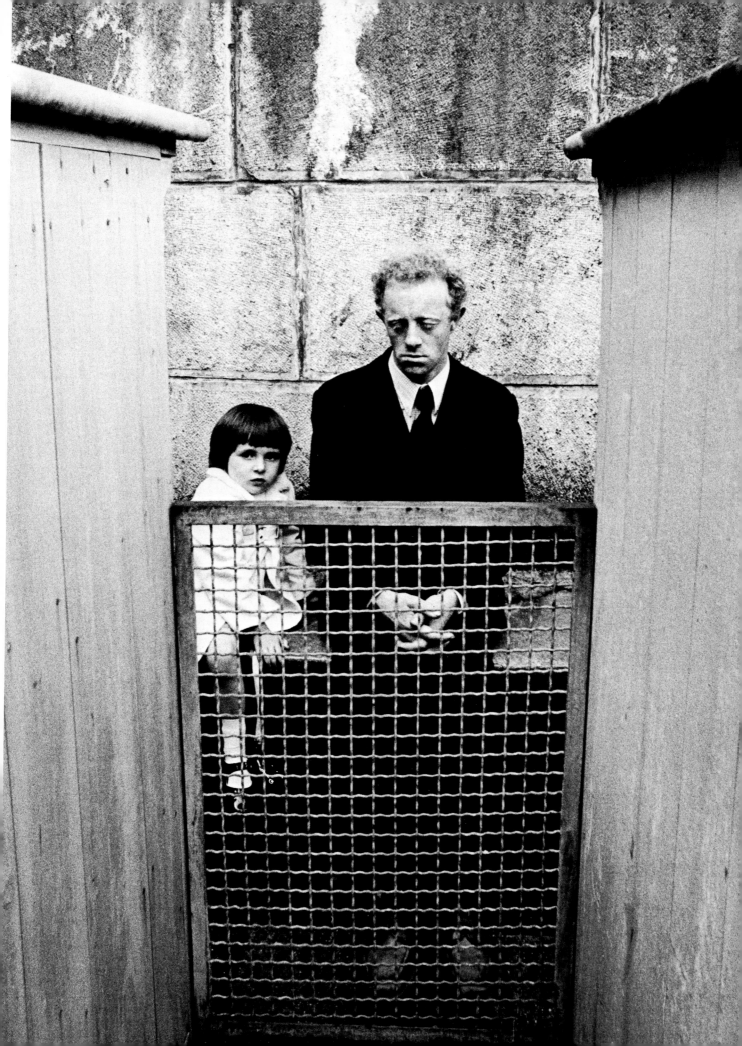

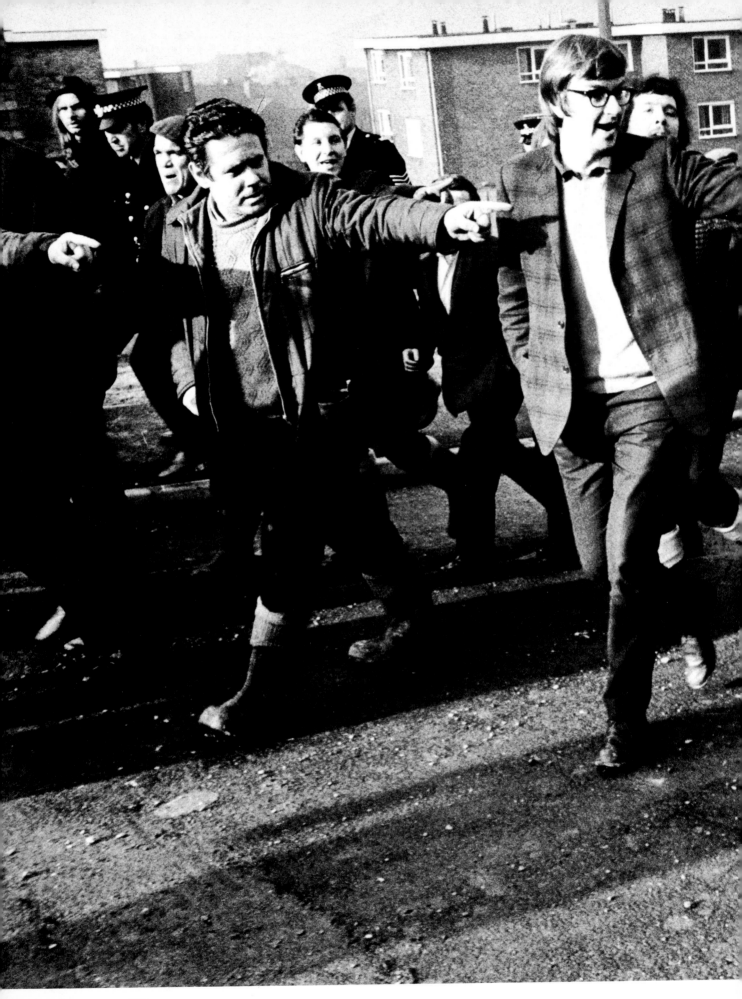

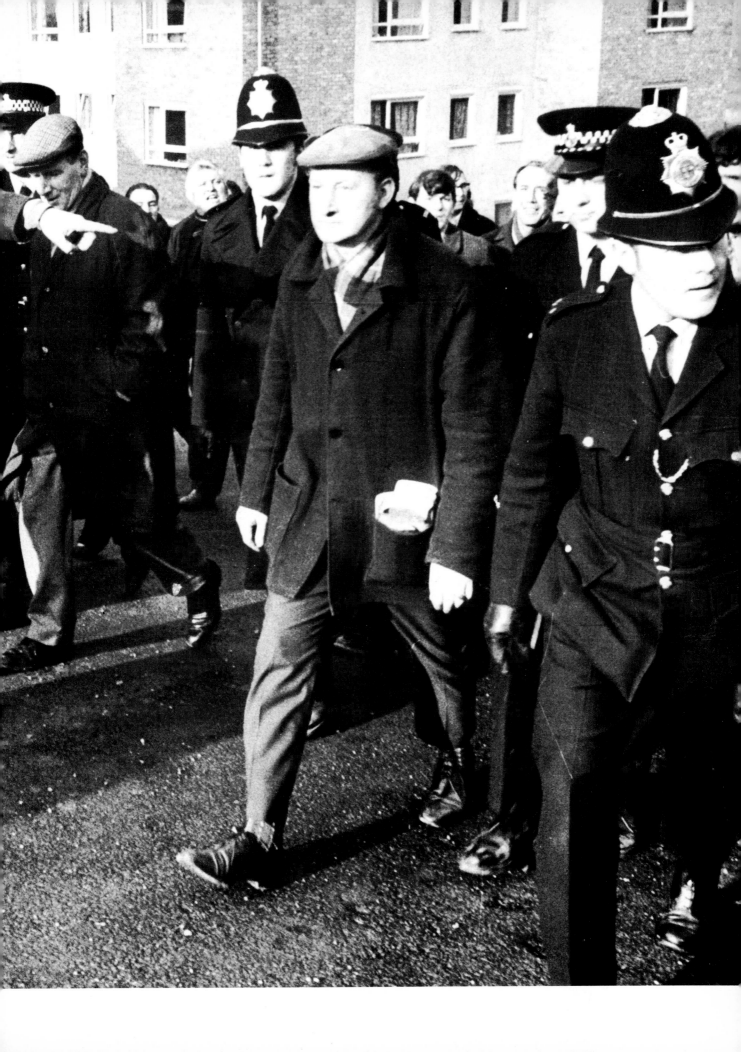

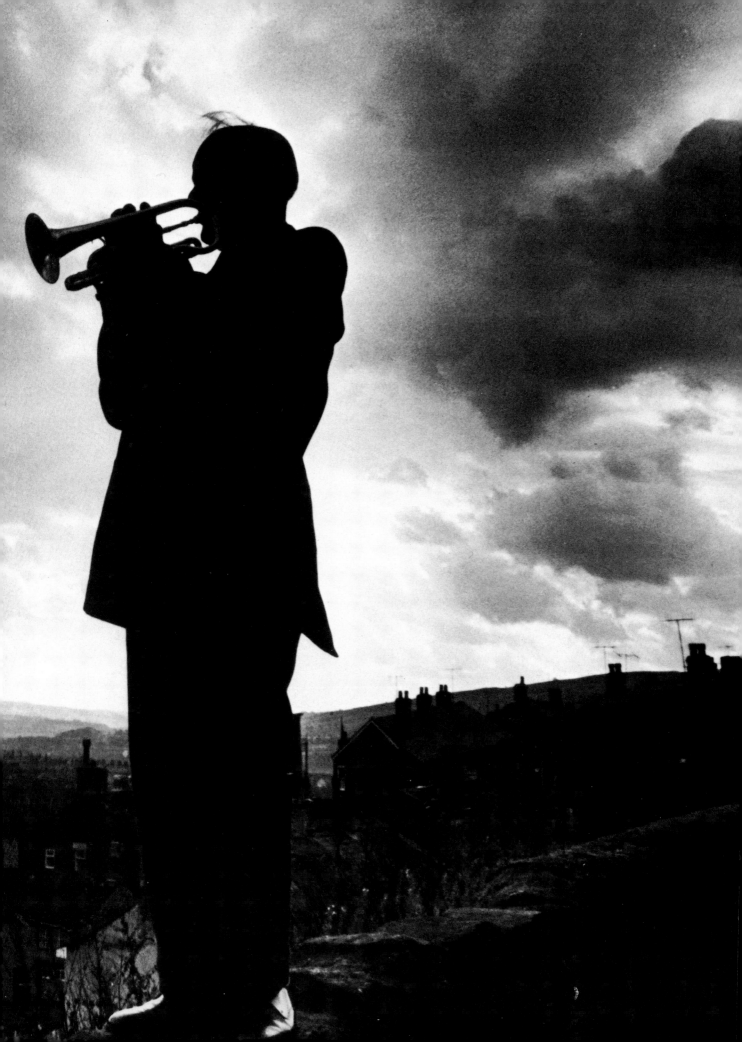

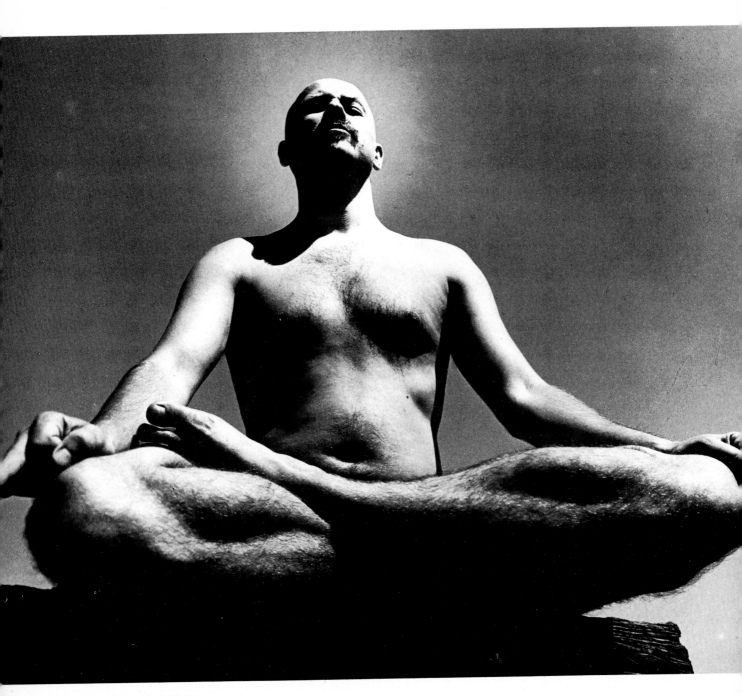

195/196 VERNER MOGENSEN

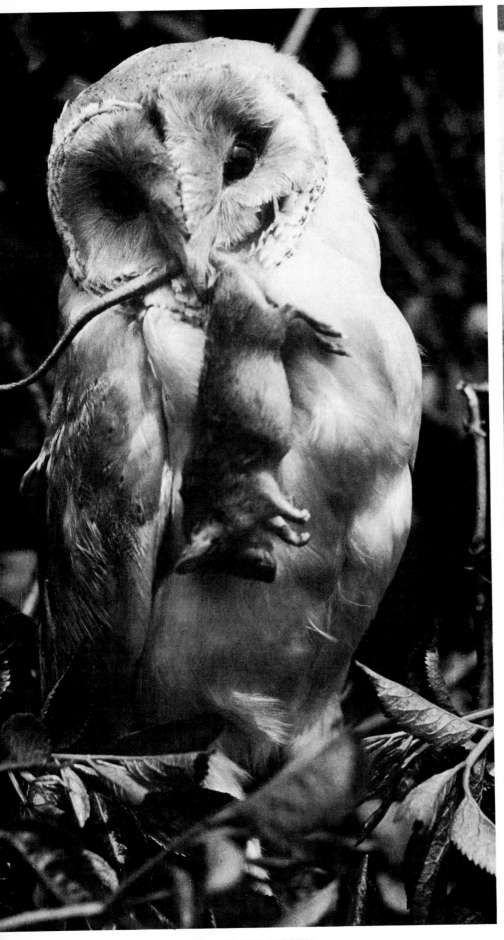

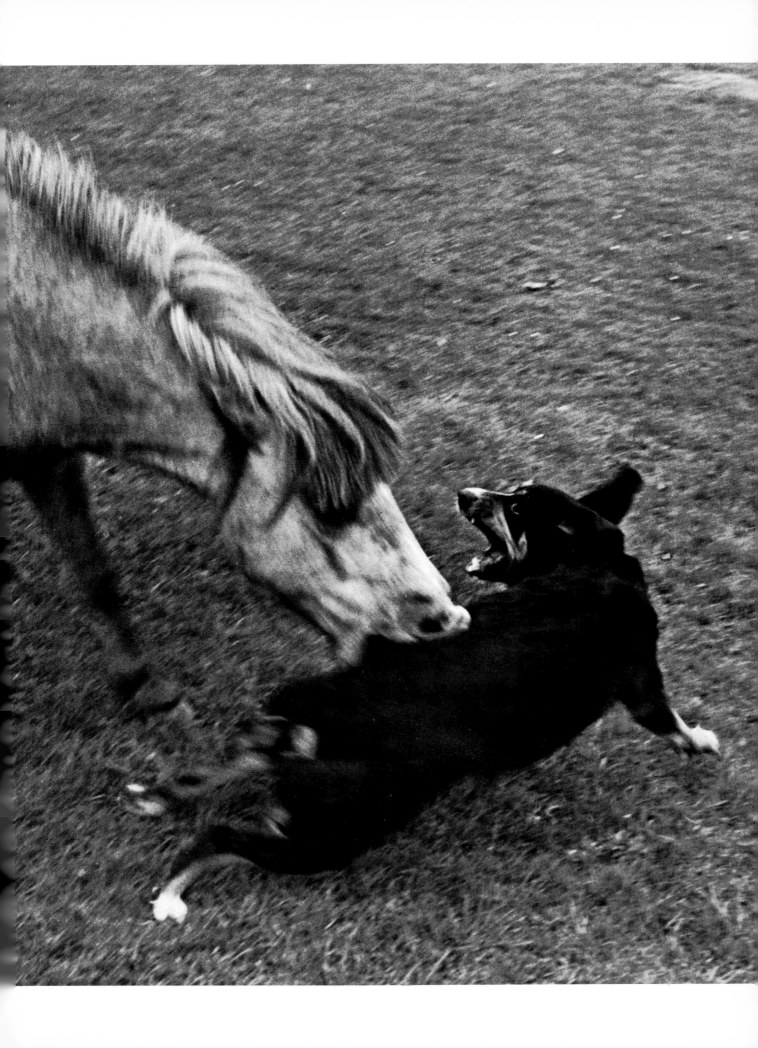

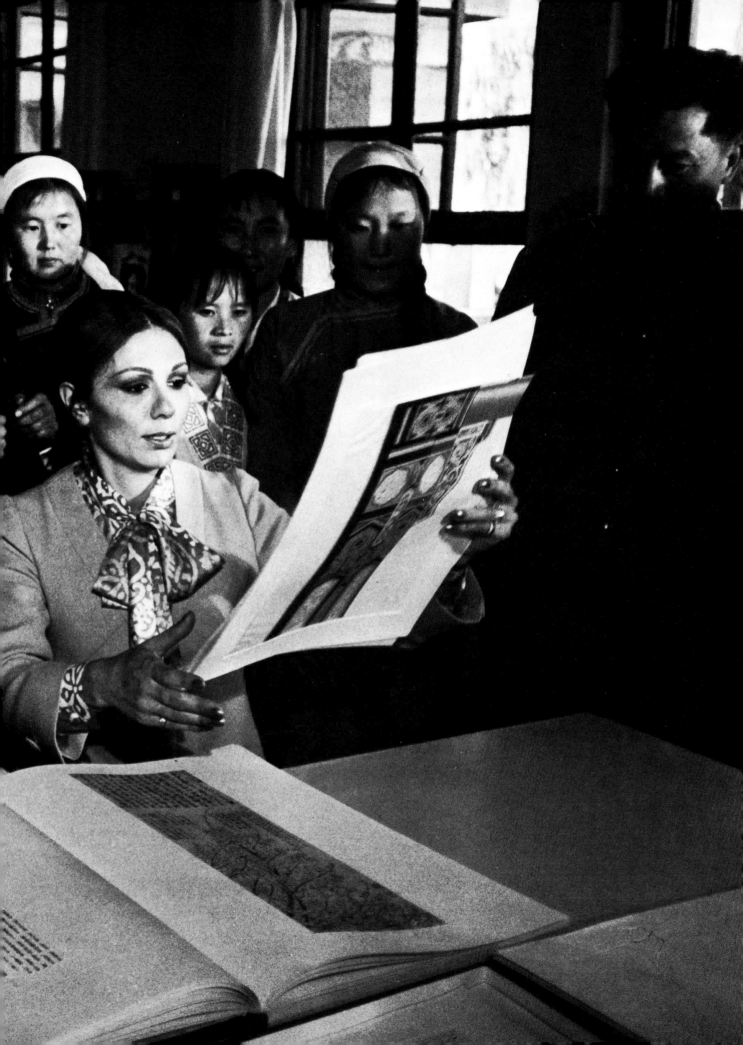

201/202 PETER KEEN

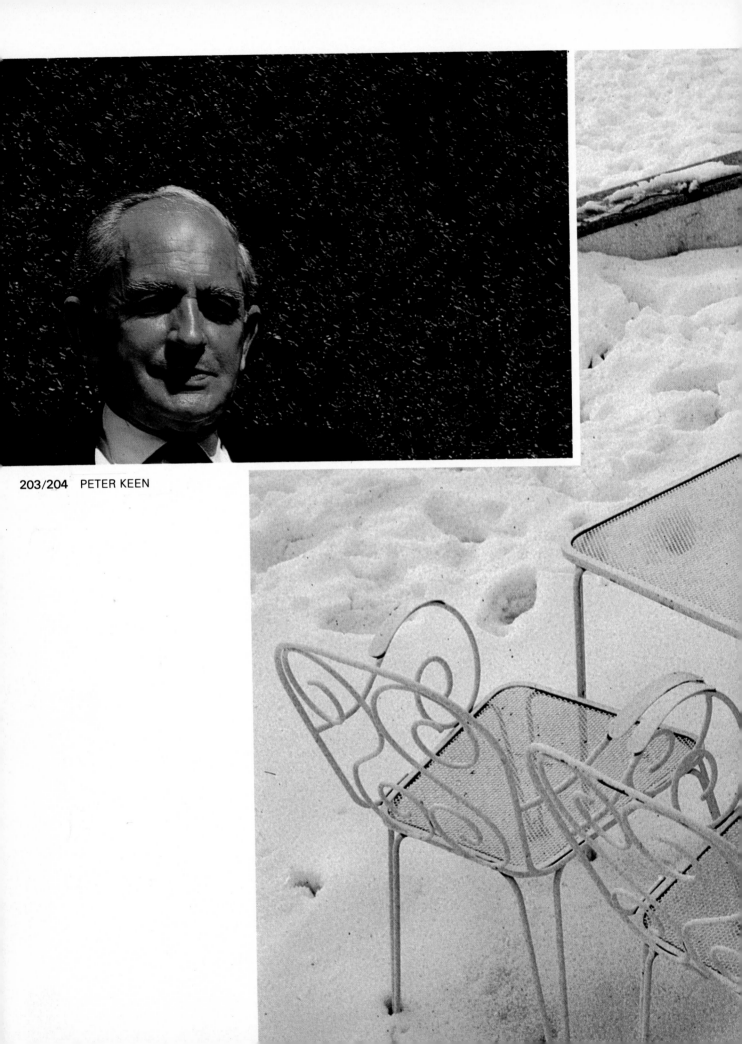

203/204　PETER KEEN

205/206 GRAHAM FINLAYSON

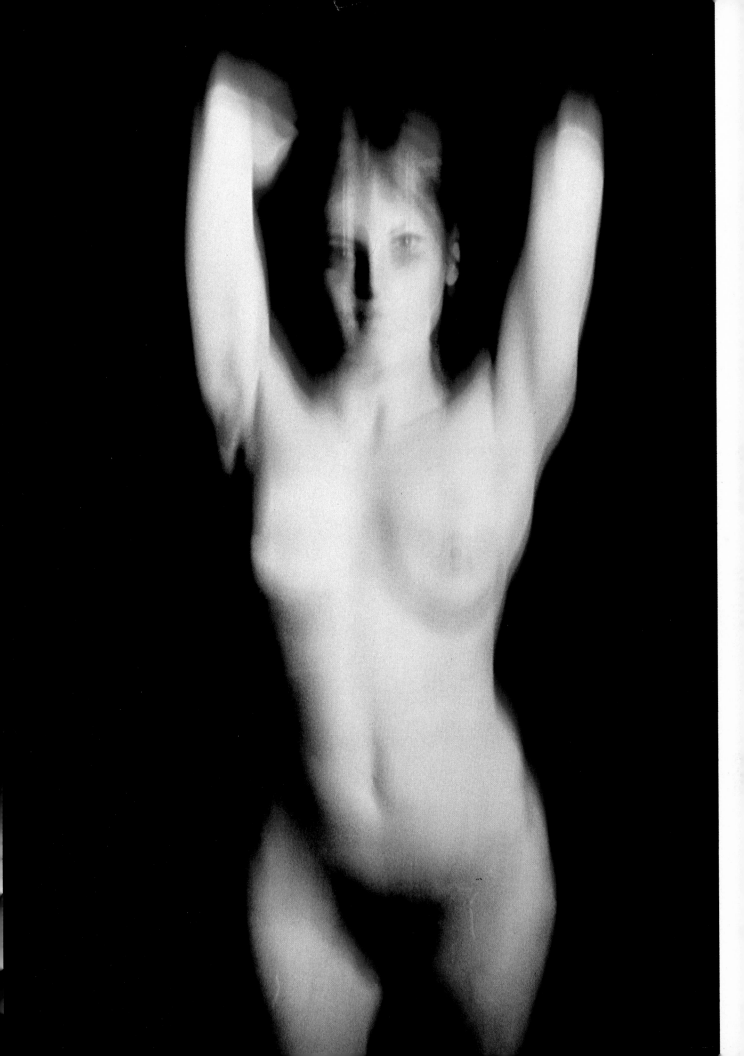

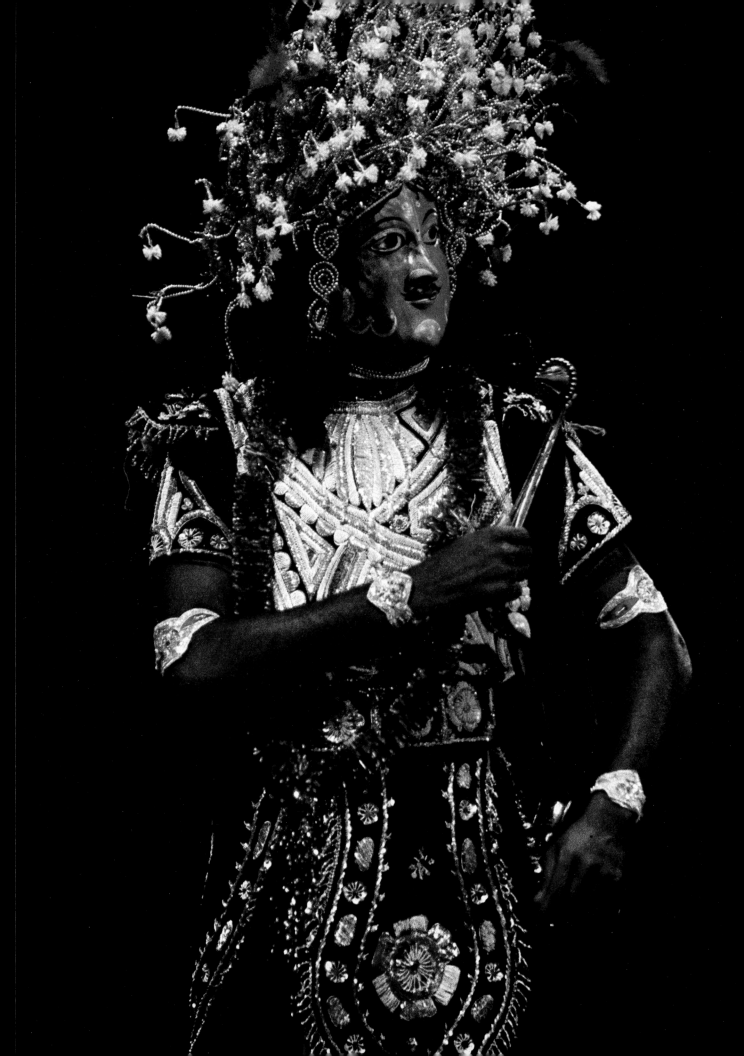

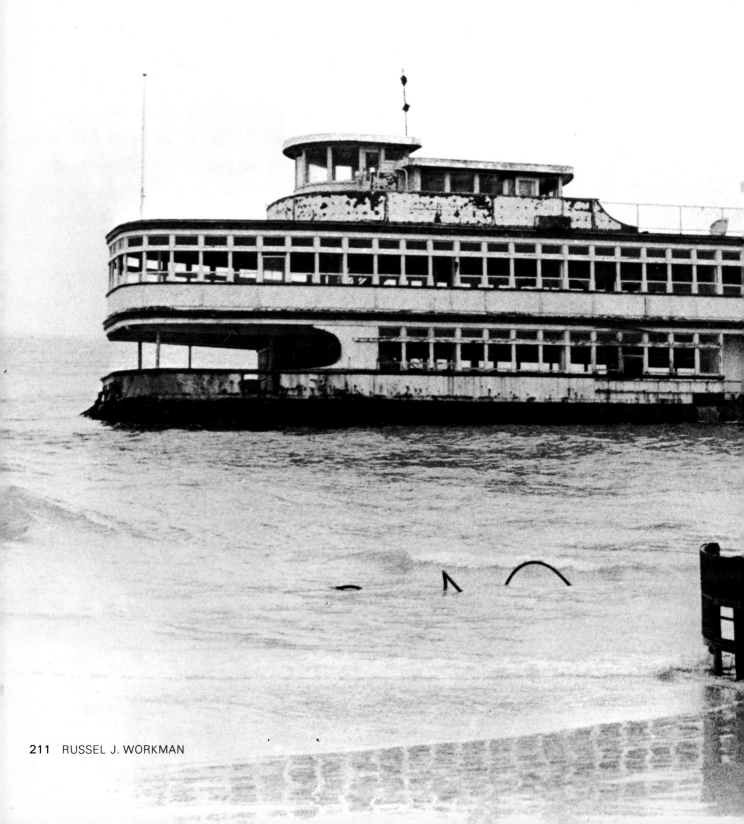

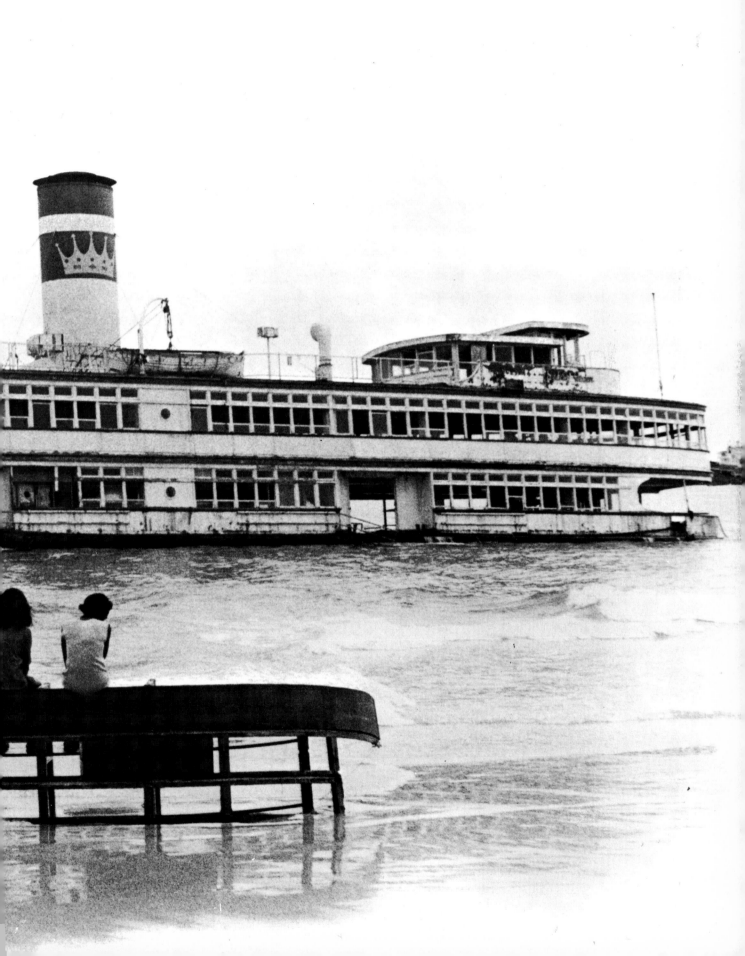

212/213 HANS W. SILVESTER

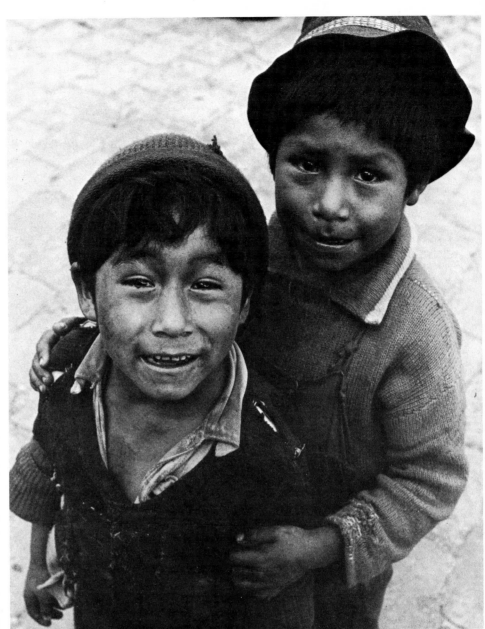

214/215 HANS W. SILVESTER

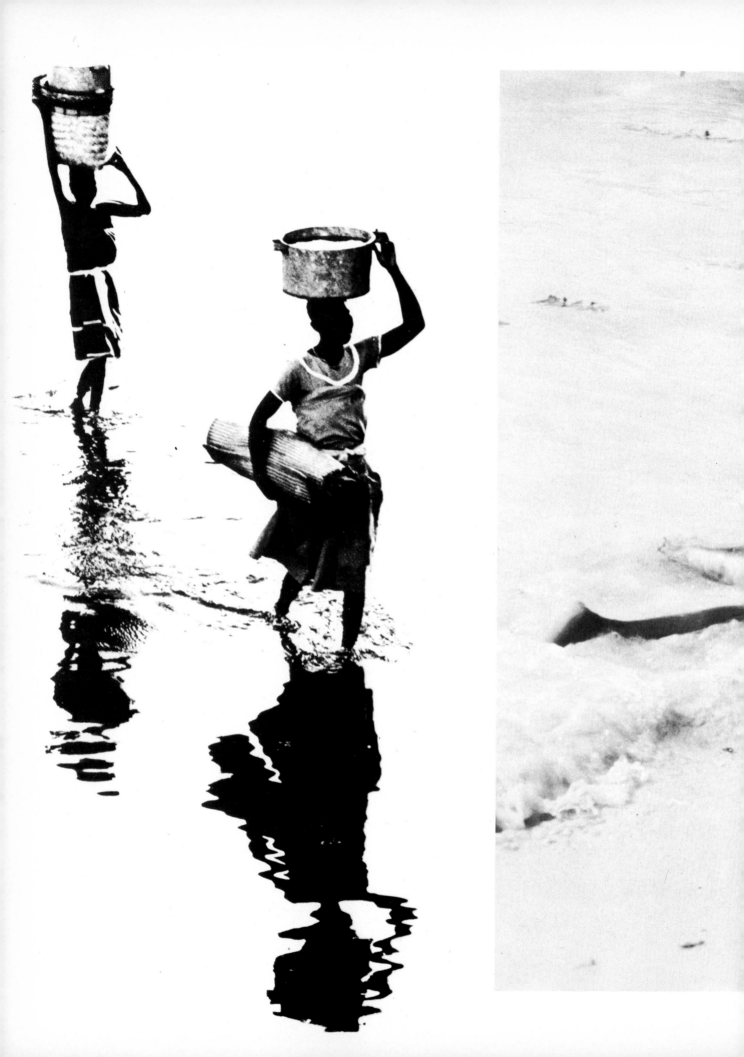

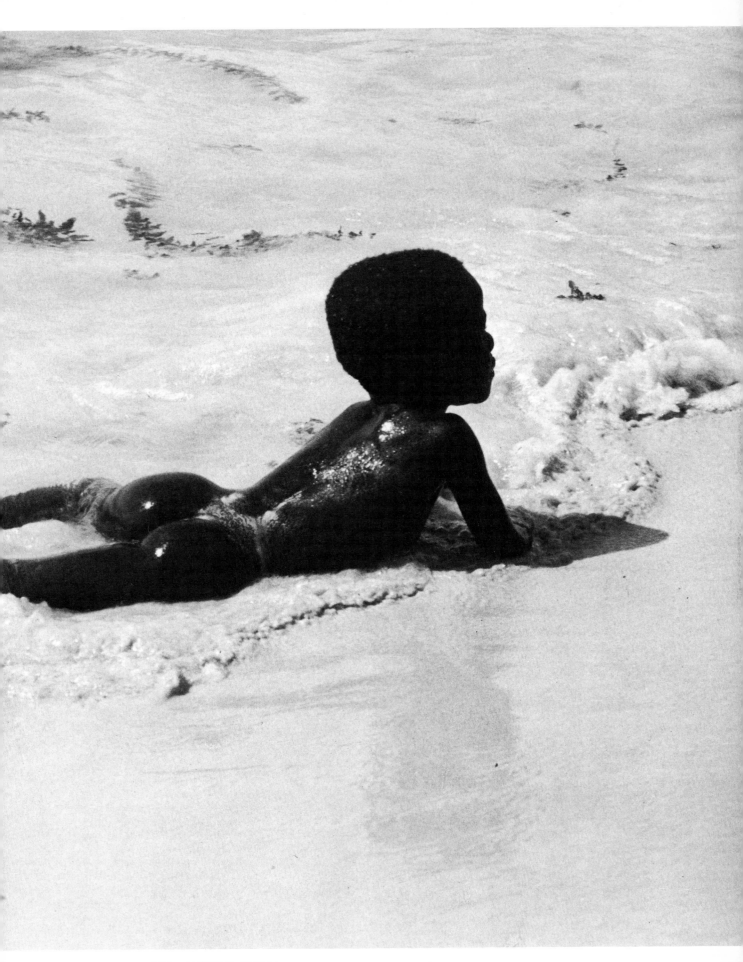

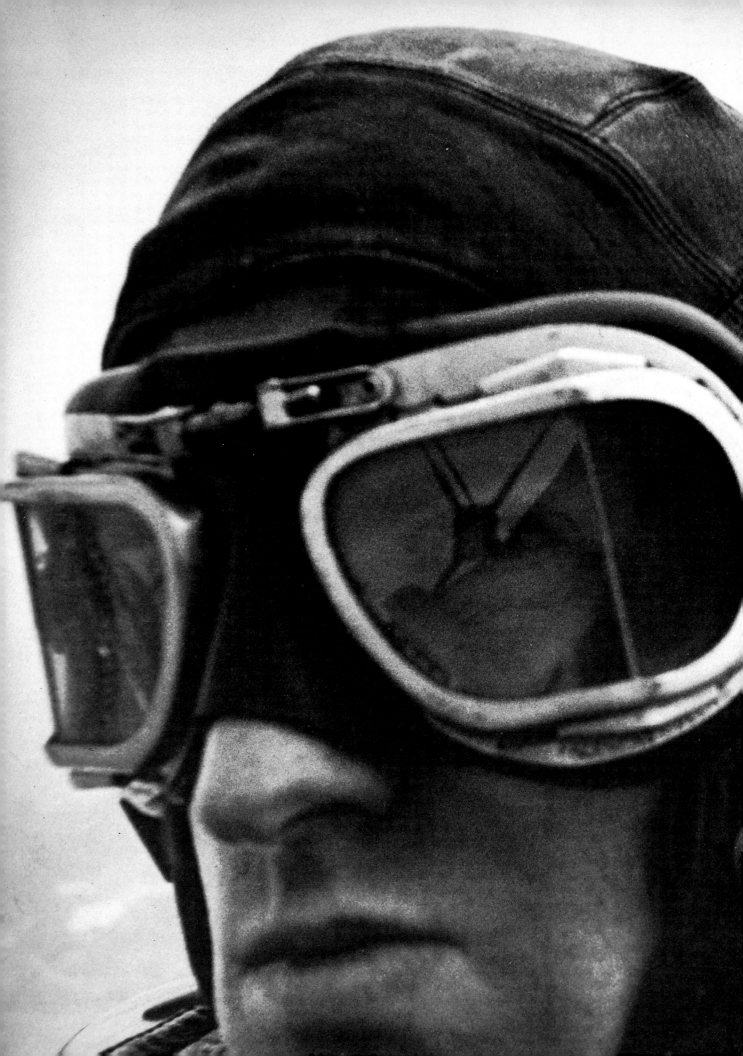

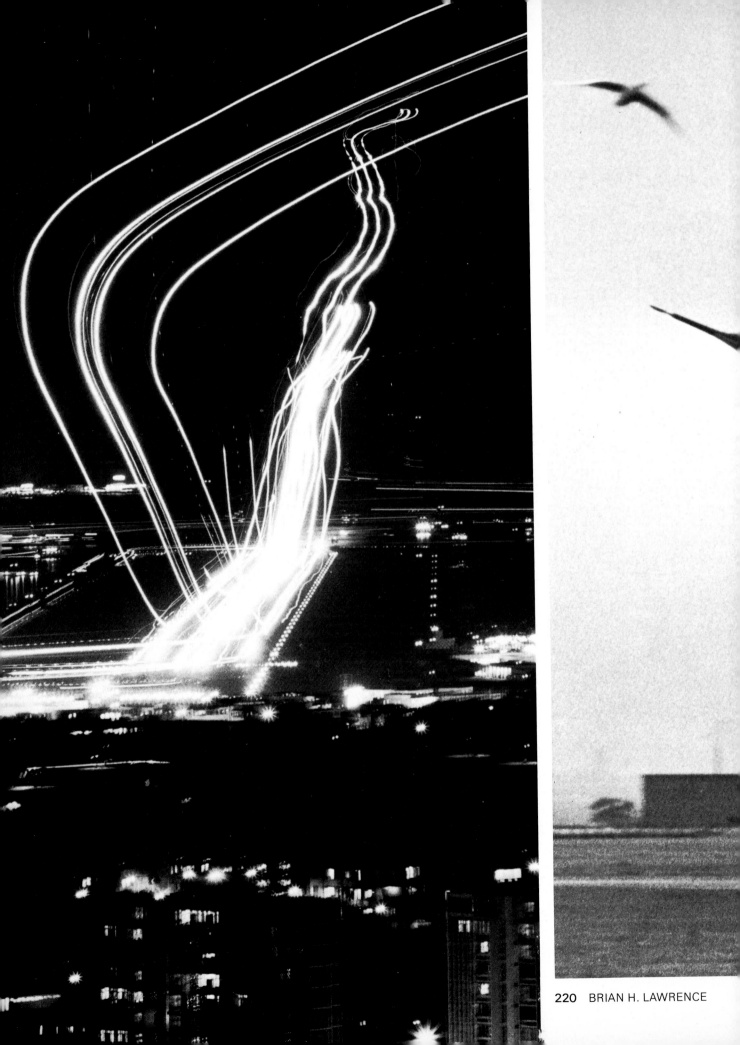

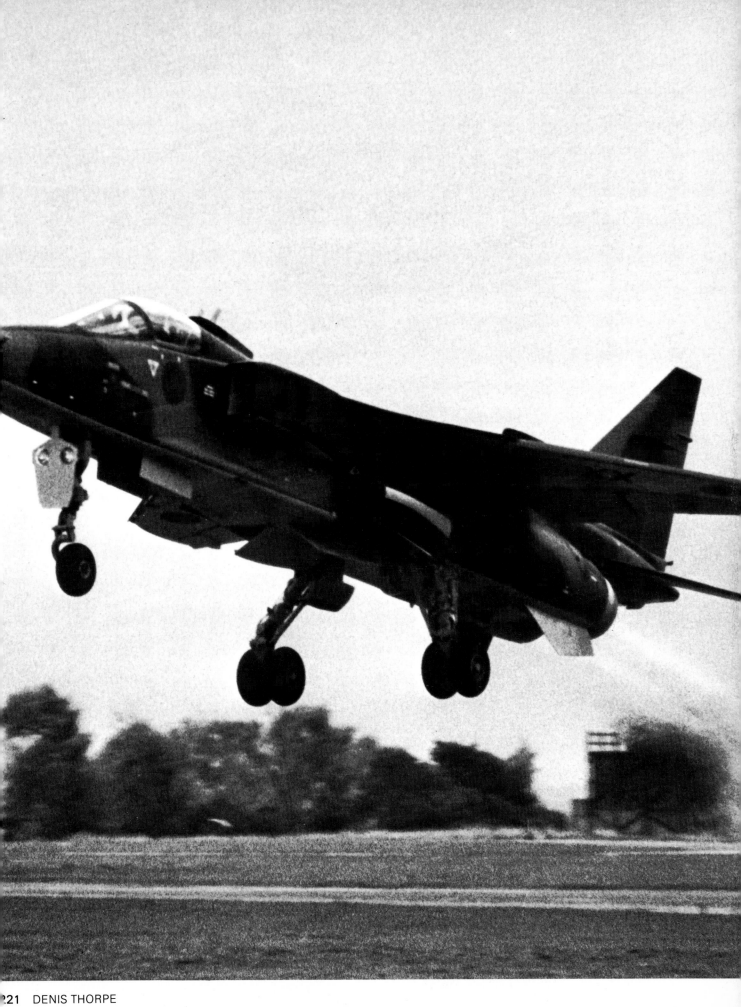

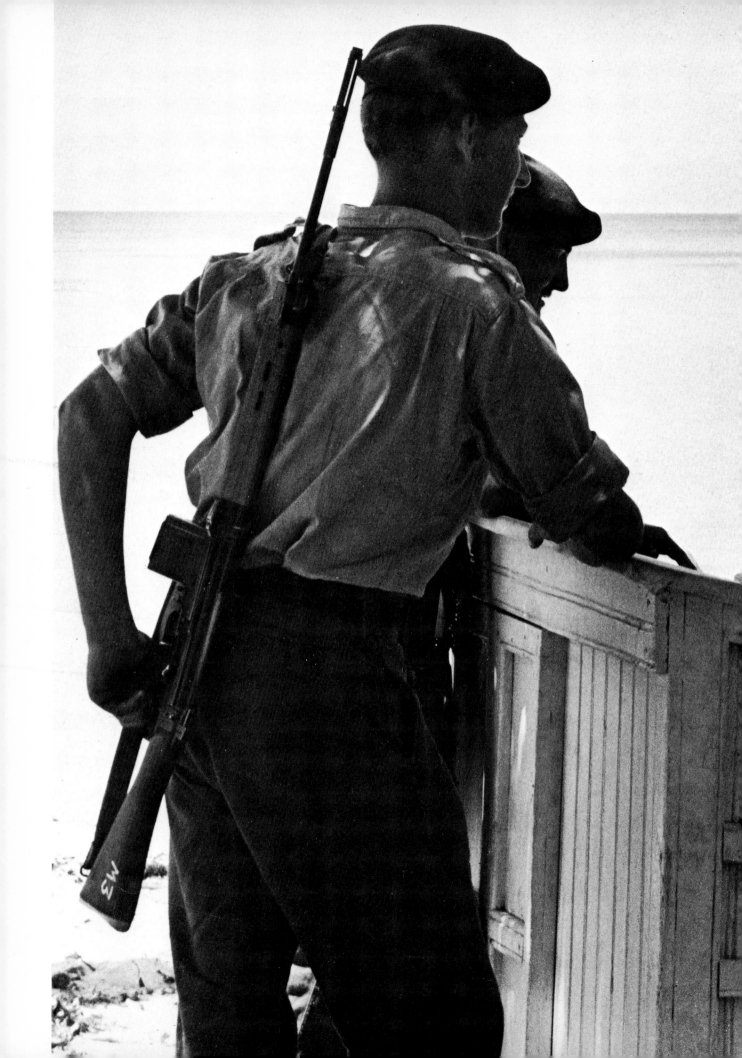

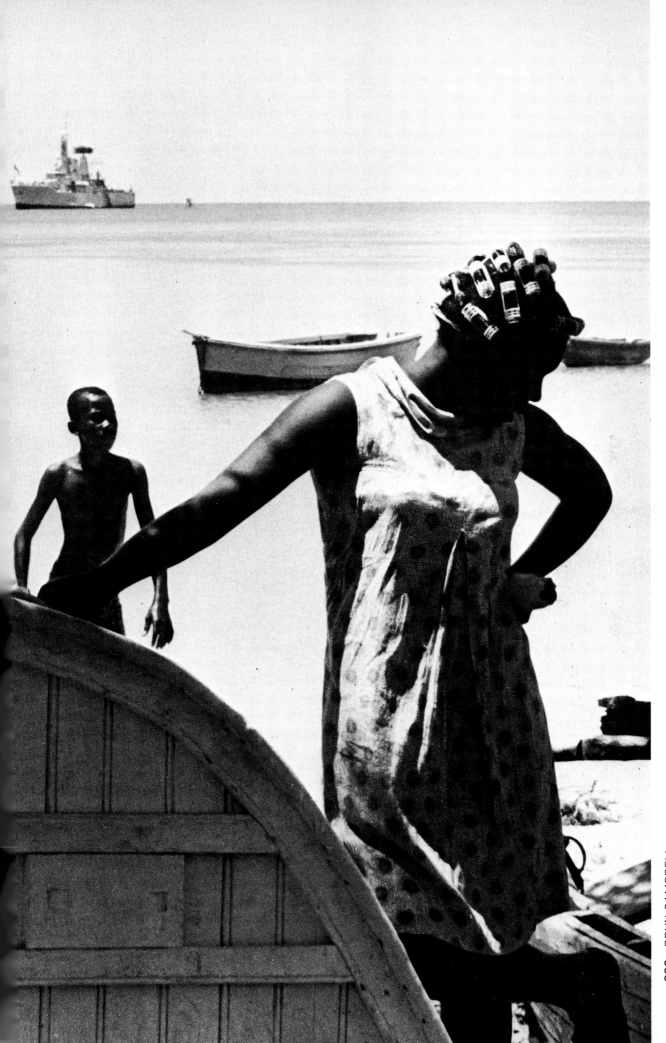

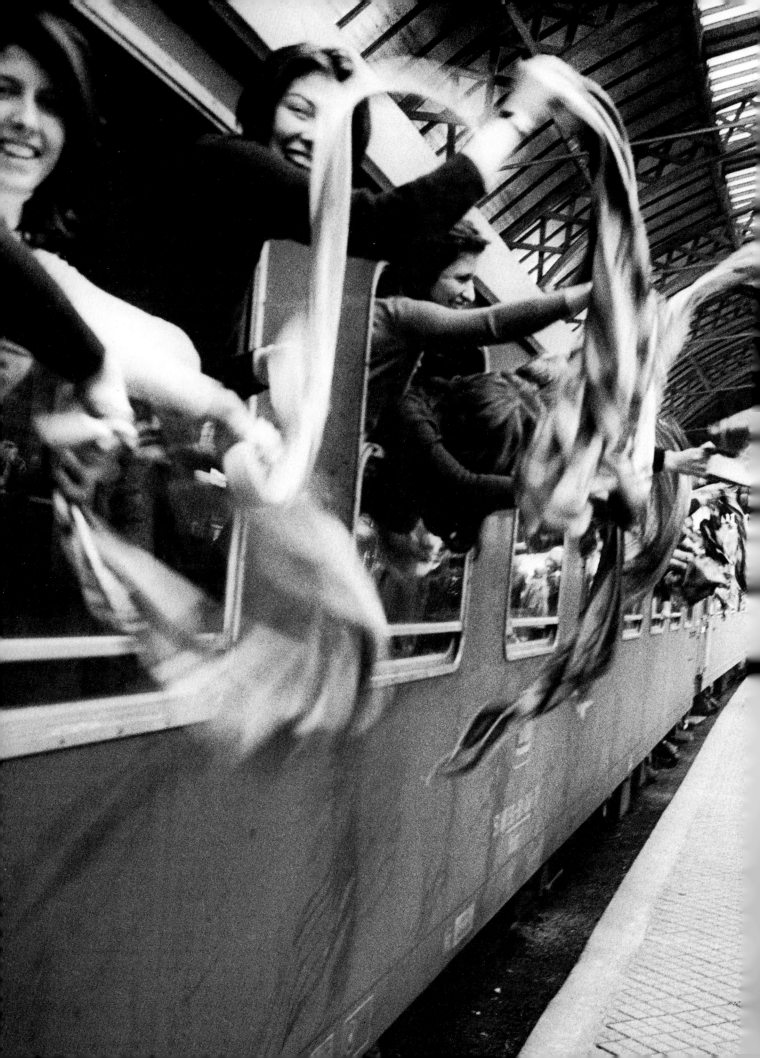

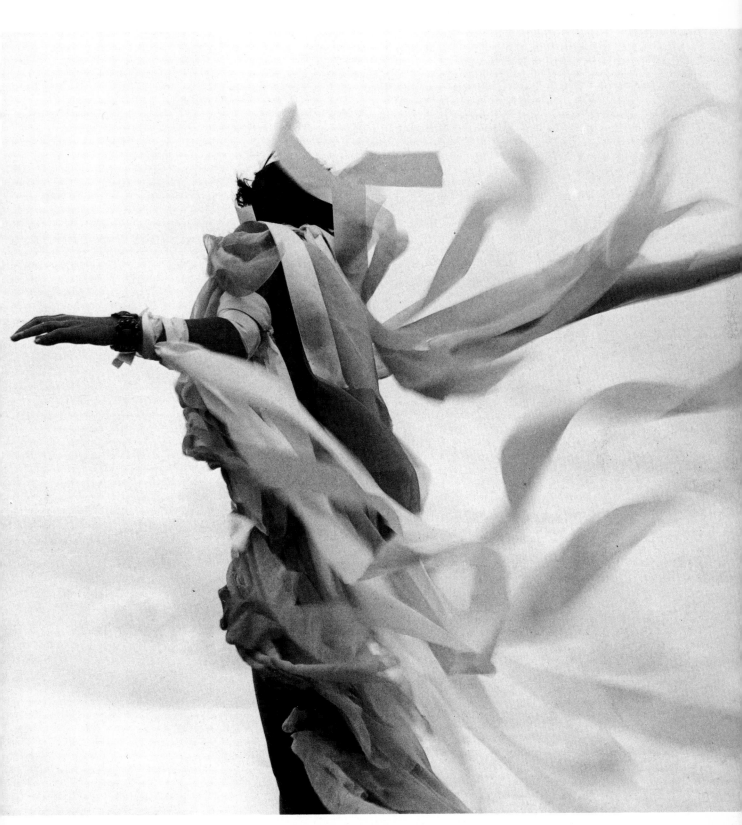

223 MOGENS LERCHE MADSEN 224 E. GEORGE SCHWARZ

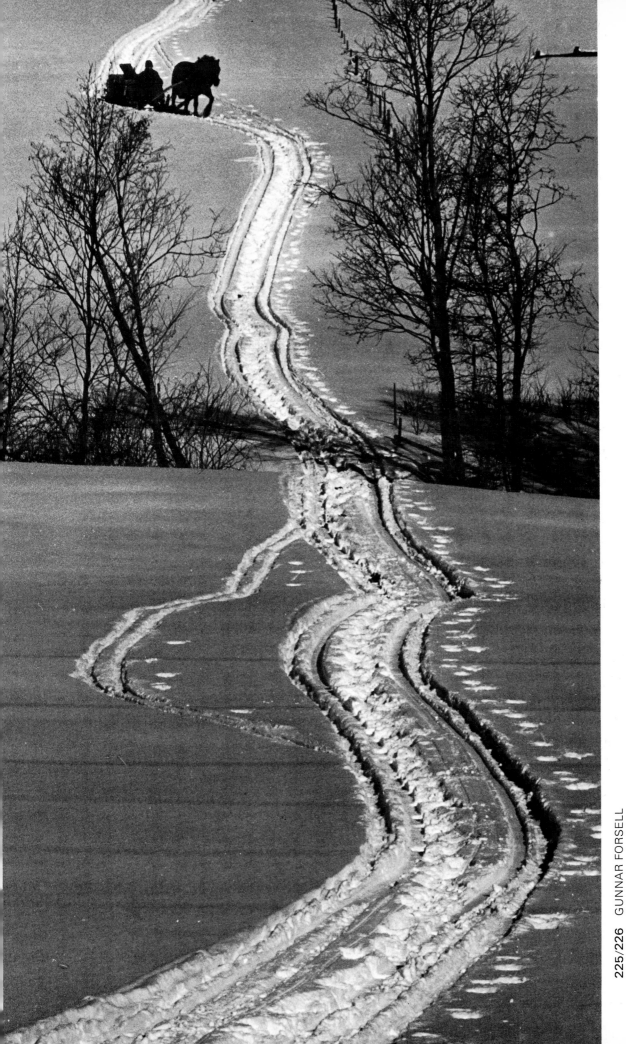

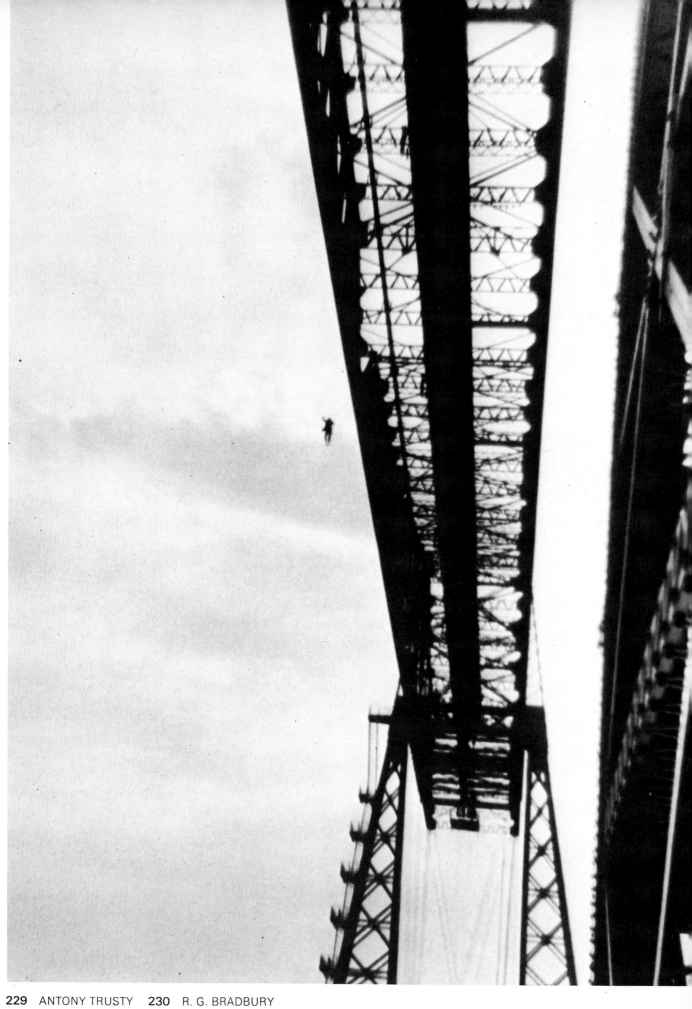

232 HOWARD WALKER

233 JOHN D. BURKE

231 J. CLARE

234 A. H. TUTTON 235 GRAHAM FINLAYSON 236 R. F. B. SHONE

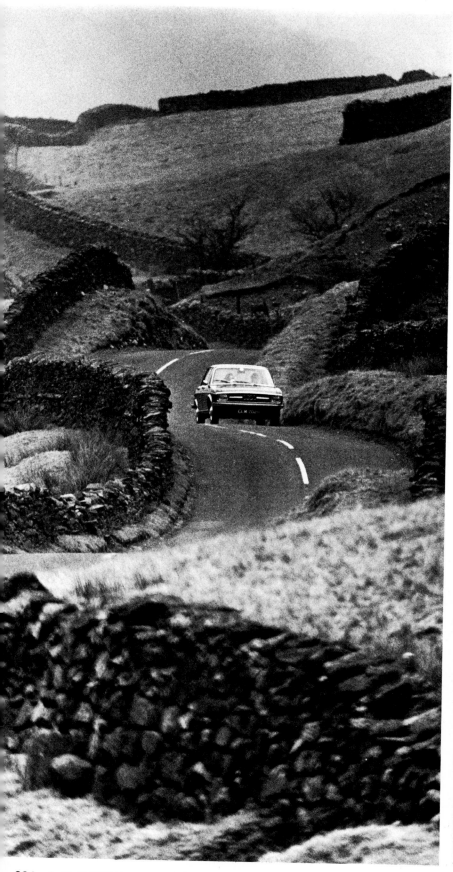

234 A. H. TUTTON **235** GRAHAM FINLAYSON **236** R. F. B. SHONE

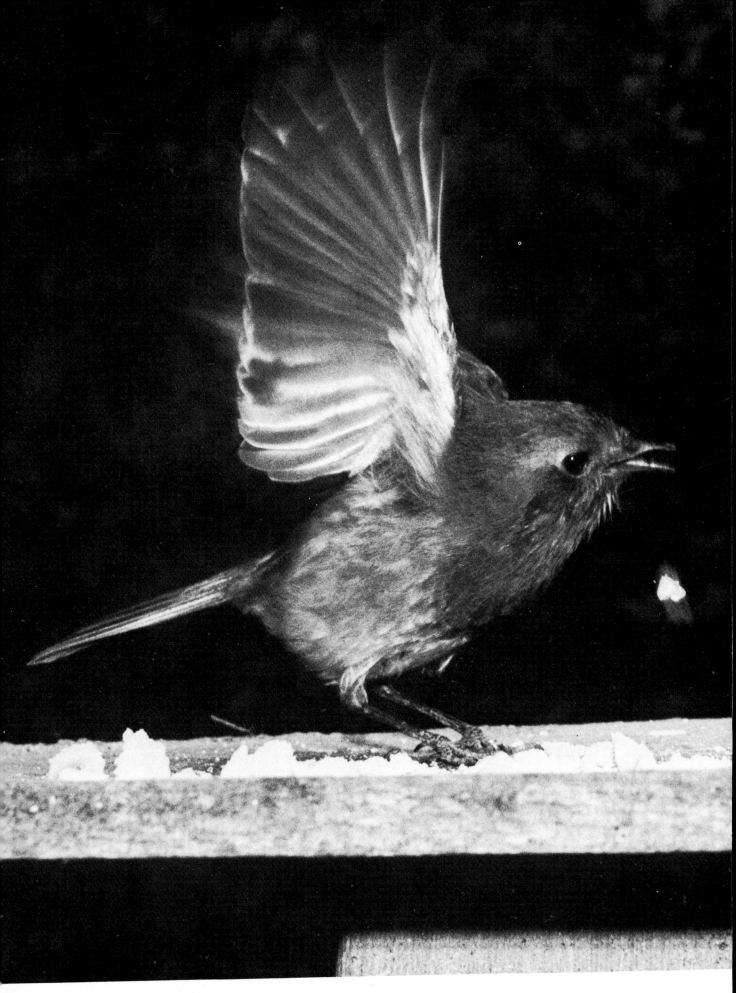

237 G. BATTY

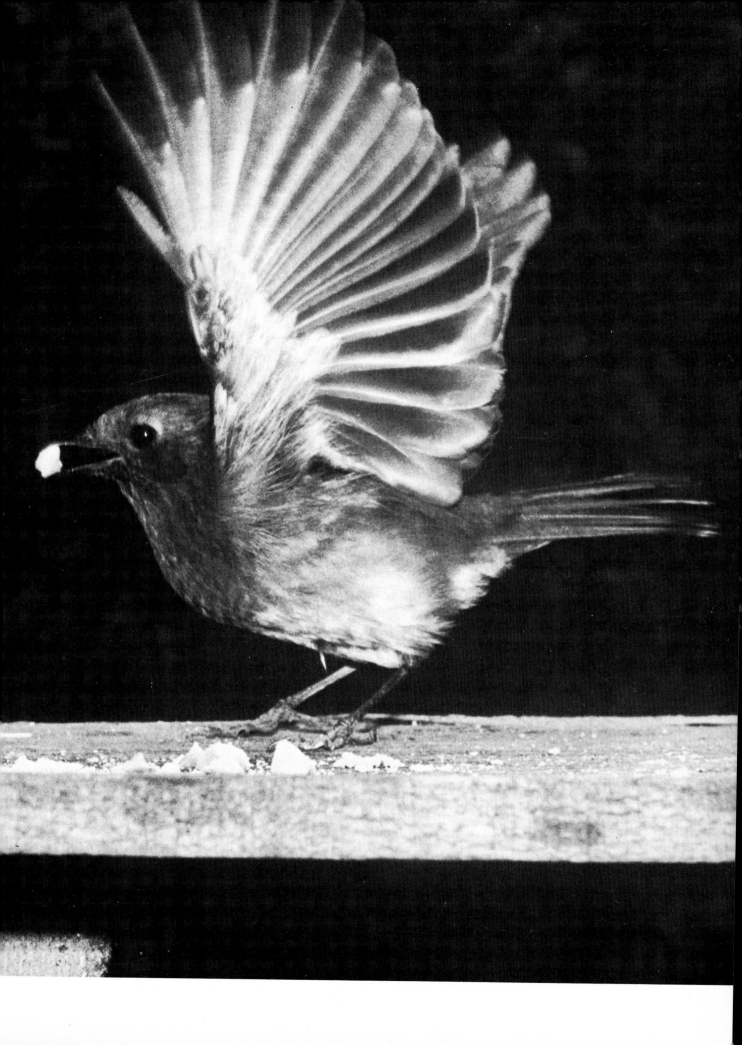

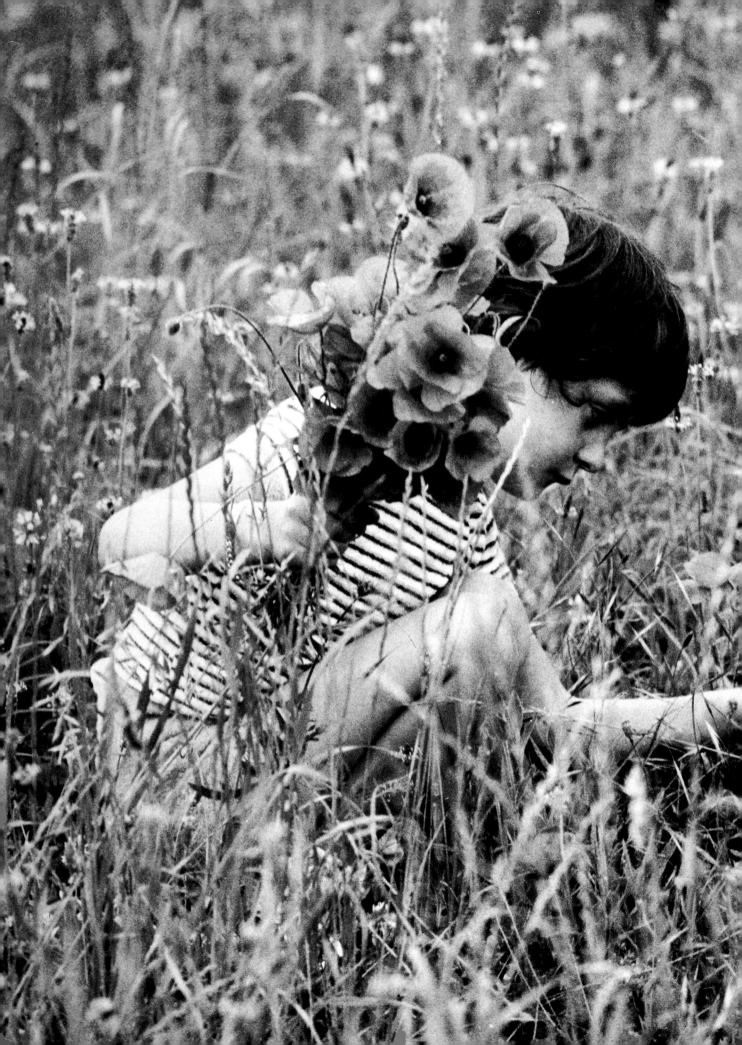

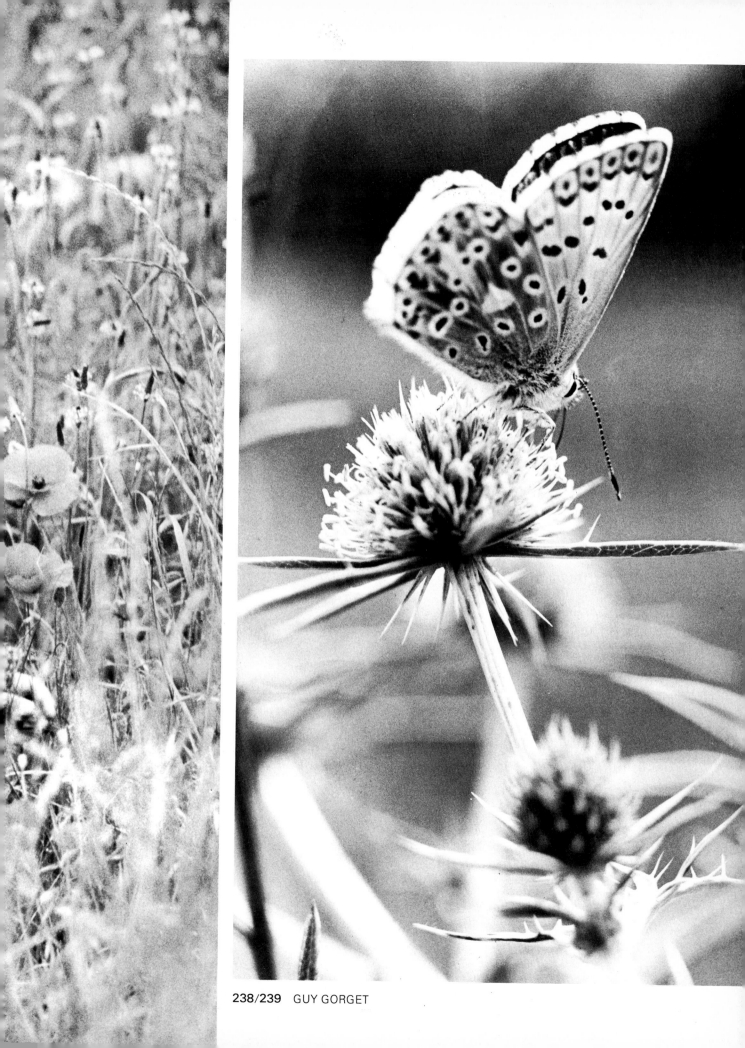

GUY GORGET

Technical Data

1

Photographer Thomas Grant

The steady increase in sales of each new edition of PHOTOGRAPHY YEAR BOOK — coupled with a growing demand for copies from outside the United Kingdom — has this year resulted in some innovations.

The first is the perhaps obvious step of printing the introduction and the technical data section in three languages for the convenience of our worldwide readership. Another is the introduction of pictures into the introduction itself — made possible here by our fortunate discovery of some remarkable press pictures which, in most circumstances, would probably have long since been thrown away by a file clerk unaware of the value of such historically important material. Happily, recent events such as the one mentioned in the introduction have led to a greater awareness of the value of such prints and brought nearer the day when more countries will have established national archives of photography.

The work of the Grant brothers would certainly deserve inclusion in any such archive. All of them worked for the London *Daily Mirror* (which the eldest brother, Tom, joined in 1905), but although they recorded hard news stories with professional skill, all had a flair for composition and an instinctive eye for the decisive moment which lifts much of their work above the mere record of events and must have influenced many of the great Fleet Street photojournalists who came after them.

In our opening plate, Tom Grant shows some of his contemporaries with the tools of their trade. At this time the Goertz-Anshutz Folding Camera was almost the 'standard' for professional use since it had a focal plane shutter giving speeds of from 1/1200 to 5 seconds. The bellows were leather and had a single fold rather than a concertina pattern while a self-capping facility made it possible for the photographer to set the shutter after the dark slide was withdrawn. The lens would be a good quality anastigmat of f/6.8 or f/4.5 and the fastest plates available would have been the equivalent of about 10 ASA.

All the illustrations used in this section are from the family albums of the photographers and the captions include quotes written by them for the benefit of their own posterity.

Im Fotojahrbuch 1974 haben wir erstmals einige Änderungen und — so hoffen wir — Verbesserungen durchgeführt. Die Gründe dafür waren die steigenden Auflageziffern der letzten Jahrbücher und ein anwachsendes Interesse am Fotojahrbuch aus dem Ausland.

Zur Erleichterung für unsere weltweite Leserschaft erscheinen die Einleitung und die Bilderläuterungen jetzt in drei Sprachen: Englisch, Französisch und Deutsch. Eine weitere Neuerung ist das Auftauchen von Fotos in der Einleitung — ermöglicht durch die erfreuliche Entdeckung bemerkenswerter Pressefotos, von denen höchstwahrscheinlich die meisten irgendwann aussortiert und weggeworfen wurden, in Unkenntnis ihrer historischen Bedeutsamkeit. Glücklicherweise haben jetzt einige Ereignisse — wie z. B. das in der Einführung erwähnte — den Wert dieser historischen Fotodokumente erkennen lassen. Es besteht berechtigte Hoffnung, daß von jetzt an mehr Länder ihre eigenen, staatlichen Fotoarchive einrichten und pflegen werden.

Das Werk der Brüder Grant würde ganz sicher in jedes dieser Archive aufgenommen. Sie waren alle beim Londoner *Daily Mirror* beschäftigt; Tom, der älteste Bruder, hatte 1905 dort begonnen. Sie lieferten harte Sensationsreportagen, bewiesen jedoch bei all ihren Aufnahmen ein angeborenes Talent für Bildkompositionen und einen unfehlbaren Instinkt für das Entscheidende. Das war mehr, als das bloße Festhalten des Augenblicks. Viele der großen Fleet-Street-Fotografen wurden stark von ihnen beeinflußt.

Auf unserem Eröffnungsfoto zeigt Tom Grant einige seiner Zeitgenossen mit ihrem Handwerkszeug. Als Berufsfotograf jener Zeit fotografierte man damals mit einer „Goertz-Anshutz" -Auszugskamera,

die einen Objektivverschluß besaß, der Belichtungen von 1/1200 sec. bis zu 5 sec. zuließ. Sie hatte einen Lederbalg mit einer Falte (im Gegensatz zur Zieharmonikafaltung). Ein Verschluß machte es möglich, die Belichtungszeit einzustellen, nachdem der Kassettenschieber bereits gezogen war. Das Objektiv bestand aus einem Anastigmaten mit einer f/6.8 oder f/4.5-Brennweite, und die hochempfindlichen Platten hatten etwa 10 A.S.A. aufzuweisen.

Alle, in diesem Abschnitt veröffentlichten Fotos, stammen aus dem Familienalbum der Familie Grant, die Bildunterschriften waren für ihre Nachkommen gedacht.

Devant l'augmentation régulière des ventes de chaque édition de l'Annuaire Photographique et une demande croissante d'exemplaires en dehors du Royaume-Uni, quelques innovations ont été introduites cette année.

La première mesure logique à prendre était la rédaction de l'introduction et des données techniques en trois langues afin de satisfaire des lecteurs de plus en plus nombreux dans le monde entier. Une autre innovation est la présentation de photographies dans l'introduction elle-même — innovation rendue possible ici par l'heureuse découverte que nous avons faite de plusieurs photographies de presse remarquables qui, en d'autres circonstances, auraient sans doute été détruites depuis longtemps par un archiviste ignorant de la valeur de documents d'une telle importance historique. Heureusement, des événements récents tels que celui dont il est question dans l'introduction (et aussi le fait que de vieilles photographies peuvent atteindre des prix très élevés dans les salles de ventes) ont résulté en une meilleure connaissance de la valeur de ces clichés et nous ont rapprochés du jour où un plus grand nombre de pays auront établi des archives nationales de la photographie.

L'oeuvre des frères Grant mériterait certainement une place dans de tels archives. Chacun d'eux travailla pour le Daily Mirror londonien (où Tom, l'aîné des frères, entra en 1905) mais bien qu'ils rendaient compte de faits d'actualité avec un talent tout professionnel, ils avaient un sens aigü de la composition et l'instinct du moment décisif, ce qui place leur travail au-dessus du simple enregistrement des faits et a dû certainement influencer nombre des grands photographes reporters de Fleet Street qui vinrent après eux.

Sur notre première planche, Tom Grant présente à ses contemporains les instruments du métier. A cette époque l'appareil pliant « Folding » Goertz-Anshutz était pour ainsi dire le modèle type pour l'utilisation professionnelle puisqu'il avait un obturateur de plan focal permettant des vitesses de 1/1200 à 5 secondes. Le soufflet était en cuir et n'avait qu'un seul pli au lieu du modèle à accordéon; il était muni d'un capuchon pliant qui permettait au photographe d'ajuster l'obturateur après avoir retirer la plaque noire. L'objectif était un anastigmat de bonne qualité de f/6,8 ou f/4,5 et les plaques les plus rapides atteignaient à peu près l'équivalent de 10 ASA.

Toutes les photographies illustrant cette première partie proviennent des albums de famille des photographes et les légendes sont en grande partie celles qu'ils ont eux-mêmes rédigé pour le bénéfice de leur descendance.

2

Photographer Bernard Grant

An Edwardian tea party. In a conservatory perhaps, or on the terrace of some fashionable restaurant. The ladies look very relaxed but the photographer's caption reveals that they were, in fact, passengers in a Zeppelin, 'taking lunch 2,000 feet above the earth'.

Eine echt edwardianische Tee-Party, vielleicht in einem Wintergarten oder auf der Terrasse eines Moderestaurants. Die Damen blicken äußerst gelangweilt — aber der Fotograf hat auf der Rückseite des Abzugs vermerkt, daß sie Passagiere eines Zeppelins sind, die in 2.000 Fuß Höhe über der Erde ihren Lunch einnehmen.

Une réception à l'époque édouardienne. Dans un jardin d'hiver peut-être ou sur la terrasse de quelque restaurant à la mode. Les dames semblent très à leur aise mais la légende du photographe indique qu'elles se trouvent en fait à bord d'un Zeppelin « en train de déjeuner à 600 mètres au-dessus du sol ».

3

Photographer Bernard Grant

The greatest name in the history of lighter than air flight. 'Count Zeppelin receives congratulations on his arrival at Dusseldorf in Zeppelin VII.' It was in this airship that the photographer made his first flight in a Zeppelin.

Der größte Mann in der Geschichte des Luftschiffes: Graf Zeppelin wird bei seiner Ankunft im *Zeppelin VII* in Düsseldorf herzlich empfangen. Der Fotograf machte in diesem Luftschiff seinen ersten Zeppelinflug.

Le plus grand nom dans l'histoire des ballons dirigeables. Le comte Zeppelin est félicité à son arrivée à Dusseldorf sur Zeppelin VII. C'est sur cette même embarcation que le photographe accomplit son premier vol à bord d'un Zeppelin.

4

Photographer Thomas Grant

It was originally hoped that the airship would prove to be the ocean liner of the skies, until a series of horrifying crashes — due to the highly inflammable hydrogen used in the gas bags — caused it to lose public confidence. This wreck is of the British dirigible 'Mayfly', but advances in modern technology could lead to revival of the lighter than air method of flight.

Man hatte ursprünglich gehofft, daß sich das Luftschiff zum Überfliegen des Ozeanes bewähren würde, jedoch ging das Vertrauen der Öffentlichkeit nach einer Reihe von schrecklichen Unglücksfällen — verursacht durch den leichtentzündbaren Wasserstoff in den Gaskammern — verloren. Dies ist das Wrack des britischen Luftschiffes *May Fly*. Der technische Fortschritt könnte heute zu einer Wiedergeburt der „Leichter-als-Luft-Flugtechnik" führen.

On avait espéré au début que cette embarcation deviendrait le paquebot du ciel, jusqu'à ce qu'une suite de terribles accidents — dûs à l'utilisation d'hydrogène extrêmement inflammable dans les sacs à gaz — vint détruire toute la confiance du public. Cette épave est celle du dirigeable britannique « Mayfly ». Les progrès de la technologie moderne permettraient aujourd'hui de reprendre ce principe de vol en ballon à gaz plus léger que l'air.

5

Photographer Thomas Grant

In 1909, heavier than air machines were also liable to frequent accidents. This one occurred at England, and Thomas Grant's picture shows the aviator Cody helping to right his Bristol Boxkite (named 'The Cathedral') after a nose dive.

Um 1909 waren auch „Schwerer-als-Luft-Maschinen" häufig Unglücksfällen ausgesetzt. Dieser Absturz trug sich bei Doncaster, in England zu. Thomas Grants Bild zeigt den Flieger Cody, der gerade mithilft seine „Bristol Boxkite" (genannt *Cathedral*) nach einer Bauchlandung wieder aufzurichten.

En 1909, les machines à gaz plus lourd que l'air étaient également sujettes à des accidents fréquents. Celui-ci est arrivé à Doncaster, en Angleterre, et l'on voit ici l'aviateur Cody aidant à redresser son Bristol Boxkite (nommé « La Cathédrale ») à la suite d'un piqué au sol.

Atlas Photoflash gives you the shortest guarantee on record: 7/1000ths of a second.

The life of a flashbulb, or of one face of a flashcube, is brief but undeniably merry.

For instance, Atlas's brand-leading Tru-Flash 1B and Mini-Flash Super AG3B bulbs and Atlas's equally brand-leading Flashcubes are guaranteed to reach peak brilliance a sudden 13 milliseconds after you hit the button.

If they didn't your shutter could beat them and they wouldn't be worth a light.

And now Atlas have put even that performance in the shade.

Magicube X chops the millisecs.

The unique percussion-ignited Atlas Magicube X is even faster. Reaching peak output in 7 milliseconds. Your picture is on the roll in a flash. There is no chance of electrical malfunction, because the Magicube simply doesn't use a battery.

And Atlas have made good the shortest and most effective guarantee in photoflash history: 7/1000ths of a second.

Atlas Photoflash

Up there on top in guaranteed milliseconds.

THORN LIGHTING Ltd., Thorn House, Upper St. Martin's Lane, London WC2H 9ED.

6

Photographer Thomas Grant

On 16 April 1917 the cargo ship S.S. *Sontay* was torpedoed by a German U-Boat one hundred miles south-east of Malta. She sank in four minutes with a loss of forty-nine lives, but not before Thomas Grant — soon to become Picture Editor of the *Daily Mirror* — had recorded a remarkable series of pictures of her last moments. It is even more remarkable to realize that he did so, not with a rapid wind 35mm camera, but with a cumbersome plate loader, and in circumstances of great difficulty and peril. The survivors were rescued by a French gunboat.

Am 16. April 1917 wurde das Frachtschiff S.S. Sontay von einem deutschen U-Boot 1000 Seemeilen südöstlich Maltas torpediert. Es sank innerhalb von 4 Minuten, 49 Menschen kamen um's Leben.
 Thomas Grant, der bald darauf Bildstellenleiter des *Daily Mirror* wurde, hat diese letzten Augenblicke vor dem Sinken in einer bemerkenswerten Bildserie festgehalten. Es verdient besonderer Erwähnung, daß ihm diese Bilder unter größten Schwierigkeiten und bei äußerster Gefahr gelangen, wenn man bedenkt, daß ihm keine 35mm-Schnellaufzug-Reporterkamera zur Verfügung stand, sondern nur eine schwerfällig zu handhabende Plattenkamera. Die Überlebenden wurden von einem französischen Kanonenboot gerettet.

Le 16 avril 1917, le cargo S.S. Sontay était torpillé par un bateau allemand à cent cinquante kilomètres au large de la côté sud-est de Malte. En quatre minutes le cargo avait coulé et quarante neuf personnes avaient péri, mais Thomas Grant, qui devait bientôt devenir le rédacteur artistique du Daily Mirror, avait eu le temps de prendre une série de photographies remarquables des derniers instants. Cela était d'autant plus remarquable qu'il ne travaillait pas avec un appareil 35mm à rechargement automatique, mais un appareil à plaque très encombrant, et ceci dans des circonstances très difficiles et périlleuses. Les survivants furent secourus par une canonnière française.

7/9

Photographer Thomas Grant

Among a series of pictures headed 'Mustafa Pasha. Bulgaria (late Turkish)' we found these grim pictures of one old Turk who received no quarter after being convicted of killing Christians. Thomas Grant's camera clicked as the victim prayed, washed his feet, and was led off to the public hangman's rope.

In einer Bildserie mit dem Titel „Mustafa Pasha", fanden wir diese erschreckenden Bilder von einem alten Türken, der zum Tode verurteilt worden war, nachdem man ihn des Christenmordes überführt hatte. Thomas Grants Kamera klickte, als der Verurteilte betete, bei der Fußwaschung und in dem Moment, da er an den öffentlichen Galgen geführt wird.

Alors que nous approchons du dernier quart du vingtième siécle, des exécutions publiques ont encore lieu dans certaines parties du monde. Dans une série intitulée « Mustafa Pasha, Bulgarie (anciennement turque) » nous avons découvert ces photographies sinistres montrant un vieux turc à qui il n'a pas éte accordé merci, après avoir été condamné pour avoir tué des chrétiens. Thomas Grant déclencha son appareil au moment où la victime prie, se lave les pieds et est conduite vers la corde du bourreau.

10

Photographer Bernard Grant

The symbolism of this hauntingly composed photograph of a First World War naval aviator is not echoed by the photographer's laconic caption. 'Sending a pigeon with a message. Many disabled

seaplanes obtained help in this way and pigeons were extensively used.'

Dieses Bild, es zeigt einen Marineflieger im 1. Weltkrieg, ist visualisierte Hoffnung, die durch den knappen Kommentar nicht einzufangen ist: „Brieftaube wird auf den Weg geschickt. Viele in Not geratene Seeflugzeuge erhielten auf diese Weise Hilfe."

Le symbolisme troublant de cette photographie d'un navigateur de la première guerre mondiale ne se retrouve pas dans la légende laconique du photographe « L'envoi d'un message par pigeon. Beaucoup d'hydravions en détresse furent ainsi secourus et des pigeons voyageurs utilisés en grand nombre ».

11

Photographer Bernard Grant

Very similar in impact and heroic content to some of the Second World War pictures that subsequently appeared in *Life* is this fine action study, taken in 1915, of young recruits at Shotley barracks (H.M.S. *Ganges*), the naval training school.

Diese Sportaufnahme ähnelt in ihrer heldenhaften Aussage sehr den Bildern des 2. Weltkrieges, die später in Life erschienen. Junge Rekruten, 1915, beim Training in den „Shotley barracks" (HMS Ganges) der Marine-Trainingsschule.

Cette excellente étude d'action, très semblable par son caractère héroïque et poignant à certaines des photographies de la seconde guerre mondiale qui parurent dans Life, fut prise en 1915 et montre de jeunes recrues à la caserne de Shotley, la grande école navale en Grande Bretagne.

12

Photographer Bernard Grant

Humour in photography has always helped to sell newspapers and the position adopted by this naval padre at sea with the British Grand Fleet must have caused many a wry smile on the lower deck.

Fotografierter Humor hat immer hohe Auflageziffern gebracht und die Stellung, die dieser Marine-Geistliche in der britischen Flotte einnimmt, muß bei so manchem auf dem Unterdeck ein krummes Lächeln hervorgerufen haben . . .

L'humour des photographies a toujours aidé à vendre les journaux et la pose de cet aumônier de la marine accompagnant la Grande Flotte britannique doit avoir fait naître plus d'un sourire ironique sur le bas pont.

13

Photographer Bernard Grant

'The effect of an aerial bomb exploding in soft ground', is Bernard Grant's pencilled note about this extraordinary picture. No further details are given as to how he managed (without benefit of a motorized camera or telephoto lens) to time his exposure so exactly.

„Wirkung einer Bomben-Explosion auf weichem Grund" ist Bernard Grants Bleistiftnotiz zu diesem außerordentlichen Bild. Keine weiteren Einzelheiten werden angeführt, z.B. wie er (ohne die Hilfe einer automatischen Kamera oder eines Teleobjektives) die Belichtungszeit so exakt einstellte.

« L'effet d'une bombe aérienne explosant sur un terrain mou », telle est la légende écrite au crayon par Bernard Grant sous cette extraordinaire photographie. Il ne donne aucun détail sur la façon dont il a pu (sans caméra mobile ni téléobjectif) mettre au point avec une telle précision.

14

Photographer Bernard Grant

Being in the right place at the right time will always be the main ingredient of the front page news

picture. In this case the place was Southampton shortly after a seaplane had crashed into the top of a 300-foot high wireless mast. The story even has a happy ending, for, as the photographer noted: 'the pilot had a wonderful escape from death'.

„Am richtigen Ort – zur richtigen Zeit", ist immer das richtige Rezept für die erste Seite der Zeitung. In diesem Falle war der Ort Southampton, kurz nachdem ein Seeflugzeug an der Spitze eines 300-Fuß hohen Sendemastes zerschmettert war. Die Geschichte hat sogar ein glückliches Ende, der Fotograf notiert: „Auf wundervolle Weise konnte der Pilot dem Tode entkommen.".

Se trouver là au bon moment sera toujours la condition essentielle d'une photographie de première page. Ici la photo a été prise à Southampton après qu'un hydravion se soit écrasé sur le sommet d'un pilone électrique de 90 mètres de haut. De plus, l'histoire finit bien puisque, comme l'a noté le photographe, « le pilote échappa miraculeusement à la mort ».

15

Photographer Horace Grant

At the end of the First World War, the German Crown Prince (contemptuously nicknamed 'Little Willie' by the Allies) was exiled to the island of Wieringen in Holland. On 30 November 1918 Horace Grant achieved a world scoop by obtaining the first interview with him after his departure from Germany. At the same time, Grant also took this photograph of the Crown Prince with the hound which he had brought from India.

Bei Beendigung des Ersten Weltkrieges war der deutsche Kronprinz (bei den Alliierten trug er den Spitznamen „little Willie") im Exil auf der holländischen Insel Vieringen. Am 30. November 1918 machte Horace Grant Schlagzeilen: er brachte das erste Interview nach dem Verlassen Deutschlands mit ihm zustande. Bei diesem Anlaß schoß Grant dieses Foto des Kronprinzen mit seinem Jagdhund aus Indien.

A la fin de la première guerre mondiale, le Prince de la couronne d'Allemagne (dédaigneusement surnommé « Petit Guillaume » par les alliés) fut envoyé en exil dans l'île de Wieringer en Hollande. Le 30 novembre 1918, Horace Grant réussit à avoir la primeur d'une interview avec lui après son départ d'Allemagne. Et Grant prit aussi à ce moment là cette photographie du Prince accompagné du chien qu'il avait ramené des Indes.

16

Photographer Horace Grant

In 1911 Horace photographed his brother Thomas Grant at a delegate conference in St Andrews, Scotland. One of the foreign delegates was a priest of the Greek Orthodox Church who was obviously fascinated by the camera which Thomas Grant explained to him.

1911 fotografierte Horace seinen Bruder Thomas Grant auf einer Delegiertenkonferenz in St. Andrews Schottland. Einer der auswärtigen Gäste war ein Geistlicher der griechisch-orthodoxen Kirche, der sich fasziniert die Kamera Thomas Grants erklären ließ.

Horace prit cette photographie de son frère Thomas en 1911 à une conférence des délégués à St. Andrews, en Ecosse. L'un des délégués étrangers était un prêtre de l'Eglise Orthodoxe grecque; on le voit ici fasciné par l'appareil-photo que lui montre Thomas Grant.

17

Photographer Thomas Grant

Three men on a rock bridge. Horace and Bernard Grant with a friend during a tour of France and Spain in the Spring of 1911.

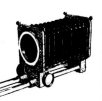

émerveillé de découvrir les épaves coulées de tant de vaisseaux de guerre britanniques de la première guerre mondiale. Presque tous avaient sombré sur le coup mais il établit par la suite que ces images, prises à la «available light» à une profondeur de 23,75m, montrent tout ce qui reste du navire de sa Majesté, le Majestic, après soixante ans sous l'eau. Avec un Calypso Nikkor, il photographia un de ses compagnons tenant d'énormes bombes provenant d'une tourelle avant et un refroidisseur incrusté d'algues provenant de la chambre de chauffe du navire.

29/31

Photographer	Rolf M. Aagaard
Camera	Nikkon F
Lenses	24–300mm
Film	Kodak High Speed Ektachrome

'These pictures,' writes Norwegian photographer Rolf M. Aagaard, 'were taken on the second day of the new volcano on Vestmannaeyar, Iceland. On assignment for my newspaper *Aftenposten*, I had arrived in Reykjavik on the first day, and got quite good aerial shots of the burning island'. An epic description follows of how he reached the island by boat in a rough sea to find the volcano hurling flaming lava hundreds of feet into the air while street lights still eerily illuminated the deserted town. After scooping the competition with his black and white pictures, his colour was airfreighted back to Oslo in time for the *Aftenposten* weekend colour supplement. Great coverage by a dedicated and courageous photographer of one of nature's most spectacular firework displays.

„Diese Bilder wurden am 2. Tage des Vulkanausbruchs auf Vestmannaeyar in Island gemacht. Im Auftrage meiner Zeitung *Aften Posten* war ich am Tage des Ausbruchs in Reikjavijk angekommen und erhielt ganz gut Luftaufnahmen von der brennenden Insel''. In der Schilderung des Fotografen folgt dann, wie er bei rauher See im Schiff die Insel erreichte, während der Vulkan glühende Lava hunderte von Fuß hoch in die Luft schleuderte. Die Straßenlaternen leuchteten noch immer gespenstisch in der verlassenen Stadt. Er versorgte die Konkurrenzblätter mit Schwarz-Weiß-Aufnahmen und schickte dann seine Farbbilder per Luftpost nach Oslo, gerade rechtzeitig für die Farbbeilage der *Aften Posten*-Wochenend-Ausgabe. Ein begeisterter und mutiger Fotograf ließ so die Welt an diesem einmaligen Naturschauspiel teilhaben.

«Ces images», écrit le photographe norvégien Rolf M. Aagaard, «ont été prises le second jour de l'éruption du volcan de Vestmannaeyar en Islande. Envoyé par le journal Aftenposten, je suis arrivé à Reykjavik le premier jour et je pus prendre quelques bonnes photographies aériennes de l'île en flamme.» Suit une description épique de la façon dont il parvint à atteindre l'île en bateau par gros temps pour trouver le volcan crachant de la lave enflammée à des centaines de mètres dans l'air tandis que les rues de la ville désertée étaient encore illuminées. Après avoir gagné la primeur avec ses photos en noir et blanc, il expédia à Oslo par avion ses photos en couleur à temps pour qu'elles paraissent dans le supplément en couleur de l'Aftenposten du week end. Un reportage sensationnel par un photographe courageux sur l'un des feux d'artifice naturels les plus spectaculaires.

32

Photographer	John Chard
Camera	Nikkormat
Lens	28mm Nikkor
Film	Kodak Aero Ektachrome Infra Red
Shutter speed	1/60
Aperture	f/5.6

An aura of mystery attaches to the hills surrounding the English town of Glastonbury in Somerset, regarded as the site of King Arthur's Avalon. Other legends tell of a visit made here by Joseph of Arimethea after Christ's crucifixion and more recent

visits by whole squadrons of Unidentified Flying Objects. The most prominent landmark is the historic Glastonbury Tor – a strange isolated tower – which the West of England photographer recorded on infra red colour film to heighten the atmosphere of his composition.

Etwas mystisches umweht die Hügel bei der englischen Stadt Glastonbury in Somerset. König Arthur soll dort seinen Sitz gehabt haben. Andere Legenden berichten vom Aufenthalt Joseph von Arimathias nach der Kreuzigung Christi, wieder andere vom Auftauchen ganzer Schwadrone fliegender Untertassen, oder zumindest unbekannter fliegender Objekte. Ein Wahrzeichen der Gegend ist das historische Glastonbury-Tor, ein einsam stehender Turm, den der Fotograf auf Infrarot-Farbfilm aufgenommen hat, um die Atmosphäre dieser Bildkomposition zu steigern.

Une atmosphère de mystère s'attache aux collines qui entourent la ville anglaise de Glastonbury dans le Somerset, considéré comme le lieu de l'Avelon du Roi Arthur. D'autres légendes parlent d'une visite rendue à ces lieux par Joseph d'Arimathie après la crucifixion du Christ et de visites plus récentes par des escadrons d'objets volants non identifiés. Le point le plus élevé est la tour historique de Glastonbury, une étrange tour isolée, que ce photographe de l'ouest de l'Angleterre a pris sur un film en couleur infra-rouge pour accentuer l'atmosphère de sa composition.

33

Photographer	John Chard
Camera	Nikkormat
Lens	200mm Nikkor
Film	Kodachrome II
Shutter speed	1/250
Aperture	f/5.6

Thirty-three-year-old John Chard studied photography at the London College of Printing. Since that time he has taught in various art colleges and is currently in charge of the photographic department at Somerset College of Art in Taunton. This picture is one of a series on the Quantock hills and about it Chard writes; 'I had spotted the horse and foal and tracked them down the hillside waiting for the best angle. The exposure was made just before they disappeared into the trees.'

Der 33 Jahre alte John Chard studierte Fotografie am Londoner *College of Printing*. Er unterrichtete seitdem an verschiedenen Kunsthochschulen und leitet zur Zeit die Foto-Klasse des *Somerset College of Art* in Taunton. Dieses Bild stammt aus seiner Serie über die Quantock-Berge. Er schreibt dazu: „Ich hatte das Pferd mit dem Füllen entdeckt, trieb sie hinunter zum Hang und wartete auf den besten Schußwinkel. Dieser Schnappschuß gelang mir gerade noch, bevor sie zwischen den Bäumen verschwanden.''

John Chard, âgé de trente trois ans, a étudié la photographie au London College of Printing. Depuis cette époque, il a lui-même enseigné dans plusieurs collèges d'art et il est actuellement responsable de la section de photographie au Collège d'Art du Somerset à Taunton. Cette image fait partie d'une série sur les collines de Quantock et Chard écrit à son sujet:
« J'avais aperçu le cheval et son poulain et les avais suivis jusqu'au bas de la colline en essayant de les saisir sous le meilleur angle. Le cliché a été pris juste avant qu'ils disparaissent parmi les arbres ».

34

Photographer	Ralph Krag-Olsen
Camera	Linhof
Film	Kodak Plus-X and Agfa Contour
Paper	Agfa

Not having previously submitted material to PHOTOGRAPHY YEAR BOOK, Ralph Krag-Olsen wondered if we would like the fine set of animal pictures he sent in. We did, but were even more attracted by this composition which demonstrates

what can be done with a man-made landscape. 'I suppose' he writes, 'being the group photographer for Roan Consolidated Mines Ltd. in Zambia, that I should submit something to do with mining'.

'Mine headframes at Mufulira Zambia' was originally shot on Kodak Plus-X 4 × 5 black and white film with a Linhof camera and then copied onto Agfa Contour film. Then, using a register punch, he contact-printed all three equidensities separately on to one piece of Agfa positive M Colour Film, using the additive method. Blue filter to make the sky yellow on film so that it would print blue on Agfa MCN III Type 7 paper.

Ralph Krag-Olsen hatte uns noch nie Bilder für das Foto-Jahrbuch zugesandt. Er fragte gespannt, ob uns wohl seine Tierbildserie gefallen würde. Sie gefiel uns. Noch mehr begeistert waren wir aber von dieser Komposition, die zeigt, wie man eine von Menschenhand geformte Landschaft aufnehmen kann. „Ich nehme an, daß ich als Hausfotograf der Firma *Roan Consolidated Mines Ltd.*/Zambia auch ein paar Fotos aus dem Bergbau beilegen sollte.'' Dieses Bild wurde mit einer Linhof-Kamera aufgenommen, ursprünglich auf Kodak Plus X 4 × 5 schwarz-weiß Film, und auf Agfa Kontur Film umkopiert. Dann wurden drei Konturen-Negative in den Grundfarben übereinander kopiert, jeweils mit leichten Verschiebungen. Er benutzte Blaufilter, so erschien der Himmel auf dem Film gelb, auf dem Abzug jedoch blau.

N'ayant encore jamais rien envoyé pour l'Annuaire Photographique, Ralph Krag-Olsen se demandait si nous aimerions la jolie série de photographies d'animaux qu'il nous a soumise. Nous l'avons aimée, mais nous avons été encore plus attirés par cette composition qui montre ce que l'on peut faire avec un paysage construit par l'homme. « Je suppose » écrit Ralph Krag-Olsen «qu'en ma qualité de photographe du Roan Consolidated Mines Limited en Zambie, je dois présenter quelque chose qui ait rapport aux mines ».
« Echafaudages de mines à Mufulira, Zambie » a été prise tout d'abord sur film noir et blanc Kodak Plus-X 4 × 5 avec un appareil Linhof, et ensuite transposée sur film Agfa Contour. Puis, à l'aide d'un poinçon, il a appliqué les trois pellicules sur un seul morceau de film couleur Agfa positif M, en utilisant la méthode additive. Un filtre bleu pour faire le ciel jaune sur le film afin d'obtenir un ciel bleu sur papier Agfa MCN III type 7.

35

Photographer	Paul Gluske
Camera	Leicaflex
Lens	180mm Elmarit
Film	Ektachrome-X
Shutter speed	1/250
Aperture	f/8

The man-made canyons of New York City have been the subject of countless photographs, but rarely can they have been pictured with such subtle use of colour as in this composition by German photographer Paul Gluske.

Die von Menschenhand geschaffenen Felsen-schluchten New Yorks sind das Motiv zahlreicher Fotografen. Selten jedoch wurde die Farbe so kunstvoll eingesetzt, wie in dieser Farbkomposition des deutschen Fotografen Paul Gluske.

Les cañons artificiels de New York ont fait le sujet d'innombrables photographies, mais ils ont rarement été aussi bien rendus, avec un emploi de la couleur aussi subtil, que sur cette composition du photographe allemand Paul Gluske.

36

Photographer	Frank Wilcox

The great American outdoors. A cross star filter was used by Frank 'Shorty' Wilcox to add sparkle to this graphic colour impression of Kayaking on the Salmon River, Idaho.

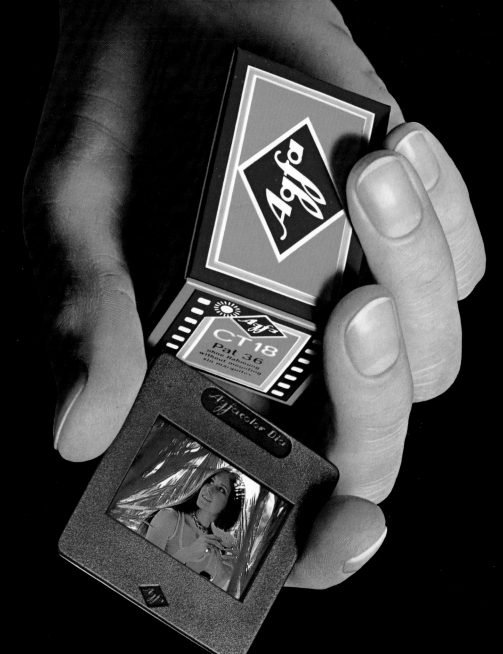

Your film.

Agfacolor CT 18
The film with the natural colours.

AGFA-GEVAERT

The secret of the unique **Praktica LLC metering system** is to be found in three pins located on the back of the lens housing. These pins make contact with three blades on the body housing which are fed electrically by a PX21 battery; thus, by means of a variable resistance, the aperture settings can be transmitted to the camera metering system whilst still maintaining the full image brightness expected from an f1.8 lens.

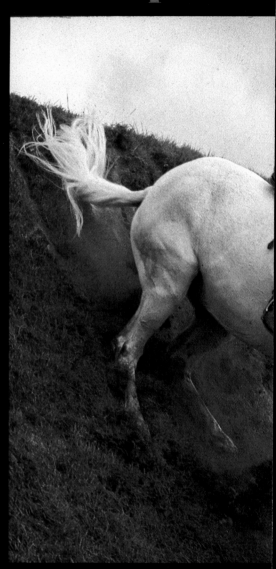

The **shutter release button** of the Praktica LLC requires two distinct pressures. The first pressure actuates the metering system, bringing the needle into view by rotating either the shutter-speed dial or aperture ring until centralised. The second pressure then fires the shutter. A shutter release lock is incorporated to ensure that the release button cannot be accidently depressed. A **delayed action** mechanism is incorporated with a delay of approx. 8-10 seconds.

The pentaprism of the Praktica LLC incorporates an **accessory shoe** with a built-in connection for flash units having a centre connection. For older units, an adaptor is available, including a standard 13mm. co-axial socket to which a standard cord can be connected. The shutter **speed dial** is conveniently placed to the right of the top plate—the film-speed setting is incorporated and actuated by just lifting the dial and rotating.

The **viewfinder** of the Praktica LLC comprises a microprism centre spot with a groundglass area around it and concentric fresnel rings, maintaining brightness right into the corners.
On the left hand side of the screen is a red arrow, indicating whether the film is wound on and on the right the TTL metering needle with the circle for alignment. All the necessary information is, therefore, clearly visible in the viewfinder.

with special EDC system lenses

The introduction of the Praktica LLC create[s] a little bit of camera history . . . for the fir[st] time ever, aperture settings were tran[s]mitted electrically from the lens to t[he] camera metering system, thus enabli[ng] through-the-lens **metering at full apertu[re]** without the inertia & friction of mechanic[al] linkages.
Not only, therefore, was it possible [to] develop a more accurate and reliab[le] system but it was also feasible for the fir[st] time to incorporate this form of f[ull] aperture metering into extension tube[s] bellows etc.—A real technical revolution!

PENTACON

Manufactured by:-
VEB KOMBINAT PENTACON
DRESDEN GDR

Recommended Retail Prices (including VAT)
PRAKTICA LLC (CHROME)
£99.90 with 50mm fl.8 Pentacon-Auto
£109.90 with 50mm fl.8 Pancolar

PRAKTICA LLC (BLACK)
£104.90 with 50mm fl.8 Pentacon-Auto
£114.90 with 50mm fl.8 Pancolar
£4.90 E.R. Case.

...THE UNIQUE

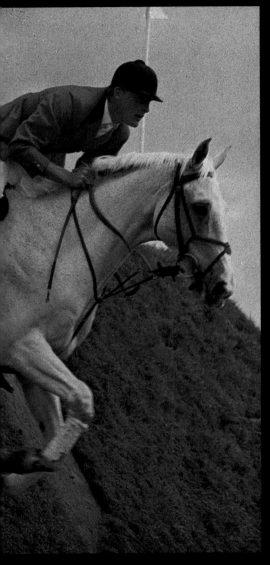

One of the major innovations in the Praktica 'L' series is the Swedish stainless steel vertical **focal plane shutter.** Constructed of five blades, this shutter sets a new standard in accuracy and reliability; the incorporation of a specially designed damping mechanism ensures a minimum of camera shake. Any vibrations will occur either before or after the time of exposure. This revolutionary shutter gives ultra-accurate speeds of 1-1/1000th sec. & B., with electronic sync. to 1/125 sec.

Another innovation in the Praktica LLC is the Pentacon PL **quick-load system.** This unique system means that it is only necessary to engage the film in the sprocket, to take the leader as far as the mark, close the back and wind on.
The Pentacon PL system takes care of the rest!
An automatically zeroing frame counter is incorporated.

The Praktica LLC is above all a **system camera;** there is little sense in having full aperture metering in the lenses if these cannot be used with extension tubes or bellows. Two accessories are available, therefore, which enable you to meter at full aperture under all circumstances.
i). **Electric coupling rings** can be fitted to both ends of the bellows or standard extension tubes. **Connecting cables** maintain electric diaphragm control. A double cable release ensures that the shutter operates concurrently with the stopping down of the lens.
ii). **Electric extension tubes** for shorter extensions, electric diaphragm control is maintained without the necessity for connecting cables.

A full **range of lenses** is manufactured specifically for the Praktica LLC camera. No less than 13 different lenses bearing four famous brand names—**Pentacon, Prakticar, Schneider** and **Carl Zeiss Jena**, in focal lengths from 24mm. to 200mm. All lenses have the connecting pins to maintain and effect accurate metering at full aperture.
The Praktica LLC system is a complete system!

ith all other
nses & applications

e advantages of full aperture metering, h a clear bright image in the focussing een at all times, are obvious.
however' you already have a range of ses and accessories, either automatic or nual, and cannot afford, or do not wish exchange them for the special LLC ses, then a simple switch on the camera ables you to use automatics on the stop- n principle by simply depressing the eview lever on the lens or switching the o/manual switch.
e-set lenses, of course, present no prob- n. This unique *"double metering system"* ows for a versatility second to none.

Distributed by:-
C.Z. Scientific Instruments Limited,
93/97 New Cavendish Street, London, W1A 2AR.
Telephone 01-580 0495

PRAKTICA LLC

Paddeln auf dem Lachs-Fluß Idaho. Um zusätzlichen Flimmer in diese Farbimpression zu bringen, wurde ein Weichzeichner benutzt.

Les grands paysages américains. Frank Wilcox a utilisé un filtre spécial pour augmenter l'effet scintillant de cette image en couleur de Kayaking sur la rivière à saumons Idaho.

37

Photographer	Pawel Pierscinski
Camera	Praktisix
Lens	80mm Biometar
Film	Orwo NP20
Shutter speed	1/60
Aperture	f/16 (with ×3 yellow filter)
Developer	Orwo RO9
Paper	Foton

A classic example of the romantic landscape. This idyllic scene was photographed in the Kielce region of Poland.

Klassisches Beispiel eines romantischen Bildes. Diese idyllische Lanschaft findet man in der Gegend um Kielce, Polen.

Un exemple type de paysage romantique. Cette scène idyllique a été prise dans la région de Kielce en Pologne.

38

Photographer	S. Paul

The well-known Indian photographer S. Paul took this immensely powerful portrait profile. No details were provided but the work of this photographer is regularly seen in collections of the world's best pictures.

Dieses kraftvolle Profil porträtierte der bekannte indische Fotograf S. Paul. Aufnahmedaten wurden nicht angegeben. Die Arbeiten dieses Fotografen findet man immer wieder in Ausstellungen, unter den besten Bildern der Welt.

C'est le grand photographe indien S Paul qui a pris ce profile d'une extrême puissance. Aucune donnée technique ne nous a été fournie, mais des oeuvres de ce photographe paraissent régulièrement dans des albums des meilleures photographies du monde.

39

Photographer	Jorge Vidal Batlles
Camera	Nikkormat
Lens	50mm
Film	Kodak Tri-X
Shutter speed	1/250
Aperture	f/5.6
Developer	Kodak D76
Paper	Agfa Brovira

This extraordinary picture was made by Spanish photographer Jorge Vidal Batlles, who describes himself as 'a technician in Information and director of a calculation centre'. But for many years he has been interested in photography and when asked by his local paper to produce an illustrated feature on the bad living conditions of children in Portugal, he devised this 'fantasy' which the paper promptly printed as their Photograph of the Week under the title 'The mystery of Life'. Technical data is given as supplied but no other information was provided.

Diese ungewöhnliche Aufnahme stammt vom spanischen Fotografen Jorge Vidal Batiles. Er bezeichnet sich selbst als Informationstechniker und Direktor eines Kalkulationszentrums. Seit Jahren interessiert er sich für Fotografie, und als seine Lokalzeitung ihn um eine Bildserie über die Lebensbedingungen der Kinder Portugals bat, schuf er diese „Phantasie". Die Zeitung druckte das Bild als „Foto der Woche" mit dem Titel „Mysterium des Lebens". Nur die oben genannten technischen Daten wurden angegeben.

Cette extraordinaire image a été réalisée par le photographe espagnol, Jorge Vidal Batlles qui se décrit lui-même comme «un technicien de l'information et le directeur d'un centre de calcul». Mais il s'intéresse à la photographie depuis longtemps et lorsque le journal de sa ville lui demanda de produire un article illustré sur les conditions de vie défectueuses des enfants au Portugal, il conçut cette «vision» que le journal publia immédiatement à la rubrique Photographe de la Semaine sous le titre «Le mystère de la vie». Nous n'avons pas reçu d'autres renseignements que les données techniques que voici.

40

Photographer	Stanislav Korytnikov

The Performing Arts are considered of great importance in the Soviet Union and consequently attract much attention from the best Russian photographers. One of these is Stanislav Korytnikov who admirably conveyed a feeling of grace and movement in his study of the Folk Dance ensemble of Turkmenia.

Die darstellenden Künste werden in der Sowjet-Union sehr gefördert, die besten russischen Fotografen widmen ihnen ihre Aufmerksamkeit. Einer von Ihnen ist Stanislaw Korytnikov, der in dieser Studie ein hinreißendes Gefühl für Anmut und Bewegung verrät: Das Volkstanz-Ensemble von Turkmenien.

En Union Soviétique, il est donné une grande importance aux arts de la scène et les meilleurs photographes russes leur portent donc une attention particulière. L'un d'eux, Stanislav Korytnikov, a su rendre admirablement un sentiment de grâce et de mouvement dans son étude de l'ensemble de danse folklorique de Turkmenia.

41

Photographer	Valentin Mastyukov
Camera	Rolleiflex
Lens	75mm
Film	Orwo
Shutter speed	1/125
Aperture	f/5.6
Developer	Kodak D76
Paper	Forte

An informal portrait of the Russian Poet Evgeni Evtushenko.

Ein zwangloses Porträt des russischen Dichters Evgeni Evtushenko.

Un portrait très naturel du poète russe Evgeni Evtushenko.

42

Photographer	Y. Somov

There can be little doubt as to who was the star performer in the Munich Olympics in terms of popular appeal. Rarely, if ever, can one young gymnast have made such an impact upon millions of television viewers, most of whom seemed to talk of nothing and no one but Olga Korbut for days after her medal-winning display. The most popular sportswoman in the world is seen here with the strongest man in the world — her team mate, the weight lifter Vasily Alexeyev.

Es besteht kaum Zweifel darüber, wer auf der Olympiade in München der Liebling des Publikums war. Selten, wenn überhaupt jemals zuvor, hat eine Sportlerin Millionen von Fernsehzuschauern so beeindruckt, wie die Goldmedaillengewinnerin Olga Korbut. Hier ist sie zusammen mit dem stärksten Mann der Welt zu sehen: ihrem Team-Kameraden Vasily Alexeyev.

Il n'y a aucun doute sur l'identité de la grande vedette des Jeux olympiques de Munich pour ce qui est de l'attrait auprès du public. Ce n'est pas souvent, si jamais, qu'une jeune gymnaste produit un tel effet sur des millions de téléspectateurs, dont la plupart

semblaient ne parler de rien d'autre que d'Olga Korbut pendant plusieurs jours après qu'elle ait remporté sa médaille. On voit ici la sportive la plus populaire du monde avec l'homme le plus fort du monde, son camarade d'équipe, le leveur de poids, Vasily Alexeyev.

43

Photographer	Lev Ustinov

'Children's Polka', a delightful picture that shows what can result from a study of children at play if the subjects are unaffected by the presence of a camera.

„Kinder-Polka", eine gelungene Moment-Aufnahme, die zeigt, was erreicht werden kann, wenn sich Kinder ungezwungen vor der Kamera bewegen.

«La polka des enfants», une ravissante image qui montre ce que l'on peut réaliser avec des enfants en train de jouer s'ils ne font pas attention à l'appareil.

44

Photographer	Carl Uytterhaegen
Camera	Asahi Pentax SV
Lens	24mm Super Takumar
Film	Kodak Tri-X
Shutter speed	1/125
Aperture	f/11
Developer	Microdol-X

Carl Uytterhaegen is a professor in photography at an Art Academy in Brussels and at the Royal Academy of Arts in Ghent. He is also a working professional. The first of the two pictures by him that we reproduce in this edition is of schoolchildren playing on a fallen log in a park near Brussels.

Carl Uytterhaegen ist Professor der Fotografie an einer Kunstakademie in Brüssel und an der Köngl. Kunstakademie in Gent. Er arbeitet auch als Berufsfotograf. Das obere dieser Bilder zeigt Schulkinder, die auf einem umgefallenen Baumstamm in einem Park bei Brüssel spielen.

Carl Uytterhaegen est professeur de photographie dans une école d'art de Bruxelles et à l'Académie royale d'arts à Gand. Il travaille également en tant que photographe professionnel. La première des deux photographies de lui que nous publions dans cette édition montre des écoliers en train de jouer sur une branche morte dans un parc près de Bruxelles.

45

Photographer	Carl Uytterhaegen
Camera	Asahi Pentax SV
Lens	135mm Super Takumar
Film	Kodak Tri-X
Shutter speed	1/125
Aperture	f/8
Developer	Microdol-X

Uytterhaegen's second contribution — oddly similar in arrangement but vastly different in context — was taken in England at a NATO Naval Review at Portsmouth.

Uytterhaegens zweiter Beitrag — ganz ähnlich im Aufbau, aber sehr verschieden im Inhalt — wurde in England bei einer Marine-Parade der NATO vor Portsmouth gemacht.

La seconde photographie de Uytterhaegen — curieusement semblable à la première par la composition mais très différente par le contexte — a été prise en Angleterre à une revue navale NATO à Portsmouth.

46

Photographer	Gerhard E. Ludwig
Camera	Nikon FtN
Film	Kodak Tri-X

Essen photographer Gerhard E. Ludwig made this picture during a huge cultural programme 'Spielstrasse', held during the Munich Olympics. Asked for a description, he replied:

Paterson does so much for your image

Acutol The premier developer combining maximum sharpness and definition with pictorial gradation on films ASA 5-200, giving a half-stop speed increase. Produces negatives with brilliant detail throughout the tonal scale. Dilution 1:10 250ml-40p 500ml-63p 1000ml-£1·09

Acuspecial Surface developer producing a special engraving type sharpness and definition with fine grain on miniature and sub-miniature films ASA 5-200. Gives half-stop speed increase. Its soft working action affords control for high contrast materials and subjects without exaggerating tonal compression. Dilution 1:29 55ml-33p 250ml-£1·02

Acutol-S Re-usable developer for all speeds of films giving a half-stop increase. Produces fine grain and superlative gradation without softening definition. In powder form to make: 600ml-33p 2·25 litres-70½p 4·5 litres-£1·06

Acuspeed Gives maximum possible film speed increase with fast films ASA 400-1600, for photography under extreme conditions. Produces normal contrast negatives with good sharpness and definition. Dilution 1:7 250ml-49p 500ml-82p 1000ml-£1·45

FX-18 A standard PQ Borax developer giving a balance of full emulsion speed, fine grain and excellent image sharpness on all films. Re-usable and in single powder form to make: 600ml-33p 2·25 litres-49p 4·5 litres-79p 13·5 litres-£1·65

FX-18R Regenerator Extends life in deep tanks. To make: 4·5 litres-79p

Acuprint Developer for all enlarging and contact papers. Produces a full range of tones from sparkling whites to rich satisfying blacks. Has high capacity, long working life and wide exposure and development latitude. Dilution 1:9 250ml-43p 500ml-79p 1000ml-£1·42 4·5 litres-£4·12

Acustop Instantly arrests development and extends fixer life by preventing carry-over of developer. Solution changes colour when exhausted. Dilution 1:30 55ml-23p 500ml-74½p

Acufix A high velocity fixer with hardening action for all films and papers. High capacity. Gives clear base on all films and does not affect brilliance of print glazing. Dilution 1:3 250ml-41½p 500ml-69p 1000ml-£1·25 4·5 litres-£3·43

Anti-Static Wetting Agent Simply squeeze a few drops into the final rinse and your films will dry without marks, sparkling and dust-free. Economical dispenser bottle 50ml-30p

Cleaning Solution Removes deposits and stains from dishes, tanks, graduates, etc. leaving them sparkling clean. May be used repeatedly until exhausted. Dilution 1:5 225ml-23p

Prices include VAT.

PATERSON

'Invited by the National Olympic Committee of Germany, artists from all over the world (all famous and well known) held theatre performances, music sessions, art exhibitions and actions, happenings and plays. The most spectacular open-air theatre was made by the Japanese regisseur Terajama; a monumental scene about the liberation of people ending with the claim to all nations that took part in the Games: "Make peace". It is a disgrace, that – after the act of the terrorists – "Spielstrasse" had to close down, including Terajama's peace-play. The Japanese Girl of my photograph is the main character in the play.'

G. E. Ludwig aus Essen fotografierte während der Olympischen Spiele in München auf der „Spielstraße". Er kommentierte dieses Bild: „Hervorragende und bekannte Künstler aus aller Welt folgten der Einladung des Olympischen Komitees, um Theater, Musik, Kunstausstellungen und -aktionen, Happenings und Spiele aller Art anzubieten. Hier das Hauptszenenbild aus dem aufsehenerregenden Freilichttheater des japanischen Regisseurs Terajama, einem Stück über die Befreiung der Menschheit. Alle Nationen, die an den Spielen teilnahmen, wurden aufgefordert: „Macht Frieden!". Unverständlicherweise wurde nach dem Akt der Terroristen die Spielstraße geschlossen, einbegriffen Terajamas Friedensstück. Das japanische Mädchen auf meinem Foto ist die Hauptdarstellerin des Stückes."

Le photographe du Essen, Gerhard E. Ludwig, a pris cette photographie pendant un grand programme culturel «Spielstrasse» organisé lors des Jeux olympiques de Munich. Lorsque nous lui avons demandé une description, il répondit: «Invités par le Comité olympique national d'Allemagne, des artistes du monde entier (tous célèbres) organisèrent des séances de théâtre, des sessions musicales, des expositons d'art, des «happenings» et des pièces. Le théâtre de plein air le plus spectaculaire fut organisé par le régisseur japonais Terajama: une scène monumentale sur la libération des peuples se terminant sur cet appel à toutes les nations qui prenaient part aux Jeux: «Faites la paix». Il est malheureux qu'à la suite de l'acte des terroristes, le «Spielstrasse» dut fermer, y compris la pièce sur la paix de Terajama. La jeune japonaise sur ma photographie est le principal personnage de la pièce.»

47

Photographer	Gerhard E. Ludwig
Camera	Nikon
Film	Kodak Tri-X

While looking for pictures typical of 'Young Swinging London' (did such a place ever exist?) Ludwig found this girl in a Kensington shop.

Gerhard Ludwig suchte typische Motive für „Young Swinging London" – existierte es jemals? Er entdeckte dieses Mädchen in einem Geschäft in Kensington.

Alors qu'il était à la recherche de vues typiques du jeune «Swinging London» (si un tel endroit a jamais existé!), Ludwig rencontra cette fille dans un magasin de Kensington.

48/55

Photographer	F. Stoppelman
Camera	Rolleiflex
Lens	80mm Planar
Film	Ilford FP4
Shutter speed	1/125
Developer	Kodak D76
Paper	Ilfobrom

Francis Stoppelman, ASMP, who describes himself as a foreign press correspondent based in Mexico, has made several notable contributions to recent editions of the YEAR BOOK. Apart from his mastery of camera technique, his special gift is his sympathetic observation of people which he has used to remarkable effect in this series which he calls 'Impressions of Panama'. In a note with the pictures,

Stoppelman adds: 'The Republic of Panama is not only the Canal Zone – which, incidentally, is American – but much more. A country of beauty and its own beautiful character which the Americans fortunately cannot take away (yet).'

F. Stoppelmann, ASMP, Auslandskorrespondent mit Sitz in Mexico, hat schon in den früheren Ausgaben des Jahrbuchs bedeutende Reportagen veröffentlicht. Meisterhafte Beherrschung der Fototechnik und einfühlsame Beobachtungsgabe bewirken den Erfolg seiner Serie „Impressions of Panama". Er schreibt über dieses Land: „Die Republik Panama ist nicht nur die Kanalzone – diese ist übrigens amerikanisch – sondern viel mehr: ein Land voller Schönheit und mit einem eigenwilligen, höchst reizvollen Charakter, der von den Amerikanern glücklicherweise nicht zerstört werden konnte. (Bis jetzt. . . .)

Francis Stoppelman ASMP, qui se présente comme correspondant de presse à l'étranger basé à Mexico, a apporté plusieurs contributions remarquables à de récentes éditions de l'Annuaire. Outre sa parfaite maîtrise de la technique de la photo, son don particulier est la façon dont il observe les gens avec compassion; et dans la présente série qu'il intitule «Impressions of Panama», l'effet est remarquable. Dans une note accompagnant ces images, Stoppelman ajoute: «La République de Panama n'est pas seulement la Zone du canal, laquelle soit dit en passant est américaine, mais c'est beaucoup plus. Un pays de beauté et d'une beauté toute particulière que les Américains ne peuvent heureusement pas emmener (pas encore).»

56/59

Photographer	Gastone Rossi
Cameras	Topcon RE-Super and Leica M2
Lenses	100mm and 35mm Summicron
Film	Kodak Tri-X
Developer	Kodak D76
Paper	Kodak WSG

Some remarkable photographs from Italy, with explanatory notes by Bergamo photographer Gastone Rossi.

'I have carried out a long series of photographs in the world of the deaf and dumb. I have photographed the young deaf and dumb, who are always hoping to be included in human society, and the old deaf and dumb who have a big sorrow and not much hope. Two of these pictures represent the hope and two the resignation and the sorrow.'

„Ich habe eine umfangreiche Fotoserie zusammengestellt: Die Welt der Taubstummen. Ich habe die Jüngsten fotografiert, die noch hoffen, in der menschlichen Gesellschaft akzeptiert zu werden, und die Alten, die nur noch Leid und kaum Hoffnung kennen. Zwei dieser Bilder zeigen Zuversicht, zwei Resignation und Schmerz."

Plusieurs photographies remarquables accompagnées de notes explicatives et envoyées d'Italie par le photographe de Bergamo Gastone Rossi.

«J'ai réalisé toute une série de photographies dans le monde des sourds-muets. J'ai photographié de jeunes sourds-muets qui espèrent encore faire un jour partie de la communauté humaine, et de vieux sourds-muets qui ont une immense tristesse et très peu d'espoir. Deux de ces images représentent l'espoir et deux autres la résignation et la tristesse».

60

Photographer	Francisco J. Elvira
Camera	Exakta
Lens	130mm
Film	Kodak Tri-X
Developer	Kodak D76

In the technical data section last year, Canadian photographer Michael Semak criticized the publication of technical data in a picture annual so we were interested to read the note accompanying this submission.

'First, I am going to introduce myself. I am a 24

year old economics student from Barcelona and also work as a semi-pro photographer. I have published some pictures in newspapers and in the "Anuaris de la Fotografiá Española 1973". I am self taught, so I found a great help in the last five Year Books that I bought, not being in agreement with Michael Semak's opinion, because in my own case the the Technical notes in the Year Books helped me a great deal and I used them as a sort of text book. I send you part of my photographic work. I must tell you that I don't know the rules for sending pictures for the Photography Year Book, so I hope the prints' size and the time of the year I send them are alright.'

To answer the question, here are the rules. If you can take photographs like this one (of a rim lit Dromedary at Barcelona Zoo) there are no rules.

Im technischen Teil des Jahrbuchs 1973 kritisierte der kanadische Fotograf Michael Semak den Abdruck der aufnahmetechnischen Angaben in einem Fotojahrbuch. Einer der Kommentare, die wir dazu erhielten, war besonders interessant: „Erst möchte ich mich vorstellen: Ich bin 24 Jahre alt, studiere Volkswirtschaft in Barcelona und arbeite nebenbei als Fotograf. Einige meiner Bilder erschienen in Zeitungen und in Anuaris de la Fotografía Espanola 1973. Ich bin Autodidakt, und die letzten 5 Jahrbücher halfen mir eine Menge, da ich die technischen Daten auswertete und so die Jahrbücher wie Lehrbücher benutzte. Mit der Meinung von Michael Semak stimme ich deshalb nicht überein. Anbei eine Auswahl meiner Arbeiten. Leider muß ich gestehen, daß ich die Einsendebedingungen für das Fotojahrbuch nicht kenne, hoffe aber, daß das Format der Fotos und der Zeitpunkt meiner Einsendung richtig sind."

Hier unsere Bedingungen: Wenn sie Fotos machen können wie dieses (von einem lichtumrandeten Dromedar im Zoo in Barcelona), dann gibt es keine Bedingungen.

L'an dernier dans la section des informations techniques, le photographe canadien Michael Semak prétendait qu'il était inutile de publier des données techniques dans un annuaire photographique. C'est pourquoi nous avons lu avec un intérêt particulier la note accompagnant cette photographie: «Je tiens tout d'abord à me présenter. J'ai vingt quatre ans, vit à Barcelone et étudie les sciences économiques; je peux également dire que je travaille comme photographe demi-professionnel et que j'ai publié plusieurs photographies dans des journaux et dans l'«Anuario de la Fotografía Española 1973». J'ai appris la photographie seul et les annuaires que j'ai achetés ces cinq dernières années m'ont beaucoup aidé; je ne suis pas du tout de l'avis de Michael Semak, car dans mon cas les notes techniques des annuaires m'ont énormément aidé, je les ai utilisées comme une sorte de manuel. Je vous envoie une partie de mes oeuvres photographiques, mais je dois vous dire que je ne connais pas les règles pour l'envoi de photographies pour l'Annuaire Photographique, aussi j'espère que le format des épreuves et la date à laquelle je les envoie conviennent».

Pour répondre à la question, voici les règles. Si vous êtes capable de prendre des photographies comme cette image (d'un dromadaire bordé de lumière au zoo de Barcelone) il n'y a pas de règles.

61

Photographer	Satinder Kumar Chadha
Camera	Nikon FtN
Lens	50mm Nikkor
Film	Kodak Tri-X
Shutter speed	1/125
Aperture	f/5.6

Noteworthy about submissions to the 1974 YEAR BOOK was a great improvement in the quantity, quality and content of the photographs that arrived from India. With a few notable exceptions, much of the work previously sent in by Indian photographers consisted of rather stereotyped pictorialism, over sentimental portraiture and views better suited to a travel brochure than these pages. Most were

The Spotmatic II
Trust your hands to tell you it's Pentax

That's one thing all Asahi Pentax products have in common. They feel as if they were made for *your* hands only.

Like the Spotmatic II. All its controls are perfectly placed for simple, easy operation. The camera feels at home in your hands the moment you pick it up.

And it takes great pictures.

The Spotmatic II's through-the-lens metering system is the simplest, most accurate method of metering for just about every shot you'll ever take. Your exposures come out spot on every time. And, of course, with 22 Super-Multi-Coated Takumar Lenses to choose from, even against-the-light shots come easy. No flare, better contrast, truer colour balance.

The Spotmatic II sports an FP/X hot shoe with safety switch; ASA 20 to 3200; 20 or 36 exposure reminder; and a sure take-up spool for easy loading. It comes complete with a 55mm f1.8 or 50mm f1.4 lens.

Like everything that carries the Asahi Pentax name the Spotmatic II is built to give you the best in quality and reliability. Every part, however small, is made with care and precision. Every product is designed to be the best of its kind. With Asahi Pentax, you look on the world with an amazingly accurate eye.

Pentax Telescopes
The real thing. 3 astronomical telescopes for serious students of the stars.

Pentax Binoculars
Range of 17, so there's one that's right for you. Each has built-in filter for UV glare protection.

Super-Multi-Coated Takumar Lenses
7-layer lens coating makes these lenses outstanding for less flare, greater contrast. Screw fitting for Pentax and many other 35mm SLR cameras.

Spotmatic II

Pentax 6 × 7
The professional large format SLR camera. Electronic shutter from 1 sec. to 1/1000. 120/220 film back.

Spotmatic 500
35mm SLR camera with TTL metering, but less expensive than the Spotmatic II.

Pentax ES
The electronic 35mm camera that automatically chooses *exactly* the right shutter speed.

ASAHI PENTAX

Rank Photographic, P.O. Box 70, Great West Road, Brentford, Middlesex TW8 9HR.

mpetently exposed and printed but revealed little
out the subject — a criticism that could not be
elled at the contributors to this edition. Although a
wcomer to the YEAR BOOK, Satinder Kumar
adha's selection stands comparison with the most
nsitive impressions received from other countries,
mmencing with a sympathetic study taken in
naras of women listening to a religious story-
ller.

ter den Einsendungen für dieses Jahrbuch war
lzahl und Qualität der aus Indien eingesandten
tografien bemerkenswert. Viele, der bisher aus
lien kommenden Arbeiten, zeigten, mit wenigen
snahmen, Stereotypes, wie sentimentale Porträts
er Landschaften — für eine Reisebroschüre besser
eignet, als für diese Sammlung. Die meisten
ren gut belichtet und richtig vergrößert, sagten
er wenig über ihr Objekt aus, und konnten so,
genüber den anderen Beiträgen, der Kritik nicht
ndhalten. S. K. Chadha ist ein neuer Name im
hrbuch. Seine sensiblen Impressionen stehen
ter den Einsendungen aus anderen Ländern nicht
rück.
Fotostudie einer alten Frau, die religiösen
zählungen lauscht.

l sujet des photographies présentées par l'Inde
ur l'Annuaire Photographie 1974, il convient de
uligner une amélioration dans la quantité, la
alité et le contenu. A part quelques rares
ceptions, les oeuvres jusqu'ici envoyées par des
otographes indiens étaient d'un pittoresque
éréotypé, des portraits d'un sentimentalisme outré
des vues convenant mieux à une brochure de
yages qu'à ces pages. La plupart étaient bien
posées et tirées, mais mettaient peu en valeur le
jet — une critique que l'on ne pourra pas faire aux
otographes qui ont contribué à la présente
ition. Bien que nouveau venu à l'Annuaire,
tinder Kumar Chadha présente une série digne
être comparée aux images les plus sensibles
voyées par d'autres pays. Pour commencer, voici
e étude très bien sentie de femmes en train
écouter un conteur d'histoires religieuses à
anaras.

2

hotographer	Satinder Kumar Chadha
amera	Asahi Pentax Spotmatic
ens	50mm Takumar
lm	Kodak Plus-X
hutter speed	1/30
perture	f/4

his picture was taken in Delhi Zoo in the late
ening,' writes Chadha, 'the sad faces of the boys
ere very attractive.'

ätnachmittag im Zoo von Dehli. „Die schwer-
ütigen Gesichter ließen mich nicht los." schrieb
ada.

Cette photographie a été prise au zoo de Delhi à la
 de l'après-midi», écrit Chadha, «les visages tristes
s garçons étaient particulièrement attirants!»

3

hotographer	Satinder Kumar Chadha
amera	Asahi Pentax Spotmatic
ens	28mm Takumar
lm	Kodak Tri-X
hutter speed	1/250
perture	f/5.6

 picture taken in a market in Old Delhi; the shops
e closed.' But not the skilfully framed eye of the
bject.

uf einem Markt in Alt-Dehli; die Geschäfte sind
schlossen, nicht aber das umrandete Auge des
annes: sein Blick ist wachsam.

Une image prise dans un marché du vieux Delhi.
s boutiques étaient fermées». Mais pas l'oeil
bilement cadré du sujet.

64

Photographer	Satinder Kumar Chadha
Camera	Asahi Pentax Spotmatic
Lens	28mm Takumar
Film	Kodak Tri-X
Shutter speed	1/125
Aperture	f/5.6

Not a picture of three down-at-heel spacemen.
These are Muslim beggars, photographed by Chadha
in a Delhi street.

Drei heruntergekommene Weltraumfahrer? Es sind
Muslim-Bettler in Dehli.

Il ne s'agit pas de trois astraunautes accroupis. Ce
sont des mendiants musulmans photographiés par
Chadha dans une rue de Delhi.

65

Photographer	Satinder Kumar Chadha
Camera	Asahi Pentax Spotmatic
Lens	28mm Takumar
Film	Orwo NP55
Shutter speed	1/60
Aperture	f/5.6

Another feature of the Delhi street scene is the cow.
Religious beliefs prevent these animals from being
molested.

Die durch die Glaubenswelt des Hinduismus
geschützten Rinder geben den Straßen von Dehli ihr
charakteristisches Gepräge.

Un autre aspect des scènes de rues de Delhi est la
vache. D'après les croyances religieuses c'est un
animal intouchable.

66

Photographer	Bhawan Singh
Camera	Nikon F
Lens	135mm Nikkor
Film	Orwo NP55
Shutter speed	1/60
Aperture	f/5.6

Bhawan Singh is also a new contributor to these
pages. He submitted an impressive selection which
included this fine composition of two women. It was
taken at a fair in Banaras.

Auch Bhawan Singh hat wieder einen Beitrag zum
Jahrbuch geliefert. Aus seiner beeindruckenden
Bildauswahl diese Komposition zweier Frauen auf
dem Markt von Banaras.

Bhawan Singh est également un nouveau venu dans
ces pages. Il nous a soumis une série
particulièrement remarquable dont cette jolie
composition de deux femmes prise à une foire à
Banaras.

67

Photographer	Bhawan Singh
Camera	Asahi Pentax Spotmatic
Lens	105mm Takumar
Shutter speed	1/60
Aperture	f/4

Confident composition also characterizes this shot,
taken on a rainy day in Delhi.

Ein regnerischer Tag in Dehli. Die Aufnahme verrät
ungewöhnliche Gestaltungskraft.

Une composition hardie caractérise également ce
cliché pris par un jour de pluie à Delhi.

68/69

Photographer	Raghu Rai

Raghu Rai is another of our regular contributors who
always reminds us of the photographic talent that
exists in India. The first example of his recent work
was captioned 'a weighty problem' but no details
were supplied about it or the striking portrait on the
facing page.

Raghu Rai liefert regelmäßig Beiträge, die uns das
fotografische Talent in Indien vergegenwärtigen.
Hier ein Beispiel seiner neuesten Arbeiten, betitelt:
„Schwerwiegendes Problem". Leider machte er keine
näheren Angaben über dem ausdrucksstarken
Gesicht auf der gegenüberliegenden Seite.

Raghu Rai est un autre photographe dont nous
publions le travail régulièrement et il nous rappelle
toujours le talent photographique qui existe en Inde.
Le premier exemple de ses dernières oeuvres était
intitulé « un problème de poids », mais nous n'avons
aucune donnée sur cette photographie ni sur ce beau
portrait de la page suivante.

70/73

Photographer	Horst Ludeking
Cameras	Leica M2, Leica M4 and Nikon F
Lenses	21, 35 and 85 mm
Film	Kodak Tri-X
Developer	D76
Paper	Agfa Brovira

Young Essen photographer Horst Ludeking (who last
year sent us a fine series of pictures all taken in one
house in Berlin) extends his theme on the
separateness of people's lives with an equally
interesting set showing patients at a health resort in
Germany. His photographs graphically communicate
the problem of non-communication between
individuals.

Der junge Fotograf Horst Lüdeking aus Essen (im
vergangenen Jahr steuerte er eine Bildserie über die
Bewohner eines Berliner Hauses bei) verfolgt sein
Leitmotiv — die Einsamkeit des Menschen — weiter.
Er zeigt Kurgäste in einem deutschen Badeort. Seine
Aufnahmen visualisieren die Unfähigkeit des
Menschen zur Kommunikation.

Le jeune photographe allemand Horst Ludeking (qui
nous a envoyé l'an dernier une jolie série de
photographies toutes prises dans une seule maison à
Berlin) développe son thème sur l'isolement des gens
dans leur vie, avec une série également très
intéressante montrant des malades dans une ville
d'eau en Allemagne. Ces photographies expriment
graphiquement le problème de l'absence de
communication entre les individus.

74

Photographer	Derek Shuff
Camera	Yashicamat
Film	Kodak Tri-X
Shutter speed	1/60
Aperture	f/5.6
Developer	Kodak D76

Putting on a face. 'A candid shot,' writes the
photographer, 'taken when I went to find out why a
friend was keeping me waiting — at the office.'

„Putting on a Face" . . . — „Ich wollte herausfinden,
warum meine Freundin mich so lange warten ließ —
im Büro!"

Changement de visage. « Un cliché nature pris alors
que je voulais voir pourquoi une amie me faisait
attendre — au bureau ».

75

Photographer	Leila Badaro
Camera	Nikon F
Lens	135mm Nikkor
Film	Kodachrome II
Shutter speed	1/125

The finest contribution by a female photographer to
this edition was a set of pictures by Leila Badaro
which she calls 'The women of Islam'. Now based
in Washington, U.S.A., Leila was born just after the
Second World War in Palestine and the quality of
her work has been recognized by its appearance in
such famous journals as the *National Geographic
Magazine* and *Camera* although it was first seen in
1967 in the Arab weekly *Aosbou Al Arabi* published
in Beirut, Lebanon. The U.S. Centre in Kabul,
Afghanistan, recently sponsored her first one-woman

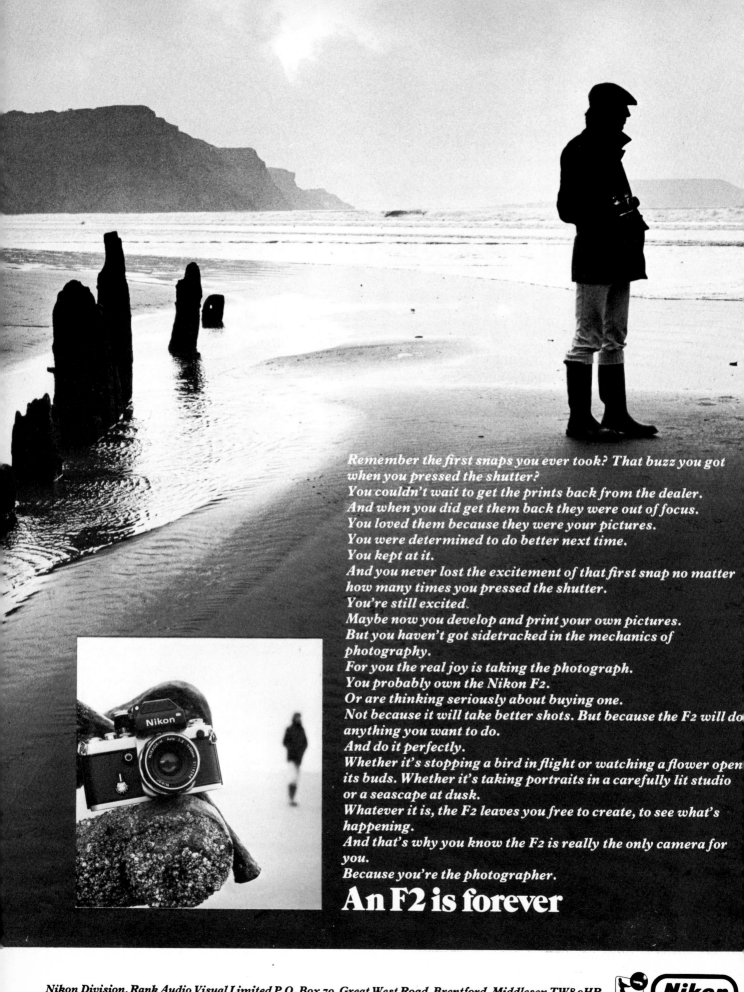

Remember the first snaps you ever took? That buzz you got when you pressed the shutter?

You couldn't wait to get the prints back from the dealer.

And when you did get them back they were out of focus.

You loved them because they were your pictures.

You were determined to do better next time.

You kept at it.

And you never lost the excitement of that first snap no matter how many times you pressed the shutter.

You're still excited.

Maybe now you develop and print your own pictures.

But you haven't got sidetracked in the mechanics of photography.

For you the real joy is taking the photograph.

You probably own the Nikon F2.

Or are thinking seriously about buying one.

Not because it will take better shots. But because the F2 will do anything you want to do.

And do it perfectly.

Whether it's stopping a bird in flight or watching a flower open its buds. Whether it's taking portraits in a carefully lit studio or a seascape at dusk.

Whatever it is, the F2 leaves you free to create, to see what's happening.

And that's why you know the F2 is really the only camera for you.

Because you're the photographer.

An F2 is forever

Nikon Division, Rank Audio Visual Limited P.O. Box 70, Great West Road, Brentford, Middlesex TW8 9HR. Nikon

xhibition there which reflected her passionate
interest in exploring subjects of concern to women
everywhere.

This striking 35mm study of a masked girl (the mask
is made of paper-thin leather) was taken in Dubai,
one of the Arabian gulf emirates.

Der beste Beitrag einer Fotografin in dieser Ausgabe
ist eine Bildserie von Leila Badaro: „Die Frauen des
Islam". Leila, die jetzt in Washington lebt, wurde
kurz nach dem 2. Weltkrieg in Palästina geboren.
Ihre Arbeit wurde in so bedeutenden Journalen wie
National Geographic Magazine und Camera
veröffentlicht und anerkannt. Entdeckt wurde sie
1967 von der arabischen Wochenzeitschrift Aosbou
Al Arabi, die in Beirut erscheint. Das Amerika-
Zentrum in Kabul, Afghanistan, veranstaltete vor
kurzem die erste Ausstellung, die sie allein bestritt,
und die ihr leidenschaftliches Interesse an der Frau
und ihrer Welt offenbarte.
Diese großartige Studie eines maskierten
Mädchens (die Maske ist aus hauchdünnem Leder)
gelang ihr in Dubai, einem der arabischen Golf-
Staaten.

La meilleure contribution apportée à cette édition de
Annuaire est une série de
photographies de Leila Badaro intitulée « Femmes de
Islam ». Résidant aujourd'hui à Washington, Etats-
Unis, Leila est née en Palestine juste après la seconde
guerre mondiale. Son talent a été consacré par la
parution de ses oeuvres dans des journaux aussi
connus que National Geographic Magazine et
Camera, mais c'est l'hebdomadaire arabe Aosbou Al
Arabi qui publia en 1967 à Beyrouth au Liban ses
photographies d'elle pour la première fois. Le Centre
américain à Kabul, en Afghanistan, vient
d'organiser une exposition consacrée aux seules
oeuvres de Leila Badaro, et qui reflète l'intérêt
passionné avec lequel elle utilise toutes les
techniques de la photo pour les sujets intéressant
les femmes du monde entier. Cette remarquable
étude en 35mm d'une jeune fille masquée (le masque
est en cuir extrêmement mince) a été prise à Dubai,
un des émirats du Golf arabe.

76

Photographer	Leila Badaro
Camera	Nikon F
Lens	135mm Nikkor
Film	Kodachrome II

The dark beauty of a woman of the Tuareg. Leila
Badaro photographed her in the south of Algeria, in
the Hogger Mountains region of the Sahara.

Die dunkle Schönheit einer Tuareg-Frau im Süden
Algeriens, im Gebiet der Hogger-Berge in der
Sahara.

La beauté brune d'une jeune Touareg. Leila Badaro
a photographiée dans le sud de l'Algérie, dans le
massif de l'Ahaggar au Sahara.

77

Photographer	Leila Badaro
Camera	Nikon F
Lens	135mm Nikkor
Film	Kodachrome II

The eyes of three women of Islam look without
hostility at the camera of a fourth. A picture by Leila
Badaro taken in Saana — the capital of North Yemen.

Saana, Hauptstadt des Nord-Jemen: Die Augen
dreier islamischer Frauen sehen ohne Feindseligkeit in
die Kamera einer vierten.

Les yeux de trois femmes islamiques regardent sans
hostilité l'appareil d'une autre femme, elle aussi
islamique. Une photographie prise par Leila Badaro
à Saana, la capitale du Yemen nord.

78

Photographer	Leila Badaro
Camera	Nikon F
Lens	135mm Nikkor
Film	Kodachrome II

A remarkably fine portrait study (the essential

feminine in pose, colour and composition) of a
Bedouin girl. The location was Southern Morocco.

Südmarokko: Besonders gelungene Porträtstudie
eines Beduinenmädchens.

Un très beau portrait (essentiellement féminin par
la pose, la couleur et la composition) d'une jeune
Bédouine. Cette photographie a été prise dans le sud
du Maroc.

79

Photographer	Leila Badaro
Camera	Nikon F
Lens	135mm Nikkor
Film	Kodachrome II

Leila Badaro's own favourite among her collection of
pictures on the women of Islam, is this hypnotically
compelling close up of a Kochi nomad, taken during
a recent visit to Afghanistan.

Leila Badaros Lieblingsbild aus ihrer Bildserie
„Islam-Frauen" ist diese fast hypnotisierend
wirkende Großaufnahme einer Kochi-Nomadin, die
sie während ihres letzten Besuches in Afghanistan
machte.

La photographie préférée de Leila Badaro parmi sa
série consacrée aux femmes de l'Islam: un premier
plan aux qualités hypnotisantes d'une jeune nomade
Kochi. Leila Badaro a pris cette photographie au
cours d'un récent voyage en Afghanistan.

80

Photographer	Bernard Plossu
Camera	Asahi Pentax
Lens	28mm Takumar
Film	Kodachrome II

Bernard Plossu (born 1945), is a talented young
French professional photographer who describes
these pictures on 'The Ghost West', as follows:
'They are all the western movies I saw in the grey
winter afternoons of a European city in childhood.
This colour essay therefore intends to take those who
will look at it along with me in my dream: we are in a
real western. To do it, I went back many times, as I
am often in the U.S.A. on photo assignments for
travel magazines. These pictures of the "Ghost West"
were done in my free time, going from California to
Nevada, to Arizona, New Mexico and Texas. I
wanted to show to all my American friends who
often complain that they have no past, that, not only
do they have one, but that it is lyrical and superb.'
The whole of 'The Ghost West' series by Bernard
Plossu was exhibited at the American Cultural Centre
in Paris in the Spring of 1973, which unfortunately
necessitated our having to reproduce this selection
from duplicate transparencies rather than the original
prints. These were made by the 'Atelier Fresson' of
Paris, about whom Plossu adds this interesting
footnote:
'They are artisans, professionals working only for
professionals. What they want is to do quality work
and their "matt" processing is absolutely unique. The
"charcoal processing" as they call it, was invented at
the end of the 19th century by Grandfather Fresson.
His son, and now his grandson, keep up the
tradition. They live very simply outside of Paris, in a
"funky" place, and refuse work often, desiring to do
only what they want. Many famous professionals
swear by them. They use four colours for printing,
just like a dye-transfer; they fix colour pigments in
powder on gelatin; they care about a harmonious
result instead of a technical one.'
Plossu's first picture shows an abandoned wagon
on a dirt road in Nevada in the light of early
morning.

Bernard Plossu (geboren 1945) ist ein talentierter,
junger, französischer Berufsfotograf. So entstand
seine Western-Serie: „Sie verkörpert für mich all jene
Wildwestfilme, die ich in meiner Kindheit an den
grauen Winternachmittagen einer europäischen
Großstadt gesehen habe. Die Farbserie versucht
daher, alle ihre Betrachter meinen Traum mittträumen
zu lassen. Schon sind wir in einem echten Western.
Um meinen Traum zu verwirklichen, bin ich

jedesmal, wenn ich in Amerika Aufnahmen für Foto-
Reisemagazine machte, in meiner Freizeit in den
„Geister-Westen" gefahren. Ich besuchte
Kalifornien und Nevada, Arizona, Neu-Mexico und
Texas. Ich wollte allen meinen amerikanischen
Freunden (die beklagen sich immer, keine
Vergangenheit zu haben) zeigen, daß sie nicht nur
eine Vergangenheit besitzen, sondern sogar eine
poetische und großartige!"
Die vollständige Wildwestserie wurde im Frühling
1973 im amerikanischen Kulturzentrum in Paris
ausgestellt, was uns leider zwang, diese Drucke
anstatt von den Originalen, von Diaduplikaten
herzustellen. Diese wurden im „Atelier Fresson" in
Paris angefertigt, dem Plossu folgende interessante
Bemerkung widmet: Sie sind Kunsthandwerker,
Fachleute, die nur für Fachleute arbeiten. Ihr
Bestreben ist es Qualitätsarbeit zu leisten, und ihre
komplizierte Entwicklungstechnik ist einzigartig. Das
„Holzkohleverfahren", wie sie es nennen, wurde zu
Ende des 19. Jahrhunderts von Großvater Fresson
entwickelt. Sein Sohn, und nun bereits sein Enkel,
setzen die Tradition fort. Sie leben sehr einfach,
außerhalb von Paris, in einem „Schlupfwinkel" und
lehnen oftmals Arbeiten ab, sie suchen sich ihre
Aufgaben selbst aus. Viele Fachleute schwören auf
sie. Sie benutzen für ihre Abzüge vier Farben,
genauso wie bei Farbumkehrungen; sie fixieren in
Puder auf einer Gelatineschicht. Was ihnen am
Herzen liegt, ist mehr ein harmonisch, als nur ein
technisch gelungenes Ergebnis."
Plossus erstes Bild: Ein verlassener Karren auf
einem Sandweg in Nevada beim ersten Morgenlicht.

Bernard Plossu (né en 1945) est un jeune
photographe français de talent qui décrit ainsi ces
photographies sur «l'Ouest fantôme»:
« Ce sont tous les « western » que j'ai vus dans
mon enfance par de tristes après-midi d'hiver dans
une ville d'Europe. L'objet de cet essai en couleur est
donc d'entraîner avec moi dans mon rêve ceux qui le
regardent: nous sommes dans un vrai western. Pour
le réaliser je suis allé dans l'Ouest maintes et maintes
fois, puisque je me trouve souvent aux Etats-Unis
pour des reportages photographiques pour des
magazines de voyages. J'ai pris ces photos de
l'Ouest fantôme à mes moments de loisir, tandis que
je me rendais de Californie au Nevada, d'Arizona à
New Mexico et au Texas. Je voulais démontrer à mes
amis américains qui regrettent souvent de ne pas
avoir de passé, que non seulement ils en ont un,
mais que c'est aussi un passé lyrique et grandiose. »
Toute la série sur «l'Ouest fantôme» de Bernard
Plossu fut exposée au Centre culturel américain à
Paris au printemps de 1973, ce qui nous a
malheureusement obligé à utiliser des duplicatas de
diapositives au lieu des épreuves originales pour
reproduire cette sélection. Les épreuves originales
ont été tirées par l'Atelier Fresson de Paris, au sujet
duquel Plossu ajoute cette note intéressante:
« Ce sont des artisans, des professionnels qui ne
travaillent que pour les professionnels. Ce qu'ils
veulent c'est faire du travail de qualité et leur
procédé « mat » est absolument unique. Le « procédé
au charbon », comme ils l'appellent, fut inventé à la
fin du XIXème siècle par le grand-père, M Fresson.
Son fils et, aujourd'hui, son petit-fils ont continué la
tradition. Ils vivent très simplement en dehors de
Paris, dans un «drôle» d'endroit, et ils refusent
souvent du travail, ne voulant faire que ce qui leur
plaît. De nombreux professionnels ne jurent que par
eux. Ils utilisent quatre couleurs d'impression,
exactement comme un transfert de teinture; ils fixent
les pigments colorés en poudre sur de la gélatine; ils
se soucient d'obtenir un résultat harmonieux plutôt
que technique. »
La première photographie de Plossu montre une
diligence abandonnée sur une piste du Nevada dans
la lumière du petit matin.

81

Photographer	Bernard Plossu
Camera	Nikon
Lens	24mm Nikkor
Film	Kodachrome II

'It was late afternoon,' writes Plossu, 'when the sun

THE WESTON MASTER
becomes the
WESTON Euro-MASTER

Still the standard by which all exposure meters are judged

WESTON *Euro-* **MASTER**

Manufactured by Sangamo Weston
Joint U.K. distributors: Jonathan Fallowfield Ltd., Strathcona Road, North Wembley, HA9 8OL. (and branches)
Gnome Photographic Products Ltd., Gnome Corner, Caerphilly Road, Cardiff, CF4 4HJ.
Export enquiries to: Sangamo Weston Limited, Enfield, Middlesex.

started going down on the great Arizona plain. I was on a hill near the Indian pueblo of Acoma. The sun, golden, was hitting the village and giving every mud adobe house a bright warm tone.'

‚Es war am Spätnachmittag, die Sonne ging gerade am Horizont der großen Ebene Arizonas unter. Ich stand auf einem Hügel nahe dem Indianerdorf Acoma. Die Sonne vergoldete das Dorf, jede Lehmhütte schimmerte in leuchtendwarmem Ton.

«C'était à la fin de l'après-midi», écrit Plossu lorsque le soleil commence à descendre sur la grande plaine de l'Arizona. J'étais sur une colline près du pueblo indien d'Acoma. Le soleil doré frappait le village et recouvrait d'une teinte chaude et brillante chacun des adobes».

82

Photographer	Bernard Plossu
Camera	Asahi Pentax
Lens	28mm Takumar
Film	Kodachrome II

After quite a drive along the dusty miles, one can arrive in Bodie, a spectacular mining ghost town on the Californian side of the Sierra Nevada mountains. Glorious! Bodie, made all of wood, was named after silver miner, who "disappeared" one day while carrying money to a city, and was found after the Spring snow had melted. Then, one day, no more silver, so everyone left.

'Taken in early morning; just like it was, chains and wood, browns of rust and of wood, cutting in super clear sky, cold air, splendid West!'

Bodie erreicht man nach einer staubigen, endlos scheinenden Fahrt. Es ist eine gottverlassene, geisterhaft anmutende Silberminenstadt auf der kalifornischen Seite der Sierra Nevada Mountains. Welch ein Bild! Der Ort, ganz aus Holz gebaut, erhielt seinen Namen nach dem Silbersucher Bodie, der eines Tages, als er Geld in eine Stadt zu bringen hatte, verschwunden war; man fand ihn später, nach der Schneeschmelze. Dann wurde hier kein Silber mehr gefunden, alles kehrte der Stadt den Rücken.

Aufgenommen am frühen Morgen, gerade so wie es war: Hügel und Wald, Brauntöne von Holz und Rost gegen den durchsichtigen Himmel; kalte, klare Luft – herrlicher Westen!

Après un bon nombre de kilomètres le long de pistes poussiéreuses, on arrive à Bodie, une étonnante ville minière «fantôme» sur le côté californien de la Sierra Nevada. Splendide! Bodie, construite toute en bois, porte le nom d'un mineur d'argent qui «disparut» un jour alors qu'il portait de l'argent à la ville et que l'on retrouva après la fonte des neiges de printemps. Puis un jour il n'y eut plus d'argent et tout le monde partit.»

Prise au petit matin, exactement comme c'était, montagnes et bois, tons bruns de rouille et de bois, découpage sur un merveilleux ciel clair, air frais, plendide Ouest!

83

Photographer	Bernard Plossu
Camera	Nikon
Lens	24mm Nikkor
Film	Kodachrome II

In Tombstone, Arizona, is the famous cemetery. Here I spent a long time talking with an old man, Oscar, who had probably seen a lot. His skin colour was just like the desert around; brown, and cracked up by the wind and the sand. He was standing in front of me like the live ghost of a West that had disappeared.'

In Tombstone, Arizona, gibt es einen berühmten Friedhof. Hier habe ich mich lange mit einem alten Mann namens Oscar unterhalten, der viel gesehen hatte. Seine Hautfarbe hatte den gleichen Ton wie die Wüste um ihn her: braun und brüchig geworden von Wind und Sand. Er stand vor mir, wie der leibhaftige Geist des Wilden Westens.

«Dans le célèbre cimetière de Tombstone, en Arizona. J'y suis resté à parler longuement avec un

vieil homme, Oscar, qui en avait certainement vu beaucoup. Sa peau était exactement de la couleur du désert qui l'entoure; brune, craquelée par le vent et le sable. Il se tenait devant moi tel le fantôme de l'Ouest disparu».

84/88

Photographer	Henning Christoph
Camera	Leica M4
Lenses	21mm Super Angulon, 35mm Summilux and 90mm Summicron
Film	Kodak Tri-X
Developer	Kodak D76
Paper	Agfa BN1

From the Ghost West of America to the Ghost West of Ireland in a poignant photo essay by the young German photographer Henning Christoph. In the last edition of PHOTOGRAPHY YEAR BOOK we featured a dramatic portfolio of pictures on the current violence in Northern Ireland but here, on Lettermore Island on the West Coast of the Republic, death has crept up more slowly, leaving only two surviving inhabitants. Born in the United States where he studied at Maryland University, Henning Christoph is now a freelance photojournalist in Germany and these beautifully composed and evocative pictures were taken for an illustrated book on Ireland which made a deep impression on him during several press visits.

Vom Geister-Westen Amerikas, zum gespenstischen Westen Irlands. Ein bestechendes Foto-Essay des jungen deutschen Fotografen Henning Christoph. In der letzten Ausgabe zeigten wir seine erschütternde Reportage über die Gewalttätigkeiten in Nordirland. Hier jedoch, auf Lettermore, einer Insel vor der Westküste der Irischen Republik, hat sich der Tod Zeit gelassen. Zwei Bewohner sind überleben. Christoph wurde in den Vereinigten Staaten geboren, studierte an der Maryland Universität und ist jetzt freischaffender Fotograf in Deutschland. Diese Aufnahmen schuf er für einen Fotobildband über Irland, das ihn während einiger Besuche tief beeindruckt hat.

De l'Ouest fantôme d'Amérique à l'Ouest fantôme d'Irlande dans un essai photographique poignant par le jeune photographe allemand, Henning Christoph. Dans la dernière édition de l'Annuaire Photographique nous avions présenté une série d'images dramatiques sur la violence qui règne actuellement en Irlande du Nord; mais ici, sur l'île de Lettermore sur la côte ouest de la République d'Irlande, la mort s'est introduite plus lentement, ne laissant que deux survivants. Né aux Etats-Unis où il étudia à l'Université de Maryland, Henning Christoph est aujourd'hui reporter photographe free lance en Allemagne et ces images évocatrices et d'une très belle composition ont été prises pour illustrer un livre sur l'Irlande qui avait fait une forte impression sur le photographe au cours de plusieurs reportages pour la presse.

89

Photographer	Jerry Cooper
Camera	Nikon
Film	Kodak Tri-X
Shutter speed	1/125
Aperture	f/11

Senator Hubert Humphrey on the campaign trail, by Orlando, Florida, photographer Jerry Cooper. A picture entirely dictated by the unusual camera position that makes one wonder just what the photographer called out to make the Presidential candidate look up so obligingly.

Senator Hubert Humphrey während einer Wahlkampagne in Orlando/Florida. Ein Bild, das durch die ungewöhnliche Kamerastellung seine Wirkung erhält. Was hat ihm wohl der Fotograf zugerufen, daß der Präsidentschaftskandidat so gewinnend nach oben lächelt?

Le Senateur Hubert Humphrey sur le sentier de la campagne électorale par le photographe Jerry Cooper de Orlando en Floride. Une image

entièrement déterminée par la position inhabituelle de l'appareil: on se demande ce que le photographe a bien pu crier pour que le candidat présidentiel lève la tête avec tant de bonne volonté.

90

Photographer	J. Clare
Camera	Nikkormat
Lens	500mm Mirror
Film	Agfapan 1000
Shutter Speed	1/250
Aperture	f/8
Developer	Acuspeed

Mr Enoch Powell, Conservative Member of Parliament for Wolverhampton, is probably the most talked and written about politician in Britain, even though it is some years since he held ministerial office. Here, the normally sober-suited Mr Powell is seen dressed for the hunting field.

Mr. Enoch Powell, konservatives Parlamentsmitglied für Wolverhampton, ist wahrscheinlich der Politiker mit der größten Publicity in England – obwohl es schon einige Jahre her ist, daß er im Ministerium saß. Hier zeigt sich der sonst förmlich-korrekt gekleidete Mr. Powell im Jagdanzug.

M. Enoch Powell, membre conservateur du Parlement pour Wolverhampton, est probablement l'homme politique en Grande-Bretagne dont on parle le plus, bien qu'il y ait pourtant déjà plusieurs années qu'il n'a eu la responsabilité d'un cabinet ministériel. M. Powell, normalement vêtu très sobrement, porte ici la tenue de chasse à courre.

91

Photographer	Stephen Shakeshaft

Show business personalities – as professional performers – always make good subjects for professional photographers. Liverpool photographer Stephen Shakeshaft took this one; a portrait of disc jockey Jimmy Saville, O.B.E. (Order of the British Empire), who was awarded the decoration for Social Services.

Leute aus dem Show-Business sind, als perfekte Schauspieler, immer dankbare Motive für Berufsfotografen. Der aus Liverpool stammende Fotograf Stephen Shaceshaft fertigte dieses Porträt: Discjockey Jimmy Saville, OBE (Order of the British Empire). Der Orden wurde ihm für soziale Verdienste verliehen.

Les personnalités du monde du spectacle, en tant qu'acteurs professionnels, sont toujours de bons sujet pour les photographes professionnels. Le photographe de Liverpool, Stephen Shakeshaft a pris ce portrait du présentateur de disques, Jimmy Saville, O.B.E. (Ordre de l'Empire britannique), qui reçut cette décoration pour services rendus à la société.

92

Photographer	Aliza Auerbach
Camera	Asahi Pentax
Lens	50mm
Film	Kodak Plus-X
Shutter speed	1/250
Aperture	f/11
Developer	Kodak D76

Aliza Auerbach is another talented woman photographer who is regularly called upon to provide stills coverage of feature film production, particularly in her native country Israel which is now a very popular location for film makers. On a recent assignment she made this powerful study of American actor Gregory Peck between takes for the film Billy Two Hats.

Auch Aliza Auerbach ist eine talentierte Fotografin, die immer wieder engagiert wird, wenn Standbilder von Spielfilmen gemacht werden sollen. Ihre Heimat, Israel, ist bei Filmemachern zur Zeit sehr beliebt. In einer Drehpause der Aufnahmen zum Film „Billy Two Hats" machte sie diese Porträtstudie von Gregory Peck.

Bradburys develop your creativity

Our processing service offers you—the professional—the advantages of high quality processing at competitive prices, with unequalled results from your creativity—either colour or black and white. Colour enlargements up to 30" x 40".

Write for details and price list.

Unser fachmännischer Entwicklungsdienst—Die Vorteile von hochwertiger Entwicklung zu konkurrenzfähigen Preisen, mit unvergleichlichen Resultaten Ihrer schöpferischen Kunst—entweder in Farbe oder Schwarz-Weiss. Farb-Vergrösserungen bis zu 76.2cm x 101.6cm (30" x 40").

Fordern Sie nähere Einzelheiten und Preisliste an.

Nuestro servicio de revelado le ofrece —a Vd., el profesional—las ventajas de un revelado de alta calidad a precios de competencia, con resultados inigualados para sus creaciones—sean en color o en blanco y negro. Ampliaciones en color hasta de 30" x 40".

Escriba para detalles y lista de precios.

BRADBURYS

Bradburys
(Photographic Processing) Ltd.,
Raymond Street, Shelton,
Stoke-on-Trent, ST1 4DS,
Staffs, England.
Tel: 0782 22316/7
Telex No: Brad Lab 36250

Established 25 years

liza Auerbach est une autre femme photographe de alent à laquelle il est régulièrement fait appel pour ournir les images fixes des productions inématographiques, particulièrement dans son pays natal, Israël, qui est devenu un centre très populaire pour les cinéastes. Lors d'un récent engagement, elle réalisa cette puissante étude de l'acteur américain Gregory Peck, entre les séances de tournage du film « Billy Two Hats ».

93

Photographer	Mike Hollist
Camera	Nikon
Lens	21mm
Film	Kodak Tri-X
Shutter speed	1/125
Aperture	f/8
Developer	Kodak D76
Paper	Ilford

When Big Cyril (six foot two inches tall and twenty-seven stone Cyril Smith) won a by-election at Rochdale, Lancashire, British Press photographers were delighted. Mike Hollist of the *Manchester Daily Mail* took one of the best pictures of the new Liberal Member of Parliament as Big Cyril laughed in triumph at Big Ben upon arrival at Westminster to make his maiden speech.

Als „Big Cyril" (Cyril Smith ist 6 ft 2 inches groß und hat 27 stone Gewicht) die Nachwahl in Rochdale, Lancashire gewann, strahlten die englischen Presse-Fotografen. Mike Hollist von der *Manchester Daily Mail* schoß eines der besten Bilder des frischgebackenen, liberalen Parlamentsmitgliedes. Hier lacht und triumphierend bei seiner Ankunft in Westminster, wo er seine Antrittsrede halten soll. Im Hintergrund Big Ben.

Lorsque Big Cyril (Cyril Smith qui mesure 1,88 m pour 170 kgs) gagna une élection de remplacement à Rochdale, Lancashire, les reporters photographes de Grande-Bretagne furent ravis. Mike Hollist du Manchester Daily Mail prit l'une des meilleures photographies du nouveau membre du Parlement libéral en train de saluer Big Ben d'une joyeuse exclamation de triomphe à son arrivée à Westminster où il allait prononcer son discours de début.

94

Photographer	Margaret Murray
Camera	Asahi Pentax Spotmatic
Lens	85mm
Film	Kodak Tri-X
Shutter speed	1/60
Aperture	f/5.6
Developer	Kodak D76
Paper	Kodak Bromide

Sir Christopher Soames, the son-in-law of Sir Winston Churchill, formerly British Ambassador in Paris and now Commissioner for Europe. A splendidly composed portrait by one of Britain's best women photographers.

Sir Christofer Soames, Schwiegersohn von Sir Winston Churchill, ehemaliger englischer Botschafter in Paris, jetzt Europa-Beauftragter. Ein großartig gelungenes Porträt, gestaltet von einer der besten englischen Fotografinnen.

Sir Christopher Soames, gendre de Sir Winston Churchill, ancien Ambassadeur de Grande-Bretagne à Paris et Commissaire de l'Europe. Un portrait merveilleusement composé par l'une des plus célèbres femmes photographes du Royaume-Uni.

95

Photographer	Giorgio Lotti
Camera	Leica M4
Lens	90mm
Shutter speed	1/30
Aperture	f/4

One of Italy's most distinguished photographers – Giorgio Lotti of *Epoca* Magazine – took this fine portrait of Chou-En-Lai. The Chinese premier's expression is characteristically enigmatic. Kodak film printed on Agfa paper.

Ein bekannter italienischer Fotograf: Giorgio Lotti, von Epoca, schuf dies Porträt von Tschu en Lai. Die Gesichtszüge des chinesischen Premiers sind wie immer rätselhaft. Kodakfilm auf Agfapapier.

Ce très beau portrait de Chou-En-Laï a été pris par l'un des meilleurs photographes italiens, Giorgio Lotti du magazine Epoca. L'expression énigmatique du Premier Ministre chinois est caractéristique.

96

Photographer	Brian Moody
Camera	Nikon
Lens	200mm
Film	Kodak Tri-X
Shutter speed	1/125
Aperture	f/4
Developer	Kodak D76

Former Beatle Ringo Starr in uncharacteristic guise during shooting of the film *That'll be the day*. Photographer Moody works through Rex Features, the well-known London picture agency.

Ex-Beatle Ringo Starr in ungewöhnlicher Aufmachung während der Dreharbeiten zu „That will be the Day". Der Fotograf Moody wird durch *Rex Features*, die bekannte Londoner Bildagentur, vertreten.

L'ancien Beatle, Ringo Star, dans un accoûtrement inhabituel lors du tournage du film « That'll be the day ». Le photographe Moody travaille pour Rex Features, la grande agence cinématographique londonienne.

97/104

Photographer Michael Evans

Michael Evans of *The New York Times* is a master of of the picture story which develops through a whole series of related photographs. He included the following notes with his submissions, the first of which concerns women on water. 'The Women's Rowing Eight Intercollegiate Championship was held at Rogers Lake, Connecticut. Princeton University's eight, coached by a man, took the top honour. I was impressed by the obvious femininity of the contestants for such a muscular sport.'

Michael Evans von der *New York Times* formt seine Bildergeschichten aus einer großen Anzahl verwandter Fotos. Seine erste Serie zeigt Frauen auf dem Wasser. „Die Studentenmeisterschaft im Frauen-Achter wurde auf dem Rogers-Lake/Connecticut ausgetragen. Der Achter der Princeton Universität, trainiert von einem Mann, trug den Sieg davon. Ich war beeindruckt vom weiblichen Charme der Ruderinnen, die diesen kräftezehrenden Sport ausüben."

Michael Evans du New York Times est un maître de l'histoire en images qui se développe tout au long d'une série de photos sur un même thème. Il joint la note suivante aux clichés qu'il nous soumet, le premier montrant des femmes sur l'eau. « Régates dames inter-collèges à Rogers Lake, dans le Connecticut. L'équipe de huit de l'Université de Princeton, entraînée par un homme, arriva en première place. Je fus frappé par l'évidente féminité des participantes, dans un sport aussi musculaire ».

105

Photographer Michael Evans

This beautifully composed impression of the not so silent American minority was shot at the Pocono Rock Festival, held at the Pocono International Speedway in (surprisingly enough) the Pocono Mountains in Pennsylvania. Approximately 250,000 made it to the concert, which lasted about 21 hours. Another 300,000 or more, it was estimated, got caught in the enormous traffic jam around the area and never got to see the concert.

Dieses Dokument, über die nicht sehr schweigsame amerikanische Minderheit, entstand auf dem Pocono Rock Festival, das am Pocono International Speed Way in den (wen wunderts?) Pocono Bergen/Pennsylvania stattfand. Etwa 250.000 Menschen

nahmen an diesem Konzert, das fast 21 Stunden dauerte, teil. Weitere 300.000 oder mehr, blieben im Verkehrsgewühl rundherum stecken und bekamen nichts zu sehen und zu hören.

Cette vue très bien composée de la minorité américaine pas tellement silencieuse a été prise au festival de Rock de Pacono organisé au Pacono International Speedway dans les montagnes de Pacono en Pennsylvanie. Environ 250.000 personnes vinrent à ce concert qui dura 21 heures. Plus de 300.000 autres personnes se trouvèrent bloquées dans un énorme embouteillage sur les routes alentour et ne purent parvenir jusqu'au concert.

106/109

Photographer Michael Evans

President Nixon paid a visit to the New York City area just prior to his impressive re-election. In a very slick, very plastic rally at the Nassau Coliseum, a brand new sports arena in suburban Nassau County, Nixon brought the word to the Republican faithful. The pictures were all taken from one position on a camera stand about 50 feet from the podium.

Kurz vor seiner überwältigenden Wiederwahl besuchte Präsident Nixon die New Yorker Gegend. Diese Bilder stammen von einer glatt und routinemäßig, aber beeindruckend ablaufenden Veranstaltung im Nassau Coliseum, einem nagelneuen Stadion. Der Standort des Fotografen war etwa 50 Fuß vom Podium entfernt.

Le Président Nixon visite la circonscription de New York City juste avant sa spectaculaire réélection. Lors d'un rallye très malléable et en bon ordre au Colisée de Nassau, le nouveau stade dans la banlieue de Nassau, Nixon s'adresse aux fidèles républicains. Les photos ont toutes été prises du même point, le pied de l'appareil étant placé à environ 15 mètres du podium.

110/112

Photographer	Leo Dickinson
Camera	Canon F1
Film	Kodachrome II

Cerro Torre (which means church steeple in Spanish) is known to informed climbing enthusiasts as the most difficult mountaineering project on earth. Although only 10,280 feet high and situated in Patagonia, it has never been climbed by conventional methods – although an Italian is said to have reached the summit by ignoring the natural fissures and hauling himself to the top by means of expansion bolts set in holes in the rock face made by a portable pneumatic drill. The man who took these pictures, young British mountaineer photographer Leo Dickinson (who made the first filmed ascent of the notorious north wall of the Eiger), preferred a more orthodox approach in his expedition's attempt on the mountain. Although he failed to reach the summit he brought back a magnificent set of still photographs, many of which were seen at the last Photokina, and a film which was subsequently transmitted by BBC TV. His was the eleventh expedition to Cerro Torre, a previous British attempt having failed to climb the peak in 1968.

Cerro Torre (spanisch: Kirchturm) in Patagonien ist dem informierten Bergsteiger als schwierigstes Bergsteigeprojekt der Welt bekannt. Obwohl er nur 10.280 Fuß hoch ist, wurde er niemals mit herkömmlichen Bergsteigemethoden bezwungen. Man sagt einem Italiener nach, er habe den Gipfel erreicht, indem er die natürlichen Spalten nicht beachtet, und sich an Ausdehnungsbolzen, die er in die, mit seiner umgehängten Pressluftbohrmaschine gefertigten, Felslöcher setzte, hochgearbeitet habe. Leo Dickinson, der junge Bergsteiger-Fotograf aus England (er filmte als erster die Besteigung der berüchtigten Eiger-Nordwand), zog bei seiner Expedition eine orthodoxere Methode vor. Er erreichte nicht den Gipfel, brachte jedoch herrliche Aufnahmen mit nach Hause (einige von ihnen waren auf der letzten Photokina zu sehen), und darüber hinaus einen Film, der kurz darauf über BBC gesendet wurde. Seine Cerro Torre-Expedition war

Take advantage of these Leitz incentives

**LEICA
LEICAFLEX
LEICINA
PRADOVIT**

to greater photographic skill and imagination

Leitz cameras and projectors are a happy union of high precision and high performance. They are the peak of the world's highest quality optical instruments. And no wonder, for they offer something unique. Just think of the world-renowned LEICA, dominant in its field since the mid-twenties. Or the LEICAFLEX, choice of world-famous professionals. Both offer accurate, selective TTL metering favoured by the experts. Then again, there is that 'king' of all projection lenses, the COLORPLAN 90mm. And in Super-8 cine the LEICINA SPECIAL & R.T.I. cameras. If you are already a top photographer, you know that Leitz equipment will meet your every demand. If you are not, but aspire to be so, it will be your spur to better things.

Further information from your Leitz Accredited Dealer or send the coupon direct to us.

der elfte Besteigungsversuch; 1968 war eine britische Gipfelbezwingung gescheitert.

Cerro Torre (qui, en espagnol, signifie clocher) est connu des fanatiques de l'alpinisme comme le projet d'alpinisme le plus difficile au monde. Bien que ne mesurant que 3.200 mètres de haut et situé en Patagonie, il n'a jamais été escaladé selon les méthodes classiques – bien qu'on parle d'un italien qui aurait atteint le sommet en évitant les fissures naturelles et en se hissant jusqu'au sommet au moyen de boulons de scellement fixés dans des trous creusés dans le roc avec une perceuse pneumatique portative. L'homme qui a pris ces images, Leo Dickinson, un jeune photographe alpiniste (qui fut le premier à filmer l'ascension de la célèbre paroi nord du mont Eiger) préféra adopter une méthode plus orthodoxe pour tenter d'atteindre le sommet. Malgré qu'il n'y ait pas réussi, il en rapporta une magnifique série de fixes, dont un grand nombre ont été exposées à la dernière Photokina, et un film fut par la suite présenté par la BBC à la télévision. Il était le onzième à tenter l'escalade, une expédition britannique avait avant lui échoué également en 1968.

113

Photographer	R. A. Damer
Camera	Microcord II
Film	Ilford FP3
Developer	Kodak D76

Mirror printing – a combined straight and reversed print from the same negative butting up at an appropriate join – is a photographic device that can sometimes be employed to interesting effect, such as in this imaginative composition by award-winning British photographer Ronald Damer, A.R.P.S. The location was Mont Blanc but we prefer Damer's description: 'Old Man Mountain'.

Spiegeleffekt-Aufnahme, bei der eine Negativ-Hälfte seitenrichtig, die andere seitenverkehrt kopiert wurde. Dabei kommt es darauf an, daß die Nahtstelle unsichtbar bleibt. Solche Spiegelbild-Kopien können manchmal zu phantastischen Effekten führen, wie es hier der mit einem Preis ausgezeichnete englische Fotograf Ronald Damer zeigt. Ort der Aufnahme: Der Mont Blanc – oder ziehen wir Damers Ortsangabe vor: „Old Man Mountain''.

Impression de miroir, l'épreuve à l'endroit et l'épreuve à l'envers d'un même négatif accolées l'une à l'autre en un endroit approprié, c'est là un «truc» photographique qui peut parfois donner des résultats intéressants, telle cette composition originale par le photographe britannique gagnant de concours Ronald Damer, A.R.P.S. Il s'agit du Mont Blanc, mais nous préférons la description de Damer: «Le vieil homme montagne».

114/115

Photographer	Wolfgang Volz
Camera	Nikon F
Lenses	24 and 200mm Nikkor
Aperture	f/16
Shutter speed	1/125
Film	Kodak Tri-X
Developer	Kodak D76
Paper	Agfa Brovia

German photographer Wolfgang Volz graduated to photography through architecture, so it is not surprising that, after winning a magazine contest that took him to the United States, he should have been interested in this very bizarre 'architectural exercise' which shows the latest work of the artist Christo who expresses himself by wrapping things. After starting small with objects like automobiles, Christo went on to wrapping mountains and finally a whole valley. The location for the 'Valley Curtain Project' was Rifle, Colorado.

Der deutsche Fotograf Wolfgang Volz gelangte über die Architektur zur Fotografie. Es überrascht daher nicht, daß Volz, nachdem er Gewinner eines Magazin-Fotowettbewerbs wurde und als solcher in die USA reisen konnte, sich für ein recht bizarres Architekturunternehmen zur Verfügung stellte:

nämlich die letzte Arbeit des Künstlers Christo, der seine Selbstverwirklichung darin fand, alles einzupacken. Er begann mit kleineren Objekten, z. B. Autos, und versuchte schließlich Berge und ganze Täler einzuwickeln. Schauplatz des Manövers: Rifle, Colorado.

Ce photographe allemand est venu à la photographie par l'intermédiaire de l'architecture, il n'est donc pas surprenant qu'il ait été attiré par cet exercice «architectural» tout à fait étrange, alors qu'il se trouvait à New York en tant que gagnant d'un concours de photographie organisé par une revue. Dans une série de belles diapositives en couleur, Volz présente les dernières oeuvres de l'artiste américain Christo qui s'exprime en emballant des choses. Après avoir débuté avec de petits objets, commes des automobiles, Christo en est venu à emballer des montagnes et finalement une vallée tout entière. Le lieu choisi pour ce «Projet Rideau Vallée» est Rifle au Colorado.

116

Photographer	Lev Ustinov

A Soviet photographer took this spectacular telephoto line up of earth movers during construction of the Kopetdag water storage reservoir, one of the largest hydraulic structures of Kara Kum Canal in Turkmenia. It will, we are told, permit irrigation of 72,000 hectares of desert land.

Ein sowjetischer Fotograf machte diese Telebild von aufgereihten Baggern beim Bau der Kopetdag-Talsperre, einem der größten Bewässerungsprojekte des Kara-Kum-Kanals in Turkmenien. Es soll 72.000 ha Wüstenland fruchtbar machen.

Par un photographe soviétique, cette image frappante prise au télé-objectif montrant une rangée de bulldozers pendant la construction du réservoir d'eau de Kopedag, l'une des structures hydrauliques les plus importantes sur le canal Kara Kum au Turkestan. On nous dit que ce réservoir permettra d'irriguer 12.000 hectares de terres désertes.

117/119

Photographer	Tomas Sennett
Film	Kodachrome II

An assignment to photograph life aboard the American icebreaker *Manhattan*, provided National Geographic Society cameraman Tomas Sennett with a fine opportunity to capture impressions of one of man's most impressive victories over the relentless forces of nature. Sennett's work has appeared in many newspapers and magazines, but no technical details were available about these examples of it.

Ein Auftrag an Bord des amerikanischen Eisbrechers Manhattan einen Bildbericht zu machen, gab T. Sannet die Möglichkeit zu diesen Aufnahmen. Sie zeigen den Sieg des Menschen über die unbarmherzigen Naturgewalten. Sannets Arbeiten sind in zahlreichen Zeitungen und Magazinen veröffentlicht worden. Zu diesen Beispielen wurden leider keine Angaben gemacht.

Chargé de faire un reportage sur la vie à bord du brise-glace américain «Manhattan», le photographe Tomas Sennett eut là l'occasion de saisir des vues de l'une des plus remarquables victoires de l'homme sur les forces implacables de la nature. Les oeuvres de Sennett ont paru dans nombre de journaux et magazines, mais nous n'avons aucune donnée techniques sur celles-ci.

120

Photographer	Ron Laytner
Camera	Nikon F
Lens	35mm Nikkor
Film	Kodak Tri-X

Ron Laytner is a Canadian free-lance photojournalist – currently based in Belgium – with an uncanny talent for finding and photographing scoop news pictures of world-wide interest. To do so, he is not only prepared to put himself at considerable personal risk but also to undertake the

meticulous background research that major news stories demand if they are to achieve international syndication. When you add to this a masterly grasp of camera technique, you have a sure recipe for the degree of success that has made Laytner a unique figure in his chosen field. On the next few pages we present examples of the work on which his reputation is based, beginning with a picture of the man largely responsible for bringing America into the Second World War.

The old master Spy holds a history book about the attack on Pearl Harbour open at a page showing a photograph of his great hero, Admiral Tsoroku Yamamoto, the Commander of the Combined Fleet of the Japanese Imperial Fleet of the Second World War. Admiral Yamamoto is named by historians as the genius who planned the Pearl Harbour attack in the Hawaiian Islands on 6 December 1941. About thirty Japanese military men died in the battle while the Americans lost over 3,000. Behind Takeo Yoshikawa, the spy who provided the crucial information from inside the American naval base to Admiral Yamamoto, stands his loyal wife, Etsuko, who supports the ex-spy in his old age by selling insurance. Because he is shunned in Japan as a former spy in a war that Japan lost, Yoshikawa cannot get a job.

Ron Laytner, freischaffender, kanadischer Bildjournalist, zur Zeit in Belgien, besitzt ein unübertreffliches Gespür für Bilder und Reportagen, die dann große Berühmtheit erlangen. Dafür geht er oftmals nicht zu verachtende, persönliche Risiken ein. Er unternimmt die wissenschaftlich genauen Untersuchungen über die sozialen, politischen usw. Hintergründe seiner Objekte, die verlangt werden, wenn eine Reportage weltweit bekannt und bedeutend werden soll. Fügt man diesen Voraussetzungen eine meisterhafte Beherrschung der Kameratechnik hinzu, so ist das Geheimnis seines Erfolges gelöst. Auf den nächsten Seiten sind Auszüge aus seinen Arbeiten zu sehen.

Als erstes ein Porträt des Mannes, der am Eingreifen der USA in den 2. Weltkrieg nicht unschuldig war. Der gealterte Meisterspion Takeo Yoshikawa hält ein Buch über Pearl Harbour in der Hand. Die aufgeschlagene Seite zeigt ein Bild seines Idols: Admiral Tsoroku Yamamoto, dem Kommandeur, der vereinten kaiserlich-japanischen Flotte im 2. Weltkrieg. Der Admiral gilt unter Historikern als das Genie, das die Schlacht bei Pearl Harbour am 6. Dezember 1941 plante. In diesem Gefecht starben etwa 30 Japaner, während die Amerikaner über 3.000 Mann verloren. Hinter dem Spion, der die tödlichen Informationen vom amerikanischen Marine-Hauptquartier zum japanischen Admiral brachte, steht seine Frau Etsuko, die den alten Mann unterhält. Sie verkauft Versicherugen. Als Spion in einem Krieg, den Japan verlor, wird er hier gemieden und kann keine Arbeit bekommen.

Ron Laytner est un reporter photographe free lance, originaire du Canada et résidant actuellement en Belgique. Il possède un don mystérieux pour trouver et photographier le premier des photographies de presse d'un interêt mondial. Pour ce faire, il est non seulement prêt à courir lui-même d'énormes risques, mais aussi à entreprendre les recherches d'informations méticuleuses qu'exige toute histoire destinée à la presse si l'on veut qu'elle connaisse un retentissement mondial. Lorsque vous ajoutez à cela une maîtrise parfaite de la technique photographique, vous avez une recette sûre pour atteindre le degré de succès qui fait de Laytner un cas unique dans le domaine qu'il a choisi. Dans les pages suivantes nous présentons quelques exemples de son travail sur lesquels sa réputation est fondée, en commençant par la photographie de l'homme qui fut pour une grande part responsable de l'entrée de l'Amérique dans la seconde guerre mondiale.

Le vieil espion tient un livre d'histoire sur l'attaque de Pearl Harbour ouvert à la page où apparaît une photo de son grand héros, l'Amiral Tsoroku Yamamoto, le commandant de la Flotte de la brillante Flotte impériale japonaise de la seconde guerre mondiale. L'Amiral Yamamoto est désigné par les historiens comme étant le génie qui combina

l'attaque de Pearl Harbour dans les îles d'Hawaï le 6 décembre 1941. Une trentaine de militaires japonais périrent dans la bataille, pour plus de 3.000 hommes du côté américain. Derrière Takeo Yashikama, l'espion qui fournit les renseignements décisifs sur la base navale américaine à l'Amiral Yamamoto, se tient sa loyale épouse, Etsuko, qui place des assurances pour faire vivre l'ex-espion dans son vieil âge. Mis à l'écart en tant qu'ancien espion dans une guerre que le Japon perdit, Yoshikawa ne peut trouver de travail.

121

Photographer	Ron Laytner
Camera	Hasselblad 500 C
Lens	250mm
Film	Kodak Tri-X

Figure-skating lessons for Prince Mikaso — the Emperor of Japan's brother — were photographed by Laytner at a Tokyo ice rink. In fact, the story he was working on concerned the skating teacher — a former champion — and not the Prince.

Eislauf-Lektion für Prinz Mikaso, den Bruder des Kaisers von Japan, in einem Eisstadion in Tokyo. Eigentlich arbeitete Laytner an einer Reportage über die Trainerin; sie war eine erfolgreiche Eiskunstläuferin.

Leçon de patinage artistique pour le Prince Mikaso, frère de l'Empereur du Japon, prise par Laytner a une patinoire de Tokyo.

122

Photographer	Ron Laytner
Camera	Nikon F
Lens	28mm Nikkor
Film	Kodak High Speed Ektachrome

Portrait of a Klansman. 'They came for me at three in the morning,' writes Laytner. 'In a deserted parking lot behind my hotel in downtown Houston I was blind-folded and placed in the back seat of an old but high-powered car.

'Our driver reported over a twoway radio. "Car Five and pickup heading to meeting." Through the early morning sky came radio acknowledgements from two other vehicles on the same frequency. I was given my instructions. I was not to talk to anyone whose photograph I was about to take. I was to obey any order given me and, above all, I was not to make anyone nervous. After some minutes the car ground to a stop. A powerful flashlight was turned on me and a City of Houston police officer removed my blind-fold. Silently, he searched me in case I was concealing an FBI tape recorder.

'He was the most frightening policeman I had ever seen in the United States. For across his face and over his head he wore the dreaded mask and hood of the Ku Klux Klan, America's secret terror organization which has been lynching, burning and murdering US blacks since the American Civil War.

'This pre-dawn meeting with the masked policemen was the high-light for me of two weeks of night-riding with the Texas Ku Klux Klan. And it was the modern day Klan's way of showing me how powerful the secret terrorist organization has become. . . . And it proved conclusively what black people have been crying out for years — that the Ku Klux Klan has klansmen who are members of police departments in the Southern United States.

'I had been secretly approached by the Houston Klan and made a tempting offer. The Klan, I was told, had a message for the world. To get this message across they would be willing for the first time to make some major concessions in their century old policy of ultra secrecy. I would be allowed to interview, photograph, name and give the addresses of members of the Klan and their families in Texas. I would be allowed to photograph night riders and even members of Texas police departments who belonged to the Ku Klux Klan.

'The message from the Ku Klux Klan turned out to be both an admission of defeat and the announcement of an entirely new battle and purpose for the organization. I was told that it had been "decided" by the new and younger leaders of today's Ku Klux Klan that Black people in America "are here to stay". That the Klan had given up for now it's long battle against integration and acceptance of blacks into American society.

'The Klan was now battling a new and far more dangerous enemy — American-Communism. The burning issue to the modern Klansman of today is the grave threat to America of a "World Communist Conspiracy".'

„Portrait of a Klansman" (Mitglied des Ku-Klux-Klan). „Sie holten mich um 3 Uhr morgens auf einem einsamen Parkplatz hinter meinem Hotel in Houston ab. Ich bekam eine Binde über die Augen und wurde auf den Rücksitz eines alten, aber schnellen Autos gesetzt. Der Fahrer meldete über Sprechfunk: „Wagen 5 steuert Treffpunkt an. Objekt auf dem Rücksitz." Der Funkspruch wurde von zwei anderen Fahrzeugen auf derselben Frequenz bestätigt. Ich erhielt genaue Anweisungen, zu niemandem zu sprechen, den ich fotografieren wollte, allen Befehlen hatte ich zu folgen, ich sollte niemanden reizen oder nervös machen. Als der Wagen hielt, wurde ein starker Lichtkegel auf mich gerichtet. Ein Houstoner Polizist entfernte meine Augenbinde. Schweigend durchsuchte er mich: für den Fall, „ich hätte ein FBI-Aufnahmegerät versteckt. Er war der furchterregendste Polizist, den ich jemals in den Staaten gesehen habe. Er trug Maske und Kopfbedeckung des Ku-Klux-Klan, der geheimen Terroristen-Organisation, die seit dem Amerikanischen Bürgerkrieg die Schwarzen verfolgt, gelyncht, verbrannt und ermordet hat. Dieses morgendliche Treffen war der Höhepunkt meiner 2-wöchentlichen Nachtausflüge mit dem Ku-Klux-Klan. Auf sehr fortschrittliche Art offenbarte mir der Klan seine Größe und Macht. Ich erhielt die überzeugende Bestätigung dessen, was die Schwarzen seit Jahren ohne Erfolg behaupten: daß Polizisten der Südstaaten gleichzeitig Mitglieder des Ku-Klux-Klan sind.

Der Klan von Houston hatte heimlich mit mir Kontakt aufgenommen und mir folgendes, verlockende Angebot gemacht: der Klan habe eine Botschaft für die Welt. Um diese zu verbreiten sei er erstmals bereit, einige der jahrhundertealten Geheimhaltungsgesetze zu brechen. Ich dürfe Interviews und Fotos anfertigen, Namen und Adressen von Mitgliedern und deren Familien würden mir mitgeteilt. Ich sollte auf nächtlichen Ritten fotografieren dürfen – sogar Mitgleider der texanischen Polizei, die zum Klan gehören.

Die Botschaft des Klan erwies sich einerseits als Eingeständnis der Niederlage, andererseits als Aufruf zu neuem Kampf. Mir wurde mitgeteilt, die neuen, jungen Führer des Klans hätten beschlossen, daß die Schwarzen in Amerika „bleiben dürften". Der Klan habe seinen langen Kampf gegen die Integration beendet und erlaube den Schwarzen die Aufnahme in die Gesellschaft. Der Klan habe nun einen neuen, weit gefährlicheren Feind zu bekämpfen: Den Kommunismus in Amerika. Jeder moderne Klansmann habe der drohenden Gefahr einer weltweiten Kommunisten-Verschwörung den leidenschaftlichen Kampf angekündigt."

Portrait d'un membre de Klan. Ils sont venus me chercher à trois heures du matin. Dans le parking désert derrière mon hôtel en plein centre de Houston, ils me mirent un bandeau sur les yeux et me firent monter à l'arrière d'une vieille mais puissante voiture.

Notre chauffeur annonçait dans sa radio émettrice «Voiture cinq en route vers lieu de rendez-vous.» La réponse de deux autres véhicules sur la même fréquence nous parvint à travers le ciel du petit matin. On me donna des instructions. Je ne devais parler à aucune des personnes dont j'allais prendre des photos. Je devais obéir à tout ordre qui m'était donné et surtout je ne devais donner d'inquiétude à personne. Au bout de quelques minutes, la voiture s'arrêta. Un phare puissant fut tourné vers moi et un policier de la ville de Houston me retira mon bandeau. Il me fouilla en silence, au cas où j'aurais caché sur moi un magnétophone du FBI.

C'était le policier le plus effrayant que j'aie jamais vu aux Etats-Unis. Car sur son visage et autour de la tête il portait l'horrible masque et capuchon du Ku Klux Klan, l'organisation secrète terroriste qui, depuis la guerre civile américaine, lynche, brûle et massacre des noirs américains.

Cette rencontre avant l'aube avec ces policiers masqués était l'événement dominant de deux semaines de randonnées nocturnes avec le Ku Klux Klan texan. C'était là la façon moderne du Klan de me montrer combien l'organisation secrète terroriste était devenue puissante . . . Et il fut donnée la preuve conclusive de ce que les noirs prétendent depuis des années, à savoir que le Ku Klux Klan et des membres dans les rangs de la police des Etats du Sud.

«Le «Klan» de Houston m'avait contacté en secret et fait une offre tentante. Le « Klan », m'avait-on-dit, avait un message pour le monde. Pour communiquer ce message, il était prêt à faire pour la première fois des concessions importantes sur la politique de grand secret adoptée depuis un siècle. J'aurais le droit de faire des interview, de photographier et de nommer et donner les adresses des membres du «Klan» et de leur famille au Texas. J'aurais le droit de photographier des cavaliers nocturnes et même des membres des services de police du Texas appartenant au Ku Klux Klan.

Le message du Ku Klux Klan se révéla être à la fois une admission de défaite et l'annonce d'une lutte et d'un objectif entièrement nouveaux pour l'organisation.

J'appris que les nouveaux chefs, plus jeunes, avaient «décidé» que les noirs d'Amérique «devaient rester». Que le Klan avait abandonné pour l'instant sa longue bataille contre l'intégration des noirs dans la société américaine.

Le Klan menait maintenant la lutte contre un ennemi nouveau, beaucoup plus dangereux pour l'Amérique: le communisme. Le problème essentiel pour le Ku Klux Klan moderne est la grave menace pour l'Amérique d'une «conspiration communiste mondiale».

123

Photographer	Ron Laytner
Camera	Nikon F
Lens	640mm Novoflex
Film	Kodak High Speed Ektachrome
Shutter speed	1/15
Aperture	f/5.6

A night rider of the Ku Klux Klan photographed at full gallop in the first light of dawn.

Ein Nachtreiter des Klans in vollem Galopp, fotografiert beim ersten Morgenlicht.

Un cavalier nocturne du Ku Klux Klan photographié en plein galop aux premières lueurs de l'aube.

124

Photographer	Ron Laytner
Camera	Nikon with Motor Drive
Lens	28mm
Film	Kodak Tri-X rated at 800 ASA

'In a show of Ku Klux Klan strength in Texas, the Klan agreed to let one of its members who is on the force of the Houston Police Department be photographed in his city police car and while still in uniform. To protect his identity the policeman wears a Ku Klux Klan hood and mask. His badge number is covered up with masking tape.'

Als Machtbeweis des Klans in Texas durfte Laytner einen Klansmann, gleichzeitig ein Angehöriger der Polizei von Houston, in Uniform und im Polizeiwagen fotografieren. Um ihn unkenntlich zu machen, trägt er Maske und Hut des Ku-Klux-Klan. Seine Ausweisnadel ist mit Klebestreifen abgedeckt.

Dans un étalage de force par le Ku Klux Klan, le klan du Texas décide de laisser photographier un de ses membres appartenant aux forces de la police de Houston dans sa voiture de police et en uniforme. Pour cacher son identité, le policier membre du klan porte la capuche et le masque du Ku Klux Klan. Sa plaque numérique est recouverte de ruban adhésif opaque.

125

Photographer	Ron Laytner
Camera	Nikon F
Film	Kodak Tri-X

A Laytner portrait of a 'former Grand Dragon' of the Texas branch of the United Klans of America. A onetime Houston gun shop owner, convinced of a Communist conspiracy within the United States, the subject has also been a candidate for Sheriff.

Porträt eines ehemaligen „Grand Dragon", dem Führer des texanischen Klan innerhalb der *United Klans of Amerika*. Er besaß früher ein Waffengeschäft, glaubt an eine Kommunistenverschwörung in den Staaten und war Kandidat für den Posten des Sherifs.

Un portrait par Laytner de l'ancien Grand Dragon de la branche texane des United Klans of America. Il fut par le passé propriétaire d'une armurerie à Houston, il fut aussi accusé d'une conspiration communiste à l'intérieur des Etats-Unis, et fut candidat au poste de sheriff.

126

Photographer	Ron Laytner
Camera	Nikon F
Film	Kodak Tri-X

'An American black man realises he has walked into a local headquarters of the Klan in Livingstone, Texas, when he sees the fiery cross picture of the Imperial Grand Wizard of the United Klans of America hanging from the wall near the entrance to the men's room of the gas station. He waits nervously and exchanges glances with the owner of the station who is wearing an ammunition belt around his waist and a confederate flag on his shoulder.'

Dieser amerikanische Schwarze hat soeben erkannt, daß er in das Hauptquartier des Ku-Klux-Klan in Livingstone (Texas) geraten ist. In dieser Tankstelle hängt neben der Tür zur Herrentoilette ein Bild des „Großen Führers" des Ku-Klux-Klan, mit einem brennenden Kreuz im Hintergrund. Der Schwarze wartet nervös und mustert unruhig den besitzer der Tankstelle, der einen Munitionsgürtel trägt und am Hemdärmel die Flagge der Südstaaten aufgenäht hat.

Un noir américain se rend compte qu'il vient de pénétrer dans les locaux du siège local du Klan à Livingstone au Texas en apercevant le portrait à la croix de feu du «grand sorcier impérial» des United Klans of America accroché au mur près de la porte menant aux lavabos de la station à essence. Il attend nerveusement en échangeant des regards avec le propriétaire de la station qui porte une cartouchière autour des reins et l'écusson aux couleurs de la confédération sur l'épaule.

127/128

Photographer	Ron Laytner
Camera	Nikon with Motor Drive
Lens	35mm
Film	Kodak Tri-X

In Calcutta during a cholera epidemic Laytner took a picture of a group of beggars sitting on the steps of a temple. He looked away and took a few other shots of other scenes. Then – when he looked back at the steps – he was startled to see that the little beggar boy who had been alive just a few minutes before, had fallen over dead. He took the second photo, then felt the boy's chest but found no heartbeat. The other beggars on the steps were obviously not related to the little boy and greeted his death with no emotion of any kind, except perhaps an inner thankfulness that they had lost some competition. A group of angry Indians began to form thinking that the photographer had something to do with the death of the child and he quickly left.

Diese Bettler auf den Tempelstufen fotografierte Ron Laytner während einer Cholera-Epedemie in Kalkutta. Er wandte sich ab, um weitere Aufnahmen zu machen, und als er wieder zu den Tempelstufen sah, war der Bettlerjunge, der vorher noch gesessen hatte, tot umgefallen. Laytner machte ein Foto, horchte dann nach dem Herzschlag des Jungen, fand jedoch keinen mehr. Die anderen Bettler zeigten keinerlei Rührung über den Tod des Jungen, es sei denn innere Erleichterung, daß ein weiterer Konkurrent weggefallen war. Eine Gruppe wütend blickender Inder schien schien Laytner den Tod des Jungen mit seinen Fotografien in Zusammenhang zu bringen, so machte er sich schnell davon.

Laytner a pris cette photographie d'un groupe de mendiants assis sur les marches d'un temple à Calcutta pendant une épidémie de choléra. Il tourna pendant quelques secondes dans une autre direction et prit plusieurs clichés d'autres scènes. Puis, lorsque son regard revint se poser sur les marches du temple, il découvrit avec stupeur que le petit mendiant qui était encore vivant quelques minutes auparavant venait de tomber, mort. Il prit la seconde photo, puis mit la main sur la poitrine du jeune garçon, mais le coeur avait cessé de battre. Les autres mendiants sur les marches étaient évidemment sans liens de parenté avec le petit garçon et ils accueillirent sa mort sans aucun signe d'émotion, sauf peut-être un sentiment de soulagement intérieur puisqu'il venait de perdre un concurrent. Un groupe d'Indiens en colère commença à se former; ils pensaient que le photographe était pour quelque chose dans la mort de l'enfant, aussi s'éloigna-t-il rapidement.

129

Photographer	David James
Camera	Nikon F
Lens	85mm Nikkor
Film	Kodachrome II
Shutter speed	1/125
Aperture	f/5.6

The filming of the rock opera *Jesus Christ Superstar*,

The interchangeable twin

The Mamiya C330 is the only twin-lens reflex available with interchangeable lenses.

Like all twin-lens reflex cameras it gives you continuous viewing and quiet action (no **kerchunk!** from the mirror).

But it gives you so much more too.

At weddings, race tracks, sports grounds, in the studio, the C330 gives you the chance to shoot the kind of creative photography you want to shoot. Choose from 8 different Mamiya Sekor lenses. Change the lens as quickly as you change your mind. Better and better, the built-in extension bellows make close-up photography without accessories no problem at all. Look – you can focus down to 14 ins with the standard 80 mm lens!

There are 6 interchangeable focusing screens too. And **you** change them in seconds. You don't wait a few days for the factory to do it.

What else? One-action wind cocking lever; 2 shutter release buttons; 120 220 film capability without any modifi-

cation; new lightweight construction; double exposure prevention. And, of course, the famous range of infinitely varied Mamiyaflex accessories is there for the taking.

Value? Outstanding. The Mamiya C330 comes with standard 80mm f2.8 lens. And you can add **two additional accessory lenses** and **still** only come out at about the same price as another well-known reflex 2¼ square camera – without any extra lenses!

If you're prepared to forego the interchangeable screens, automatic cocking, lever wind, parallax compensation, there's the economy model Mamiya C220.

Your Mamiya franchised dealer is the man to ask about them – and about the rest of the range of Mamiya professional cameras.

Or write to:
Rank Photographic,
PO Box 70, Great West Road,
Brentford, Middlesex TW8 9HR.

MAMIYA C330 & C220

provided yet another opportunity for Birmingham-born photographer David James to prove that he is one of the best stillsmen in the movie business. Already praised for his work on *Women in Love*, *Battle of Britain* and *Fiddler on the Roof*, a spokesman for Universal Pictures is reported as saying that his coverage of their film *Superstar* resulted in the best portfolio of stills that the company had ever seen from a motion picture. These two examples suggest why; the first being a fine colour close up of the two principal characters, Christ (Ted Neeley) and Judas (Carl Anderson) in a dramatic Last Supper confrontation. About it James comments:

'The nice thing about photographing a musical is that you can shoot whenever you like, as ninety per cent of the sound is playback. This proved invaluable here, when Director Norman Jewison was trying to beat the sunset in order to finish the scene and no extra time was available for still photography. I was thus able to shoot while the artistes were involved in the actual scene, which produces far better results than trying to set it all up again for a still camera afterwards.'

Bei den Standaufnahmen zur Rock-Oper ,,Jesus Christ Superstar'' bewies der in Birmingham geborene Fotograf David James, daß er einer der besten Standfotografen der Filmbranche ist. Bereits berühmt wegen seiner Arbeiten an ,,Women in Love'', ,,Battle of Britain'' und ,,Fiddler on the Roof'', wurde ihm nun durch den Pressereferenten der *Universal Pictures* höchstes Lob erteilt: Seine ,,Superstar''-Aufnahmen hätten alles Fotografische übertroffen, das jemals von einem Film gemacht wurde. Diese beiden Beispiele zur Verdeutlichung: das Erste, eine Farb-Nahaufnahme, zeigt die beiden Hauptdarsteller, Christus (Ted Neeley) und Judas (Carl Anderson), in der dramatischen Abendmahl-Szene. Hierzu James: ,,Was mir gefällt, wenn ich ein Musical fotografiere, ist, daß ich jederzeit, wenn ich will, ,,schießen'' kann, da ja 90% des Tones Play-back ist. Da Direktor Norman Jewison versuchte, das Stück noch vor Sonnenuntergang in den Kasten zu kriegen und auch keine Zeit für nachträgliche Standaufnahmen gegeben war, hatte ich die Darsteller während der Aufnahmen zu fotografieren, was bessere Ergebnisse brachte, als wenn man nach Beendigung des Spiels nochmals alles gestellt hätte.''

Le tournage du film sur l'opéra rock «Jesus Christ Superstar» a fourni au photographe de Birmingham David James une nouvelle occasion de prouver qu'il est l'un des meilleurs photographes de fixes dans l'industrie du cinéma. Il a déjà apprécié son travail sur «Women in Love», «Battle of Britain» et «Fiddler on the roof»; et depuis, un représentant de Universal Pictures aurait dit que son travail sur leur film «Superstar» est la meilleure série de fixes que la société ait jamais vue pour un film. Ces deux exemples montrent pourquoi; le premier est un très bon gros plan en couleur des deux principaux personnages, le Christ (Ted Neeley) et Judas (Carl Anderson) dans la confrontation dramatique de la scène. James nous a envoyé ce commentaire:

«Ce qu'il y a d'agréable lorsqu'on photographie un musical, c'est que l'on peut prendre les photographies à n'importe quel moment puisque quatre vingt dix pour cent du son est en playback. Cela a été extrêmement utile ici, car le metteur en scène Norman Jewison essayait toujours de terminer une scène avant le coucher du soleil et il ne restait pas de temps pour les fixes. J'ai donc pu prendre les photographies pendant que les artistes jouaient, ce qui m'a permis d'obtenir des résultats bien meilleurs que lorsqu'on essaie de tout reconstituer ensuite pour prendre les fixes. »

130

Photographer	David James
Camera	Nikon F (Motorized)
Lens	20mm Nikkor
Film	Kodak Plus-X rated at 50 ASA and underdeveloped to reduce contrast
Shutter speed	1/250
Aperture	f/5.6

'The Simon Zealotes number from the film *Jesus Christ Superstar* is a fast freak-out dance routine that was charged with movement and changes of expression faster than any still photographer obliged to manually wind on after each exposure could reasonably hope to capture,' writes David James. 'In such circumstances a camera motor becomes a necessity rather than a lazy luxury.'

A book of his photographs from the film has now been published by Fountain Press.

,,Die Simon-Zealotes-Nummer'' des Films ,,Jesus Christ Superstar'' ist eine schnelle Grotesk-Tanzszene, vollgepackt mit Bewegung und Ausdruckswechsel. ,,Ein Standfotograf, der nach jeder Aufnahme neu zu spannen hätte, müßte es von vornherein aufgeben'', schreibt David James. ,,In solchen Fällen ist eine Kamera mit automatischem Filmtransport kein bequemer Luxus mehr, sondern unbedingte Notwendigkeit.'' Bei Fountain Press/Großbritannien erschien jetzt ein Bildband über diesen Film.

«La scène de «Simon le Zélote» dans le film «Jesus Christ Superstar» est une danse folle qui était chargée de mouvement et de changements d'expressions plus rapides que ce que pouvait suivre un photographe de fixes obligé de recharger manuellement son appareil après chaque photo» écrit David James. «Dans de telles circonstances un moteur devient une nécessité qu'un luxe de paresseux ». – Fountain Press vient de publier un livre de ses photographies du film.

131

Photographer	Geri Della Rocca De Candal
Camera	Nikon F
Lens	200mm Nikkor
Film	Kodak High Speed Ektachrome

Italian photographer Geri Della Rocca De Candal is a master observer of the pavement parade – with a style reminiscent of Lartigue – who regularly submits memorable photographs to us. This year his location was New York and his comments as follows:

'The "Easter Sunday Fashion Parade", which is actually a promenade along Fifth Avenue, partly closed to the traffic for this occasion, takes place every year on Easter Sunday at the end of the religious services. It celebrates an old tradition by which the New York ladies used to greet the coming Springtime by walking up and down the famous avenue with their well-cared for dogs, and wearing their most elegant dresses, and their new Easter bonnets, generally trimmed with flowers.'

Das Spezialgebiet des italienischen Fotografen Geri Della Rocca De Candal ist die ,,Modenschau auf der Straße''. Seine Fotos – der Stil erinnert entfernt an Lartigue – vergißt man nicht. Dieses Jahr war sein Arbeitsrevier New York: ,,Am Ostersonntag trägt man die neue Mode auf der Fifth Avenue spazieren. Die Straße ist zum Teil sogar für den Verkehr gesperrt. So begrüßen nach alter Tradition die New Yorker Damen nach Beendigung der Ostermessen den Frühling. Sie führen ihre gepflegten Hunde auf und ab und stellen ihre neuesten Kleider und ihre neuen Osterhüte, die seit eh und je mit Blumen dekoriert sind, zur Schau.''

Le photographe italien Geri Della Rocca De Candal est maître dans l'art d'observer des défilés de rue, son style rappelant un peu celui de Lartigue. Il nous soumet régulièrement d'admirables photographies. Cette année il les a prises à New York et il les commente ainsi:

« Le défilé de mode du dimanche de Pâques, qui est en fait une promenade le long de la Cinquième Avenue, en partie fermée à la circulation pour cette occasion, a lieu chaque année le dimanche de Pâques, après les services religieux, et il continue une vieille tradition selon laquelle les dames de New York avaient l'habitude d'accueillir le printemps en se promenant le long de la célèbre avenue accompagnées de leurs chiens bien pomponnés et revêtues de leur plus belle robe, coiffées de leur bonnet de Pâques, généralement orné de fleurs».

132/133

Photographer	Geri Della Rocca De Candal
Camera	Nikon F
Lens	20mm Nikkor
Film	Ilford HP4
Paper	Agfa Brovira

More shrewdly observed impressions of New York's Easter Sunday Fashion Parade – this time in black and white – by Milan photographer De Candal.

Vom gleichen Fotografen: wieder die New Yorker Osterparade, hier etwas kritischer gesehen.

Autres vues, ici en noir et blanc, du défilé de mode du dimanche de Pâques à New York finement observées par le photographe milanais De Candal.

134/135

Photographer	F. Florian-Steiner
Camera	Asahi Pentax Spotmatic

When F. Florian-Steiner first showed us his colour derivatives at the 1970 Photokina, we felt that they deserved a showing in the YEAR BOOK even though this was not possible at the time as the original prints were scheduled for one man exhibitions at the Museum of Modern Art, Rio de Janeiro, and in Bogota Columbia. Since then, they have also been seen in Pacific Palisades, California (with the assistance of 'Friends of Photography') and in over forty leading galleries in Europe and the Americas where they commanded high prices from enthusiastic collectors of the artist's work. Florian-Steiner invented his own colour printing system from 35mm black and white negatives which is done on non-emulsive papers, but declined to give any further details of the technique employed.

Als wir auf der Photokina 1970 Color-Derivative von Florian-Steiner sahen, stand für uns fest, daß wir sie im Foto-Jahrbuch zeigen müßten. Damals war das jedoch leider nicht möglich, da die Originale auf Ausstellungen im *Museum of Modern Art,* Rio de Janeiro und in Bogota, Kolumbien gebracht wurden. Seine Arbeiten wurden seitdem auch in Kalifornien (*Pacific Palisades*) und in ca. 40 großen europäischen und amerikanischen Galerien gezeigt. Enthusiastische Sammler zahlen für diese Kunstart recht stattliche Preise. Der Fotograf entwickelte sein eigenes Farbabzugs-Verfahren. Er geht von 35 mm – schwarz/weiß – Negativen aus und benützt emulsionsloses Papier. Weitere Einzelheiten über seine Technik will er jedoch nicht preisgeben.

Lorsque F. Florian-Steiner nous montra pour la première fois ses dérivés en couleur à la Photokina 1970, nous savions qu'il méritait de figurer dans l'Annuaire bien qu'à ce moment-là cela eut été impossible puisque les épreuves originales étaient retenues pour l'exposition consacrée à ses oeuvres au Musée d'Art moderne à Rio de Janeiro et à Bogota en Colombie. Depuis ils ont été présentés aussi à Pacific Palisades, en Californie (avec l'assistance des « Amis de la Photographie») et dans plus de 40 grandes galeries en Europe et sur le continent américain où ils se vendirent à des prix élevés auprès de colectionneurs enthousiasmés par l'oeuvre de l'artiste. Florian-Steiner a inventé son propre système d'impression en couleur à partir de négatifs 35mm en noir et blanc et sur papier sans émulsion, mais il se refuse à donner d'autres détails sur la technique utilisée.

136/145

Photographer	Bogdan Paluszynski
Camera	Asahi Pentax
Lens	20 and 28mm Super Takumar
Film	Kodak Tri-X
Aperture	f/8
Shutter speed	1/30
Developer	Kodak D76
Paper	Kodabrom

The photo sequence is quite a different application of photography to the picture story used in more

conventional photojournalism since it often has surrealistic overtones that leave a question mark in the viewer's mind. As a statement by the photographer it must, therefore, be used in its entirety for to do otherwise would be as pointless as printing just one word from an author's complete sentence.

In fact two sequences are used on these pages. 'Isabelle' in the horizontal format and 'Natacha' in the vertical. Both were made in Paris and exhibited at the last Photokina in Cologne.

Die Foto-Sequenz ist eine eigene Art der Fotokunst, anders als die Bildreportage, die man im konventionellen Fotojournalismus benutzt. Oft ist sie surrealistischen Inhalts und hinterläßt beim Betrachter ein großes Fragezeichen. Der Fotograf will, daß man sie als Ganzes auf sich einwirken läßt; es wäre sonst etwa, als zitiere man nur ein einziges Wort eines Autoren, anstelle des vollständigen Satzes, meint er.

Auf diesen Seiten werden 2 Sequenzen gezeigt, „Isabelle" im Querformat und „Natacha" im Hochformat. Beide entstanden in Paris. Sie wurden auf der Photokina 1972 in Köln gezeigt.

La séquence photographique est une forme tout à fait différente de l'histoire en photos utilisée dans le reportage d'un caractère plus classique, car elle contient souvent des nuances surréalistes qui laissent dans l'esprit du spectateur un point d'interrogation. Puisqu'il s'agit d'une déclaration du photographe, elle doit être reproduite dans son intégrité; autrement cela serait tout aussi ridicule que d'imprimer un mot choisi dans une phrase complète d'un auteur. Ici, nous avons placé deux séquences: «Isabelle» dans le format horizontal et «Natacha» dans le format vertical. Toutes deux ont été réalisées à Paris et exposées à la dernière Photokina à Cologne.

146

Photographer	Toni Angermayer
Camera	Hasselblad 500C
Lens	250mm Sonnar
Film	Agfachrome 50S
Shutter speed	1/500
Aperture	f/5.6

Munich photographer Toni Angermayer is well known for his superb animal studies of which he now has a large collection. This picture is typical of the humour which distinguishes much of his work.

Toni Angermayer aus München ist unter anderem auch als meisterhafter Tierfotograf bekannt. Seine Sammlung an Tierstudien ist berühmt, besonders durch den Humor, der viele seiner Arbeiten auszeichnet. Hier ein typisches Beispiel dafür.

Le photographe munichois, Toni Angermayer, est bien connu pour ses très belles études d'animaux dont il a maintenant une vaste collection. Cette photographie est caractéristique du style de la majeure partie de son oeuvre.

147/150

Photographer	Sam Haskins
Camera	Asahi Pentax 6 × 7
Film	Kodak Tri-X and High Speed Ektachrome

We present a portfolio by Sam Haskins, who, although one of the world's most successful advertising photographers, is probably best known because of his five best-selling photographic books – *Five Girls, Cowboy Kate and Other Stories, African Image, November Girl* and *Haskins Posters.*

Featured in a Photokina exhibition as one of 'Four Masters of Erotic Photography', Sam is a master photographer of beautiful women – always with sensitivity, good taste and a touch of humour. Most of these examples of his work were taken during preparation of his most recent book, *Haskins Posters,* although not all of them finally appeared in it.

About advertising photography he wryly comments: 'It is one of the last great professions. Otherwise how would one account for the fact that it is so hopelessly overpopulated.'

Sam Haskins gehört zu den erfolgreichsten Werbefotografen der Welt. Berühmt wurde er durch seine 5 Fotobände „Five Girls", „Cowboy Kate", „African Image", „November Girl" und „Haskin Posters". Auf der Photokina wurde er als einer der „Vier Meister erotischer Fotografie" vorgestellt. Tatsächlich findet man bei ihm Empfindsamkei, guten Geschmack und ein leises Lächeln. Die meisten der hier gezeigten Arbeiten entstanden bei den Aufnahmen zu seinem Buch „Haskins Posters", sind jedoch nicht alle darin zu sehen.

Sein etwas gequälter Kommentar über die Werbefotografie. „Sie ist einer der letzten großen Leidenschaften. Wie ließe es sich sonst erklären, daß sie so hoffnungslos überlaufen ist?"

Nous présentons une série d'images de Sam Haskins qui, bien que l'un des photographes de publicité les plus recherchés du monde, est sans doute mieux connu pour ses cinq livres de photographies qui ont eu un grand succès: Five Girls, Cowboy Kate and Other Stories, Africa Image, November Girl et Haskins Posters. Présenté dans une Photokina comme l'un des « Quatre maîtres de la photographie érotique», Sam est un maître photographe des belles femmes, toujours avec sensibilité, bon goût et une note d'humour. La plupart des photographies que nous présentons ont été prises pendant qu'il préparait son tout dernier livre, Haskins Posters; toutes n'ont cependant pas parues dans le livre. Au sujet de la photographie de publicité, il écrit laconiquement: «C'est l'une des dernières grandes professions. Autrement comment expliquer qu'elle soit à ce point encombrée.»

151

Photographer	Gianni Turillazzi

When Gil, of Max Factor, one of the most famous make-up experts in the world, decided to revolutionize the make-up of the seventies, top Italian photographer Gianni Turillazzi was called in to record the results on film.

The idea, we understand, is that 'make-up which previously was considered showy and heavy, will now even be able to be used by girls in convents, for the true make-up (which Gil is launching for the following ten years) does not only involve the eyes, but the whole face and sometimes even more. Colour, lots and lots of colour on women's faces, to emphasize perfect features, or soften not-so-perfect ones, but above all to create a complete harmony between make-up, hair-style and dress.'

We hope that when they run this up the flag pole everyone salutes. Meanwhile, Gil has provided Turillazzi with a very pretty picture.

Gil, von *Max Factor*, einer der berühmtesten Make up Experten der Welt, beschloß, das Make up der 70er Jahre zu revolutionieren. Er berief den italienischen Spitzenfotografen Gianni Turillazzi, der für die Publikation des neuen Stils sorgen sollte. Hier das Ergebnis: Make up, bisher so auffällig und schwer, soll nun sogar von Klosterschülerinnen benutzt werden dürfen. Dieses „einzig wahre" Make up – und Gil will es für dieses Jahrzehnt durchsetzen – bezieht nicht nur die Augenpartie ein, sondern das ganze Gesicht, und oft sogar mehr. Farbe und nochmals Farbe auf jedem Frauengesicht: die vorteilhaften Züge sollen betont, weniger gute gemildert werden. Vor allem aber soll perfekte Harmonie von Make up, Frisur und Kleidung bestehen.

Zu hoffen bleibt nur, daß keine Frau sich diesem neuen Stil widersetzen wird. Vorläufig jedoch bleibt festzustellen, daß Gil den Fotografen zu einem sehr hübschen Bild animiert hat.

Lorsque Gil, de Max Factor, l'un des plus grands experts du maquillage, décida de révolutionner le maquillage des années soixante-dix, le grand photographe italien Gianni Turillazzi fut chargé de photographier les résultats. Il semble que l'idée soit que «le maquillage, qui jusqu'ici était considéré comme voyant et lourd, pourra désormais être adopté jusque dans les couvents, car le vrai maquillage, que Gil lance pour les dix prochaines années, ne se limite pas seulement aux yeux, il vaut pour tout le

visage et parfois plus. De la couleur, beaucoup de couleur sur le visage des femmes: pour mettre en valeur des traits parfaits, ou adoucir des traits moins parfaits, mais surtout pour créer une véritable harmonie entre le maquillage, la coiffure et les vêtements».

Nous espérons que lorsqu'on hissera cela au mât tout le monde saluera. En attendant, Gil a donné à Turillazzi l'occasion de faire une très jolie photographie.

152

Photographer	Michelangelo Giuliani

The life-style of Rome photographer and film maker Michelangelo Giuliani is almost as interesting as his imaginative photography, but the simplicity of this montage of female fingers is as charming as it is evocative.

So interessant wie sein Lebensstil, sind die phantastischen Fotografien des römischen Fotografen und Filmproduzenten Michelangelo Giuliani. Diese Montage weiblicher Finger fasziniert durch ihre Einfachheit.

Le style de vie du photographe et cinéaste romain Michelangelo Giuliani est presque aussi intéressant que ses créations photographiques, mais la simplicité de ce montage de doigts féminins est aussi charmant qu'évocateur.

153/157

Photographer	Hideki Fujii
Cameras	Fujica ST701, Nikon F and Asahi Pentax
Lenses	20–200mm
Film	Neopan SS rated 400 ASA
Developer	Kodak D76
Paper	Fuji Bromide

'Past' is the title given to this new series of pictures because with them, Fujii went back to his past; to the 'past' of any photographer. At present Hideki Fujii is one of the most appreciated and sophisticated commercial photographers in Japan. But at the beginning of his career, his only tool was a 35mm camera – and his studio the open air with the only light that given by nature. And using the same means – with an Italian girl living in Japan as his model – Hideki Fujii shot hundreds of black and white pictures during a one-month stay in Spain last summer. On the following pages we present a selection from them.

„Past" – „Vergangenheit", nannte der japanische Fotograf diese Bildvorlage. Fujii griff auf die frühesten Anfänge eines jeden Fotografen, so auch seiner selbst, zurück: Er begann damals mit einer 35 mm Kleinbildkamera, sein Studio war die freie Natur, seine einzige Lichtquelle das Tageslicht. Heute wird er in Japan hoch geschätzt, seine Arbeiten sind technisch perfekt und von hoher intellektueller Aussagekraft. Hunderte von Bildern – hier eine kleine Auswahl – entstanden während eines Aufenthaltes in Spanien. Benutzt wurden nur die oben erwähnten, primitiven Mittel. Das Modell: eine Italienerin, die auch in Japan mit ihm arbeitet.

«Le Passé», tel est le titre donné à cette nouvelle série de photographies, car avec ces images Fujii est retourné à son passé, le «passé» de n'importe quel photographe. Hideki Fujii est actuellement l'un des photographes commerciaux les plus appréciés et les plus élaborés au Japon. Mais au début de sa carrière, il n'avait pour instrument qu'un appareil 35mm, et son studio était à l'air libre, le seul éclairage disponible étant celui de la nature. Et c'est dans ces mêmes conditions, avec une jeune italienne vivant au Japon lui servant de modèle, que Hideki Fujii a pris des centaines de photos en noir et blanc au cours d'un séjour d'un mois en Espagne l'été dernier. Nous en présentons quelques unes dans les pages suivantes.

158

Photographer	A. Fletcher
Camera	Nikon F

Lens	135mm Nikkor
Film	Kodak Tri-X
Shutter speed	1/60
Aperture	f/4
Developer	Kodak D76

Watch it. Portrait of a pop-star's body guard', was the title given to this well-observed candid by Mrs A Fletcher when she first submitted it to *Photography* Magazine.

Watch it!'' – ,,Paß auf!'', nannte die Fotografin ihren Schnappschuß. Er zeigt die Leibwache eines Pop-Stars. Erstveröffentlichung im Magazin *Photography*.

Attention. Portrait d'une vedette pop» tel est le titre donné à cette étude particulièrement bien observée par Mme A. Fletcher lorsqu'elle la présenta pour la revue «Photography». Elle nous a tellement plu que nous la reproduisons de nouveau dans l'Annuaire.

159

Photographer	Wieskaw Debicki
Camera	Pentacon Six
Lens	80mm Biometar
Film	Orwo NP20
Shutter speed	1/500
Aperture	f/4
Developer	Orwo RO9
Paper	Foton Extra Hard

No wonder the gentleman on the facing page looks apprehensive. 'Unformal Group', is the caption on this print by Polish photographer Wieskaw Debicki.

Verständlich, daß der Herr auf der Seite gegenüber besorgt ist. ,,Zwanglose Gruppe'' wurde dies Bild von seinem polnischen Fotografen betitelt.

Il n'est pas étonnant que l'homme sur la page apposée ait l'air aussi appréhensif. «Groupe régulier» est la légende de ce cliché par le photographe polonais Wieskaw Debicki.

160

Photographer	Federico Grau
Camera	Telerollei
Lens	135mm
Film	Kodak Tri-X
Developer	Kodak D76

Some of the best photographs of classical ballet to reach us for a long time came from Madrid photographer Federico Grau who, for eighteen years, has been a stillsman on major feature films including (most recently) *Papillon*, and has also been a Laboratory Supervisor for the Samuel Bronston Studios. These pictures were taken during the film versions of *Giselle*, and *Fabulous Dr. Coppelius World*.

Nach langer Zeit erreichten uns jetzt wieder bestechende Aufnahmen von klassischem Ballett. Sie kommen aus Madrid und entstanden während der Dreharbeiten zu ,,Giselle'' und ,,Die wunderbare Welt des Dr. Coppelius''. Der Fotograf fertigte 18 Jahre lang Standfotos für große Spielfilme (darunter ,,Papillon'') und war Laborleiter der *Samuel Bronston Studios*.

Il y a longtemps que nous n'avions reçu d'aussi bonnes photographies sur le ballet classique. Elles nous ont été envoyées par le photographe madrilène Federico Grau, qui depuis dix huit ans est photographe de fixes pour de grands films comme très récemment) «Papillon», et aussi directeur de laboratoire aux studios Samuel Bronston. Ces images ont été prises pendant le tournage des versions cinématographiques de «Giselle» et «Fabulous Dr. Coppelius World».

161/163

Photographer	Federico Grau
Cameras	Telerolleiflex and Nikon F

Two cameras were used to make the pictures on this page. A Telerolleiflex for plate 162 (the male

dancer's solo leap) while a tripod-mounted Nikon F fitted with a 135mm lens was used for the medium close ups. The panoramic head tripod also enabled Grau to isolate the central figure (plate 161) by turning the moving figures into ghost images by means of a slow shutter speed.

Für die Bilder auf dieser Seite wurden zwei Kameras benutzt: eine Telerolleiflex für den Solotänzer (Bild 162), für die Nahaufnahme (Bild 163) eine auf ein Stativ geschraubte Nikon F mit 135 mm Linse. Das Panorama-Drehkopf-Stativ ermöglichte es auch bei Abbildung 161 die Mittelfigur zu fixieren, indem durch lange Belichtungszeit die bewegten Figuren in geisterhafte Schemen verwandelt wurden.

Deux appareils ont été utilisés pour les images figurant sur cette page. Un Telerolleiflex pour la planche 162 (le saut du danseur) tandis que les gros-plans ont été pris avec un Nikon F monté sur pied et muni d'un objectif 135mm. Le pied à tête panoramique a également permis à Grau d'isoler le personnage central (planche 161) et de transformer les personnages en mouvement en images fantômes en utilisant une vitesse d'obturation lente.

164

Photographer	Federico Grau
Camera	Nikon F
Lens	135mm
Film	Kodak Tri-X

'Resting Exercises'. Grau rarely uses a standard lens but employs wide angles and telephotos for compressing or widening his composition as the circumstances demand.

,,Entspannungs-Übung''. Grau benutzt selten ein Standard-Objektiv, sondern er wechselt vom Teleobjektiv zum Weitwinkel, um – je nach Erfordernis – seine Kompositionen zu erweitern oder zusammenzufassen.

«Exercices de relaxation» Grau utilise rarement un objectif standard mais un grand angulaire et un télé-objectif pour comprimer ou élargir ses compositions selon les circonstances.

165/166

Photographer	David Redfern
Camera	Hasselblad
Lens	250mm
Film	Ilford HP4 rated 800 ASA
Shutter speed	1/125
Aperture	f/5.6

David Redfern, probably Britain's best photographer of jazz and jazz musicians, took these pictures of Charlie Mingus conducting at the Newport Jazz Festival, New York.

David Redfern, wahrscheinlich Englands bester Jazz-Fotograf, gelangen diese Bilder von Charles Mingus, als Dirigent auf dem Newport-Jazz-Festival in New York.

David Redfern, sans doute le meilleur photographe britannique du monde du jazz, a pris ces images de Charles Mingus au Newport Jazz Festival à New York.

167

Photographer	Morten Langkilde

A line print montage by Danish photographer Morten Langkilde, supplied with this note about the subject: 'A demon, a devil, a coquette, a seducer – those are just a few of the expressions applied to the Roumanian-born conductor Sergiu Celibidache. ''Cirkus Celibidache'', some people have muttered when watching the tall man with the flying Einstein mane on the conductor's platform. But the fact is that Sergiu Celibidache is one of the greatest contemporary musical personalities. Within him burns a fire – a fire which he is able to convey to his musicians and, by means of them, to his audience. Sparks fly from his baton, when he begs, demands, forces his musicians to play better than they ever did before.'

Eine Konturendruck-Montage vom dänischen Fotografen Morten Langkilde mit dem Kommentar: Dämon – Teufel – Gefallsüchtiger – Verführer . . . , – dies sind nur ein paar Bezeichnungen, die den in Rumänien geborenen Dirigenten Sergiu Celibidache schmücken. ,,Zirkus Celibidache'' murmelte mancher, wenn er den großen Mann mit der fliegenden Einstein-Mähne am Dirigentenpult sah. Jedoch besteht kein Zweifel, daß Celibidache eine der größten, zeitgenössischen Persönlichkeiten der musikalischen Welt ist. In ihm brennt Feuer – ein Feuer, das er auf sein Orchester überträgt, und das dann überspringt auf das Publikum. Funken sprühen von seinem Zauberstab, wenn er bettelt, fordert, seine Musiker bezwingt, noch besser zu spielen als je zuvor.

Un montage par le photographe danois, Morte Langkilde, présenté avec cette note concernant le sujet: «Un démon, un diable, une coquette, un séducteur, ce sont là quelques unes des expressions utilisées pour définir le chef d'orchestre d'origine roumaine, Sergiu Celibidache – Circus Celibidache, ont murmuré certains en voyant sur le podium du chef d'orchestre cet homme de grande taille, la crinière flottante à la Einstein. Mais en réalité ce Sergiu Celibidache est l'une des plus grandes personnalités musicales contemporaines. Il brûle en lui un feu qu'il a le don de passer à ses musiciens et, par eux, à son audience. Son bâton étincelle lorsqu'il supplie, implore, force ses musiciens à jouer mieux qu'il n'ont jamais joué.

168

Photographer	Tony Russell
Camera	Nikon
Lens	35mm
Film	Kodak Tri-X
Shutter speed	1/30
Aperture	f/8 (TV lighting)

That a young photographer can benefit enormously from working with an experienced professional is evident from this fine picture of harmonica king Larry Adler by Tony Russell (see also plate 18) who is now associated with David Redfern (plates 165/166).

Toni Russell (auch Bild 18) arbeitet nun mit David Redfern (auch Bild 165/166) zusammen. Ein junger Fotograf kann vieles lernen, wenn er sich mit einem erfahrenen Kollegen zusammentut. Das sieht man an diesem Bild vom Mundharmonikakönig Larry Adler.

Cette belle image du roi de l'harmonica Larry Adler par Tony Russell (voit également No. 18) qui est maintenant associé à David Redfern (No. 165/166) montre à quel point un jeune photographe peut bénéficier du travail en collaboration avec un photographe professionnel expérimenté.

169

Photographer	Bo Soderberg
Camera	Practica Nova
Lens	50mm Oreston
Film	Ilford HP4

Swedish photographer Bo Soderberg sent us a number of interesting insect close ups for this edition and we particularly liked the way he has incorporated water droplets in this picture to indicate scale. Lighting was by electronic flash.

Der schwedische Fotograf Bo Sodenberg sandte uns eine Reihe interessanter Insekten-Nahaufnahmen. Besonders gefiel uns daran, wie er zur Verdeutlichung der Größenverhältnisse die Wassertropfen benutzte. Die Lichtquelle war Blitzlicht.

Le photographe suédois Bo Soderberg nous a envoyé pour cette édition un certain nombre de gros plans d'insectes très intéressants et nous avons particulièrement aimé la façon dont il a introduit de petites gouttes d'eau sur cette photographie pour indiquer l'échelle. L'éclairage est au flash électronique.

170

Photographer	Pete Turner
Camera	Nikon
Film	Kodachrome

The following colour portfolio is by Pete Turner, one of America's most important – and successful – photographers. After completing his education at the Rochester Institute of Technology (and what better place to learn the techniques of photography) Turner was first published in *Holiday* magazine and his work has subsequently appeared in most of the world's leading illustrated journals. Assignments take him all over the world and he took this picture while in Sweden.

Die folgenden Farbfotos stammen von Pete Turner, einem der bedeutendsten und erfolgreichsten Fotografen Amerikas. Er absolvierte das *Rochester Institute of Technologie* (wo könnte man die Technik der Fotografie besser erlernen?). Seine ersten Veröffentlichungen brachte das *Holiday Magazine*, danach wurden seine Arbeiten in den meisten großen Bildjournalen veröffentlicht. Von überall in der Welt erhält er seine Aufträge. Dieses Bild entstand in Schweden.

La série suivante en couleur est de Pete Turner, l'un des photographes les plus en vue des Etats Unies. Après des études à l'Institut de Technologie de Rochester (où pouvait-il mieux apprendre les techniques de la photographie), Turner vit son travail publié dans le magazine « Holiday », puis par la suite dans la plupart des grands journaux illustrés du monde. Il réalise des reportages dans le monde entier et cette image a été prise en Suède.

171

Photographer	Pete Turner
Camera	Nikon
Film	Kodachrome

Pete Turner's colour photography is designed in the camera, for he does not like to rely on afterwork. Visual simplicity is the keynote to his approach, typical of which is this close up of a leaf and water droplets.

Pete Turners Fotodesign wird beim Fotografieren entworfen. Nachträgliche Verbesserungen lehnt er ab. Er strebt sichtbare Einfachheit an, wie bei dieser Großaufnahme eines Blattes mit Wassertropfen.

Les photographies en couleur de Pete Turner se font dans l'appareil car il n'aime pas compter sur le travail en laboratoire. La simplicité est le trait dominant de sa manière, dont ce gros plan de feuille et gouttelettes d'eau est caractéristique.

172

Photographer	Pete Turner
Camera	Nikon
Film	Kodachrome

The recipient of numerous awards, including one from the German Art Director's Club for his photography in *Twen* magazine, Pete Turner is a master of monochromatic colour, used very successfully in this dramatic seascape which he made in Portugal.

Turner erhielt zahlreiche Auszeichnungen, unter anderem auch den Preis der deutschen „Art Directors" für seine in *Twen* erschienenen Fotos. Er ist ein Meister der Monochrom-Fotografie, hier effektvoll angewandt bei einer Aufnahme an der portugiesischen Küste.

Gagnant d'un grand nombre de prix, dont un du Club allemand du Directeur d'Art pour sa photographie dans le magazine « Twen », Pete Turner est un maître de la couleur monochromatique, qu'il utilise ici avec succès dans ce très beau paysage de mer au Portugal.

173

Photographer	Pete Turner
Camera	Nikon
Film	Kodachrome

A ruthless disciplinarian in regard to his own work,

Turner devotes much time to editing his material, a great deal of which he discards. 'If it is no good, then why keep it?' he is reported as saying.

One he did keep was this graphic close up of lips and fingers, commonplace enough in themselves but given extraordinary power and impact by his visual treatment of them.

Turners schärfster Kritiker ist er selbst, er nimmt sich viel Zeit, seine Arbeiten selbst auszuwählen. Dabei werden eine Menge Fotos weggeworfen. „Wozu aufheben, wenn es nichts taugt?" soll er oft gesagt haben.

Ein Bild, das er behielt, ist diese Nahaufnahme von Lippen und Fingern. An sich ein abgedroschenes Thema – durch sein Können jedoch von großer Aussagekraft.

Critique implacable de son propre travail, Turner consacre beaucoup de temps à trier ses photographies et il en jette un grand nombre. « Pourquoi les garder si elles ne sont pas bonnes? » aurait-il l'habitude de dire.

Il a gardé par contre ce gros plan graphique de lèvres et de doigts, assez ordinaires en eux mêmes mais auxquels son traitement visuel donne une puissance extraordinaire.

174

Photographer	Algimantas Bareisis

It seemed appropriate to follow a portfolio by one of Amercia's best photographers with a section by some of the best in the U.S.S.R. All belong to the Photography Art Society of Lithuania, which, in recent years, has regularly submitted material of outstanding quality. The Society is based in Vilnius, the capital of Soviet Lithuania and an international city of individualistic character, but this composition was also exhibited at the Sydney International Salon.

Nach Bildern der besten amerikanischen Fotografen folgt jetzt eine Auswahl von Werken aus der UDSSR. Die Fotografen sind Mitglieder des Fotokunstvereins von Litauen, der in den letzten Jahren Bildbeiträge von aufsehenerregender Qualität hervorbrachte. Die Gesellschaft hat ihren Sitz in Vilnius, der Hauptstadt von Sowjet-Litauen, einer internationalen Stadt mit individuellem Charakter. Dieses Bild wurde auch im *Sydney International Salon* ausgestellt.

Après cette série de photographies d'un des meilleurs photographes américains, il convient, semble-t-il, de présenter une section consacrée à quelques uns des meilleurs photographes soviétiques. Ils appartiennent tous à la société d'art photographique de Lithuanie qui, ces dernières années, a proposé des oeuvres de très grande qualité. La société a son siège à Vilnius, capitale de la Lithuanie soviétique et ville internationale au caractère très particulier. La présente composition a été également exposée au Salon internationale de Sydney.

175

Photographer	Aleksandras Macijauskas

Pictures of friends and relatives are a staple of most amateur camera clubs, yet this spread by members of the Photography Art Society of Lithuania shows the freshness and vivacity that can result from a really professional approach to the subject.

'A Family' is the caption given by photographer Macijauskas to this plate.

Fotos von Freunden und Verwandten liegen stapelweise in den meisten Amateur-Fotoclubs. Dieses jedoch zeigt ursprüngliche Lebendigkeit, die nur durch perfektes Können und durch Interesse am Menschen zu erreichen ist. „Eine Familie" nannte der Fotograf dieses Bild.

Les photos de parents et d'amis sont la principale production de la plupart des clubs de photographie amateurs, mais la présente image prise par les membres de la Société d'Art photographique de Lithuanie montre la fraîcheur et la vie qu'une technique vraiment professionnelle peut donner au sujet. Le photographe Macijauskas y joint la simple légende: « Une famille ».

176

Photographer	V. Kopius

'Prudent Rita', is the intriguing title of this wide angle close up by V. Kopius. One wonders how long she will be able to resist the whispered persuasions of her dancing partner.

Titel dieser Weitwinkel-Aufnahme: „Die standhafte Rita". Wie lange wird sie noch widerstehen?

« Prudente Rita », tel est le titre mystérieux de ce gros plan pris avec un grand angulaire par V. Kopius. On se demande combien de temps elle sera capable de résister aux murmures persuasifs de son cavalier.

177

Photographer	Romualdas Rakauskas

'Tenderness', by Romualdas Rakauskas. A familiar treatment of a familiar subject, but here handled with deceptive skill by the photographer – as well as by the young man in the centre of his picture.

„Zärtlichkeit" – ein oft fotografiertes Motiv. Hier mit großer Geschicklichkeit ausgeführt, sowohl vonseiten des Fotografes, als auch vonseiten des jungen Mannes.

« Tendresse » par Romualdes Rakauskas. Un sujet familier traité familièrement, mais ici le photographe l'aborde avec une technique qui trompe, – tout comme celle du jeune homme au centre de l'image.

178

Photographer	Romualdas Rakauskas

Also by Rakauskas is 'Two Generations', in which selective focus has emphasized the smoothness of the baby's skin against the wrinkled visage of the old woman.

Vom gleichen Fotografen: „Zwei Generationen". Durch Scharfeinstellung wird die glatte, junge Haut des Babys im Gegensatz zum runzligen Gesicht der alten Frau hervorgehoben.

Par Rakauskas également, « Deux Générations ». Une mise au point sélective a mis en valeur la douceur de la peau du bébé contre le visage ridé de la vieille femme.

179

Photographer	L. Ruikas

This serene portrait by L. Ruikas reminded us of a similar composition by the well-known French photographer Jeanloup Sieff in PHOTOGRAPHY YEAR BOOK 1968. The props are the same – a chair, a table, a plain background – but while the Lithuanian model has a greater air of innocence the skill of her photographer is no less sophisticated. Exhibited at the 23rd Singapore International Salon.

Dieses heitere Porträt erinnerte uns an ein ganz ähnliches Bild des französischen Fotografen Jeanloup Sieff aus dem Jahrbuch 1968. Die gleichen Gegenstände: Ein Stuhl, ein Tisch, ein ruhiger Hintergrund. Das litauische Modell allerdings, verkörpert naive Unschuld. – Doch die unerfahrene Miene des Mädchens läßt nicht auf die Unerfahrenheit des Fotografen schließen. Er ist ein ebensolcher Könner, wie der oben erwähnte. Ausgestellt im *23. Singapur International Salon.*

Ce portrait serein par L. Ruikas nous rappelle une composition similaire par le photographe français bien connu Jean-Loup Sieff, qui était parue dans l'Annuaire Photographique 1968. Les accessoires sont les mêmes – une chaise, une table, un fond nu – mais tandis que le modèle lithuanien a un air de plus grande innocence, l'art du photographe est tout aussi recherché. Cette photographie a été exposée au 23ème salon international à Singapour.

180

Photographer	A. Kuncius

'Peasants Portrait' by Algimantas Kuncius. A superb study of an old man that says all that need be said

bout the standard of which Lithuanian hotographers are capable.

Bauernportrait''. Nach diesem überzeugenden Bild muß über das Können der litauischen Fotografen nicht mehr gesagt werden: es spricht für sich selbst.

Portrait de paysan» par Algimantas Kuncius. Une ès belle étude de vieil homme qui dit tout ce qu'il a à dire sur le niveau que sont capables d'atteindre es photographes lithuaniens.

81/182

Photographer	J. Vilaseca Parramon
Camera	Pentacon Six
Film	Valca H27
Shutter speed	1/250
Aperture	f/5.6
Developer	Rodinal

Ve were attracted by the 'period' feeling of these photographs reminiscent of some *fin de siecle* photography in, say, Paris or Madrid. They were, owever, taken by a Spanish photographer in Barcelona-Sitges at a vintage car rally.

An diesen Fotografien gefiel uns der „Hauch von Zeitgeist", der Erinnerungen an die Jahrhundertwende in Paris oder Madrid aufkommen läßt. Sie wurden jedoch in unserem Jahrzehnt beim Weinberg-Autorennen in Barcelona-Sitges aufgenommen.

Nous avons beaucoup aimé l'atmosphère «ancienne» de ces photographies qui ont quelque chose de photographie fin de siècle à, disons, Paris ou Madrid. Iles ont pourtant été prises par un photographe espagnol lors du rallye de vieilles automobiles entre Barcelone et Sitges.

83

Photographer	Struan Robertson
Camera	Leica M2
Lens	35mm Summilux
Film	Kodak Tri-X

Schoolboy in train. Cape Town. 'There was puzzlement and suspicion in his eyes', writes South African photographer Struan Robertson, 'but any anger was kept far down while all life went on outside him as if behind a pane of glass'.

Schuljunge im Zug, Capetown. „Grübelei und Argwohn sprachen aus seinen Augen", schreibt der südafrikanische Fotograf Robertsen. „Aber er ließ den Unwillen in seinem Inneren nicht aufkommen – während das Leben um ihn herum wie hinter einer Glasscheibe ablief."

Écolier dans le train, Cape Town. «Ses yeux reflétaient l'étonnement et la méfiance» écrit Struan Robertson, photographe sud-africain, «mais toute colère était maintenue à l'intérieur tandis que la vie se déroulait en dehors de lui comme s'il la voyait au travers d'une vitre».

84

Photographer	Tony Boxall
Camera	Mamiya C3
Lens	80mm
Film	Kodak Tri-X
Shutter speed	1/250
Aperture	f/5.6
Developer	Microdol-X

By a fortunate chance, two superbly rendered studies of gypsy children were available for this edition. The first, 'Huckleberry Jimmy', was taken by the well-known British photographer Tony Boxall, F.R.P.S., once named by *Photography* Magazine as Photographer of the Year'.

Durch einen glücklichen Zufall erhielten wir für diese Ausgabe zwei großartige Studien von Zigeuner-kindern. Das erste, „Huckleberry Jimmy" wurde von dem bekannten britischen Fotografen Toni Boxall aufgenommen, der einst vom Magazin *Photography* zum „Fotografen des Jahres" gewählt worden war.

Par un heureux hasard, nous avons reçu pour cette édition deux magnifiques études d'enfants gitans. La

première, «Huckleberry Jimmy», a été prise par le photographe britannique connu Tony Boxall, F.R.P.S., qui fut une fois désigné Photographe de l'Année par «Photography Magazine».

185

Photographer	Kalervo Ojutkangas
Camera	Konica Autoreflex T
Lens	28mm Hexanon
Film	Kodak Tri-X

The work of Finnish photographer Kalervo Ojutkangas has appeared in many photo books and magazines (not least in previous editions of this volume) and he tells us that this picture, 'A Gypsy's Daughter' was taken in Salla, Lapland, in the cottage of the Gypsy family.

Die Arbeiten des finnischen Fotografen Ojutkangas sind aus vielen Fotobüchern und Magazinen bekannt (auch aus früheren Ausgaben dieses Jahrbuches). Dieses Bild „Tochter eines Zigeuners" hat er in Salla/Lappland in der Hütte der Zigeunerfamilie aufgenommen.

Des oeuvres du photographe finlandais Kalervo Ojutkangas ont paru dans nombre de livres et revues de photographie (sans parler de précédents numéros de cet annuaire) et il nous dit qu'il a pris cette photographie, «Fille de gitan», à Salla en Laponie, dans la maisonnette d'une famille de gitans.

186/190

Photographer Lafontan

When South American strong man Juan Peron returned to the Argentine Republic after many years exile in Spain, his enthusiastic reception by Peronista supporters provided Agence Sipa photographer Lafontan with the opportunity of obtaining some remarkable pictures of the sort of political hero worship now rarely seen in the West. At the time of going to press no technical details were available.

Als der „starke Mann Südamerikas", Juan Peron, nach vielen Jahren im spanischen Exil wieder in die Republik Argentinien zurückkehrte, hatte der für die Agentur *SIPA* arbeitende Fotograf Lafontan seine Chance. Während des begeisterten Empfangs durch seine Anhänger, konnte Lafontan Dokumente einer politischen Heldenanbetung sammeln, wie man sie in der heutigen westlichen Welt selten zu sehen bekommt. Als dies Buch in Druck ging, waren noch keine technischen Daten zu den Fotos vorhanden.

Le retour en Argentine après de longues années d'exil en Espagne de l'homme fort de l'Amérique du Sud, Juan Peron, auquel les péronistes ont réservé un accueil enthousiaste, a donné au photographe de l'Agence Sipa, Lafontan, l'occasion de prendre de remarquables images de cette sorte d'adoration du héros politique aujourd'hui très rare en Europe. Au moment de mettre sous presse, nous n'avions reçu aucune donnée technique.

191

Photographer	Peter O'Reilly
Camera	Hasselblad 500C
Lens	150mm Sonnar
Film	Kodak Tri-X
Shutter speed	1/500
Aperture	f/8
Developer	Microdol-X

Eyes up for members of the Parachute Regiment band as they watch the descent of the regimental free-fall team 'The Red Devils' during a Liverpool air display.

Die Musiktruppe des Fallschirmjägerregiments verfolgt den Absprung des Frei-Fall-Teams der „Roten Teufel" während der Flugvorführungen in Liverpool.

Les membres de l'orchestre du régiment de parachutistes ont les yeux tournés vers le ciel alors qu'ils regardent la descente de l'équipe de chute libre «les diables rouges» au cours d'une fête aérienne à Liverpool.

192

Photographer	Robert Michel
Camera	Nikon F2
Lens	24mm Nikkor
Film	Kodak Tri-X
Shutter speed	1/125
Aperture	f/8
Developer	Kodak D76
Paper	Agfa

Eyes down in sober reflection for this pilgrim to Lourdes. But the child stares curiously at the camera of leading Belgian photographer Robert Michel.

Ein gesenkter Blick geziemt sich für die Pilger nach Lourdes. Nur das Kind riskiert einen neugierigen Blick zur Kamera des belgischen Fotografen.

Ce pélerin de Lourdes a lui les yeux tournés vers le sol dans une grave méditation. Mais l'enfant regarde avec curiosité l'appareil du grand photographe belge Robert Michel.

193

Photographer	Robert Aylott
Camera	Nikon F
Lens	28mm
Film	Ilford HP4
Shutter speed	1/250
Aperture	f/5.6
Developer	Kodak D76

Since Trade Unionists believe that the whole basis of their strength and security is collective action, their scorn is particularly bitter against blacklegs, individuals who – for one reason or another – refuse to conform. Such feelings are graphically portrayed in this shot by photojournalist Robert Aylott of the London *Daily Mail*, taken during a miner's strike in Yorkshire as militants escorted a stony-faced recalcitrant and his police bodyguard home from the pit.

Da die englischen Gewerkschafter ihre Macht und Stärke auf solidarische Kollektivhandlungen gründen, richtet sich ihre bittere Verachtung gegen jene Außenseiter, die sich aus diesem oder jenem Grunde weigern ihre Meinung zu teilen. Die sozialen Folgen dieser Einstellung zeigt Robert Aylott von der Londoner Daily Mail, an einem Beispiel vom Bergarbeiterstreik in Yorkshire. Mit versteinerter Miene läßt sich ein Streikbrecher von einer Militärleibwache von der Grube bis zu seinem Haus begleiten.

Les syndicalistes pensent que leur force et leur sécurité reposent entièrement sur l'action collective, aussi ont-ils un mépris particulièrement amère des «jaunes», individus qui pour une raison ou pour une autre refusent de se plier. Ces sentiments sont rendus graphiquement sur ce cliché du reporter photographe Robert Aylott du London Daily Mail, pris lors d'une grève des mineurs dans le Yorkshire alors que des militants escortent de la mine jusque chez lui un récalcitrant au visage fermé protégé par un policier.

194

Photographer	Denis Thorpe
Camera	Nikon F
Lens	24mm Nikkor
Film	Kodak Tri-X
Shutter speed	1/500
Aperture	f/16

Denis Thorpe of the Manchester *Daily Mail* has a great affection for the North of England where he lives and works and spends much time photographing traditional pursuits and activities that are in danger of dying out as society changes. Brass bands have always been popular in the North and he tells us that the subject of this picture is 'the oldest member of the New Mills Old Prize Band'.

Denis Thorpe vom *Manchester Daily Mail* lebt und arbeitet im Norden Englands. Er fotografiert gern auf Traditionsfesten und Veranstaltungen, die in Gefahr sind auszusterben. Blasorchester waren im Norden

immer beliebt. Hier zeigt uns Thorpe das älteste Mitglied der „New Mills Old Prize Band''.

Denis Thorpe du Manchester Daily Mail aime particulièrement le nord de l'Angleterre où il vit et travaille, et il consacre beaucoup de temps à photographier les activités et occupations traditionnelles qui sont menacées de disparaître dans une société en évolution. Les orchestres de cuivres ont toujours été très populaires dans le Nord et le photographe nous dit que le sujet de cette photographie est «le plus vieux membre du New Mills Old Prize Band».

195

Photographer	Verner Mogensen
Camera	Pentacon Six
Film	Ilford FP4
Shutter speed	1/250
Aperture	f/11
Developer	Kodak D76
Paper	Agfa BN1

Danish photographer Verner Mogensen took this picture as one of a series on Swedish Yoga instructor Bert Jonson. Every day, we are told, Mr Jonson meditates and when he is not meditating he plays the flute.

Verner Mogensen entnahm dieses Bild seiner Serie über den schwedischen Yoga-Lehrer Bert Jonson. „Jeden Tag meditiert Mr. Jonson, und wenn er gerade nicht meditiert, dann bläst er seine Flöte.''

Le photographe danois, Verner Mogensen, a pris une série de photographies dont celle-ci du professeur de yoga suédois Bert Jonson. M. Jonson, nous dit-on, médite chaque jour et quand il ne médite pas il joue de la flûte.

196

Photographer	Verner Mogensen
Camera	Pentacon Six
Lens	180mm Sonnar
Film	Ilford FP4
Shutter speed	1/30
Aperture	f/4
Developer	Rodinal
Paper	Agfa BH1

'Straight portraiture no longer interests me,' writes Mogensen. 'But my wife is a patient model – and a good one I think.' Point proved by this amusing and attractive flash bulb lit composition.

„Einfache Porträts interessieren mich nicht mehr'', schreibt uns Mogensen. „Aber meine Frau ist ein geduldiges, und ich glaube ein gutes Modell. Beweis: dieser amüsante Blitzlicht-Schnappschuß.''

«Le portrait classique ne m'intéresse plus», écrit Mogensen, «mais ma femme est un modèle patient – et un bon modèle à mon avis!». Ce que vient prouver cette composition amusante et attrayante réalisée à la lampe-éclair.

197

Photographer	J. Whitworth
Camera	Practica
Lens	135mm
Film	Ilford FP4
Shutter speed	1/125
Aperture	f/5.6
Developer	Kodak D76

Animals and birds are regular subjects for photo contests such as *Photography* magazine's 'World of Photography'. One particularly striking submission was this shot of a barn owl and prey by a Manchester photographer.

Säugetier und Vögel sind ein immer wiederkehrendes Motiv von Teilnehmern an Fotowettbewerben, wie im Fotomagazin *World of Photographie*. Ein hervorragender Beitrag war diese Aufnahme: „Schleiereule mit Beute'' von einem Fotografen aus Manchester.

Les animaux et les oiseaux sont des sujets courants dans les concours de photographies tel que celui

organisé par le magazine «Photography», «Le Monde de la photographie». Une oeuvre particulièrement frappante était ce cliché d'un effraie et de sa proie par un photographe de Manchester.

198

Photographer	Les Rubenstein
Camera	Canonet QL17
Film	Kodak Tri-X
Shutter speed	1/250
Aperture	f/8
Developer	Promicrol

Horse bites dog. Quick thinking by Dutch photographer Rubenstein resulted in this interesting variation on an editorial cliché.

„Pferd beißt Hund''. Dieses originelle Tierfoto verdanken wir der Geistesgegenwart des dänischen Fotografen Rubenstein.

Le Cheval mord le chien. La rapidité d'esprit du photographe hollandais Rubenstein lui a permis de prendre cette variation intéressante d'un cliché de presse.

199

Photographer	Brian Duff
Camera	Nikon F
Lens	105mm
Film	Kodak Tri-X
Shutter speed	1/250
Aperture	f/4
Developer	Johnsons Fine Grain
Paper	Ilfobrom

Football has a huge following in the North of England where streets such as this abound and where the popular idols are players such as Kevin Keegan, the son of a Doncaster miner and now a Liverpool F.C. and England star. To convey this visually, Brian Duff (chief photographer of the Manchester *Daily Express*) shot from ground level to emphasize the link between Keegan and his background.

Im Norden Englands, wo Straßen oft aussehen wie diese, und wo Sportler wie Kevin Keegan Volkshelden sind, ist der Fußball sehr beliebt. Keegan ist der Sohn eines Bergarbeiters aus Lancester; er spielt jetzt im FC Liverpool. Brian Duff, Chef-Fotograf des *Manchester Daily Express*, machte dieses fast symbolische Bild aus der Froschper-spektive, damit Keegan sich besser vom hellen Hintergrund abhebt.

Le football est particulièrement populaire dans le nord de l'Angleterre où les rues comme celle-ci abondent et où les idoles du peuple sont des joueurs tel que Kevin Keegan, le fils d'un mineur de Doncaster, qui aujourd'hui joue pour le club de Liverpool et est devenu une vedette du football anglais. Pour exprimer cela visuellement, Brian Duff, premier photographe du Manchester Daily Express, a pris cette photographie au niveau du sol afin de faire ressortir le lien entre Keegan et l'arrière-plan.

200

Photographer	Bijan Baniahmad
Camera	Leica M2
Lens	28mm Elmarit
Film	Kodak Tri-X
Shutter speed	1/125
Aperture	f/4
Developer	Kodak D76
Lighting	Available and 1000 w Tungsten

Royal appreciation. Iranian photographer Bijan Baniahmad made this attractively informal picture of Her Imperial Majesty the Empress Farah studying examples of Chinese art during her official visit to the Peoples Republic.

„Kaiserliche Würdigung''. Der iranische Fotograf Baniahmad machte dieses charmante, natürliche Bild seiner „Kaiserlichen Hoheit'' Kaiserin Farah, als sie gerade chinesische Kunstblätter studierte.

Aufgenommen während ihres offiziellen Besuches in der Volksrepublik China.

Appréciation royale. Bijan Baniahmad, photographe iranien, a pris cette image d'un naturel attrayant montrant sa Majesté Impériale l'Impératrice Farah en train d'étudier des exemples de l'art chinois pendant sa visite officielle en République populaire de Chine.

201

Photographer	Peter Keen
Camera	Nikon F
Lens	105mm Nikkor
Film	Kodak Tri-X
Shutter speed	1/60
Aperture	f/4

Peter Keen is a British photojournalist with an international reputation who has made many fine contributions to these pages. This year he concentrates on literary figures, beginning with a rare photograph of Irish playwright Samuel Beckett. 'Sam', he writes, 'is one of those exceptional men who shun publicity like the plague. I was assigned to photograph him when he visited London to watch a rehearsal of his play ''End Game''. Many theatrical people said it was impossible to do. I spent a week watching him, talking to him and drinking with him. On his last day in London I produced the camera and asked the inevitable question. He hesitated for a moment and then agreed. After three or four exposures I left him to his private world.'

Peter Keen ist ein international bekannter, englischer Fotojournalist, der für diese Seiten schon ausgezeichnete Beiträge geliefert hat. Dieses Jahr porträtierte er bekannte Schriftsteller. Als erstes ein Foto des irischen Stückeschreibers Samuel Beckett. „Sam ist einer von den außergewöhnlichen Köpfen, die die Publicity scheuen wie die Pest. Ich hatte den Auftrag, ihn während seines London-Besuches, anläßlich der Proben zu seinem Stück „Endspiel'', zu fotografieren. Viele Theaterleute sagten es, daß es mir nie gelingen würde. Ich verbrachte eine ganze Woche mit ihm, sprach mit ihm, trank mit ihm. Am letzten Tage vor seiner Abreise zog ich die Kamera hervor und stellte die unvermeidliche Frage. Er zögerte für einen Augenblick, willigte dann aber ein. Nach drei oder vier Aufnahmen entließ ich ihn in seine private Welt.''

Peter Keen est un reporter photographe britannique de renommée internationale dont nous avons publié plusieurs fois dans ces pages de très bonnes photographies. Cette année, il se spécialise dans les personnalités littéraires. Et voici pour commencer une rare photographie de l'auteur de théâtre irlandais Samuel Beckett, au sujet duquel il écrit: «Sam est un de ces hommes exceptionnels qui fuient la publicité comme la peste. Je fus chargé de le photographier lorsqu'il vint à Londres pour surveiller les répétitions de sa pièce «End Game». Plusieurs personnalités du théâtre prétendaient que c'était impossible. Je l'ai observé pendant une semaine, bavardant et prenant des «pots» avec lui. Le dernier jour de son séjour à Londres, je sortis mon appareil et lui posai l'inévitable question. Il hésita un moment, puis accepta. Après trois ou quatre photos, je le quittai pour le laisser à son univers privé».

202

Photographer	Peter Keen
Camera	Nikon F
Lens	105mm Nikkor
Film	Kodachrome II
Shutter speed	1/30
Aperture	f/4

'The rich, flamboyant and mystical figure of Robert Graves is pronounced in this shot I did of him whilst working in Majorca. I arrived, unannounced and without introduction, at his house at Deya and asked if I might have a few minutes to photograph him. Robert kindly agreed. The light was failing and I had only two exposures left on my last roll of film.'

„Dieses Porträt fängt die üppige, auffällige und ausgeprägte Gestalt von Robert Graves ein. Die Aufnahme gelang mir in Mallorca. Unangemeldet

kam ich in sein Haus, und fragte, ob ich ihn ein paar Minuten lang fotografieren dürfe. Robert erlaubte es mir sehr freundlich. Das Tageslicht ließ schon nach, und auf meinem letzten Film hatte ich gerade noch 2 Belichtungen.''

Le personnage riche, flamboyant et mystique de Robert Graves est prononcé sur ce cliché que je pris alors que je travaillai à Majorque. Je me présentai sans être annoncé et sans introduction à sa maison de Deya et je lui demandai s'il pouvait m'accorder quelques minutes pour le photographier. Robert accepta aimablement. Le jour baissait et je n'avais plus que deux photos sur mon dernier rouleau ».

203

Photographer	Peter Keen
Camera	Nikon F
Lens	105mm Nikkor
Film	Kodachrome II
Shutter speed	1/60
Aperture	f/11

'Christopher Fry in his garden in Sussex. It was refreshing to meet a writer who did not advertise the fact by his appearance. He was dressed in a crisp white shirt and wore a tie and his dark blue sports jacket was neatly pressed. Beneath the business-like facade dwelt a man with a need to explore the world of dreams and spiritual planes.'

,,Christofer Fry in seinem Garten in Sussex. Wie wohltuend einen Schriftsteller zu finden, der seinen Beruf nicht schon durch seine äußere Erscheinung erraten ließ. Er trug ein frisches, weißes Hemd, eine Krawatte, und sein dunkelblaues Sportjackett war sorgfältig gebügelt. Hinter der Fassade eines Geschäftsmannes aber steckt ein Mensch, den es dazu treibt, die Welt der Träume und die Wege der Gedanken zu erforschen.''

Christopher Fry dans son jardin dans le Sussex. C'était rafraîchissant de rencontrer un écrivain qui n'annonçait pas ce fait par son apparence. Il portait une chemise blanche et une cravate et sa veste de sport bleu foncé était bien repassée. Derrière cette façade d'homme d'affaires se cachait un homme avec le besoin d'explorer le monde des rêves et des domaines spirituels.

204

Photographer	Peter Keen
Camera	Nikon F
Lens	35mm Nikkor
Film	Kodachrome II
Shutter speed	1/60
Aperture	f/16

'Georges Simenon photographed in the garden of his home near Lausanne, Switzerland. The late Cecil Day-Lewis and myself were assigned by the *Daily Telegraph Magazine* to profile Georges at home.'

Georges Simenon im Garten seines Hauses bei Lausanne/Schweiz. Der inzwischen verstorbene Cecil Day-Lewis und ich hatten vom *Daily Telegraph Magazine* den Auftrag erhalten, Simenon bei sich zu Hause zu porträtieren.

Georges Simenon photographié dans le jardin de sa maison près de Lausanne en Suisse. Cecil Day-Lewis, aujourd'hui disparu, et moi-même avions été chargés par le Daily Telegraph Magazine de réaliser un reportage sur Georges dans son foyer.

205

Photographer	Graham Finlayson
Camera	Nikon F
Lens	21mm Nikkor
Film	Kodachrome II
Shutter speed	1/8
Aperture	f/5·6

Another regular contributor both to PHOTOGRAPHY YEAR BOOK and to the *Daily Telegraph Magazine* (for which this picture was taken) is Graham Finlayson. He visited the world-famous sculptress Dame Barbara Hepworth at her home in St Ives,

Cornwall, and photographed her in a garden filled with characteristic examples of her work.

Dem Publikum des Fotojahrbuchs ist Graham Finlayson von seinen früheren Beiträgen her bekannt. Für das *Daily Telegraph Magazine* besuchte er die weltberühmte Bildhauerin Barbara Hepworth in ihrem Haus St. Ives/Cornwall. Er fotografierte sie in ihrem Garten, vor einigen charakteristischen Beispielen ihrer Arbeit.

Le travail de Graham Finlayson paraît aussi régulièrement à la fois dans l'Annuaire Photographique et dans le Daily Telegraph Magazine (pour lequel il a pris cette photographie). Il est allé rendre visite à la célèbre femme sculpteur, Barbara Hepworth, dans sa maison de St. Ives en Cornouaille et il l'a photographiée dans un jardin rempli d'exemples caractéristiques de son oeuvre.

206

Photographer	Graham Finlayson
Camera	Nikon F
Lens	180mm Nikkor
Film	Kodachrome II
Shutter speed	1/30
Aperture	f/2.8

A stylish colour study of model Lolly Boxer, about whom the photographer comments: 'Lolly is to be seen in quite a lot of fashion magazines. She has a house in the country where she breeds dogs, and is married to a stockbroker.'

Eine stilvolle Farbstudie mit dem Fotomodell Lolly Boxer. ,,Lolly findet man in vielen Modejournalen. In einem Haus auf dem Lande unterhält sie eine Hundezucht; ihr Mann ist Börsenmakler.''

Une étude en couleur pleine d'élégance du mannequin Lolly Boxer, sur laquelle le photographe écrit: « On peut voir Lolly dans un grand nombre de magazines de mode. Elle a une maison à la campagne où elle élève des chiens; elle est mariée à un courtier en bourse».

207

Photographer	Jochen Harder

Born in Munich in 1940, Jochen Harder grew up with cameras, since both his father and grandfather were photographers. For many years he worked for *Jasmin* magazine and is now associated with the Appollon Agency which specializes in producing creative photographic concepts for use in advertising and magazine editorial. Typical of his imaginative approach is this soft focus figure study taken in the 35mm format.

Jochen Harder, 1950 in München geboren, ist mit der Kamera groß geworden. Sowohl sein Vater, als auch sein Großvater waren Fotografen. Er arbeitete jahrelang für die Zeitschrift *Jasmin*, und ist jetzt bei der Agentur *Apollo*. Diese Agentur spezialisiert sich auf kreative Fotografie für Anzeigen und Zeitschriften. Typisch für seinen phantasievollen Stil ist diese weiche Körperstudie, aufgenommen im 35 mm Kleinbildformat.

Né à Munich en 1940, Jochen Harder a grandi entouré d'appareils puisque son père et son grand-père étaient photographes. Il a travaillé pendant longtemps pour le magazine Jasmin et il est maintenant associé à l'Agence Appollon qui est spécialisée dans la production d'idées photographiques originales pour la publicité et les magazines. Cette étude en flou en 35mm est caractéristique du style imaginatif de Harder.

208

Photographer	Michel Kempf
Camera	Nikon
Lens	135mm Novoflex
Film	Kodak Aero Ektachrome Infra-red
Shutter speed	1/60
Aperture	f/8
Lighting	Umbrella flash

Young Paris photographer Michel Kempf has a flair for design which he uses to great effect in his colour photography. A prism was used to create this picture and since a previous contribution to PHOTOGRAPHY YEAR BOOK was also a nude (solarized), we hasten to assure readers that his portfolio of transparencies covers a much wider subject spectrum.

Der junge, in Paris lebende Fotograf Michel Kempf hat ein großes Talent für Formen- und Farbendesign, das er bei seinen Farbfotos mit großem Erfolg anwendet. Für dieses Bild hat er ein Prisma benutzt. Da ein früherer Beitrag für das Fotojahrbuch ebenfalls ein Aktfoto war, beeilen wir uns hiermit festzustellen, daß seine Farbdia-Sammlung noch weitaus mehr Themen behandelt.

Le jeune photographe parisien, Michel Kempf, a un talent particulier pour le design dont il tire les meilleurs effets dans ses photographies en couleur. Pour créer cette image il a utilisé un prisme. Une de ses précédentes contributions à l'Annuaire étant également un nu (solarisé) nous nous empressons de dire que son dossier de diapositives couvre une gamme de sujets beaucoup plus large.

209

Photographer	Morris Newcombe

Kabuki Theatre by Morris Newcombe, a British photographer with an international reputation for his camera coverage of stage events and personalities. About his recent work he writes: 'During the summer of 1972, over a period of three weeks, London had the pleasure of three unusual visiting theatre groups, two for the first time. The KATHAKALI visited the Aldwych and I went to photograph the actors making up. This in itself is unusual as they take up to six hours and the last stages are put on by a make-up artist with the actor lying on his back. In India the performance takes place at night and I decided to concentrate on very simple photographs.

'Then the CHAU warrior dancers visited the Sadlers Wells theatre and I eventually paid five visits, working from the wings, and to arrest some of the movement I rated the film at 1000 ASA.

'Finally the Japanese theatre represented itself with an important group, the KABUKI theatre, which is very specialised. This was the first ever visit by such a group to this country. The Japanese asked me to photograph the show for publicity in Japan which was an honour I had to decline as they wanted all the transparencies to go to Japan and I like to retain control over my editorial work. This is the first time, therefore, that any of these pictures have been published.'

,,Kabuki'' von Morris Newcombe, einem britischen Fotografen mit internationalem Ruf für Aufnahmen von Theateraufführungen und bekannten Persönlichkeiten. Über seine letzte Arbeit schreibt er: ,,Im Sommer 1972 waren in London drei ungewöhnliche Theatergruppen zu Gast. Zwei davon kamen zum ersten Male. Ich besuchte die Kathakali-Gruppe im Aldwych-Theater, um die Schauspieler beim Schminken zu fotografieren. Die Schminkvorgänge sind ungewöhnlich lang: bis zu sechs Stunden. Die letzte Vollendung besorgt der Maskenbildner, dabei liegt der Schauspieler auf dem Rücken. In Indien finden die Aufführungen nachts statt, und ich beschloß, nur ein paar ganz einfache Aufnahmen zu machen.

Die Chau-Kriegstänzer gastierten im Sadlers Wells Theater, das ich schließlich fünf mal besuchte. Ich arbeitete von den Seitenbalkonen aus. Um die Bewegungen festzuhalten, benutzte ich einen 1000 ASA Film.

Schließlich wurde das japanische Theater noch durch die bedeutende Kabuki-Gruppe vertreten, erstmals sah das Londoner Publikum eine solche Gruppe aus Japan. Die Japaner baten mich, ihre Aufführung für eine Veröffentlichung in Japan zu fotografieren. Diese Ehre mußte ich leider abschlagen, da dann alle Originale nach Japan gegangen wären, ich jedoch über meine Veröffenlichungen jeweils selbst entscheiden möchte. Es ist daher das erste Mal, daß einige dieser Bilder veröffenlicht werden.''

Le théâtre Kabuki par Morris Newcombe, photographe britannique de réputation internationale pour ses photographies de spectacles et d'acteurs. Il écrit au sujet de ses dernières oeuvres: «Au cours de l'été 1972, sur une période de trois semaines, Londres a eu le plaisir de recevoir trois groupes théâtraux inhabituels, deux d'entre eux pour la première fois.

«Le Kathakali fut reçu au théâtre d'Aldwych et je m'y rendis pour photographier le maquillage des artistes. Cela est en soi assez extraordinaire puisqu'il faut plus de six heures et que les dernières touches sont posées par un artiste maquilleur, l'acteur étant allongé sur le dos. En Inde le spectacle a lieu la nuit et je m'en suis tenu à des photographies très simples.

«Ensuite les danseurs guerriers du Chau firent des représentations au théâtre de Sadler's Wells où je me rendis cinq fois et travaillai à partir des coulisses; pour saisir le mouvement j'utilisai un film d'une rapidité de 1.000 ASA.

«Enfin, le théâtre japonais fut représenté par un groupe important de théâtre Kabuki, spectacle très spécialisé. C'était la première fois qu'un groupe Kabuki venait en Grande-Bretagne. Les Japonais me firent l'honneur de me demander de photographier le spectacle pour faire de la publicité au Japon. Je dus refuser car ils voulaient que toutes mes diapositives soient envoyées au Japon et je tiens à conserver un droit de regard sur la publication de mon travail. Ces photographies sont donc publiées ici pour la première fois».

210

Photographer	Morris Newcombe

The General (Philip Locke) and the girl (Helen Mirren) in a scene from The Royal Shakespeare Company's production of *The Balcony* at London's Aldwych Theatre.

Der General (Philip Locke) und das Mädchen (Helen Mirren) in dem von der *Royal Shakespeare Company* aufgeführten Stück „The Balcony" im Londoner Aldwych-Theater.

Le général (Philip Locke) et la jeune fille (Helen Mirren) dans une scène du «Balcon» par la Royal Shakespeare Company au théâtre d'Aldwych à Londres.

211

Photographer	Russell J. Workman
Camera	Nikon F
Lens	28mm
Film	Kodak Tri-X
Shutter speed	1/250
Aperture	f/11

A shipwreck, this time by Australian photographer Russell J. Workman. Added interest has been given to the composition by the placement of the two onlookers and Workman informs us that the vessel itself was a ferry which ran aground at Trial Bay, New South Wales, and was later destroyed by surf.

Noch ein Schiffswrack. Diesmal von dem australischen Fotografen Workman. Besonders interessant wirkt es durch die beiden Betrachter im Vordergrund. Der Fotograf teilt uns hierzu mit, daß dieses Wrack eine Fähre war, die in der Trial-Bay, New Southwales auf Grund gelaufen und später von der Brandung zerstört worden war.

Un autre naufrage, ici par le photographe australien Russel J. Workman. Il ajoute à l'intérêt de la composition en plaçant deux spectateurs et Workman nous informe que le vaisseau était un bac qui avait échoué dans la baie de Trial, en Nouvelles Galles du Sud, et qui fut par la suite détruit par le ressac.

212/215

Photographer	Hans W. Silvester

These photographs by the well-known French photographer Hans W. Silvester are from a project on which he was recently engaged to record impressions of the Children of Peru. It is interesting to compare them with the work of F. Stoppelman in Panama (plates 48–55) but unfortunately no other background information or technical data was available at the time of writing.

Diese Aufnahmen des bekannten französischen Fotografen Silvester stammen aus seiner Reportage über die Kinder Perus. Es ist interessant, sie mit den Arbeiten von Stoppelmann in Panama (Bilder 48–55) zu vergleichen, doch fehlen zu dieser Einsendung leider Bildtexte und technische Angaben.

Ces photographies du photographe français bien connu Hans W. Silvester font partie d'un projet qu'il a réalisé récemment sur les enfants du Pérou. Il est intéressant de les comparer à celles de F. Stoppelman au Panama (Planches 48/55) mais malheureusement nous n'avions aucun autre renseignement ou donnée technique au moment de rédiger.

216

Photographer	Ed Busiak
Camera	Nikon FTN Photomic
Lens	200mm Nikkor
Film	Ilford FP4
Shutter Speed	1 sec.
Aperture	f/11
Developer	Ilfosol
Paper	Ilfobrom Grade 3

Television designer Ed Busiak made this interesting self portrait in a maze of metal racking. He calls it 'Searching', and used the self-timer on his Nikon FTN to include himself in the composition.

Der Fernseh-Designer Ed Busiac machte dieses ungewöhnliche Selbstportrait inmitten eines Metall-Wirrwarrs. Er nennt es „Suche". Um sich selbst mit auf das Bild zu bekommen, benutzte er den Selbstauslöser.

Ed Busiak, «designer» de téléviseur, a pris cet auto-portrait curieux dans un labyrinthe de rayons métalliques. Il l'appelle «Recherche» et il a utilisé le déclencheur automatique de son Nikon FTN pour se prendre lui-même dans ce décor.

217

Photographer	Stan Winer
Camera	Canon FT
Lens	105mm
Film	Kodak Tri-X
Shutter speed	1/125
Aperture	f/8
Developer	Microdol-X

Strong backlighting and contrasty printing were used to produce this picture of two women refugees from Portuguese bombing in flight across a shallow river on the border between Malawi and Mozambique.

Starkes Gegenlicht und ein starker hell-dunkel Kontrast sind besondere Kennzeichen dieses ergreifenden Bildes. Es zeigt zwei Flüchtlingsfrauen, die versuchen, den seichten Fluß an der Grenze zwischen Malawi und Mosambique zu überqueren, um dem portugiesischen Bombardement zu entkommen.

Un fort éclairage de fond et une impression contrastée ont permis d'obtenir cette image de deux femmes réfugiées qui, pour fuir les bombes portugaises, traversent ici une petite rivière à la frontière entre le Malawi et le Mozambique.

218

Photographer	James R. Rudin
Camera	Asahi Pentax
Lens	55mm Super Takumar
Film	Kodak Plus-X
Shutter speed	1/250
Aperture	f/16
Developer	Kodak D76

More fortunate is this young bather, enjoying the sun, sea and sand of the island of Grenada in the West Indies.

Viel besser dran ist dieser badende Junge, der sich auf der Insel Granada in West-Indien im Sommer in Sonne, See und Sand tummelt.

Ce jeune baigneur a davantage de chance; il profite du soleil, de la mer et du sable sur l'île de Grenada aux Antilles.

219

Photographer	Paul E. Sheldon
Camera	Practika Super TL
Lens	28mm Hanimex
Film	Kodak Tri-X
Shutter speed	1/250
Aperture	f/8

The De Havilland Tiger Moth is one of the best-loved biplanes ever built and many are still flown by enthusiasts. Photographer Paul E. Sheldon is one of them and took this fine self portrait (including in it his pilot friend Dick Sherwin) while their Moth was being used as a glider tug at the London School of Gliding, Dunstable.

Die „De-Havilland-Tiger-Moth" ist eines der beliebtesten 2-Mann-Sportflugzeuge, das je gebaut wurde. Noch heute wird es von Enthusiasten geflogen. Der Fotograf Paul E. Sheldon ist einer von Ihnen, und er schoß dieses Bild, das ihn zusammen mit seinem Freund Dick Shervin zeigt. Ihre „Motte" wurde damals in der Londoner Segelfliegerschule als Anschleppmaschine benutzt.

Le De Havilland Tiger Moth est parmi tous les biplans l'un des plus appréciés et il y en a encore beaucoup d'utilisés par des enthousiasts. Le photographe Paul E. Sheldon est l'un d'eux et il a pris ce très bel autoportrait (où apparaît également son ami le pilote Dick Sherwin) alors que son biplan remorquait un planeur à l'école de vol à voile de Londres à Dunstable.

220

Photographer	Brian H. Lawrence
Camera	Hasselblad
Lens	250mm Sonnar
Film	Ilford HP4
Aperture	f/22

An indication of how much flying has grown since the days of wood, fabric, and fresh air, is this time exposure, 'Flight Pattern', by Brian H. Lawrence. The location is the international airport at Hong Kong, where he was serving with the Royal Air Force, and the streaks of light were painted on his film by aircraft taking off and landing. The lens was capped between movements.

Vom Fortschritt der Luftfahrt zeugt dieses Foto mit dem Titel „Flight-Pattern", das Brian H. Lorenz mit Langzeitbelichtung gemacht hat. Ort der Aufnahme ist der internationale Flughafen von Hongkong, auf dem Lorenz bei der *Royal Air Force* stationiert war. Die Lichtstreifen entstanden durch die startenden und landenden Flugzeuge. Zwischen den Flugbewegungen war während dieser langen Zeitaufnahme die Linse abgedeckt.

Cet instantané, «motif aérien» par Brian H. Lawrence, montre à quel point l'aviation a évolué depuis l'époque du bois, des voiles et de l'air frais. Le photographe a pris ce cliché à l'aéroport international de Hong Kong où il servait dans la Royal Air Force; les raies de lumière ont été peintes sur son film par les avions qui décolaient et attérissaient. L'objectif était couvert entre les mouvements.

221

Photographer	Denis Thorpe
Camera	Nikon F
Lens	200mm Nikkor
Film	Kodak Tri-X
Shutter speed	1/1000
Aperture	f/4
Developer	Johnsons Fine Grain

'I luckily happened to be at the British Aircraft Corporation Factory at Preston when they decided to try out the Anglo-French Jaguar for the first time,' writes Denis Thorpe. 'The Seagull was just an extra bonus.'

zufällig war ich gerade an der Flugzeug-Werft der British Aircraft-Corporation bei Preston, als man sich dort entschloß, den englisch-französischen Jaguar auszuprobieren'', schreibt uns Dennis Thorpe. ,,Die Möwe am Bildrand war noch eine kleine Zugabe.''

J'ai eu la chance de me trouver à l'usine de la British Aircraft Corporation à Preston lorsqu'ils décidèrent d'essayer le Jaguar franco-britannique pour la première fois» écrit Denis Thorpe. «La mouette m'a été donnée en surplus.»

222

Photographer	Bryn Campbell
Camera	Nikon F
Film	Kodak Tri-X

Award-winning British photojournalist Bryn Campbell made this picture in the Caribbean while on a news assignment for *The Observer* newspaper. He noticed two paras indulging in a little 'chatting up' with a reticent local girl and immediately took the opportunity of recording what he regards as 'a faintly comic episode in the history of British gunboat diplomacy'.

Der britische Fotojournalist und Preisgewinner Brian Champbell nahm die Gelegenheit wahr und machte diesen Schnappschuß auf den Karibischen Inseln, wo er als Bilderichterstatter für die Zeitung *The Observer* arbeitete. Er beobachtete 2 Soldaten, wie sie mit einem schüchternen Mädchen im Geplänkel begannen und hielt fest, was sich hier als recht ungewöhnliche Episode in der Geschichte der britischen Kanonenboot-Diplomatie bot.

Le reporter photographe britannique, gagnant de concours, Bryn Campbell a pris cette photographie aux Caraïbes alors qu'il effectuait un reportage pour le journal The Observer. Il remarqua ces deux paras en train de «baratiner» gentiment une jeune indigène réticente et il saisit immédiatement cette occasion de prendre ce qu'il considère comme «un épisode légèrement comique de l'histoire de la diplomatie britannique au bout du fusil».

223

Photographer	Mogens Lerche Madsen
Camera	Leica
Lens	Summicron
Film	Ilford HP4
Shutter speed	1/30
Aperture	f/8
Developer	Rodinal
Paper	BN 111

The gaiety and movement of this picture by Danish photographer Madsen resulted in its exhibition at a Polish photo salon. Entitled 'goodbye', it now finds a place in PHOTOGRAPHY YEAR BOOK for the same reasons.

,,Good bye'' – die fröhliche Bewegung dieses Bildes vom dänischen Fotografen Madsen führte zu seiner Ausstellung in einem polnischen Fotosalon. Aus dem gleichen Grunde findet es nun einen Platz im Foto-Jahrbuch.

Pour sa gaité et son mouvement cette photographie du Danois Mogens Lerche Madsen fut choisie pour être exposée à un salon de la photographie en Pologne. Intitulée «Au revoir», cette image trouve sa place dans l'Annuaire Photographique pour ces mêmes qualités.

224

Photographer	E. George Schwarz
Camera	Mamiya C330
Lens	80mm
Film	Agfa Isopan 1SS
Shutter Speed	1/60
Aperture	f/8
Developer	Rodinal

One of a series of black and white and colour pictures and stanzas of verse entitled 'The Song Oblivion', which is described by the photographer as 'an allegorical confrontation between the Time Wind and a human female on a Pacific beach'. E. George

Schwarz was born in Zurich and obtained his professional training and experience in Switzerland. A world traveller, he has expressed himself through painting, sculpture, lithography and prose, but now inclines toward cinematography and photography, with emphasis on colour. He lectures at the National Art School, Sydney, Australia.

,,The Song Oblivion'' heißt eine neue Sammlung, die sich aus Schwarz-Weiß-Fotos, Farbfotos und Versen zusammensetzt. Der Fotograf beschreibt sie als ,,eine allegorische Konfrontation zwischen dem Zeitwind und einer jungen Frau am Strande des Pazifiks''. E. G. Schwarz wurde in Zürich geboren und erhielt seine berufliche Ausbildung und Erfahrung in der Schweiz. Er ist durch die Welt gereist und hat sich in Malerei, Bildhauerei, Lithografie und Schriftstellerei betätigt. Jetzt zieht es ihn zu Film und Fotografie, besonders zur Farbfotografie. Er unterrichtet an der *National-Art-School* in Sidney, Australien.

Cliché appartenant à une série de photos en noir et blanc et en couleur et de petits poèmes intitulée «La chanson de l'oubli» que le photographe décrit comme une confrontation allégorique entre le Vent Temps et une femme sur une plage du Pacifique. E. George Schwarz est né à Zürich et a acquis sa formation et son expérience en Suisse. Il a voyagé dans le monde entier et il s'est exprimé au moyen de la peinture, de la sculpture, de la lithographie et de la prose, mais il semble s'orienter maintenant vers la photo et le cinéma en s'attachant tout particulièrement à la couleur. Il enseigne à l'Ecole nationale d'art à Sydney en Australie.

225

Photographer	Gunnar Forsell
Camera	Hasselblad 500C
Lens	Zeiss Planar
Film	Kodak Tri-X
Shutter speed	1/30
Aperture	f/2.8
Developer	Kodak D76
Paper	Agfa Bromide

A boldly composed industrial subject by the well-known Swedish photographer Gunnar Forsell, taken in a wood processing factory. The flexible tubing is for sawdust extraction and anyone who has heard the noise made by power saws and planes will readily appreciate why the operator is wearing ear protectors.

Kühn komponiertes Industriefoto von dem bekannten schwedischen Fotografen Gunnar Forsell, aufgenommen in einer holzverarbeitenden Fabrik. Das bewegliche Rohrsystem dient zum Ansaugen des Holzstaubes. Wer jemals den Lärm der automatischen Holzsägen und -hobel gehört hat, wird verstehen, warum der Mann an diesen Maschinen Ohrenschützer trägt.

Un sujet industriel traité d'une façon hardie par le photographe suédois bien connu Gunnar Forsell. Il a pris ce cliché dans une usine de transformation du bois: le tube flexible sert à l'extraction de la sciure et quiconque connaît le bruit que font les scies et rabots électriques comprendra tout de suite pourquoi cet ouvrier a les oreilles protégées.

226

Photographer	Gunnar Forsell
Camera	Hasselblad 500C
Lens	50mm Zeiss Distagon
Film	Kodak Tri-X
Shutter speed	1/250
Aperture	f/16
Developer	Kodak D76
Paper	Agfa Bromide

An equally attractive vertical composition by the same photographer, 'The Wood Way', taken in Vasterbotten, Sweden.

,,Der Holzweg''. Ein Foto desselben Fotografen, aufgenommen in Vasterbotte/Schweden.

Une composition verticale également intéressante du

même photographe, intitulée «Le chemin du bois» et prise à Västerbotten en Suède.

227

Photographer	Richard Reed
Camera	Nikon F
Lens	28mm
Film	Ilford HP4
Shutter speed	1/250
Aperture	f/8
Developer	Johnsons Fine Grain
Paper	Ilfrobrom

'A penny-farthing fanatic', writes Richard Reed, 'who rides it around his village in Berkshire and stops off for a pint'. A 'penny-farthing' was an early type of cycle and a farthing was Britain's smallest non-decimal coin. Both, alas, are now extinct.

,,Hier ein Penny-Farthing-Fan,'' schreibt Richard Reed, ,,der um sein Dorf in Yorkshire radelt und hie und da zu einem Gläschen stoppt. Ein Penny-Farthing ist eines der ersten Fahrradtypen und ein Farthing war Englands kleinste Münze. Beides ist – leider – heutzutage verschwunden.''

«Un fanatique du «Penny-Farthing» qui se promène dans son village du Berkshire et s'arrête pour boire un coup» explique Richard Reed. Le «Penny-Farthing» était le nom donné en Angleterre au vélocipède; un «farthing» était la plus petite pièce de monnaie britannique non décimale. Le vélocipède et le farthing ont malheureusement tous deux disparu.

228

Photographer	Richard Reed
Camera	Nikon F
Lens	105mm
Film	Ilford HP4
Shutter speed	1/500
Aperture	f/5.6
Developer	Johnsons Fine Grain
Paper	Ilfrobrom

With his camera shutter set at 1/500, Reed stopped Windsor Safari Park's whale trainer Doug Cartridge in mid-flight as the latter dived off the back of 'Ramu', the park's killer whale.

Seine Kamera auf ein 1/500 sec. eingestellt, hielt Reed den Walfischtrainer des Windsor-Safari-Parks, Doug Cartridge, mitten im Flug fest, als dieser gerade vom Rücken des ,,Killerwals Ramu'' wegtauchte.

Avec son appareil mis au point à 1/500ème Reed saisit le dresseur de baleine du Windsor Safari Park, Doug Cartridge, en plein vol alors qu'il vient de plonger du dos de «Ramu», l'épaulard du parc.

229

Photographer	Antony Trusty
Camera	Zorki 4
Lens	50mm Jupitor
Film	Ilford FP4
Shutter speed	1/1000
Aperture	f/2
Developer	Microphen

It would be very easy to fill any volume such as this with pictures of death and disaster since it is a sad fact that good news is not supposed to sell newspapers. People have always been morbidly fascinated by the misfortunes of others and so, since the earliest days of photography, there have always been photographers ready and willing – often at considerable risk – to satisfy this interest. However one may deplore such a motivation, much remains to be admired in some examples of this kind of photography even though it must be admitted that luck – if that is the right word – plays a crucial part in it.

Photographically speaking, Durham photographer Antony Trusty was 'lucky' when a man decided to leap to his death from a Teeside transporter bridge while he was in the vicinity with a loaded camera. Not so easy to define is the cool detachment which enabled him to freeze the victim on film split seconds after he had observed the tiny figure launch itself into space.

Man könnte leicht einen Band wie diesen mit Bildern über Todesfälle und Katastrophen füllen, denn es ist eine traurige Wahrheit, daß sich gute Nachrichten schlecht verkaufen lassen. Die Menschen waren immer vom Unglück anderer fasziniert, und die Fotografen immer dazu bereit, oft unter größtem Risiko, diese Sensationslust zu befriedigen. Wenn man auch die Motive bedauern mag, so ist doch bei dieser Art von Fotografie noch viel Bewundernswürdiges zu finden, obwohl natürlich das Glück (falls man dies Wort benutzen will) meist eine große Rolle spielt. Fotografisch gesprochen hatte Fotograf Anthony Trusty aus Durham das „Glück" sich mit geladener Kamera in der Nähe aufzuhalten, als ein Mann von einer Transportbrücke herab in den Tod sprang. Es ist nicht leicht, die schnelle Auffassungsgabe des Fotografen zu verstehen, der blitzartig (nur wenige Sekunden nach dem Wahrnehmen) diese winzige Gestalt im Fall auf dem Film festhielt.

Il serait facile de remplir un album comme celui-ci d'images de mort et de désastre puisqu'il est tristement vrai que ce ne sont pas en général les bonnes nouvelles qui font vendre les journaux. Les gens sont toujours fascinés d'une façon morbide par les malheurs des autres et c'est pourquoi depuis les premiers jours de la photographies il y a toujours eu des photographes prêts à satisfaire cet interêt, souvent au prix de risques considérables. On peut déplorer une telle motivation, mais il n'en demeure pas moins qu'il y a de nombreux exemples de ce genre de photographie dignes d'être admirés même s'il faut reconnaître que la chance, si c'est là le mot juste, y a une part essentielle. Photographiquement parlant, le photographe de Durham, Antony Trusty, a eu de la « chance » lorsque cet homme décida de se jeter du haut d'un pont transbordeur sur le Teeside alors qu'il se trouvait lui-même sur place avec un appareil chargé. Ce qu'il n'est pas si facile à définir c'est le sang-froid qui lui a permis de fixer la victime sur son film quelques fractions de seconde après qu'il ait aperçu la minuscule silhouette de l'homme qui se lançait dans l'espace.

230

Photographer	R. G. Bradbury
Camera	Nikon F
Lens	280mm Novoflex
Film	Kodak Tri-X
Shutter speed	1/500
Aperture	f/8
Developer	P.Q. Universal

The fatal crash of Prince William of Gloucester and his co-pilot seconds after their light plane had taken off in an air race at Halfpenny Green Airfield, Wolverhampton, was headline news, even though few of the cameramen present were able to do more than photograph the wreckage afterwards. In this case the 'lucky' exception was quick-witted R. G. Bradbury of the Wolverhampton Express and Star who captured the moment of impact from a mile away with the 280mm Novoflex fitted to his Nikon F and subsequently improved the contrast of the resulting print by making a copy of it on Grade 4 paper.

Der tragische Absturz Prinz Wilhelms von Gloucester und seines Co-Piloten, wenige Sekunden nachdem sich ihre leichte Maschine zu einem Wettflug in die Luft erhoben hatte, machte Schlagzeilen. Den meisten Kameraleuten, die sich zur Zeit des Absturzes am Green-Airfield bei Wolverhampton aufhielten, gelangen nach dem Absturz ein paar Bilder von den zerstörten Flugzeugteilen. Eine Ausnahme machte der geistesgegenwärtige R. G. Bradbury vom Wolverhampton Express and Star, der den Unglücksmoment mit seinem 280mm-Nuroflex-Objektiv (an einer Nikon F) aus 1 Meile Entfernung aufnahm und das Ergebnis dann noch verbesserte, indem er den Abzug auf sehr kontrastreichem Papier (Grad 4) vornahm.

L'accident d'avion dans lequel le Prince William of Gloucester et son co-pilote trouvèrent la mort quelques secondes après le décolage de leur petit avion lors d'une course aérienne au terrain d'aviation de Halfpenny Green à Wolverhampton. Cet accident

fit la une dans la presse malgré le fait que peu parmi les reporters présents furent en mesure de prendre autre chose que l'avion écrasé au sol. Dans le cas présent, celui qui eut de la « chance » fut un photographe à l'esprit rapide, R. G. Bradbury du journal Express and Star de Wolverhampton. Il réussit à saisir l'instant du choc à une distance d'environ un kilomètre cinq cents avec l'objectif Novoflex 280mm sur son Nikon F et il améliora par la suite le contraste du cliché en en faisant une copie sur papier Grade 4.

231

Photographer	J. Clare
Camera	Nikkormat
Film	Kodak Tri-X
Shutter speed	1/250
Aperture	f/5.6

The love affair between man and motor-car has all the ingredients, from comedy to tragedy, of more natural relationships — all of which were covered by submissions to the YEAR BOOK and of which this spread is representative. Our first example was taken on the famous Veteran car run to Brighton and shows a very sick old vehicle indeed.

Die Liebesaffaire zwischen Mann und Auto kennt viele Variationen: Von der Kommödie bis zur Tragödie. In den Einsendungen zum Jahrbuch kamen sie alle vor: hier ein repräsentativer Querschnitt. Unser erstes Bild wurde während des Veteranen-Autorennens nach Brighton aufgenommen und zeigt ein wirklich todkrankes Automobil.

L'histoire d'amour entre l'homme et l'automobile a toutes les caractéristiques, de la comédie à la tragédie, de rapports plus naturels — toutes caractéristiques qui ont été illustrées dans l'Annuaire et dont cette planche est représentative. Notre premier exemple a été pris lors de la célèbre course de vieilles voitures jusqu'à Brighton et il s'agit en effet d'un véhicule bien malade.

232

Photographer	Howard Walker
Camera	Asahi Pentax
Lens	135mm
Film	Kodak Tri-X
Shutter speed	1/250
Aperture	f/4
Developer	Kodak D76

That traffic jams can have compensating advantages is seen from this shot, captioned 'Festive Spirit', taken in Wolverhampton, Staffordshire.

Verkehrsstauungen können auch freundliche Seiten haben, wie dieser Schnappschuß mit dem Titel „heitere Stimmung" aus Wolverhampton/ Staffordshire zeigt.

Que les embouteillages puissent avoir leurs avantages est bien mis en évidence par ce cliché intitulé « Esprit en fête » et pris à Wolverhampton dans le Staffordshire, en Angleterre.

233

Photographer	John D. Burke
Camera	Asahi Pentax
Film	Ilford Pan F

Nor are roads always necessary. This Dune Buggy race took place on Pismo beach, California.

Straßen sind manchmal unnötig. . . . Dieses Sandrennen fand an der Pismo-Küste in Californien statt.

Les routes ne sont pas non plus toutes nécessaires. Cette course de « Dune Buggy » a eu lieu sur la plage de Pismo en Californie.

234

Photographer	A. H. Tutton
Camera	Asahi Pentax
Lens	105mm Super Takumar
Film	Kodak Plus-X
Shutter speed	1/125
Aperture	f/2.8
Developer	Microdol-X

And this pleasant jaunt, 'Bumper Fun' — with two drivers sharing the wheel — on a dodgem circuit.

Ein Riesenspaß — die Fahrt im Autoscoter. Un agréable petit tour en auto tamponneuse — avec deux conducteurs au volant.

235

Photographer	Graham Finlayson
Camera	Nikon F
Lens	500mm Mirror
Film	Kodak Tri-X
Shutter speed	1/30
Aperture	f/8
Developer	Promicrol
Paper	Ilfobrom

Roads are not always straight — particularly when compressed by a telephoto lens. This one was used in England's Lake District to provide another contribution by well-known photojournalist Graham Finlayson.

Daß Straßen nicht immer gerade sind, beweist der bekannte Bildjournalist Graham Finlayson. Aufgenommen in Englands Lake-District, mit Teleobjektiv.

Les routes ne sont pas toujours droites, surtout lorsqu'elles sont compressées par un téléobjectif. Celui-ci a été utilisé dans la Région des Lacs en Angleterre pour produire cette nouvelle contribution du reporter photographe bien connu Graham Finlayson.

236

Photographer	R. F. B. Shone
Camera	Rolleiflex
Film	Kodak Tri-X
Developer	Acutol

End of the road. A graphic lith tone separation by Shrewsbury photographer Shone which he calls 'Statistic'.

Ende der Straße. Ein hartes Bild, betitelt „Die Statistik".

Fin de route. Une séparation graphique intitulée « Statistique » par le photographe de Shrewsbury, Shone.

237

Photographer	G. Batty
Camera	Minolta SRT 101
Lens	100mm
Film	Ilford FP4
Aperture	f/16
Developer	Unitol

Let us confess that this plate consists of two electronic flash exposures of a robin submitted as separate prints by Leeds photographer Batty which we were unable to resist using as a facing pair.

Wir geben zu, daß wir dieses reizvolle Bild aus zwei verschiedenen Aufnahmen des gleichen Rotkehlchens, die uns Fotograf Batty aus Leeds zugesandt hat, zusammengesetzt haben. Wir konnten nicht widerstehen, daraus ein sich gegenübersitzendes Pärchen zu machen.

Avouons tout d'abord que cette planche se compose de deux photographies d'un rouge-gorge prises au flash électronique qui nous ont été présentées séparément par le photographe de Leeds, Batty, mais nous n'avons pu. résister à l'envie de les utiliser comme une paire face à face.

238

Photographer	Guy Gorget
Camera	Nikon FTN
Lens	200mm Nikkor
Film	Ilford HP4
Shutter speed	1/125
Aperture	f/8
Developer	D76

The answer, perhaps, to critics who have complained that PHOTOGRAPHY YEAR BOOK mirrors too much of the world's unhappiness, and further proof that superb photography can result from locations no farther away than the nearest clump of wild flowers — even in dull weather such as the photographer tells us existed when he took this picture, 'Les Coquelicots'.

„Jenen Kritikern, die es falsch finden, daß Fotojahrbücher zu viel Elend widerspiegeln, soll dieses Bild als Trost dienen. Es beweist außerdem, daß man für eine hervorragende Aufnahme nicht weiter zu gehen braucht, als zum nächsten Büschel Feldblumen – und sei es bei schlechtem Wetter, wie zur Zeit dieser Aufnahme," meint Fotograf Guy Gorget.

Peut-être une réponse aux critiques de ceux qui se plaignent de ce que l'Annuaire Photographique reflète trop largement les malheurs du monde et une nouvelle preuve que l'on peut réaliser une magnifique photographie sans chercher au-delà du bouquet de fleurs sauvages le plus proche, et cela même par un temps triste comme celui qui régnait lorsque le photographe prit cette photo, « Les Coquelicots ».

239

Photographer	Guy Gorget
Camera	Nikon FTN
Lens	Micro Nikkor
Film	Ilford FP4
Shutter speed	1/60
Aperture	f/5.6
Developer	Kodak D76

Guy Gorget of Orleans, France, also took this butterfly close up, which he titles 'Summertime'.

Er machte auch diese Nahaufnahme eines Schmetterlings, die er „Sommer" nannte.

Egalement de Guy Gorget, d'Orléans, ce gros plan d'un papillon qu'il intitule « Eté ».

240

Photographer	Michael Gnade
Camera	Leica M3
Lens	50mm Summicron
Film	Kodak Tri-X
Shutter speed	1/125
Aperture	f/2.8
Developer	Neofin
Paper	Agfa

It is perhaps fitting that the last image in PHOTOGRAPHY YEAR BOOK 1974 should be that of an image maker in the round, for the best photographs are always those which seek more than the surface impression and attempt to give a deeper vision of man and his world. Here an art training is of far more value than the mere acquisition of a technical facility – although this Dusseldorf art student seems intent on gaining both.

Wir entschieden, daß dieses Bild der letzte Eindruck des Fotojahrbuches 1974 sein sollte. Die besten Bilder sind meistens jene, die außerhalb des Sichtbaren Tiefe besitzen, die unser Innerstes berühren und unser Leben bereichern. Auch halten wir Bereicherungen im Künstlerischen für wertvoller, als die bloße Aneignung technischen Wissens. – Obwohl dieser Düsseldorfer Student beides zu begreifen versucht.

Il est peut-être tout-à fait approprié que la dernière image de l'Annuaire Photographique 1974 soit celle d'un créateur d'images par excellence, car les meilleurs photographes sont toujours ceux qui cherchent au delà de l'impression superficielle et essaient de donner une vision plus profonde de l'homme et de son monde. Ici une formation artistique est beaucoup plus utile que l'acquisition d'une certaine facilité technique – bien que cet étudiant des beaux-arts de Düsseldorf semble bien déterminé à acquérir les deux.

Front Endpaper

Photographer	Rolf M. Aagaard
Camera	Nikon F
Lens	200mm Nikkor
Film	Kodak Tri-X
Shutter speed	1/500
Aperture	f/16

In addition to his remarkable colour pictures of the Icelandic volcanic eruption (plates 29/31), Rolf M. Aagaard of the Oslo newspaper *Aftenposten*, also submitted this superbly lit sea-shore figure study.

Vorsatzbild—

Den hervorragenden Farbaufnahmen vom Vulkanausbruch auf Island (Bilder 29–31) von Rolf M. Aagaard fügen wir diese herbe, freie Lichtstudie am Meeresufer bei.

Garde de Front—

En plus d'une série de remarquables photographies en couleur de l'éruption volcanique en Islande (planches 29/31), le grand reporter photographe norvégien Rolf M. Aagaard Aso, du journal d'Oslo Aftenposten, nous a soumis cette étude d'une silhouette au bord de la mer dans un superbe éclairage.

Back Endpaper

Photographer	M. J. Horacek
Camera	Nikon
Lens	24mm
Film	400 ASA (not specified)
Shutter speed	1/125
Aperture	f/5.6
Developer	Kodak D76
Paper	Agfa

This picture did not so much remind us of the famous poem about the shattered statue of the 'King of Kings' found buried in the shifting sands, but rather of a cartoon that once appeared in the English humorous magazine *Punch*. The cartoon consisted of an elaborate drawing of ancient Rome with – tucked away in a corner – the tiny figures of two film makers. One was saying to the other, 'We built it in a day'.

Which is a fair comment on this study in ephemera since it was taken in the back lot of a film studio in modern Rome after the completion of Fellini's 'Satiricon'.

Nachsatzbild—

Dieses Bild erinnerte uns nicht so sehr an die ausgegrabene, zerbrochene Statur des „Königs der Könige", sondern an eine Karikatur, die einmal im englischen Magazin *Punch* erschienen ist. Die Karikatur stellte eine riesige Nachbildung des alten Roms dar, – verschwindend klein standen die winzigen Gestalten zweier Filmproduzenten in der Ecke. Einer sagte zum anderen: „Wir haben Rom an einem Tage gebaut". Dies als Kommentar zu dieser Scheinweltstudie, die hinter einem modernen Filmstudio in Rom nach der Fertigstellung von Fellinis „Satiricon", gemacht wurde.

Garde de Queue—

Cette photographie ne nous évoque pas tant le fameux poème sur la statue brisée du « Roi des Rois » retrouvée ensevelie dans les sables mouvants, mais plutôt un dessin humoristique paru dans le magazine humoristique anglais Punch. Le dessin représentait un croquis élaboré de la Rome ancienne avec, dans un coin, les silhouettes de deux cinéastes. L'un disait à l'autre « Nous l'avons construite en un jour ! ». Ce qui serait un bon commentaire pour cette étude d'une Rome éphémère puisqu'il s'agit d'un cliché pris dans la cour d'un studio cinématographique de la Rome moderne après la fin du tournage du film de Fellini « Satirikon ».

Dust Jacket

Photographer	Francisco Hidalgo
Camera	Nikon

The fine work of French photographer Francisco Hidalgo has been reproduced in many books and magazines. He describes himself as a photographer/illustrator and often uses his original exposure just as a preliminary to graphic after-work (such as solarization or colour masking) in order to produce the end result. In this case the chance of seeing a bird so perfectly positioned against the setting sun would have been very remote so Hidalgo made two separate exposures and then sandwiched the transparencies at leisure in order to complete his composition. The location was Africa.

Umschlagbild—

Die großartigen Arbeiten des französischen Fotografen Franzisco Hidalgo sind bereits in vielen Büchern und Zeitschriften veröffentlicht worden. Er nennt sich selbst einen fotografischen Illustratoren. Oft benutzt er seine ursprüngliche Aufnahme als Grundlage, auf der er dann seine Plakatentwürfe entwickelt, indem er allerlei verschiedene Techniken anwendet (z.B. Solarisation, Farbmasken, Doppel-negative), bis er schließlich das graphische Endprodukt enthält.

In diesem Falle hier wäre es ein vergebliches Bemühen gewesen, einen Vogel so perfekt plaziert gegen den sinkenden Sonnenball fotografieren zu wollen. Hidalgo machte 2 verschiedene Farbdias, die er dann zu der von ihm beabsichtigten Komposition vereinigte. Die Aufnahmen stammen aus Afrika.

Couverture—

La très belle oeuvre du photographe français Francisco Hidalgo a été reproduite dans un grand nombre de livres et revues. Il se décrit comme un photographe/illustrateur et il utilise souvent son cliché original comme base à un travail graphique (telles que solarisation ou caches de couleur) pour obtenir le résultat définitif. Dans le cas présent, il avait peu de chance de jamais voir un oiseau placé aussi parfaitement contre le soleil couchant, aussi Hidalgo a-t-il pris deux clichés et ensuite placé les deux diapositives l'une sur l'autre pour obtenir cette composition. L'emplacement est en Afrique.

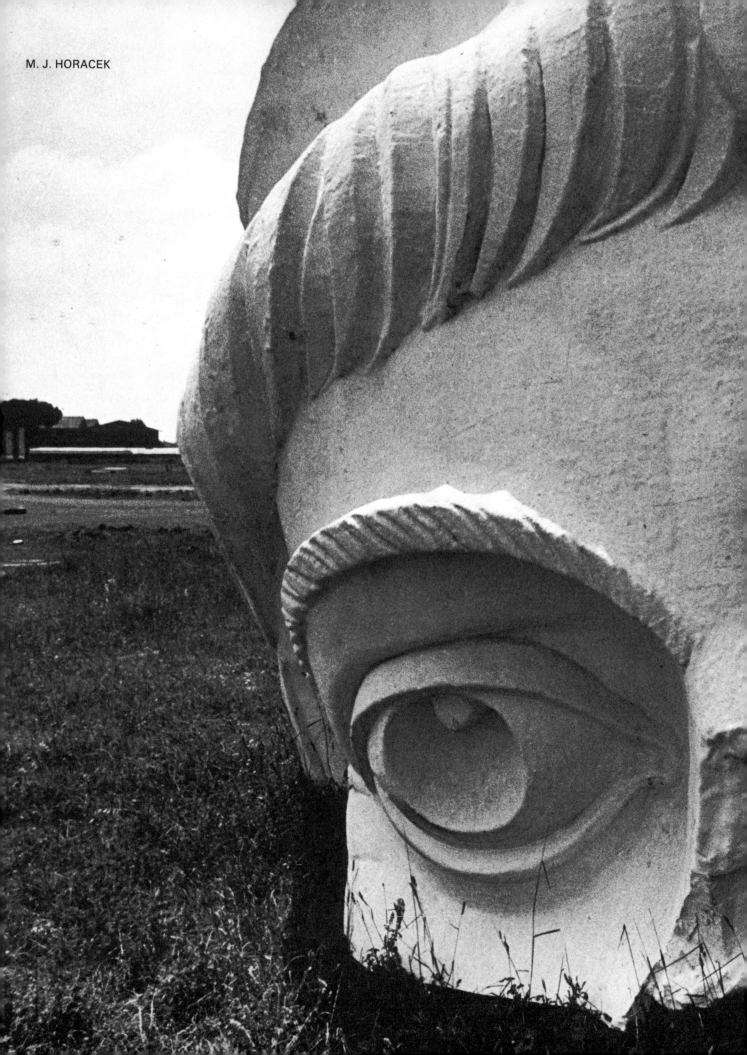

M. J. HORACEK